PICTURING RUSSIA

Picturing Russia

Explorations in Visual Culture

Edited by

Valerie A. Kivelson and *Joan Neuberger*

YALE UNIVERSITY PRESS / NEW HAVEN AND LONDON

Published with assistance from the Mary Cady Tew Memorial Fund.

Designed by Mary Valencia
Set in Minion by Tseng Information Systems, Inc.
Printed in the United States of America by Sheridan Books, Ann Arbor, Michigan.

Library of Congress Cataloging-in-Publication Data
Picturing Russia : explorations in visual culture / edited by Valerie A. Kivelson and Joan Neuberger.
p. cm.
Includes bibliographical references and index.
ISBN 978-0-300-11961-9 (alk. paper)
1. Art, Russian. 2. Russia — In art. 3. Art and history. 4. Visual communication. I. Kivelson, Valerie A. (Valerie Ann) II. Neuberger, Joan, 1953–
N6981.P53 2008
709.4709
2007039315

A catalogue record for this book is available from the British Library.

The paper in this book meets the guidelines for permanence and durability of the Committee on Production Guidelines for Book Longevity of the Council on Library Resources.

10 9 8 7 6 5 4 3 2 1

We dedicate this joint project to our fathers:

Daniel Kivelson
July 11, 1929–January 23, 2003

Henry L. Neuberger
July 11, 1921–January 23, 2004

Contents

CONTENTS

Illustrations

Acknowledgments

We would like to thank the University Co-operative Society at the University of Texas at Austin for its generous support of this project with a subvention award. We would also like to thank the History Department and the Office of the Vice President for Research at the University of Texas at Austin and the History Department, the Office of the Vice-President for Research, and the College of Letters, Arts, and Sciences at the University of Michigan for their financial support for our research.

We would like to thank all the contributors to this volume for their extraordinarily creative responses to the challenge of rethinking Russian history in visual terms. Our sincere thanks also go to Chris Rogers, Jonathan Brent, and Mary Pasti at Yale University Press for shepherding this gargantuan project into print. We would especially like to acknowledge the contribution of our colleague Lindsey Hughes, who sadly did not live to see the publication of this book.

Citations for direct quotations are provided at the end of each essay. Full citations for all other references can be found in the Selected Bibliography.

PICTURING RUSSIA

1

Seeing into Being

An Introduction

Valerie A. Kivelson and Joan Neuberger

I llustrating publications and presentations is easier than ever. Digital technology, the easy transfer of images from the Internet, and the willingness of conference centers, businesses, schools, and universities to invest in projection equipment make it increasingly attractive to insert images into lectures and books, presentations and papers. The result has been paradoxical. Within the humanities and social sciences, a new visual discourse has grown up alongside conventional scholarly activities, but even as we employ visual aids, we, as students, teachers, readers, audiences, and presenters, rarely give enough thought to the specific ways that visual sources contribute to our understanding of history and culture or to the ways that visual experience shapes historical experience. All too frequently, images are used merely as accompaniment (for readers' viewing pleasure) or distraction (from the density of an academic monograph) or advertisement (read *my* book, take *this* course).

One purpose of this book is to explore ways to use images more thoughtfully and integrate them more productively in historical and cultural analysis, to use images to enhance and not merely to illustrate. To that end, we hope this book will encourage readers to pay attention to the special qualities of the visual, to think about images *as images*. The second purpose is to explore Russia through its visual culture, to look at the range of visual images and material objects that Russians have produced throughout their history. Each essay provides a sustained, careful reading of an image or set of images to help us understand how Russians of different eras represented themselves visually, understood their own visual environment, and used images to construct identities and to exert or subvert power. The book covers the entire span of Russian history, from ancient Kiev to contemporary, post-Soviet society, and it examines the entire Russian/Soviet Empire: from famous monuments in the capitals, such as St. Basil's Cathedral, to family photograph albums from the Russian provinces, to the objects of Russian imperialism, such as Turkmen rugs of Lenin and porcelain figurines of all the peoples of the empire, collected by Russians as consumer objects. The essays consider a wide variety of genres: material objects (stirrups, a snuffbox, the tsar's crown, painted distaffs, folk embroidery); architectural monuments (a cathedral, a war memorial, the Moscow metro); icons, paintings, and

portraits; news and art photography; cheap popular prints, posters, and advertisements; films, fashions, money, and maps.

In this book, visual culture is defined as including the visual products, practices, and experiences of a culture. It encompasses artifacts considered high culture, which are produced for a select audience, as well as objects and practices of mass culture. Our conception of visual culture also includes the meanings and values attributed to vision, to the act of seeing, and to the various objects viewed. Finally, visual culture embraces the interaction between producers and consumers of the visual—that is, the intentions, uses, and meanings imputed by producers and the understandings and practices of viewers and consumers. If culture was once thought to be shared by all members of a given community and at the same time to be virtually unchanging, cultural historians have become far more attuned to the ways that cultural practices and values are experienced differently by people in different social circumstances. The same can be said for visual culture, which can be imagined as a galaxy of vibrant, diverse, at times conflicting, at times complementary values, concepts, and practices expressed in visual form.

Visual *studies* is the field devoted to studying visual *culture*. It differs from art history (although they are not incompatible) in its emphasis on seeing as an embedded social practice. Visual studies follows the also relatively new field of cultural studies in its attention to the shifting, fragmentary, culturally and individually specific responses to visual objects and in its awareness of visual artifacts as commodities produced in a world of exchange and power.

APPROACHES TO VISUAL CULTURE

Working within this broad conception of visual culture, the authors of the essays in this book adopt various methodological approaches and pose widely varying questions. Although most of the authors combine more than one approach, the essays fall into four rough groups, which together serve to outline a broad-ranging methodology of visual analysis. The four approaches are: (1) using the visual to uncover information not recorded in written sources; (2) decoding symbolic or connoted meanings in visual sources; (3) identifying historically specific modes of viewing and of attributing meaning to visual knowledge at a given time; and (4) studying seeing practices as formative and sometimes transformative aspects of historical experience. The first two approaches employ visual sources as supplementary to written ones and read them using the kinds of skills and questions traditionally used by historians. The second two set the visual itself as the question for investigation and push historical inquiry in new directions.

Many of the authors in this volume use the first approach, turning to the visual record to discover information that would otherwise remain inaccessible. The prosaic details of life rarely merit recording in the grand chronicles of history, but scholars can examine visual sources— such as wax drippings on manuscript pages or objects and practices depicted in paintings, embroideries, maps, and photographs—to unearth such information. Not surprisingly, the most glaring gaps in current knowledge of everyday life appear in the earliest centuries, so the most telling examples of this kind of visual examination are found in the essays on medieval Rus. But even in modern times, visual documents reveal everyday practices that have been hidden from view, especially in connection with private life. Visual and material culture can offer exciting insights into otherwise invisible communicative practices: unspoken social codes

are embedded in middle-class fashions, and the social identities of merchants are represented in particular conventions of portraiture.

The second way our authors put visual evidence to use for historical understanding involves reading visual materials for their embedded meanings, intended and unintended, and attempting to parse the ways they were viewed and understood in their own time. This approach is based on the assumption that viewing is not a natural, transparent process; rather, seeing and understanding are mediated through the cultural codes of specific times and places. Understanding visual material as historical evidence requires familiarity with conventions and symbols. By offering explanations of the meanings embedded in a particularly significant icon or a highly abstract Soviet-era film, the authors reconstruct the ways in which historical actors made sense of what they saw. This approach draws on many of the same skills required for carefully contextualized readings of written texts—close reading and reading against the grain—but draws on a visual rather than (or in addition to) a verbal vocabulary.

Third, several of the authors in this volume investigate the meanings attributed to vision itself in particular periods and for particular viewers. Approaches to the visual relate in integral ways to the epistemological orientations of given societies. In many times and cultures, the visual has been understood to provide solid, incontrovertible proof of the reality of that which is depicted or seen. The evidence of the eyes, whether the viewer is a religious visionary or an eyewitness to a crime, is inextricably linked with ways of establishing "truth." The formulaic visual codes employed by painters of Russian Orthodox icons, for instance, conveyed compelling evidence of the spirit of the divine. Regardless of the kind of visual experience deemed most true by a given society (or by discrete groups of people in a given society), believing one's eyes is not always a simple matter. Uncertainties about the reality of visual evidence—in connection with saintly apparitions, spectral photography, or more earthly visual encounters—exemplify common cultural apprehensions about accepting the testimony of the eyes. Tension and doubt are not just products of the modern or postmodern age, where photography and virtual reality have introduced new ways of manipulating the depiction of objects and destabilizing the relation between the seen and the real. Contemporary distrust of the "reality" of the photographic record, however, has taken skepticism to a new level and may indicate a profound shift in the cultural meaning attributed to visual evidence and the changing framework in which visual knowledge is assessed.

Some of the authors here work with textual material that explicitly addresses how seeing works, how the visual affects the viewer, and how visual impressions work differently than do those of the other senses. Twentieth-century filmmakers and painters, for example, wrote about how their works engaged with specific viewing practices. Other authors have excavated less explicit evidence to reconstruct the underlying assumptions about viewing as epistemology and process. Medieval miniaturists, for instance, clearly thought differently than modern viewers do about what visual information to include when illustrating their manuscripts. Formulaic and symbolic details were more important to them than strict realism was. A similar gulf in visual understanding surfaces in the mutual incomprehension of nobles and peasants in the late nineteenth century, who drew altogether different conclusions while viewing one and the same woodblock print.

Along these lines, several essays show that images themselves take on entirely different meanings when viewed in different contexts. The potential meanings contained in images become legible only when the ways viewers saw and used them are understood. A painting presented with great fanfare in a museum and widely discussed in the press strikes viewers differently than does a painting hung on the wall of a merchant's parlor or tucked inside a private album. A commemorative church modeled on medieval Russian antecedents loses meaning and comprehensibility when revolutionary politics and a modernist aesthetic replace monarchist politics and nostalgic aesthetics. Non-Russians looked at images of themselves produced by Soviet authorities with very different eyes than did the purveyors of socialist enlightenment. Photographs of the victims of Nazi atrocities mean different things when published in a 1940s Soviet newspaper or displayed in a Holocaust museum.

The fourth and final set of questions raised by our authors revolves around the idea of seeing as experience. These essays investigate questions raised by Walter Benjamin in his musings on the knowledge constructed by the flaneur strolling through the arcades of Paris. They offer exciting insights into the ways that the experience of seeing can be constructed as visual knowledge by those actively viewing the painted hall of a palace, toying with a bejeweled snuffbox, mingling with the well-dressed crowds at an elegant St. Petersburg musical soirée, or walking into a Soviet metro station. Beyond constructing knowledge, the experience of seeing can operate as a transformative force in history. The experience of looking at an icon's representation of an ideal reality or at a socialist realist evocation of a brave new world, the experience of participating in an eschatological ceremony on Red Square or looking at revolutionary crowds on Nevsky Prospect—all of these can change the parameters of the possible, the conceivable, and hence change actions and outcomes. This in itself offers a new angle on the study of Russian history and opens new possibilities for understanding how religious commitment, emancipation, imperial encounter, revolutionary transformation, or other crucial historical processes were shaped as human actors encountered the visual world around them.

ORGANIZATIONAL STRATEGIES

The wide range of images and approaches represented here highlights the importance of the visual in Russian history and culture and the richness of the visual as an analytical sphere. The material could be organized in any number of ways, each drawing attention to a different set of issues and questions. Some confirm conventional interpretations; others show how a focus on visual culture challenges reigning paradigms. We have arranged the essays in conventional chronological order, which allows readers to picture Russia through time and to understand how ways of seeing and attitudes toward the visual changed over time.

In some ways, this periodization repeats and confirms traditional continuities and ruptures in Russian history. The objects and images from the pre-petrine period that are examined here reflect the hieratic and formulaic productions of a state and society suffused with religious thought and restricted in form and genre by Orthodox Christianity's suspicion of graven images. The reign of Peter the Great predictably brought an unmistakable change, with the introduction of Western imagery and the beginnings of more secular visual expression. The nineteenth and early twentieth centuries ushered in still more innovations, most dramatically

with the development of new technologies (notably photography and film) and new systems of distribution in an expanding commercial market for mass-produced images. The Soviet era was characterized by greater political control and a sharply limited and highly directive range of messages. Again predictably, rampant consumerism and commercialized capitalism dominate the visual sphere in the post-Soviet period.

In spite of the enduring power of this familiar periodization, some of the essays and images pose challenges to the reigning master narratives of Russian history and suggest alternative chronologies. Soviet visual culture, for instance, replicated some pre-petrine practices: in both periods, forms and meanings were highly regulated and deliberately limited. The increasingly vital public sphere of the eighteenth and nineteenth centuries, where images and their meanings were routinely debated by diverse audiences, persisted, if in an attenuated form, into the Soviet era. The essays on the Soviet period also demonstrate the degree to which impeccable socialist concepts could be expressed through visual forms open to a surprising range of interpretations and robust, if often surreptitious, debate. Visual appeals to commerce and consumption lie at the heart of some of the most orthodox socialist creations examined here. Conversely, as Fredric Jameson and others have pointed out, commercial advertising looks a lot like propaganda for capitalism.

The chronological organization of the chapters also allows readers to enter an ongoing discussion in the theoretical literature concerning the proposition that different eras of human history (usually implicitly western European and U.S. history) have variously esteemed or denigrated the visual. The essays compiled here indicate more continuity than discontinuity in the primacy of the visual in the hierarchy of the senses. Even as the modes and meanings of visual communication shift over time, and as the density of manufactured images increases with new technologies, the visual consistently remains a highly valued ingredient in the construction of identities, power structures, and forms of social communication.

Different kinds of questions would arise if the essays were categorized non-chronologically. Clustering them by genre, for example, would allow paintings, buildings, or ceremonial regalia to be examined for information about their distinctive natures and histories. The essays here show that Russian painting, for instance, mediated between powerful institutions and viewing publics through the centuries. Painting played a prominent role in constructing national identity by representing Russia's relations with its divine protectors, its imperial acquisitions, and its western European allies and competitors. In other contexts, painting offered an opportunity for individuals to insert themselves on the historical stage. By examining this particular genre over time, readers can consider painting as an arena for communication between powerful institutions and viewing publics and as a method of normalizing, disseminating, and appropriating political power.

The technologies involved in producing and disseminating images provide another basis for thinking about thematic links among the essays. In Russia's early history, few representational genres met the approval of the Orthodox Church, and little from the quotidian world of crafts production survives, leaving a limited visual legacy. The expansion of the range of visual genres in later centuries, especially with the appearance of mass production, raises questions about the changing historical conditions of visual cultures. Walter Benjamin famously argued that the

saturation of the visual field with mass-produced images resulted in new practices of seeing in the modern era. Essays in this book allow readers to compare viewing practices in a variety of technological contexts, revealing both changes over time and some unexpected similarities. For example, mass-produced images created for a consumer market connect filmgoers with movie stars much as religious icons connected worshippers with the divine, and as socialist realist works linked soviet spectators with a communist utopia.

Clustering the essays by producer opens another set of questions. When does it matter that objects and images were created by the church or by the state, by commercial enterprises or by folk artisans, by men or by women, by dissidents or by defenders of the establishment? Do viewing practices differ when images are directed at elites in possession of arcane knowledge or at mass viewers, or at a national or international audience? Does the status of images as evidence change when they are meant to allure potential purchasers or when they are meant to convince viewers of the truth of a religious or political message?

Linear chronology is convenient for thinking about the sweep of Russian history, but alternative linkages may refresh or even shift our understanding of the historical narrative and enable us to come up with new questions and new insights.

RUSSIAN VISUAL CULTURE

In a volume devoted to the artifacts of one national culture, it is hard to resist the urge to search for cultural uniqueness. In compiling these essays we found ourselves repeatedly asking if there was something uniquely Russian in the historical trajectory of the images or viewing practices analyzed here. Asking such a question poses significant intellectual dangers. We are wary of drawing broad conclusions based on a collection of essays that is not intended to provide definitive coverage of Russia's visual history. We are also reluctant to suggest that any trends we find might constitute a new master narrative. Nor do we wish to suggest that we have discovered fundamental or unchanging markers of what it means to be Russian, a condition that is surely fragmentary, diverse, and in flux. In global terms, we cannot declare particular elements of visual culture to be uniquely Russian without an extended comparative study. Nevertheless, in spite of these caveats, a number of trends emerge from the essays that seem to us important ways to rethink Russian history and culture. We present them here to stimulate discussion both about visual constructions of national identity and about visual experiences that transcend or subvert national traditions and issues of identity.

Most striking to us is a conspicuous predisposition, across most of the thousand years covered in this book, for Russians to turn to the visual in order to summon a new reality into being, for them to use the experience of viewing as an engine of historical or eschatological transformation. This visual practice, which we call *seeing into being*, is most pronounced in the transcendent viewing experience associated with medieval and early modern religious imagery and in the transformative quality ascribed to Soviet socialist realism, but it appears in many other visual experiences discussed in this book. The recurrent and powerfully effective idea that it is possible to depict what exists just out of reach, just out of sight, was a central feature of Orthodox and Soviet iconography, but it also crops up in nineteenth-century painting, photography, and commercial artifacts, including popular woodcuts. The prevalence of seeing into

being in these essays makes a compelling case for a transformative, and perhaps particularly Russian, way of viewing. We do not mean to assert that all Russians adopted this mode of visual transcendence, or that it was equally in effect at all times, or that it was in effect only in Russia and never elsewhere, but the commitment to seeing into being accords well with a familiar Russian maximalist idealism, a belief in the perfectibility of humanity and in the possibility of transforming reality to match an ideal form.

The very diversity of the images and analyses collected in this book, however, serves as a brake on overgeneralization. Seeing into being was less prominent in the eighteenth and nineteenth centuries and in the post-Soviet years, when other modes of viewing became dominant. In these eras, perfectionist visionaries coexisted with people whose viewing practices were based on connoisseurship, consumerism, humor, erudition, and nostalgia. Some Russian viewers glared critically at the world around them while others looked at the accoutrements of middle-class life with hungry and approving eyes. And yet these types of viewing, which seem so secular and non-apocalyptic in other cultural contexts, seem marked (perhaps in hindsight) by a heightened transformative quality, by a special effort to bring another reality into being. Such caveats serve as a reminder that viewing practices are always historically situated and that seeing occurs in varying registers at different times, or even in the same time in different contexts. Overall, we believe that the recurrence of seeing into being in Russian visual experience is a significant finding.

Two more specific, less sweeping aspects of a particularly Russian visuality emerge from these essays: the progressive westernization or modernization of the visual field and the overwhelming role of reigning authorities—the church, the state, and the party—in producing, shaping, and controlling images. Organized chronologically, the artifacts and images in this book show an unmistakable transition from something evidently Russian and premodern to something recognizably of a piece with the modern visual universe, much of which originated in western Europe. Identifying precisely what constitutes the Russian and premodern character of the earlier images or the Western, modern content of the later ones poses one kind of challenge. Explaining how that westernizing and modernizing of the visual field took place and what that transformation means constitutes a second. Although our authors, probably wisely, do not directly tackle the first, definitional question, they do address the second by attempting to identify a visual component in the interaction between Russia and the West. A number of authors find pockets of easy, unselfconscious appropriation of Western imagery, quite different from the intensely conscious and culturally fraught polarizing polemics familiar from other sources. Bourgeois photography and fashions in clothing, for instance, and the creation of fin-de-siècle stars of screen and stage served more as signifiers of prosperity, respectability, urbanity, sophistication, or up-to-the-minute modernity than as indicators of a specifically Russian cultural identification or a stance in the westernization debates.

The unmistakable dominance of the ruling authorities in the production of the images and artifacts discussed in this volume raises another set of questions. This anthology conveys the impression that the state, with its ideological partners of church and then party, played a crucial role in producing Russian visual culture. That conclusion would support long-standing historical claims about the hypertrophy of the state in Russian history, but that impression

may be misleading. The conspicuous presence of the authorities may reflect the selection bias of scholars predisposed to take an interest in political power, or it may reflect the ability of the state to control the preservation of its own visual products. Many of our authors, however, stress their subjects' independence from state institutions. On this question, our suspicion is that the overriding presence of church, state, and party reflects a genuine and significant aspect of Russian visual history, rather than a spurious by-product of authorial focus.

VISUAL CULTURE AND NEW HISTORICAL QUESTIONS

If the essays in this book confirm familiar stories—of periodization, westernization, or state control—they also show that the visual can open up new lines of inquiry that enhance the study of history and culture. Attention to the visual introduces new topics as worthy historical ones and brings new aspects of the past under the historical gaze. This is one of the most productive contributions that any theoretical literature can make: to provoke new questions and new directions for investigation.

Everyone interested in visual culture struggles to understand what distinguishes sight from the other senses, what gives seeing its unique power. People seem to have an instinctive sense that visual images are different from anything else, but defining that difference turns out to be devilishly hard. This subject has bothered and inspired thinkers since ancient times and has generated a huge literature that nonetheless leaves many questions unresolved. We do not intend to address the issues involved in the philosophical investigation into the nature of images or the physiological study of perception. Instead, the essays here demonstrate that images have been used differently and function differently than do texts. Such differences lead us to ask: What is being conveyed visually at any given time? What is being said visually that could not or would not be articulated in words or in print? These new questions enable rigorous comparison of the functions of the visual and the textual on a historical level.

One of the most controversial aspects of the visual is the extent to which images are more open to interpretation than texts are. Because words are thought to express finite meanings, images can seem more open to interpretation than words are, but conversely, because words bear only an abstract and conventional relation to the objects they signify, images can seem more fixed in meaning. In this book we consider the ways images function as open or closed signifiers in specific historical contexts and, in comparison with textual documents, whether they suffer more or less restriction in a controlled society, whether they can be read more or less subversively, and whether they can on occasion be subject to more blatant misreadings and misunderstandings.

Some of the authors address these issues head on. A number of the essays analyze visual propaganda, which presupposes an ability to create closed or directed messages. Propaganda loomed large in Soviet life and in that era, as in the premodern era, images were assumed to have more or less set meanings with a range of relatively closed and predictable interpretations. Although today viewers may be alert to possible counter-readings and subversive interpretations of the visual, propagandists of all kinds assume that their scripted ceremonies and directive images can lead the viewer to the desired conclusion. Essays in this book provide evidence to confirm that propagandistic images were indeed frequently read in the prescribed manner,

which we, in our desire for subversive subtlety and heroism, are sometimes reluctant to accept. Although we tend to scoff at the simplistic efforts of propagandists, the images they produce often work in frighteningly effective ways, suggesting a power and a mystery inherent in the viewing process that continue to elude efforts to explain.

Conversely, several of the authors here make the case that in politically constricted times, artists and filmmakers played on the inherent ambiguities of visual address to complicate and challenge the prevailing orthodoxy. Even the most conventional socialist realist films and paintings contained opportunities for diverse readings. Several essays on posters and popular prints illustrate how propagandistic images were read, misread, or parodied by their target audiences. Others show how messages were embedded — sometimes deliberately, at other times accidentally — in visual imagery that contradicted, undermined, or destabilized the official verbal scripts. Architects in the 1950s, for instance used unimpeachable socialist rhetoric in textual descriptions of their work while incorporating prohibited modernist visual forms in their structures. Stalinism and Nazism could be subtly linked visually at a time when verbal comparisons were out of the question. These instances of visuals functioning against the thrust of official discourse suggest, first, that images can sometimes operate in a more open, less prescriptive mode than words can and, second, that in a society like the Soviet Union, where communication was closely monitored, the visual can be used to convey complex, multivalent ideas. The ambiguity that characterizes the visual allows multiple messages to be expressed safely in a dangerous context. Some of the images that move us most potently or intrigue us most hauntingly are those whose ambiguity overrides the prevailing political or cultural binaries.

One finding that surfaces frequently in our authors' analyses is that producers of images expressed their ambivalence and anxieties, acknowledged or unacknowledged, in specifically visual form because the visual can encompass dialectical tensions or conflicts without requiring that they be sorted out, analyzed, or resolved. Here, visual images function like humor, incorporating not only what artists and others cannot say out loud but also what they do not want to confront fully. In Andrei Bolotov's domestic album, watercolor landscapes were skillfully contoured to embody the landlords' subliminal fears of serfs' latent anger, fears that found no expression in the accompanying texts and had no place within the conventions of the arcadian idyll that the album purports to celebrate.

The capacity of the visual to express unresolved or unacknowledged contradictions makes images particularly suitable for expressing ambivalent and layered views of time itself. The chronological layout and sweep of the essays collected here emphasize the degree to which images can engage with the past, whether in nostalgic, anguished, celebratory, humorous, or critical mode. The past appears frequently in visual artifacts, where it is consciously or unconsciously appropriated, redeployed, reinvented, and reimagined. Even images that aggressively deny the existence or the relevance of a historical legacy are haunted by that past through its conspicuous absence. The integral connection between history and the visual is not only fundamental to our explorations here but is inscribed in the artifacts themselves.

Images create particular kinds of dialogue with the past, whether consciously or unconsciously. The Cap of Monomakh, for instance, a crown of medieval steppe origin, acquired an

overlay of Russian Orthodox and dynastic ornamentation, which has allowed diverse political and symbolic appropriations by later rulers up to and including President Vladimir Putin. In market-driven contexts as well, the humorous redeployment of familiar images—using Viktor Vasnetsov's nineteenth-century painting *Bogatyrs* in post-Soviet advertising, for example—can evoke feelings about history, gender, and nation without explicitly labeling them. In a highly self-conscious return to one of the key moments in the history of Russian painting, a number of late Soviet nonconformist artists reimagined and repainted Kazimir Malevich's *Black Square* to position themselves in the Russian artistic tradition. Through their creative dialogue with this visual icon, they defined themselves as artists and, in so doing, redefined Malevich's legacy.

Representational media, such as painting, seem to promise easy access to a static and transparent past, but they often simultaneously underscore the elusiveness of the past and the difficulties of recovering historical experience. Their ability to fix a single moment can make viewers aware of the invisible, unknowable instants before and after the one depicted, evoking a poignant sense of the distance of the past. What the art historian James Elkins wrote about painting rings true for other media: "The ephemeral instant and the unending duration are forced very close together."[1] Obsolescence, decay, and reconstruction all play important roles in shaping images and their meanings in the present. Photographs of the northern Russian forest engulfing the sites of an abandoned Soviet prison camp illustrate this paradox. Images of the natural beauty that surrounds the unnatural prison enhance understanding of the prison experience, while at the same time, the sight of the vibrant forest overtaking the ruined barracks makes the harsh realities of the prison regime seem irretrievably distant in time.

All historical sources reach out across a chasm in time. Photographs and films appear to bridge this gulf because celluloid bears the molecular imprint of the light that once reflected off the photographic subject. This physical property creates a tension, identified by Roland Barthes, between a sense of the irrefutable reality of the moment captured in a photograph and an awareness of the constructed nature of images and the vagaries of visual perception. In spite of the ever-increasing sophistication of technologies for altering photographs and in spite of vigorous popular suspicion of the authority of photographic evidence, people today still tend to view historical photographs and films as direct links to the past. The persistent impression that photographs and films depict an unmediated past distinguishes these visual media from other historical documents. The essays in this book that treat photographic sources offer a variety of strategies for reading them, for acknowledging their contingencies while still valuing the extraordinary information they contain.

The idea that technology can create entirely new modes of visual experience leads back to the question of whether there is something special about the modern in visual terms. Defining the modern is not a new problem, but multiple and conflicting answers arise when it is posed in connection with visuality. While we share the thinking of current Soviet historians who stress the USSR's participation in a pan-European modernity, we also see visual continuity or, rather, striking throwbacks to Muscovite visual practices. In specifically visual terms, distinctively modern technologies of power were put to use in the Soviet drive for mass mobilization, but the actual visual instruments of modern power operate very much like premodern ones in their use of the time-tested Russian practice of seeing into being. As Benjamin argued, the

permeation of commercial and urban settings with mass-produced posters, newspapers, and other mass media affected the way viewers experienced modernity, in particular by desacralizing the visual field. Nonetheless, the essays in this book show that the evocative, inspirational, transformative use and reception of images carries across the divide between hand-painted icons and the most casually produced advertisements.

Seeing exerts a potent force on the human imagination, a force that is conditioned by the kinds of cultural, historical, and aesthetic forces addressed by essays in this book. Our vulnerability to searing images in the morning paper demonstrates this power, as does the way that certain images come to encapsulate particular moments and events. Videos of the collapsing World Trade Center, photographs of humiliated prisoners at Abu Ghraib, and inflammatory though largely unseen newspaper cartoons of Muhammad provide the most recent instances as we write this introduction, but by the time this book is published, equally indelible images will displace them. In everyday life, people imagine themselves, their surroundings, their present, and their past through what they see. Focusing on visuality adds an entirely new dimension to the study of Russian literature, history, art, and culture.

NOTES—1. James Elkins, *Pictures and Tears: A History of People Who Have Cried in Front of Paintings* (New York: Routledge, 2004), 140.

2

Dirty Old Books

Simon Franklin

W e all know what writing is for. It is there to be read. It converts words into a visual code, which we then, in the act of reading, convert back into words. The specific purpose of writing is to convey a verbal message. The idea of the written, verbal message is central to a common cultural perception of the entire past of humankind. A "prehistoric" age is widely taken to mean an age before written sources. History begins when we can read the words that people in the past wrote. To put it crudely: before the written source—before the technology to record articulate contemporary witnesses—we have only archaeology, which, fascinating and informative though it may be, does not yet quite amount to "real" history. In this perception, writing makes history, in the most literal sense.

The "we" in this caricature are less sophisticated than the real "we." But even those who are more finely attuned to nuance can slip into the habit of treating writing simply as a verbal medium, of using written historical sources simply as encoded words, of ignoring or under-estimating the significance of the graphic, hence visual, nature of writing. What writing conveys need not be limited to the words themselves. Here we consider some aspects of what can be gained from reading the written historical source as a visual object. Our examples are two contrasting images of manuscripts of the Gospels.

In medieval Rus, where high culture was virtually monopolized by the church, the Gospels were among the commonest of books. The texts of the Gospels are important for our under-standing of early Rus culture, but the text of an individual copy of the Gospels says nothing new or distinctive or historically informative, except to highly specialized textual and linguistic historians whose passion is to analyze every minute variation of expression or spelling. It is not surprising, therefore, that the oldest surviving dated manuscript book from Rus is a Gos-pel lectionary, containing readings arranged for church services, rather than the texts of the four Gospels in sequence (fig. 2.1). The colophon (inscription at the end) by the manuscript's scribe, Grigorii, does provide some hard historical information: that he worked on the book from October 12, 1056, to May 12, 1057; that Prince Iziaslav ruled both Kiev and Novgorod; and that the manuscript had been commissioned by Ostromir, Iziaslav's appointee as governor of Novgorod. Otherwise, a Gospel is a Gospel is a Gospel, and historians who encounter the manuscript only in lists of texts may well assume it to be of no further interest.

This would be a pity, for the *Ostromir Gospels* is a far more eloquent witness to the culture of

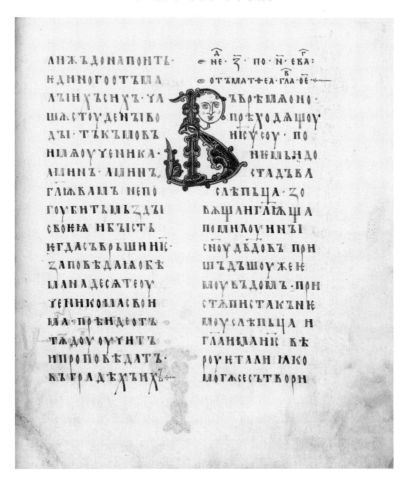

2.1. *Ostromir Gospels,* 1056. Manuscript on parchment.

its time when interpreted as a visual document than when read as a verbal text.[1] As a verbal text, it is merely typical. As a visual document—indeed, as a made object—it is quite exceptional. No expert eye is needed to see, even from a cursory glance at a not-to-scale reproduction of a random opening, that this book is meant to be visually impressive. The proportions of the page, the generous margins, the evenness and precision of the lettering, the balancing frills and swirls of the decorated initial letters—all suggest a care for appearance well beyond the basic textual requirement that the words be legible. The book also contains full-page portrait miniatures of the Evangelists: only three other dated Rus manuscripts from before the fourteenth century include miniatures. This obvious expertise and—we may surmise—expense already suggest that although the *Ostromir Gospels* is the earliest surviving dated East Slav book, it was by no means the first book to be produced, but was part of a established tradition and culture of book production. However, this in itself does not yet tell us to what extent we can generalize, to what extent the *Ostromir Gospels* represents an eleventh-century cultural norm, a general medieval norm, or a small subcategory only. Does it imply, for example, that books in general

were treated as objects of beauty and luxury? Or that Gospel lectionaries in particular were elevated as devotional objects central to the ritual performances of Christianity? Some clue is perhaps provided by another superficial aspect of the book's appearance: its remarkably clean condition and fine state of preservation. The *Ostromir Gospels* was written nearly a thousand years ago. Even allowing for the important fact that parchment (which is made of animal skin) survives much, much better than does paper (which was not regularly used in Rus for a further three centuries) and allowing, too, for some careful restoration in the 1950s, this book, with its eminently functional text, does not look as though it can have been used very much. Should we therefore suspect that it survives not as a random product of its time but as a product unusual or nonstandard in some way?

Such speculation can be prompted by the object alone, but to go further we need to look specifically at the context and at the basis for comparison. Let us start with measurements. By the standards of the age and culture, the *Ostromir Gospels* is huge. Each of its 294 parchment leaves measures 13 ¾ by 11 ¹³⁄₁₆ inches, which means that the whole book uses more than 35 square yards of animal skin. With a page-area of nearly 163 square inches, it is—among approximately three hundred East Slav manuscript books that survive from the first three centuries of Rus Christianity—not merely the earliest with a date but also the grandest.[2] In fact, one would be hard pressed to find a larger-format manuscript even among the most prestigious and luxurious Greek books from Byzantium itself. Although the verbal text of the *Ostromir Gospels* is absolutely typical of its cultural milieu, once we treat the book as a visual document, it turns out to be very exceptional indeed: exceptional enough to be accorded, for almost a millennium, the special treatment that has ensured its survival; exceptional enough, I might suggest, for it not to function primarily as a book at all but as a physical manifestation of piety and devotion. And here, among other mid-eleventh-century visual manifestations of piety, is where we can find a more meaningful context than by simply placing it among books whose verbal texts were necessary components of church services. The *Ostromir Gospels* is a monumental product of an age noted for its monumentalism across the cultural forms: the church of St. Sophia in Kiev—the largest in Rus until the fifteenth century, and among the most magnificent in the contemporary Eastern Christian world; the *Sermon on Law and Grace* by Metropolitan Ilarion, with its bold and confident vision of the dignity of Rus among Christian nations. In this sense, the *Ostromir Gospels* is typical: among analogous luxury products of this first, self-conscious and self-declaratory "Golden Age" of early Rus Christianity. It tells us a great deal more as an exceptional visual document than as a standard verbal text.

Contrast the cleanness of the *Ostromir Gospels* with the dirt and general bedragglement of our second illustration (fig. 2.2 [color section]). This, too, is a manuscript of the Gospels, although here the text is of the four Gospels complete and in sequence rather than arranged as a lectionary. The manuscript is paper, rather than parchment, and the watermarks used in the manufacture of the paper indicate that it was produced in the third quarter of the sixteenth century (which is consistent with the style of handwriting), so it about half a millennium younger than the *Ostromir Gospels*. It is also much smaller, measuring a comparatively modest 9 ⅝ by 6 ½ inches. It has no scribal colophon, no name, no acknowledged significance. It was

sold by the Soviet government in the 1930s in a miscellaneous batch of manuscripts, and it has migrated through various private collections in America and Europe since then. The reason for its collectability is, presumably, that it does preserve three pretty illustrations of the Evangelists (Mark, Luke, and John). But here we are more interested in the dirt, for it is the dirt that brings this otherwise standard object to life as a visual document.

How should the dirt be "read"? The first point to note is that the dirt is not evenly distributed throughout the manuscript. Many of the pages are reasonably clean; the dirt suddenly accumulates toward the end, and nowhere except in these last few leaves is the paper itself so badly damaged that it requires—as in this illustration—major repair to the margins. Should we then surmise that the final leaves became soiled and damaged in handling, perhaps because the book was unprotected by a binding? Or was the book stored next to moisture or dust? Or was it dropped and soiled? None of the above. If we look closely at the dirt, we can see that it appears in droplets, but these are not traces of water damage. These are the remains of droplets of candle wax. Spilling wax onto manuscripts was a known hazard of reading before the age of gaslight and electricity. It was all but unavoidable over time (there are even some traces of wax droplets in the *Ostromir Gospels*). Manuals of monastic discipline warned specifically against melted wax: then, as now, librarians were anxious not just to preserve books *for* readers but also to preserve books *from* readers.[3] This kind of dirt is therefore evidence not of neglect but of use, and it transforms the manuscript from a static text into a dynamic historical witness. In Alexander Pushkin's *Evgeny Onegin* (7:XXIII–XXIV), Tatiana finds it a revelation to peruse the marginal marks in Onegin's books—the pencil marks, the nail marks—as clues to the living reader. So here also, by following the distribution of wax droplets and other signs of intense use (such as the damaged margins) we can, so to speak, read the reader. And what the distribution of this dirt shows is that the book's functional value was not to be found in the Gospel texts, and certainly not in the miniatures, where the staining is relatively light and infrequent. Wax droplets and marginal damage proliferate in the final section of the manuscript because this section contains the summary calendar of saints' days for the year, together with indications of the appropriate passages for those days. This section was the reference section, needed regularly for practical purposes, whereas not many of the book's users seem to have turned very often to the texts from the complete Gospels (a lectionary would have been the more functional version).

This pair of examples from opposite ends of the spectrum—from the ultra-luxurious to the relatively plain and scruffy—barely begin to convey the range of information that can be gleaned from examining early books visually, physically, individually, as objects in living use. Reading the texts (often in modern printed editions) we can only reflect on what the words mean to *us*. Reading the visual document we gain insight into what the book meant to those who made it, to those for whom it was made, and to the generations of those who owned or used it.

The visual study of fine books such as the *Ostromir Gospels* has long been a standard component of medieval art history, but the visual implications of dirtier books—specifically, of the dirt in books—are, at least among historians of Russian culture, surprisingly underexplored. A systematic, comprehensive mapping of wax stains over a large number of manuscripts might

go some way toward providing a more nuanced and dynamic picture of the real functions of texts. Viewing such manuscripts only as written sources, we see only their verbal messages. Viewing them as visual sources, we extract aesthetic (and economic and social) information about their nonverbal aspects; the visual document can be a vital clue to the intonation, to the differentiated significance, of the words themselves.

NOTES—1. For a description of the *Ostromir Gospels,* see *Svodnyi katalog slaviano-russkikh rukopisnykh knig, khraniashchikhsia v SSSR. XI–XIII vv.* (Moscow: Nauka, 1984), no. 3; for a facsimile edition, see *Ostromirovo Evangelie. Faksimil'noe vosproizvedenie* (Moscow: Avrora, 1988).

2. I have not been able to identify a book with a larger page area produced before a mid-fourteenth-century Gospel lectionary, which measures approximately 14 $\frac{9}{16}$ by 12 $\frac{3}{16}$ inches; see *Svodnyi katalog slaviano-russkikh rukopisnykh knig, khraniashchikhsia v Rossii, stranakh SNG i Baltii. XIV vek: vypusk 1 (Apokalipsis-Letopis' Lavrent'evskaia)* (Moscow: Indrik, 2002), no. 132.

3. A sentence instructing monks to take care not stain manuscripts with candle wax or spittle occurs as early as the eleventh century, in the first monastic "Rule" to be adopted in Rus, at the Caves monastery in Kiev; see A. M. Pentkovskii, ed., *Tipikon patriarkha Aleksiia Studita v Vizantii i na Rusi* (Moscow: Izd-vo Moskovskoi Patriarkhii, 2001), 408.

3

Visualizing and Illustrating Early Rus Housing

David M. Goldfrank

Almost everybody pairs shelter with food as a basic need for survival. On the most funda-mental sensory level, we associate shelter with touch and smell, with the entire experi-ence of feeling warm and dry, with the scents of the materials, the fuel, and humans living in close quarters, not with sight. So, in fact, did the early Rus, and one piece of writing showers pity on those lacking winter abodes, who could warm only one side of their bodies by an open fire and then try to stay warm by huddling together.

Housing also has its purely visual side. When people see their own and others' dwellings, they react mentally and emotionally. Everywhere the external aspects of private homes are public space, sometimes with strict uniformity requirements, as with clothing, adornments, foods, drink, music, dance, and plastic arts. Special people have special housing as well as special clothing, with the finest and rarest reserved for royalty. In medieval Rus (as elsewhere) the sight of a luxurious house tempted not only robbers but also rapacious officials. The bitter twelfth- or thirteenth-century satirist known as Daniel the Prisoner wrote: "Do not have your house near the king's house, and hold no village near the prince's village: for his steward is like a fire kindled by an asp, and his servants are like sparks."

So how did the Old Rus live, and how did they visualize their housing? For the first question we turn to what the archaeologists envision above the ground on the basis of remains found underneath it. For the second question, we have few sources but can elicit the unexpected out of Old Rus's earliest extant illustrated chronicle.[1]

Archaeology shows that in medieval Rus most dwellings of any size lay partially dug into the ground, a development from the fully sunken Upper Paleolithic quasi-burrow, which preceded woodworking and partial elevation. Starting around the first century of the Christian Era and then with greater skill and frequency, the Rus used iron axes and saws to hew precise grooves in logs and crafted boards, planks, beams, girders, support columns, and small rectangular sliding wooden windows.

Archaeologists have determined that in the eleventh to twelfth centuries, several types of partially dug-out, rectangular houses could be found together in the same town. A clay oven-stove in a corner removed from the door of a one-room house or in a corner close to the door

of the interior, larger room of a two-room house was typical of all dwellings and was used for cooking and heating. Combinations of branches, twigs, brush, earth, and sod provided the materials for insulation and, sometimes—we lack sure evidence here—for the upper walls and roofing. Remains of attached, non-sunken outer buildings, a few with their own stoves, have also been found, indicating that people tried, weather permitting, to avoid overly cramped quarters.

Of the two most common of the rectangular types, the one-room *zemlianka* (from *zemlia*, "ground, earth"), a sod, clay, or mixed clay and wooden house set as deep as 5 feet into the ground, with about 10 by 13 feet of floor space, proved the easiest and fastest to erect. It sometimes served as a temporary shelter after a fire or while a frame house was under construction. In determining the nature of these structures, specialists have been able to draw on modern examples, not just archaeological remains. For example, Ukrainian immigrants to rural Alberta before World War I built modified zemliankas as their first houses.

The other popular type of house is usually called the *poluzemlianka*, or half-*zemlianka*. Normally sunk less deeply into the ground, it had a frame that looked like Lincoln Logs set together in matched grooves at the corners, and it rose with a continued log frame or with sod walls, or both. A commoner living in one of these half-zemliankas in Kiev's Podol area might hold with it the equivalent of a 50-by-60-foot plot of land—historians have no idea about the actual ownership of such houses or land. Inside the city walls, the houses stood closer together and usually constituted part of a larger complex or an urban villa. Solid, complete log frames, with corners set on stumps or planks, with floors of split logs placed on the earthen bed, with birchbark and moss used as padding insulation where the perimeters of the 4- to 6 ½-inch-diameter wall logs touched, and with a wood-framed clay foundation for the oven-stove characterized some workshop houses with 200 square feet of floor space.

The "carcass" frame house, a third type of construction, had a shallower foundation, maybe 8 to 28 inches deep. It was anchored by log columns or posts 10–14 inches in diameter (roughly the size of nine standard American four-by-fours combined), set into their own deeper holes in the corners and sometimes also at the middle of the sides. Board walls rose from their own trenches in the foundations and were set into groves in the posts. The builders plastered the inner and outer walls with a thin layer of yellow clay and then whitened the plaster. The excavated remains of one frame house built into the side of a hill—a clever way to utilize land space—contains an uncharacteristic inventory of iron goods (pipe-locks, keys, clamps, cauldrons, rings, hooks, and nails), as well a structural signs that the house had two stories.

What passed for prosperity among the upper classes of early Rus and most other premodern societies fell well below modern middle-class standards. The inventory of a small log frame house near the metropolitan's palace in Kiev contained remains of ceramics, bracelets, knives, arrowheads, and single-edge swords, indicating some connection of the inhabitants to the military elite. The larger farmsteads in Kiev's Podol might have been 85 by 85 feet, and in Novgorod, 105 by 105 feet, maybe three times the size of the commoners' houses, but they were by no means urban villas as understood in early modern Europe. The two-story carcass frame houses, each with an elevated canopy extension to attain maybe 450 square feet of interior space, and the elongated, yet still partially sunken, solid log frame houses with 450–650 square feet of

floor space constituted the two large types of urban dwelling. The various sorts of elevated entrances and canopy constructions or lower floors allowed for storage of food and implements, as did separate sheds, some made simply of light pine, others made of sturdier material and with foundations.

All of this information stems from visually as well as technically imaginative archaeology; it is informed by the persistence of some of the old building methods into the modern era, but it has no written sources. The Kievans of the time surely could have read the visual architectural clues of their own day. When Rus townspeople saw these sturdy little houses, they must have known what kinds of people had lived inside them, how they had lived, and what kinds of household and other goods they had possessed. So common, indeed, would have been this knowledge that few people articulated or represented it.

When, however, early Rus artists did depict housing, they felt free to resort to typified representations, in which the visual did not need to be accurate. Generalized representations were common in chronicle illustration, which, like purely religious art, had its own set of visual tropes, like the halo representing sanctity. As with rhetoric, a visual representation or symbol can be used as metaphor (a dove for the Holy Spirit), simile (the late Roman double-headed eagle for both the Holy Roman Empire and Russia), metonymy (the fish for Jesus from his Greek monogram IXΘΥΣ as Son of God and savior), or synecdoche. In an illustrated chronicle, as in a simple cartoon, synecdoche predominates—one tower represents an entire fort or city; a throne, a palace; a few animals, a herd; and seven or eight armored men on horses with a banner, an entire army—but simile is not absent.

Now let us look at two drawings from the illustrated *Radzivill Chronicle,* a fifteenth-century recension of a lost Kievan chronicle ending in 1205 and known by the name of the family that once owned the manuscript (figs. 3.1 and 3.2 [color section]). How many of the pictures hark back to Kievan originals is uncertain, since no such manuscripts survive. But some of the sketches—for example, the one featuring the baptism of Vladimir I—are similar to older Byzantine illustrations, so some Kievan-period originals are likely.

We must be ready for surprises, for the apparent here is not the real. The first frame accompanies an alleged event in still pagan Kiev in 983. The artist depicts in cartoon style the punitive and murderous attack by pagan Varangians on a Christian landsman, who has understandably resisted participating in a pagan thanksgiving ritual, his own son having been selected by lot to be sacrificed. His house with a flat roof and a several-column portico is a visual anomaly, belonging in a warm Mediterranean climate, not in Rus, with its snowy winters and slanted roofs. This fine, Byzantinesque structure, whose architectural and decorative motifs were partially replicated in some Rus masonry churches and maybe palaces, most likely represented the eminence automatically accruing to elite Christians. The picture also confirms that for chronicle illustrators, symbolic meaning, in this case as visual simile, trumped material actuality. We find this also in the representation of an Estonian shaman's masonry tower house, dated 1071 in the same chronicle.

The second sketch has the virtue of approximating, also cartoon style, a two-story carcass frame house as envisioned by our material historians. It is the only wooden Rus house depicted in any of the 613 illustrated frames in the chronicle but has nothing to do with Kiev itself or any

other Rus town. Rather, the artist has fancifully illustrated a Rus attack on neighboring Qip-chaks (Cumans, Polovtsy) in 1152 and the seizure of their flocks. That the Qipchaks as steppe nomads lived in tents or other types of mobile homes did not hinder the artist from drawing a farmstead dwelling with some unmistakable characteristics of a half-zemlianka, as the Qipchak inside is himself partially underground. Contemporaries probably read the picture, as they did real houses, to signify material substance but not high status in Rus terms on the part of its resident. In depicting dwelling, as well as cavalry, the artistic convention here is indifferent to ethnicity.

Paucity of visual data limits our conclusions concerning how people felt about their housing. The archaeology indicates the expected relative uniformity of dwellings in this low-consumption, premodern society. Anthropology explains the general conformity to established norms. How seriously we can take these quasi-cartoons from the *Radzivill Chronicle* and their stylized depictions of murderers, victims, and even cattle, sometimes with smiles and smirks, is a problem in itself. What we do not know is far greater than what we do.

Nevertheless, the Mediterranean mansion inside Kiev and the Rus farmstead out on the Qipchak prairie are striking in their apparent incongruity, yet rich in symbolism. In the first, the eminent Varangian Christian and his son, located in the windows of a house that seems lifted from Constantinople or Thessalonica, are about to become Christian martyrs. In the second, a middling Qipchak herdsman in the window of an average Rus prosperous farmstead house is about to lose his livestock and maybe his life to a typical Rus cavalryman. In the first picture, religion, not ethnicity, was the defining feature of the victim, and the Byzantine-like house represented that religion. In the second frame, status and circumstance seem to have counted the most, as if Qipchak nomads were not so different from, not so "other" than, Rus herders, despite differences in faith and ethnicity, for the Qipchak has a house, not a tent.

In early Rus, as elsewhere, "clothes made the man" (and the woman), but houses could, too, even if the man was about to be killed.

NOTES—1. The sources for this chapter include Russian Academy of Sciences, *Radzivilovskaia letopis'* (photo-copy reproduction; St. Petersburg: Glagol; Moscow: Iskusstvo, 1994), 47, 196; the Sermon (Slovo) of Daniel the Prisoner, in *Pamiatniki literatury drevnei Rusi. XII vek,* ed. L. A. Dmitrieva and D. S. Likhachev (Moscow: Khudozhestvennaia literatura, 1980), 392–94.

4

The Crosier of St. Stefan of Perm

A. V. Chernetsov

The Perm Oblast Museum of Local Lore keeps in its collection the so-called staff of St. Stefan of Perm, which is richly decorated with bone carvings illustrating the biography of this missionary (fig. 4.1). Saint Stefan, who died in 1396, was renowned during his lifetime and afterward for his work converting the Komi people, Finnic pagans who populated the extreme northeast of European Russia. Saint Stefan is best known to us through the hagiographic *Life of St. Stefan of Perm,* composed in panegyric form by a contemporary, Epifany the Wise, who knew the saint. This voluminous *Life* is of rhetorical character but lacks concrete details. Epifany was fascinated by Stefan's intellectual accomplishments; his *Life* describes no miracles at all, making this an unusual hagiography.

The only other version of the life of Stefan is that by Pakhomy the Serbian, an extremely short version, written in 1473, derivative of Epifany's. Some folkloric legends are known from passages in local chronicles, which recount a number of miracles. In these various texts, we can read many words of fulsome praise for the great missionary, but we learn almost nothing about Stefan's day-to-day work and even less about the culture and practices of the Komi themselves, a topic that interests many people today.[1]

Fortunately for us, this extraordinary staff communicates a great deal that authors of texts saw no reason to record for posterity. In illustrating the saint's encounter with pagan peoples, the sculptor had to employ visual indicators to identify who was Christian and who was pagan, who was the bringer of enlightenment and who the benighted object of Christian teaching. In a text, a reference to "pagans" would differentiate the missionary from the missionized, but a visual medium has to clarify its terms. To aid viewers, the carved compositions on the staff are supplemented with numerous inscriptions.

The compositions and inscriptions on the staff do not strictly follow any written text. The carvings portray not the "life" of the saint, which would conventionally run from birth to the taking of monastic vows through accomplishments to death and posthumous miracles; rather, they detail his "acts," which constitutes a different genre of writing about a saint's life and works. In contradistinction to Epifany's text, the version carved on the staff includes a number of miraculous episodes: the appearance of a devil before the saint; the devil's attempt to sink the saint's ship; the role of the devil in the illness and death of the missionary; the miraculous

4.1. Crosier of St. Stefan, 15th century.
Photograph showing details of the bone
carvings.

delivery of the saint from drowning; the miraculous blinding of the infidels who rose in arms against the missionary (fig. 4.2). Some of these episodes have no parallels in existing texts; others have only obscure parallels. The story about the attempt of a devil to sink the ship of the missionary, who was on his way to destroy the main shrine of the pagans, is different from the story reported by Epifany. The latter wrote that the shrine was situated near the saint's cell; there was no reason to go anywhere by water (see fig. 4.4). Epifany judged St. Stefan's most impressive achievements to be his translations of biblical texts and his invention of an alphabet for the Komi. The compositions and inscriptions on the staff, by contrast, lack any information concerning this (although possibly they were once present on some lost fragments).

Judging from paleographic data, the staff was created before the mid-fifteenth century. Stefan is never mentioned as a saint in the inscriptions, making it necessary to date the carvings before 1473, when a special holy service dedicated to St. Stefan was compiled by Pakhomy the

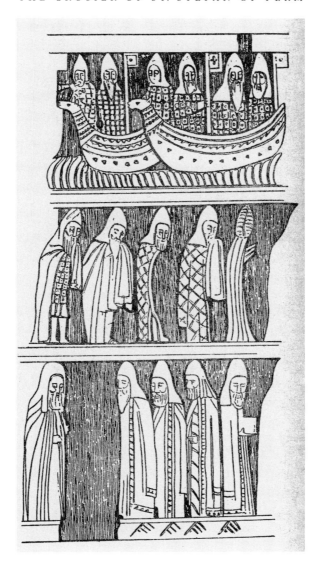

4.2. Projection of compositions on the crosier of St. Stefan. *Top,* The pagans attack the missionary. Battleships and warriors wearing mail shirts and carrying banners can be seen. *Middle,* The saint has miraculously blinded his enemies; they are weeping. *Bottom,* The pagans are converted.

Serbian on the order of the Perm bishop Filofei; this marked the beginning of official worship of Stefan as a saint in Ust-Vym, the residence of Perm bishops.

The primitive character of the carvings and the cheap material used (elk horn) point to the local origin of the staff. Judging from some mistakes in the inscriptions, the artist may even have been illiterate and was copying the inscriptions by rote, without understanding the letters

23

that constituted the text. The staff was probably carved not by a professional craftsman but by an ordinary monk as a work of penance or in fulfillment of a vow. In this case, these carvings served as a sort of prayer for the carver himself.

In assessing the meaning and accuracy of the depictions of Russian and indigenous practices, whether the sculptor was Russian or Komi is key. The visual evidence embodied in the staff suggests that the carver was a monk from the Komi region, but of Russian and not native origin. No inscriptions on the staff reflect either the Komi language or the alphabet invented by St. Stefan; all of them can be interpreted as medieval Russian/Church Slavonic. The acts of the saint represented in the compositions show hostility against the indigenous population. The Komi, usually called "infidels" in the inscriptions, are shown undertaking a military campaign against the missionary; they rejoice at the saint's death (see fig. 4.3).

The scenes and inscriptions on the staff reflect a specific regional version of his life, which has not survived in manuscripts. Saint Stefan's cult was a highly local one and was strictly limited for political reasons. His activity was not completely legal from an ecclesiastical point of view, because he was a representative of Moscow, whereas the Komi region was nominally part of the diocese of the Novgorodian archbishop. Peripheral forest regions like the Komi lands were the main sources of furs, an extremely valuable commodity. That is why Moscow princes had made many attempts to control these territories and their riches, which placed Moscow and Novgorod in direct conflict. Saint Stefan's unauthorized missionary work was taken by Novgorod authorities as an unfriendly action and even led to a military campaign. Moscow princes and high clergy certainly supported Stefan's mission and also those of his successors, but they kept their support quiet. Saint Stefan's *Life* was written just after his death at the end of the fourteenth century, but he was not recognized as a saint until the late fifteenth century, approximately a century later. Canonization became possible only after the downfall of independent Novgorod and a Muscovite military campaign in the Komi region.

The carvings on the staff reflect unofficial veneration of Stefan: the word "saint" is never used in the inscriptions. So the pastoral staff, in spite of being an official symbol of ecclesiastical rank, at the same time reflected unofficial veneration of a local ascetic.

Some of the most fascinating aspects of the carvings are their portrayal of the life of the native population of the region. In assessing the ethnographic accuracy of the depictions, we have to sort out artistic conventions from details based on direct observation and local knowledge, and this proves a difficult task. Once we establish the standard conventions of representation, then we can try to distinguish artistic innovations from reliable reporting. Architecture, for instance, is represented on the staff in a stylized and fantastic way, typical of Byzantine-Slavic iconography. But the fortified settlements of Komi pagans are represented as walls with multistory towers (see fig. 4.3). The gates are placed not in the towers but in adjacent sections of the walls, probably an accurate portrayal of local features. The ships decorated with animal heads are shown as in standard medieval Russian depictions, which matched actual ship style. The cross decorating the flag of the pagans fighting against the Christian missionary seems to be a mistake of the carver, striking in that the whole point of the engagement was that the pagans were fighting against what the cross symbolized. However, a cross-marked banner frequently served as a generic indicator of a military battle standard, so the inconsistency may

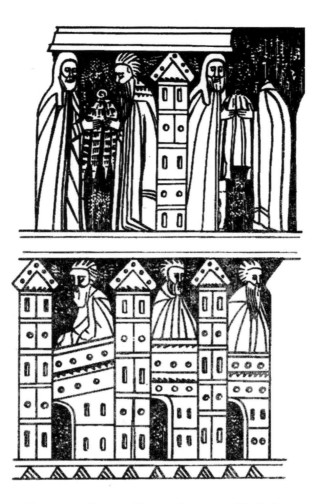

4.3. Projection of compositions on the crosier of St. Stefan.
Top, Secular pagans give bundles of furs to the monks. *Bottom,*
Pagans sitting in their multistory fortresses rejoice at the death of
the missionary.

have been unnoticeable to carver and viewer alike. (See chapter 3 for an illuminating discussion of similarly inappropriate conventions in representations of medieval housing.)

The clothing of the "infidels" appears in equally unedifying terms, with extremely long sleeves that reflect the Russian (and not only the Russian) fashion of the time. In general, medieval Russian craftsmen, icon painters, and miniaturists were unable to represent foreign clothes, or perhaps they were uninterested in doing so. If necessary, foreign origin might be indicated by exotic caps, which sufficed to communicate the point. In the carvings on the staff, the cap of some obscure person (either a local shaman or a devil) follows a Byzantine iconographic tradition used to represent the biblical magi, for whom the term in Church Slavonic was *volkhv;* the same word applied to magicians or pagan shamans.

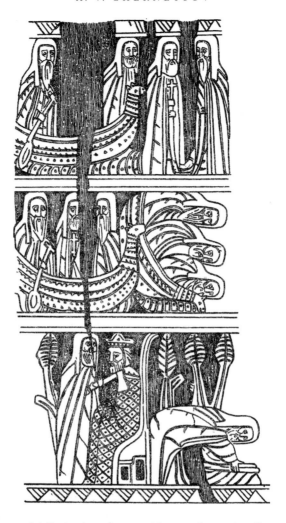

4.4. Projection of compositions on the crosier of St. Stefan. *Top,* St. Stefan with other monks looks for the main pagan shrine. *Middle,* A devil (not visible) attempts to sink St. Stefan's ship (represented in vertical position). *Bottom,* St. Stefan destroys the pagan idol (the seated crowned figure) and burns its remains.

Although some features are shown generically, they also apparently represent likely realities. Bundles of furs are shown as means of payment (fig. 4.3). Similar bundles of furs are typical in other Russian and western European images of the time. Their conventional nature, however, does not obscure the fact that the quest for furs and the revenues they generated had propelled both Muscovite and Novgorodian interests in the northern regions and that tribute in fur was already, and remained, a standard obligation imposed by Russian conquerors on their non-Russian subjects. This detail, then, must be assessed as both conventional and accurate.

Other scenes on the staff appear to be original to the artist and probably represent practices with which the local artist was personally familiar. For instance, the carvings depict a pagan idol, or "demon," as the inscription calls it, in an absolutely unique manner (fig. 4.4). Standard Byzantine-Slavic iconography denoted a generic pagan idol as a naked human standing on a column. Here we can see instead a seated figure, crowned and dressed and surrounded by trees (that is, the shrine was situated in the open air). A similar seated and crowned idol from Biarmia is described in Scandinavian sagas. Probably both the Scandinavian sagas and the image on the staff reflect the same or similar pagan idols in use among the native populations of these arctic (or subarctic) regions. The practice of clothing idols richly in furs is mentioned in the *Life of St. Stefan*. It is clear that the carver understood local practices and represented them at least to some extent. The idol is made of wood, and St. Stefan is shown putting it to the torch. The carvings thus contain and communicate visually a great deal of valuable historical and ethnographic information, much of which is otherwise inaccessible.

How would the rich carvings of the staff have been viewed or understood by those who stood in church services while the bishop walked about, leaning on the staff, or when a clergyman standing behind the bishop held it aloft at key moments in the ceremony? The brief answer is that they would have seen and understood very little of its complex imagery. Neither the images nor the inscriptions could have been seen by the faithful in any kind of detail. Embroidered linen, now lost, would have been attached to the staff, obscuring the carvings even more. Some honorary visitors might have examined the staff in the sacristy of the cathedral, but never the common people. On the other hand, everyone could see during the holy service that the staff was a luxurious object—carved from top to bottom. Its ornateness and its status as a bishop's mark of power would have communicated its sanctity and authority to the churchgoers.

NOTES—1. On the staff, see Baron de Baye, "La crosse de S. Etienne de Perm (XV siècle)," *Revue de l'art Chrétien* (Bruges, 1898); A. V. Chernetsov, "Posokh Stefana Permskogo," *Trudy otdela drevnerusskoi literatury* (Leningrad: Nauka, 1988), vol. 41; Archimandrite Makarii, *Skazanie o zhizni i trudakh sviatogo Stefana, episkopa Permskogo* (St. Petersburg, 1853). For the life of St. Stefan, see *Zhitie sviatogo Stefana, episkopa Permskogo, napisannoe Epifaniem Premudrym* (St. Petersburg, 1897). For a linguistic analysis of his translations, see V. I. Lytkin, *Drevnepermskii iazyk* (Moscow: Akademiia nauk SSSR, 1952).

5

Sixteenth-Century Muscovite Cavalrymen

Donald Ostrowski

W hen the Mongols conquered Rus in the thirteenth century, they did so with the most advanced weapons, tactics, and strategy of the time. Traditional Russian historians have tended to deny that Mongol-Tatar weaponry and military ways had any impact on the Muscovite cavalry. Yet archaeological, written, and visual evidence belies that denial and tends to corroborate the assertion of other historians that borrowing occurred. A case in point is this woodcut, which appeared in the first edition of Sigismund von Herberstein's *Rerum Moscoviticarum Commentarii* and is thought to be based on drawings he made when he went to Moscow (fig. 5.1). Baron von Herberstein (1486–1566) was a member of the Imperial Council of the Holy Roman Emperor and, as a diplomat, visited Russia twice, in 1517 and 1526.

Depicted are three Muscovite mounted cavalrymen, whose equipment and weapons demonstrate steppe influence. The saddles are of the Mongol-Tatar type with short stirrups, which allow the mounted archer to stand while riding with his derriere free of the saddle seat. On the Mongolian steppe, standing in the stirrups is the normal way of riding a horse, and even today Mongols are taught from early childhood to ride this way. They sit in the saddle only when stopped or resting, as these three cavalrymen seem to be doing here. The advantage of standing for a mounted archer was to stabilize the upper part of the body for aiming and shooting. Bareback and long-stirrup riders with their buttocks in continuous contact with saddle are jostled about so much that it is difficult to attain any accuracy when shooting a bow (or later a carbine or rifle). Standing in the stirrups allows the legs to act as shock absorbers, so the rider can take careful aim without having the bow bounce up and down with the horse's gait.[1]

Mongolian saddles, like the saddle of the first rider represented here, have two belly cinches. These are fastened more tightly than the one belly cinch of other saddles. For western saddles, for example, the recommendation is that the cinch be loose enough to put a finger between the strap and horse. In contrast, the explorer and author Tim Severin, who traveled to Mongolia in the 1980s, describes the horsehair cinches of modern Mongolian saddles being tightened "severely, the rear girth almost disappearing into a fold of the animal's gut." From the back of each saddle, two cords can be seen extending and joining in a loop under the tail. These cords form the crupper strap, which prevented the saddle from slipping forward. Severin tells us that modern Mongolian pastoralists are unfamiliar with the crupper strap. But an illustration in his book of a detail from an early Chinese silk painting, *Halt of the Tatar Riders,* shows a steppe

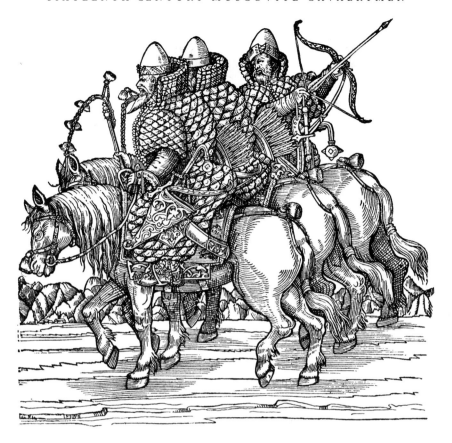

5.1. Three Muscovite mounted cavalrymen. Woodcut, from the first edition of Baron Sigismund von Herberstein's *Rerum Moscoviticarum Commentarii* (Vienna, 1549).

saddle with both front cinch and crupper straps.[2] One notices in our woodcut the absence of such a front cinch strap intended to keep the saddle from slipping backward when riding up hills. Although front and back slippage of the saddle is usually not a problem on the flat steppe, we do find a front cinch strap mentioned in, among other places, an episode in a thirteenth-century source, *The Secret History of the Mongols*.[3] Most likely the Muscovites, as the Mongols did before them, outfitted the saddle with a front (or breast) strap when encountering steep hilly terrain but otherwise left it off.

The bows the Muscovite cavalrymen can be seen carrying are the steppe recurved composite bow. These bows are smaller but more powerful than the English longbow. The draw weight (the amount of energy required to pull the bow to full draw) of a composite bow is equal to, or not much more than, the draw weight of the *Mary Rose* longbows (from 100 to 140 pounds), but the recurved limbs of the composite bow, which act as levers, and the snap of its spine provide a greater velocity and range. The result is an increase in the distance an arrow can be shot: whereas the longbow has a range of up to 300 yards, the composite bow's reported range is more than 350 yards. The steppe composite bow was the most effective long-range shooting

29

weapon in the world. Not until the nineteenth century with the invention of the breech-loaded repeating rifle did a weapon come into existence with the range, accuracy, and rate of fire of the recurved composite bow.

The spine of the composite bow was made of wood, typically birch, which provided resiliency. The wood was covered with bone or horn, or both, from a wild or domestic ungulate, such as a mountain sheep or yak. This hard covering extended from the grip to the limbs of the bow and gave the bow its snap. On top of this hard covering was another layer of specially prepared birchbark, which protected the bow from moisture, and, finally, a layer of sinew from deer, moose, or mountain sheep. The glue holding all the layers together was made from boiled fish bladders and was highly moisture resistant. To give the bow its extra power, it was strung against the natural bend, such that an unstrung composite bow forms a semicircle in the direction opposite from the curvature it has when strung. Its total length could be between 4 feet 10 inches and 5 feet 2 inches, but the curvature made it stand only about 3 to 4 feet high when strung. The "shortness" of this bow allowed it to be used from horseback; the longbow could not. The bowstring of the recurved bow was usually made from stretched and twisted animal hide (preferably horsehide), which was taut and would not stretch further.[4]

The arrows, shown extending from the quivers of the first and second riders and being drawn in a bow by the third rider, were typically made of birch wood. They were 31 to 39 inches in length, with a shaft diameter of about ⅜ inch. The length and diameter of the arrows depended on their function. Normal arrows had bone heads, armor-piercing arrows had heavy, tempered steel heads, and signal arrows had bone heads in which air channels were cut. Although the Mongols used incendiary arrows, these do not seem to have been used by the Muscovite cavalry. For proper rotation and balance, birds' tail feathers were preferred in the fletching as they create less wind drag than wing feathers. The name the Russians used for the cloth case covering of both the quiver and the bow was *tokhta,* a Tatar word, and the name they used for the entire ensemble of bow, arrows, quiver, and case coverings was *saadak,* another Tatar word. In the woodcut, the rider drawing his bow is holding the bow string and arrow in the "Mongolian release" position, with the index finger over the thumb, which pulls the string, instead of in the European way, in which three fingers curve around and pull the string.

Attached by a cord to a finger of the right hand of the first and third riders is a whip, and another cord around the wrist is connected to a knife (*kinzhal*) in a scabbard. The rider would put a finger of his left hand through a hole in the bridle strap so he could shoot the bow and hold the bridle at the same time. Rounding out the weaponry were a Damascus steel saber (*sabel*), often of Central Asian or Persian origin, and a flail (*kisten'*), of a type used by the Mongols. The saber was carried in a curved scabbard, which can be seen going under the bow case and crossing the leg of the first rider. The iron- or bronze-studded metal weight of the flail was attached to a handle with a chain or leather thong that could be up to 19 inches long. The weights can be seen positioned in the belts of the first and third riders.

The coat (*tegaliai*) each cavalryman is wearing was quilted with hemp or cotton and could have an armored vest made with small overlapping metallic breast plates in front. Although the undershirt cannot be seen here, we know from written sources that underneath the coat the cavalrymen generally wore a silk shirt, which in the winter was stuffed with wool. The silk

resisted piercing by the arrow, and the fabric wrapped around the head of the arrow when it entered the body. As a result, the arrowhead could be removed more easily and with less damage to the surrounding flesh than otherwise. The particular type of metal helmet the riders are wearing is called *erikhonka* and began appearing in Rus in the fourteenth century. Around the lower edge (*venets*) of the helmet is a metallic decorative motif, which was often copper but sometimes silver or gold. There does not seem to be any particular function to the shape of the helmet except to allow it to fit over a cloth cap or lining for added protection of the head, but it has the same shape as Tatar helmets found in archaeological sites from the period.

The horses themselves were most likely Tatar "ponies," bred and raised on the steppe. We have chronicle accounts of forty thousand horses being brought to Moscow for sale by Nogai pastorialists each year in the late fifteenth and early sixteenth centuries. Tatar horses are small (between 13 and 14 hands high) yet sturdy and weigh as much as 40 percent less than European or Arabian horses. They may be closely related to the wild Przewalski horse, but differ from the Przewalski in having long manes instead of short and in having sixty-four chromosomes instead of sixty-six. Tatar ponies are reported to have enormous stamina, being able to travel long distances without tiring. Severin reports "around 30 miles at their maximum speed" on mounts that were in poor condition, but allows that mounts in top condition could cover the 70 to 80 miles that we find reported in thirteenth-century sources. The horses the Muscovites used may have been slightly larger than their Tatar counterparts because they were fodder fed rather than having to depend solely on wild grass for their food. Thus, they would have been able to carry a correspondingly heavier load of rider and equipage.[5]

Until the middle of the sixteenth century, the Muscovite army was made up almost entirely of cavalry (although Grand Prince Vasily III [1505–33] did supplement the cavalry with infantry in two engagements). The weaponry and equipment of the Muscovite cavalry was ideally suited for steppe warfare tactics, or as Herberstein describes it: "Whatever they do, whether they are attacking, or pursuing, or fleeing the enemy, they do everything suddenly and rapidly, so that neither infantry nor artillery can be of any use to them."[6] Muscovite cavalrymen were formidably equipped warriors ideally suited for steppe warfare and effectively used the same kinds of weapons, equipment, and tactics that the Mongol conquerors of Rus had used.

NOTES—1. In the feature film *Dances with Wolves* (dir. Kevin Costner, Panavision, 1990), footage of in the buffalo hunt scene shows the difficulty bareback riders have in trying to aim and shoot a bow and of a long-stirrup rider in trying to aim and shoot a rifle. In contrast, "The Mongol Onslaught, 850–1500," *World TV History* (BBC Production, 1985), contains footage of members of the modern Mongolian army easily aiming and shooting a rifle on horseback at full gallop while standing in the stirrups.

2. Tim Severin, *In Search of Genghis Khan* (London: Hutchinson, 1991), 82 (quotation), 177–78 (crupper strap), following 20 (Chinese illustration).

3. Igor de Rachewiltz, ed., *The Secret History of the Mongols: A Mongolian Epic Chronicle of the Thirteenth Century,* 2 vols. (Leiden: Brill, 2004), § 80.

4. On Mongol warfare, see Timothy May, *The Mongol Art of War: Chinggis Khan and the Mongol Military System* (Yardley: Westholme, 2007). For more information on the longbow and the composite bow, see Robert Hardy, "The Longbow," in *Arms, Armies and Fortifications in the Hundred Years War,* ed. Anne Curry and Michael Hughes (Rochester, N.Y.: Boydell, 1994), esp. 170–80; David Nicolle, *Medieval Warfare Source Book,* vol. 2: *Christian Europe and Its Neighbours* (London: Arms and Armour, 1996), esp. 108–18; Per Inge Oestmoen,

"The Mongolian Bow," http://www.coldsiberia.org/monbow.htm (December 27, 2002); John Sloan, "Russian Medieval Arms and Armor," http://www.xenophon-mil.org/rushistory/medievalarmor/parti.htm (January 15, 2007).

5. Ann Hyland, *The Medieval Warhorse: From Byzantium to the Crusades* (Conshohocken, Pa.: Combined Books, 1994), esp. 124–39; John Masson Smith, Jr., "Nomads on Ponies vs. Slaves on Horses," *Journal of the American Oriental Society* 118 (1998): 54–62.

6. Sigismund von Herberstein, *Notes upon Russia,* 2 vols., trans. R. H. Major (New York: Burt Franklin, 1851–52), 1:96–97.

6

Blessed Is the Host of the Heavenly Tsar

An Icon from the Dormition Cathedral
of the Moscow Kremlin

Daniel Rowland

In the sixteenth century the Muscovite state, like many early modern European states, faced the problem of securing the allegiance of its subjects in the absence of the military and bureaucratic means to compel this allegiance. In other words, the tsar and his ecclesiastic image makers had continually to persuade his subjects, particularly his major courtiers, that he and his state were worthy of their support, including their willingness to fight and even to die for him. This ongoing campaign to establish the legitimacy of the regime was complicated by the illiteracy of many, perhaps most, of these courtiers. An icon from the Dormition Cathedral in Moscow gives us a unique look at how the Russian government made this vital claim of legitimacy through one complex image, and tells us about the values and assumptions on which that claim was based (fig. 6.1 [color section]).

The icon was painted in the middle of the sixteenth century to celebrate the victory of Ivan IV (reigned 1547–1584) over the Tatar Khanate of Kazan in 1552. It shows an army, led by the Archangel Michael, returning from a burning city on the viewer's right (Kazan) to a city in a circle on the viewer's left. At the simplest level, this image shows the victorious return of Ivan's troops to Moscow, but using this simple format, the icon painter expresses a number of political ideas that were crucial to the worldview of early modern Russians. Its sheer size (over seven feet long) gives it an imposing presence, and its location in the Dormition Cathedral, at the sacred heart of the Kremlin, which was itself the heart of the Muscovite state, assured it a powerful role in Russian political life.

This position at the symbolic "glowing center" of the country vastly increased the potency of the messages that the icon conveyed. Because it was an image (rather than a text), and a very large image at that, it was accessible to illiterate courtiers. I invite you to join me in a careful look at this icon as we explore several of these messages and marvel at the economy and visual force with which these ideas were expressed. Our eyes are first drawn to the figure of the Archangel Michael on his winged horse leading the troops from the burning city of Kazan. Michael had been seen as the patron of royal families and the protector of their armed forces since early Byzantine times. Russian iconographical tradition since at least 1400 had shown

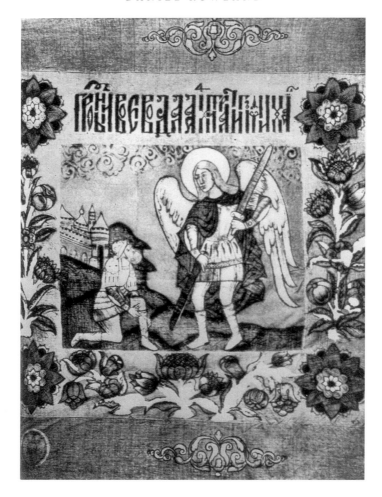

6.2. Linen battle standard of Yermak, 1580s. Yermak conquered
much of Siberia in the latter part of the 16th century.

Michael acting in a number of Old Testament military scenes, including many where official biblical texts do not specify his presence, such as meeting with Joshua before the battle of Jericho or helping Gideon or King Hezekiah. Numerous other icons and literary texts before the 1550s had depicted the Archangel Michael as the protector of righteous troops against pagan or unjust enemies. Perhaps the most touching evidence of the way Russians personalized this imagery is the simple linen battle standard of Yermak, a simple Russian adventurer (rather than a Kremlin propagandist) who conquered much of Siberia in the latter part of the sixteenth century (fig. 6.2). we see Yermak, wearing the typical military garb of his time, with his armor and pie-plate-shaped helmet, portrayed as Joshua removing his sandals before the Archangel Michael, in front of a walled city. Just as the kneeling figure may represent both Joshua and Yermak, so the walled city could symbolize both Jericho and the Tatar Khanate of Sibir. This cyclical or typological sense of time, where the same event was seen as recurring at several

different historical moments (Joshua / Jericho / Old Testament; Yermak / Sibir / the sixteenth-century present) seems to have been internalized by this relatively uneducated lay painter to create a Bible-based personal identity for Yermak; with Yermak's conquest of the Khanate of Sibir, the resulting expansion of the Russian kingdom made it, by analogy, a new promised land.

This layered sense of time can seen more clearly in two Bible chapters, Daniel 12 and Revelation 19, that are important to the interpretation of the *Blessed Is the Host of the Heavenly Tsar* icon.

In Daniel's vision, the Archangel Michael leads the heavenly host against an unnamed northern king in the last days:

> And at that time shall arise Michael, the great prince [*kniaz veliky,* the title used by Rus rulers before Ivan IV officially adopted the title of tsar] who has charge of your people. And there shall be a time of trouble such as never has been since there was a nation till that time; but at that time your people shall be delivered, every one whose name shall be found written in the book. (Dan. 12:1)

In Revelation, Christ on a white horse leads an army, conventionally interpreted as an army of martyrs, against the forces of evil in the last days:

> Then I saw heaven opened, and behold, a white horse! He who sat upon it is called Faithful and True, and in righteousness he judges and makes war. . . .
>
> From his mouth issues a sharp sword with which to smite the nations, and he will rule them with a rod of iron; he will tread the wine press of the fury and the wrath of God the Almighty.
>
> And on his robe and on his thigh he has a name inscribed, KING OF KINGS AND LORD OF LORDS. (Rev. 19:11–16)

These passages connect Ivan's army returning from Kazan with God's armies struggling against the forces of evil at the apocalypse. The figure of the archangel is also connected, via the white horse and references to an army of martyrs in liturgical texts closely related to the icon, to Christ in Revelation 19. Through these references to Michael, Christ, and holy martyrs, the Russian army is made a part of an eternal struggle of good against evil that began in Old Testament Israel and will continue until the end of time. (Michael's supernatural powers also ensure victory for the Russian troops.)

If the image of the Archangel Michael connects the Russian warriors returning from Kazan with the heavenly host of God struggling with the forces of evil at the apocalypse, then in the icon we would expect to see depictions of holy figures from sacred history, as well as depictions of soldiers who took part in the Kazan campaign. Although we cannot identify the figures in our icon, a cruder icon, copied from this one later in the sixteenth century, enables us to speculate about who these warriors might have represented (fig. 6.3 [color section]). In the later icon, some of the warriors are labeled, including "Tsars" David and Solomon, Byzantine Emperors Leo and Constantine, Grand Prince Vladimir, who brought Christianity to Rus, and Boris and Gleb, the popular martyred saints who accepted death rather than fight their brother for the

throne of Kiev. These names reinforce the timeless and ongoing nature of the struggle of good against evil of which the conquest of Kazan is depicted as an integral part. Figures from sacred history—from Old Testament times through the Byzantine period to the age of Kievan Rus— were all imagined to be fighting on behalf of Ivan IV and his army against the "evil" Kazanians. The selection of warriors also emphasizes the *dynastic* basis of royal power by including former members of the ruling Riurikovich clan, Vladimir, Boris, and Gleb, while depicting that dynasty as a successor to the ancient kings of Israel and the emperors of Byzantium.

Two other themes that were central to the sixteenth-century Russian imagination are also emphasized in the *Blessed Host* icon. The first is the identity of Moscow as Jerusalem, established by showing Moscow, the city on the left to which the troops are returning, as the new Jerusalem. This identity is signaled, first, by the colored circles, called glories, around the town. Icon painters used glories to signify a particularly holy person or place. Other signs, particularly the river arising in the city with flowering trees growing along it, recall the account of New Jerusalem in the book of Revelation 22:1–2. This theme of Moscow as Jerusalem or New Jerusalem and the East Slavs as God's new chosen people was a central theme in Rus and Russian culture from the conversion to Christianity down at least to the time of Peter the Great. Historical East Slavic rulers such as St. Vladimir, Yaroslav the Wise, Dmitry Donskoy, and Ivan III were routinely compared to Old Testament leaders such as Moses, David, and Solomon. Likewise, the Church of the Intercession on the Moat, popularly known as St. Basil's, was called Jerusalem by Russian contemporaries, with its own Golgotha (Lobnoe mesto) nearby. Our icon, then, builds upon a long tradition of identifying Moscow with Jerusalem and uses this tradition to strengthen the message that Ivan's war was part of a cosmic struggle between good and evil, a common message for Christian states at war from the early Middle Ages to the present.

Seated in Moscow / New Jerusalem is the Mother of God, with the Christ-child on her lap, who is handing out martyrs' crowns to angels who then bestow them on those who fell in battle. By the time of the painting of this icon, the protection of Rus/Russia by the Mother of God had become probably the single most important theme in Russian political thought. The famous icon called the Vladimir Mother of God played a role in Russian remembrance of history equaled only by the most active and successful political actors. The icon became a palladium of the Rus state, its presence conferring legitimacy on rulers and whole lands where the icon was located. It also was believed to have saved Moscow from conquest by Tatar invaders. By including the Mother of God in our icon, the painter reminded his viewers of the importance of other icons of her, and of the role that both she and her images were imagined to have played in Rus/Russian history.

All of these themes—the Muscovite army as the "Blessed Host of the Heavenly Tsar"; Moscow as Jerusalem, and Muscovy as a New Israel; the protection of Rus by the Mother of God; the importance of the royal dynasty—were concisely conveyed in this one complex image. The first (and chief) of these themes is summed up less concisely in a letter that Metropolitan Makarii sent to Ivan on the eve of his conquest of Kazan. Makarii states that the Tatars are agents of the devil, and asks that God send the Archangel Michael and other "incorporeal powers" to help the Muscovite army in its fight against Kazan, just as Michael helped Abraham against the king of Sodom, Joshua against the Canaanites at Jericho, Gideon against the

Midianites, and Hezekiah against Sennacherib. The Muscovite host will be strengthened by the prayers of the Mother of God, the apostles, the church fathers, and various Rus saints, including Alexander Nevsky, and helped by the aid of the Archangel Michael and four military saints (George, Dmitry, Andrei, and Theodore Stratilates), together with Ivan's ancestors St. Vladimir, Boris, and Gleb. God will send his angels and all the holy martyrs to help defeat the enemy. Those who shed their blood for the cause will have all their sins forgiven; those who die will go to heaven.

This icon, then, conveys a powerful message: The Muscovite army is part of an agelong struggle between good and evil, God and the devil, that has been going on since Old Testament times and will last to the apocalypse. God's incorporeal powers, personified by the Archangel Michael, against whom no enemy can stand, will help the army against its enemies, while those who fall in battle will gain eternal life. The icon, by virtue of its placement, its large size, and its clear pictorial language, was well suited to communicate with members of the court elite, who also formed the backbone of the army and thus could see themselves in the troops returning from Kazan. The readability of the icon, which enhanced its political effectiveness, was further increased by its visual references to other themes, like the protection of the Mother of God, and Moscow as a new Jerusalem, that were already commonplace in Russian political thought. Most important, the icon gave the army and members of the elite a preeminent role in salvation history and a good reason to support the state that led them in this cosmic struggle.

As we look at the icon, we see Ivan's image-makers actively reworking these themes in a new context—the conquest of Kazan—and in the process creating a powerful new image of Ivan and his army as agents of God's will. This work of image making helped to strengthen the Russian state in the sixteenth century for subjects who could understand visual images far better than they could written texts.

7

The Cap of Monomakh

Nancy Shields Kollmann

The Cap of Monomakh—in Russian, the Shapka Monomakha—is so powerful a symbol of Russia's past that supporters of Russian president Vladimir Putin awarded him an exact replica on his birthday in 2002.[1] Bestowing upon a democratically elected leader of a constitutional federation a facsimile of the crown of Russia's autocratic tsars may send a politically mixed message, but it demonstrates the evocative power this object carries for Russians (fig. 7.1 [color section]).

The Cap (or Crown) of Monomakh symbolizes to modern Russians the glory and power of Russia's past. They read it in the light of the myth that they learned in childhood history books, a myth that links Russia with world Christianity, universal empires, and the Western heritage. According to that myth, contained in the "Tale of the Princes of Vladimir," the Russian founding dynasty of the 800s, the Riurikovichi, was descended from Roman emperors. According to the "Tale," in the 1100s the Byzantine emperor Constantine Monomakh bestowed the cap and other regalia on Vladimir, grand prince of Kiev, who thereupon was called Monomakh.[2]

The "Tale" links these Kievan-era events with subsequent history more seamlessly than actual events warrant. The political chronicle is complex. Vladimir Monomakh died in 1125, and by the end of the century his Kievan grand principality had dissolved into rival polities in modern-day western Ukraine and Belarus, Novgorod, and Vladimir. By defeating various rivals in the upper Volga region in the 1300s the grand princes of Moscow assumed the title, lands, and legitimacy of the grand princes of Vladimir. By the fourteenth century two regional contenders—the Grand Duchy of Lithuania and the Grand Principality of Moscow—controlled almost all the territories of the once-great grand principality of Kievan Rus. So when the "Tale" declared, "And thus even to this day the grand princes of Vladimir are crowned with the imperial crown which the Greek tsar Constantine Monomakh sent," it was bolstering a Muscovite claim of exclusive control over what was in reality a disputed and divided Kievan heritage.

The "Tale of the Princes of Vladimir," then, gave Moscow multiple heritages: those of ancient Rome, Byzantium, universal Christianity, Kievan Rus, and the Grand Principality of Vladimir. It was composed in the 1520s, when Moscow was expanding westward toward the booming Baltic trade and initiating diplomatic relations with the Habsburgs, the Poles, and other central European powers. As a founding myth, the "Tale" matched that being spun at the same time

by the grand dukes of Lithuania (significantly, the "Tale" included a derogatory genealogy of the Lithuanian dynasty). The legend of Monomakh's gifts lent legitimacy to Muscovy as it was coming into its own in east European power politics.

The legend was widely disseminated in the sixteenth century. It was reported by the German ambassador Sigismund von Herberstein, who visited Russia in 1517 and 1526. Excerpts of the "Tale" were carved on the panels of the Tsar's Throne, installed at midcentury in the Cathedral of the Assumption, where Russian rulers were crowned. The "Tale" was included in several monumental compositions of the early and mid century: the comprehensive Voskresenie and Nikon chronicles; the *Great Menology,* a compendium of liturgical texts for the church year, saints' lives, and historical compositions; the *Book of Degrees,* a history of Russia arranged by ruler, starting from Kiev. In all of these works the myth of the gifts of Monomakh provided a bridge between the Kievan and Muscovite polities.

The physical crown provided a potent visual symbol to accompany the myth. The scene of Constantine Monomakh's transfer of the crown is shown, for example, in frescoes of the throne room in the Kremlin's Golden Palace from the mid-1550s. The crown was used in the tsar's coronation of 1547 and in every coronation thereafter through 1682. Its power outlasted that of the "Tale" itself: by the seventeenth century the legend of Monomakh's gift and the Byzantine-Kievan inheritance was rarely mentioned in sources that justified the tsar's authority. But the crown was revered and displayed in processions at coronations and royal funerals until the last imperial coronation, of Nicholas II, in 1896.

The "Tale of the Princes of Vladimir" and the physical crown are striking markers of Russia's connection with Christianity and universal empire. But, like many myths, the one surrounding the Cap of Monomakh does not stand up to much testing. The dating in the "Tale" is off (for example, Constantine Monomakh lived almost a century before Vladimir Monomakh), and its historical references are improbable. Even more remarkable, the physical object itself is not what it looks to be—the crown had to be radically transformed in order to look the part it was called to play. The Cap of Monomakh was not a gift from Byzantium to Rus. Nor was it a fabrication of sixteenth-century image makers. Rather, it was an esteemed treasure in the regalia of the Moscow grand princes for almost two centuries before the "Tale of the Princes of Vladimir," and it had come to Moscow not from Byzantium but from the East, through the culture of the Golden Horde.

Art historians have determined that the cap was probably made in an urban center of the western realm of the Mongol Empire, such as Crimea or central Asia, sometime around the late thirteenth or early fourteenth century. Scholars postulate that Grand Prince Ivan Kalita received it as a gift in the mid-fourteenth century during one of his regular visits to his Mongol overseers at Sarai, perhaps from Khan Uzbek. In its original shape it consisted of a circlet mounted with eight gracefully arching gold panels, which formed a softly rounded half-sphere of gold. The golden pieces are overlaid with an intricate gold filigree of six-pointed rosette stars and lotus flowers. As one scholar noted, in its original form it is a typical central Asian *tiube-teika,* or skullcap, but a very fancy one indeed.[3]

This beautiful exemplar of Mongol goldwork was a treasured piece of the Moscow grand princes' regalia long before it was reinvented in the "Tale of the Princes of Vladimir." It is first

mentioned in Ivan Kalita's 1341 will, where it is called simply the "gold cap." The gold cap was passed on to successive eldest sons and future grand princes; it was mentioned in the wills of Ivan II around 1358, Dmitry Donskoi in the early 1370s and 1389, Vasily I around 1406 and in 1417 and 1423; and Vasily II around 1461.[4] In the earliest (late-fifteenth-century) description of the coronation in 1498 of Ivan III's grandson, the crown is simply called "the cap."[5] Only in revisions of this coronation text done in the 1510s or 1520s—in other words, around the time of the composition of the Monomakh legend—is the crown first called the Cap of Monomakh.

So, at one level, seeing the Cap of Monomakh should remind us of the century-long domination of the Mongol Empire in the Rus lands. From the mid-1200s through the 1300s, the Golden Horde was a crucial factor in some, though not all, aspects of Russian life. In culture the Mongols did not have major impact, for example. They did not invade Russia en masse—they were steppe nomads, Turkic speakers, Muslims. They did not insinuate themselves into Rus landholding or farming; they did not intermarry; they did not persecute Orthodox Christians or convert Russians to Islam.

But in economic and political spheres Mongol influence was profound. The Mongols caused great suffering, with high taxes and frequent large-scale seizures of people for the slave trade. They drained Russia's resources away from domestic development. And they shaped Russian politics definitively. Those princes lucky enough to win the favor of the khans received the lucrative right to collect taxes for the Horde, as well as valuable military alliances. Moscow was the persistent victor in this competition, and evidence of Moscow's intimate relation with the Horde is attested in the many Mongol military, political, and fiscal institutions and terms that endured after the Golden Horde's decline in the 1400s.

Moscow's associations with the Mongols have long been problematic for Russians. When in the late fifteenth century the Muscovite princes faced the challenge of representing themselves to outsiders, they struggled with their Mongol past. After a false start—projecting a symbolic image based on Mongol legitimacy (Ivan III styled himself the "white emperor" to the Holy Roman Emperor)—they opted instead to stress Russia's Christian heritage. The church took over the symbolic, ritual, and textual representation of the grand principality in the late fifteenth and sixteenth centuries, designing coronation ceremonies, composing textual narratives such as those discussed above, and promulgating the "Tale of the Princes of Vladimir."

And it was most certainly during this work of reenvisioning that the Cap of Monomakh was physically transformed. The Eastern-style circlet of gold filigree was made Christian and Russian: the finest sable pelts surrounded its base (symbolic of the tsar's Siberian riches in fur); precious stones were added, much the way revered icons were covered with metal overlays studded with gems; a pearl-tipped cross was added on top. Several additional crowns were made in the sixteenth and seventeenth centuries in imitation of the cap: the "Kazan" crown, made in celebration of Ivan IV's conquest of Kazan, features filigreed gold pieces standing up like flames; the dazzling "Diamond" crown was made in the 1680s for Peter I. The style of the cap—circlet of fur, softly rounded gold dome, cross on top—fell out of favor when Peter I and his successors redesigned the royal regalia in the early eighteenth century. The *korona* of the self-styled Russian *imperatory* (emperors) took the shape of crowns that medieval European kings had modeled after Roman Catholic miters and the papal tiara. But even so, in Russia the

Cap of Monomakh continued to be revered as a touchstone of Russia's legitimacy, antiquity, and holiness.

So, to the informed eye, the Cap of Monomakh presents a dilemma. Do we read it as what it was created to be, a physical link between the Moscow grand princes and the culture of the Golden Horde? Or is its significance to be found in the crown as we see it now—transformed by myth and by reconstruction into a symbol of Muscovy as a Christian community, ruled by a tsar who traced his ancestry back into the history of Europe, the Orthodox Church, and the East Slavs? The object embodies conflicting visions of Russia's history and projects multiple layers of meaning.

NOTES—1. Dmitrii Ivanov, "Korol' edva ne okazalsia golym . . ." [The king was practically naked], *Pravda,* April 10, 2002 (open letter by director of National Institute of the Shield and Flag protesting replica of Shapka as gift to President Putin).

2. R. P. Dmitreeva, *Skazanie o kniaz'iakh vladimirskikh* (Moscow: Akademiia nauk SSSR, 1955) (Russian texts of the "Tale of the Vladimir Princes"); J. A. V. Haney, trans. and ed. "Moscow—Second Constantinople, Third Rome or Second Kiev?" *Canadian Slavic Studies* 3, no. 2 (1968): 354–67 (English translation of "Tale").

3. M. G. Kramarovskii, "'Shapka Monomakha': Vizantiia ili Vostok?" [The Cap of Monomakh: Byzantium or East?], *Soobshcheniia gosudarstvennogo Ermitazha* 47 (1982): 66–70 (discusses the origins of the cap); Donald Ostrowski, *Muscovy and the Mongols: Cross-Cultural Influences on the Steppe Frontier, 1304–1589* (Cambridge: Cambridge University Press, 1998) (surveys the fifteenth- and sixteenth-century conflict between Mongol and Byzantine Christian visions of Russia's past; see pp. 171–77 for discussion of the Monomakh myth).

4. Robert Craig Howes, trans and ed., *The Testaments of the Grand Princes of Moscow* (Ithaca, N.Y.: Cornell University Press, 1967) (English translations of the wills of the Muscovite grand princes).

5. I. A. Tikhoniuk, "Chin postanovleniia Dmitriia-vnuka," *in Russkii feodal'nyi arkhiv,* vol. 3 (Moscow: Akademiia nauk SSSR, Institut istorii SSSR, 1987): compare pp. 608 and 615 to p. 621 (the first three of four versions of the 1498 Coronation of Dmitry "the Grandson").

8

Church of the Intercession on the Moat / St. Basil's Cathedral

Michael S. Flier

Saint Basil's Cathedral, the most famous building in all of Russia, strikes us today as a quintessential example of Eastern exoticism, with its onion-dome cupolas in brightly colored facets, zigzags, or swirls and its brilliant frescoes with twisting vines and leafy flowers—it is a fantasy straight out of the *Arabian Nights*. A native of Moscow returning to the capital in late 1561 after a prolonged absence would have been shocked to discover the strange and wondrous assemblage on the market square, close to the bridge that spanned the moat and led to the main gate of the fortress, the Kremlin. The crosses atop each dome would have announced the group of buildings as churches, but none like any the returning traveler had seen in Moscow before (fig. 8.1 [color section]). Numerous domes and a tall, central tower loomed above other towers of different heights, their surfaces decorated with rows of geometric figures and niches, all in brick or smooth stucco painted to resemble brick. Some of these architectural details were familiar, but our traveler had never encountered a grouping quite like this one. How were these churches interrelated, being so close together? Where were the entrances? Where were the round protruding bays—the apses—that would indicate the eastern location of the sanctuary inside? What was an ensemble of this magnitude doing in the common marketplace rather than inside the fortress walls, where the other major churches and towers were located? And why was it constructed to look like a city in microcosm? Whatever the reason for its placement outside the elite space of the Kremlin, it must be important: the central tower was now the tallest building in Moscow.[1]

A picture, they say, is worth a thousand words. But let me say at the outset that the building we see today is not identical to its 1561 counterpart. There were no extravagantly decorated onion domes, no floral frescoes, no closed gallery that bound the individual towers together. Nor was the original ensemble even named for St. Basil. What would have amazed mid-sixteenth-century contemporaries was not the decoration so much as the arrangement of components, their location, and the sheer size of the whole. When viewed from the north or the south, the grouping looks asymmetrical and somewhat disorderly. But a bird's-eye view, as provided by the plan in figure 8.1, shows a purposeful arrangement.

The ensemble consists of a large chapel surrounded by eight lesser ones, all built on a single

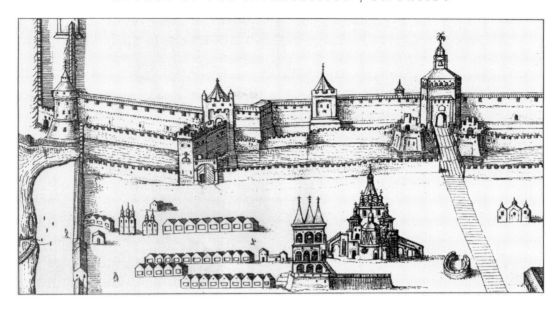

8.2. "Kremlenagrad," a map of the Kremlin made in the early 1600s. This detail shows the Church of the Intercession on the Moat from the east with Golgotha to the right and the Kremlin behind it. The staircases leading up to the Jerusalem chapel are not yet covered.

foundation. Chapels 4, 5, and 6 lie along an east-west axis that mediates between northern chapels 1, 2, and 3, and southern chapels 7, 8, and 9. The western facade, with its staircases flanking chapel 6, faces the Kremlin directly, thereby establishing spatial tension with the fortress wall and its main gate. Each chapel is a separate church, each with its own entrance, its own sanctuary with altar, and its own screen of icons closing off the sanctuary from direct view. Some of the chapels have different shapes in order to remain within the bounds of the common foundation and allow sufficient room for a walkway. The four chapels on the orthogonal axes— 1 (north), 4 (east), 6 (west), 9 (south)—are all octagonal. The diagonal chapels 2 (northeast) and 7 (southeast) are square, whereas the diagonal chapels 3 (northwest) and 8 (southwest) are triangular, with rounded eastern extensions for their sanctuaries. The orthogonal chapels are larger and taller than the diagonal ones. The central chapel 5 is essentially octagonal, but its center is shifted west to accommodate its large sanctuary to the east. The net effect is to produce a visually picturesque, asymmetrical grouping of masses toward the Kremlin side when one views the ensemble from the side (north or south), but a symmetrical arrangement of individual structures when one views the ensemble from the front or back (west or east; fig. 8.2). Such an overall arrangement of masses had never been attempted in Muscovy before Ivan IV's reign and was clearly intended by the tsar to express the unique status of Muscovy in the most public of settings: not behind the closed walls of the Kremlin but in the open space of the marketplace.

Ivan had fought two unsuccessful campaigns against the Muslim Tatars of Kazan, who occupied huge portions of the Volga River basin to the east of Muscovy, a territory of great political

and economic potential for the Russians. When his army finally achieved victory in the fall of 1552, he entered Kazan as a conqueror and returned to Moscow in triumph. After changing from military to royal garb, Ivan walked on foot through the main gate of the Kremlin to the acclamation of his subjects, not only as a military hero but as a great Christian victor over the Muslim infidels. He vowed to build a church dedicated to the Trinity in Moscow to commemorate his magnificent achievement. Apparently by 1553, a masonry church of the Trinity had been erected on the square by the moat, but by 1554, the project had grown more ambitious, and that church, with appended wooden chapels, was removed in favor of the eight separate chapels arranged around a ninth, many of them commemorating the feastdays of saints that coincided with the dates of major events in the Kazan campaign.[2] The ensemble was completed in 1561.

Looking again at the photograph in figure 8.1, we are guided by the architecture to assign prominence to two parts of the overall ensemble: the central tent tower for its mass and height and the western tower at the top of the staircases for its marked position in front. The central chapel was named in honor of the Intercession and Protective Veil of Mary, Mother of God; the western chapel, in honor of Christ's Entry into Jerusalem on Palm Sunday.

The Intercession, celebrated on October 1, refers to a vision of Mary spreading her protective veil over the Christian congregation in the Blacherna church in Constantinople in the mid-tenth century. October 1 was also the date of the storming of Kazan, and Mary's assistance was seen as instrumental in the Russian successes on that day and in the entire campaign. She had long been revered as the great protector of Moscow, especially in battles against non-Christians. The giant tower in her name declared her central importance for the Muscovite state and its ruler. Popular usage gave her name to the entire ensemble as well: the Church of the Intercession of the Most Pure Mother of God on the Moat.

The Jerusalem chapel, in contrast, had no calendar connection with Kazan. Rather, it was concerned with issues of Orthodox conviction and promise, with the themes of resurrection and the salvation of the righteous in the New Jerusalem foretold in the book of Revelation. As predicted in the Old Testament (Zechariah 9:9), Christ entered Jerusalem as a humble king, hailed by believers who accepted him as their savior. In an age of apocalyptic expectation, Muscovites looked to the tsar as a great Christian victor who would also lead them to their destiny following the Last Judgment. In the book of Revelation (chaps. 20, 21), this apocalyptic event is set in the context of a new age without end when New Jerusalem descends to earth from heaven above. In the sixteenth century, Moscow increasingly saw itself as the New Jerusalem, and the Church of the Intercession, this image of a wondrous city with its Jerusalem chapel, encouraged that belief.

The Jerusalem chapel was intentionally positioned in the front at the top of the stairs to become a station for one of the most important public ceremonies of the year, the Palm Sunday ritual, performed one week before Easter (fig. 8.3). An enormous procession of clergy, nobles of all ranks, merchants, and highly placed officials featured a reenactment of Christ's Entry into Jerusalem with the head of the church, the metropolitan, mounted on a horse disguised as an ass. The tsar walked on foot pulling the reins. The solemn procession, apparently introduced in Moscow after Ivan's victory over Kazan, made its way from the cathedral church inside

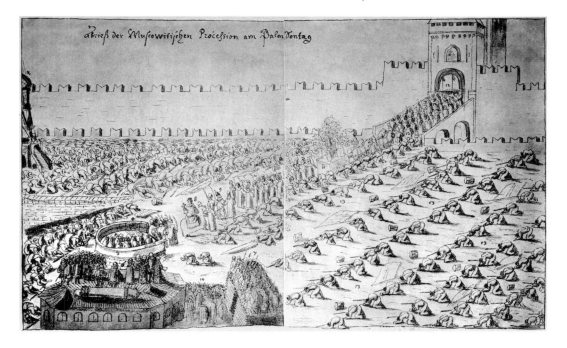

8.3. Palm Sunday ritual in Moscow, 1662. The procession shown leaving the Kremlin will return to the Kremlin following the service in the Jerusalem chapel of the Church of the Intercession on the Moat, just visible at the left. Engraving from *Al'bom Meierberga* (1903).

the Kremlin out onto the square and over to the Church of the Intercession. The tsar and the metropolitan ascended the staircase and participated in a small service in the Jerusalem chapel before rejoining the procession back to the Kremlin (note the ceremonial entrance to chapel 6 flanked by round columns, in the fig. 8.1 plan [color section]). The reenactment of the Entry into Jerusalem recalled the tsar's own triumphal march into Kazan and his return to Moscow. It lent credence to the realization of Moscow's messianic future. Visually and ritually, the Jerusalem chapel was accorded elevated status, thus prompting foreigners to extend the name of the part to the whole, referring to the entire ensemble as Jerusalem.[3]

As time went on, ruling elites felt a need to make the image of the New Jerusalem even more explicit and fabulous, in accordance with styles that favored greater elaboration and ornamentation. It is likely that when the devastating fire of 1571 destroyed the first cupolas, probably of the spherical helmet type, they were replaced around 1584–85 with the more exotic onion-dome cupolas decorated in brightly colored facets, zigzags, and swirls.[4] In the course of the seventeenth century the open gallery was enclosed and the walls repainted with frescoes of bright flowers, leaves, and vines, suggesting an attempt to create an image of the New Jerusalem that resembled the mystical, fantastic ideal described so vividly in Revelation 21. Ironically, the wild exoticism we so associate with the church today was the product of later development, and not the original conception in the 1550s. But even in its earlier, less colorful state, the Church of the Intercession was unusual and evocative of a sacred site not seen in Moscow before.

Saint Basil the Blessed, who figures in the current name of the church, was a "fool in Christ,"

an unconventional holy man much beloved in the Moscow of Ivan the Terrible (Ivan IV). Basil was a prophet renowned for speaking the unvarnished truth, even to the tsar himself. After his death in 1557, his remains were buried adjacent to the Trinity chapel.[5] The wooden chapel soon built there became a major site for pilgrims seeking to be healed and to worship at his grave. In 1588, Tsar Fyodor, son of Ivan the Terrible, commanded that a masonry chapel with its own cupola be adjoined to the existing ensemble (see chapel B in fig. 8.1 plan [color section]). Over time, the name of Basil the Blessed came to be extended by popular usage from his chapel to the whole ensemble (compare the earlier transfer of names from the Intercession and Jerusalem chapels). The official name of the ensemble, however, remains the Church of the Intercession of the Most Pure Mother of God on the Moat. It is remarkable nonetheless that a church ensemble so closely identified with the power and success of Ivan the Terrible was eventually re-identified with the very person who by legend criticized the moral standing of the tsar himself. At different periods (the middle and end of the sixteenth century) and in various contexts (ritual and nonritual) one and the same building came to be associated with very dissimilar meanings.

This discussion of the photograph and plan, the map, and the engraving (figs. 8.1 [color section], 8.2, and 8.3 [color section]) has shown that often both a picture *and* a thousand words are required to gain a clear perspective on the origin and development of historical artifacts. One medium complements the other, enriching our understanding of the cultural values that all great works of art and architecture are intended to express.

NOTES—1. It remained the tallest until the addition in 1600 of the third and higher tiers and cupola to the Kremlin bell tower named Ivan the Great.

2. *Polnoe sobranie russkikh letopisei* (Moscow: Akademiia nauk SSSR, Institut istorii, 1959–89), 13:251, 255, 320, 334.

3. Samuel H. Baron, trans. and ed., *The Travels of Olearius in 17th-Century Russia* (Stanford, Calif.: Stanford University Press, 1967), 72, 99–100; Friedrich Adelung, ed., *Augustin Freiherr von Meyerberg und seine Reise nach Russland* (St. Petersburg: Karl Kray, 1827), 153.

4. *Polnoe sobranie russkikh letopisei,* 34:200. See A. L. Batalov and L. S. Uspenskaia, *Sobor Pokrova na Rvu (Khram Vasiliia Blazhennogo)]* (Moscow: Severnyi Palomnik, 2002), 39–40.

5. Batalov and Uspenskaia, *Sobor Pokrova,* 37 n. 40.

9

Mapping Serfdom

Peasant Dwellings on Seventeenth-Century Litigation Maps

Valerie A. Kivelson

For the majority of the population of the Russian Empire from the mid-seventeenth century to emancipation in the mid-nineteenth century, serfdom was the defining and limiting condition of life. Bound to the land and thereby to the landlords who owned the land, peasants could not travel or move without their masters' permission and rendered to their masters heavy payments in labor, goods, and cash. Landlords or their bailiffs had nearly unlimited powers to intervene in the lives of their serfs, mandating marriages, selecting military conscripts, and administering what passed for justice on the estates. From the moment of its legal enactment in the law code of 1649, the system of serfdom robbed peasants of mobility, independence, and freedom, crushed them under insupportable obligations, and condemned them to near slavery.

At least, this is the image of serfdom that most of us carry in our heads. Visual sources, however, suggest that during its formative decades in the seventeenth century, serfdom functioned more as a system of land distribution, protection, and usage than as a system of coercive human bondage.

Studying serfdom presents significant challenges. Largely illiterate, serfs left few written records. Fortunately, we have a large set of visual sources—local maps—that show us much about the status of peasants in the first half-century of serfdom. Officials involved in adjudicating real estate disputes charged local mapmakers to clarify where boundaries between estates lay by drawing detailed sketches showing fields and pastures, forests, rivers, swamps, bogs, and disputed property lines. Drafts of the maps were roughed out in brown or black ink, but the final copies were often painstakingly drawn and prettily colored in watercolor wash, suggesting more artistic care than one might expect in a utilitarian document made for the factual edification of the court. Why provincial mapmakers expended so much energy on the artistic presentation of their cartographic findings is unclear. They may have felt a need to impress the court officials, but such care was not usually required of judicial or administrative documents, most of which were jotted down in hurried, often scarcely legible script, with no attention at all wasted on aesthetics. The echoes of the visual imagery of icons suggest a more compelling ex-

planation for the artistry evident in these maps. As images rather than texts, maps reflected and drew on the quite limited range of painted forms available to seventeenth-century Russians, and icons ranked as the most highly esteemed and most commonly seen genre. Borrowing from the nature imagery common in iconography, mapmakers treated their visual depictions of the world with the care, if not the reverence, due to a religious artifact.

The people commissioned with making the maps were generally men of middling social rank, retired military men, clerks, and administrators, who commanded basic literacy skills but could boast of no particular cartographic or artistic expertise. Given the task of mapping the land, they recorded what they saw as important and omitted whatever they felt was irrelevant. Because of their intensely local focus, mapmakers often included a variety of pictorial detail: such notable landmarks as a tree with a double trunk or a ditch overgrown with raspberry bushes. Given the importance of Russian Orthodox Christianity, as well as the lofty presence of church steeples on the otherwise flat landscape of central Russia, the prominence of churches on the maps is not surprising. What may be surprising, in the context of serfdom, is the ubiquitous representation of peasant houses dotting the landscapes of the maps.

The first map shown here comes from the province of Uglich, slightly north of Moscow on the Volga River (fig. 9.1 [color section]).[1] It was made in 1678 in the course of a dispute between I. Ia. Piatkov and the widow Solomida Onikeeva and her son over an uninhabited piece of land, a field called Ploskoe (Flat) in the district of Gorotsk. It is a simple schematic layout of four solid, almost monumentally scaled structures (or groups of structures) and a forest of stylized trees, with a few simple property lines. The lovely blue-green Luksha River wends its way through the quiet scene. The map neatly labels Ploskoe, the rounded field at the center of the map, and shows its position relative to the neighboring fields and structures, each indicated with the standard administrative handwriting of the time. The map itself is large, nearly 3 feet by 2 ½ feet, and is painted on heavy rag paper that has aged well, except for the wear evident along the lines of the folds. The labels and the buildings face in different directions, suggesting that the artist had to move around the paper as he completed his work.

The most easily identifiable structure on the map is the church, topped with a characteristic onion dome and Orthodox cross. Instead of indicating the name of the church, the mapmaker labeled it with the name of the village that it served: "Church of the village of Shershavino." Through that textual allusion to their proprietary interest in the church, the residents of the village make their presence felt on the map, even though the village is not depicted. The mapmaker drew in three other structures, each shown in stylized form as a row of three adjoining houses. Nearest to the church and perpendicular to it are the houses belonging to the priest and his household. Below the church and oriented in the opposite direction is the village of Zareche (Beyond the River). The third cluster of houses is labeled "Village of Ploskoe." These two village settlements and the third village evoked by the church are depicted here as solidly in place, exercising an unequivocal and powerful claim to position and belonging. Although the claims to the uninhabited field Ploskoe may be in doubt, nothing is questionable about the location or solidity of these peasant villages. These were in fact villages of enserfed peasants who belonged to the various landholders of the region.

Why did the mapmakers waste their time depicting peasant houses and villages, if the legal

dispute pitted one landlord against another and had nothing to do with peasants, who, after all, should have had no legal claim on the land whatsoever? Answers are embedded in the map itself, although without a good understanding of the legal conventions of land usage and litigation and the social conventions of witnessing and testifying to claims, those embedded meanings would remain incomprehensible. By another stroke of luck, these real estate maps have been carefully preserved in the Russian archives along with voluminous judicial transcripts from the cases they document. The trial records show that landlords' claims to uninhabited land were by definition hard to prove. Who could say whether Piatkov or Onikeeva rightfully owned the empty plot of land near the river? One piece of land looked more or less like another, and without human witnesses, legal wrangling became a pointless matter of one person's word against another. Peasants, however, lived in the neighborhood and could testify to the fine points of ownership on the basis of their long-term residence. Their testimony shaped the drawing of maps and the outcomes of cases. To establish rightful boundaries, court officials interviewed local peasants and even assembled them in the hundreds to walk the boundaries and point out distinguishing landmarks. Peasant testimony is recorded on many maps, though not on this one, and their signatures, or those of their literate delegates, fill the backs and margins of many maps. Peasant voices were highly valued, indeed indispensable, in establishing legal claims to land.

This reliance on peasant witnesses carried with it another, extremely important implication for the status of serfs. If we, from a modern, liberal, individualistic perspective, see in serfdom the limitations imposed on a peasant's freedom of movement, Muscovite peasants, with an immediate interest in access to the land that sustained life, might rather have focused on the flip side of the their bondage. If they could not leave the land, neither could the land be taken from them. As Steven Hoch writes: "In fact, being tied to the land is a much underrated notion; in Russia, from the mid-seventeenth century being a peasant (with few exceptions) implied an entitlement to land, which is not a bad deal, if you are subsistence-oriented."[2]

Maps offer us otherwise inaccessible evidence about the ways peasants were imagined in relation to the land. What effects, if any, did the visual impression of these maps have on viewers at the time? Much of the recent literature in the history of cartography argues that maps exert transformative power; once a place and a society are mapped, they are imagined, governed, and valued in new ways. Can we make a similar case for Muscovite real estate maps?

In an immediate sense, one can certainly argue that they contributed to determining judicial verdicts and hence the practical distribution of land among various contesting claimants. They were, however, only one of many forms of evidence produced in a given case, and their versions of the particulars could be contested. The second map reproduced here was one of two sharply differing plans submitted in conjunction with a case that dragged on from the late 1680s until 1691 (fig. 9.2 [color section]).[3] This version shows the land and settlements in the southern province of Elets, depicted as a wild garden filled with gigantic flowering plants of teal blue and dusty rose. A picturesque church picks up the same bright color scheme, while rows of houses, belonging to landlords and peasants stand along the riverbank. In contrast, the accompanying court records present a sordid story of an ugly legal battle between two groups of landlords, each of whom claimed property along the Great Ravine (the elongated brown triangle on the

lower left). The accepted dividing point between their two collectively held properties were the clusters of *kurgany,* ancient burial mounds, shown here as dark circles grouped around the boundary line (the thin straight line running vertically between the ravine and the wavy green-gray river at the top). There, however, the agreement between the two groups ended, with each group claiming that a different array of barrows signified the termination of their holdings. Each side submitted a map drawn by a local provincial clerk, and each side questioned the testimony provided by the masses of peasant witnesses mustered by the opposing camp. As a factor determining a practical outcome, then, a map was only one of many pieces, and its claim to establishing truth was rarely uncontested.

Still, in less immediate ways, these maps and the hundreds of others like them may be said to have solidified and confirmed ambient notions about the organic linkage between peasants and their land, about the power of peasant claims to the land they tilled and the impropriety and almost impossibility of attempting to invalidate those claims. If landlords, clerks, and judges turned to serfs to determine and uphold proprietors' titles to land, and if mapmakers depicted those serfs as present and powerfully connected to that land, then, in viewing the resulting map, all those concerned would be confirmed in their conviction that peasants had strong, irrefutable, simultaneous, or even prior claims to those pieces of property. With circular, self-confirming logic, maps represented and deepened the Muscovite sense that peasants belonged to and on particular plots of land. Moreover, as official documents upheld and affirmed by the state, these illustrated sketch-maps contributed to the transformation of informal, customary recognition of peasant land usage into something more recognizably modern, bureaucratic, legal, and *visual.* Landlords' claims could be seamlessly layered on top of peasants' claims, and masters' rights to exploit and control their peasants grew apace in these last decades of the seventeenth century and in the century that followed; but as peasants became serfs, they retained their primary relationship to the land that they worked. In very visual ways, both on paper and in their conspicuous presence on the land, they retained a direct connection to their means of survival and their distinctive status.

NOTES—1. Russian State Archive of Early Acts (Rossiiskii Gosudarstvennyi Arkhiv Drevnikh Aktov, RGADA) (Moscow), f. 1209, op. 77, Uglich, stlb. 35741, ch. I.

2. Steven Hoch, "The Serf Economy, the Peasant Family, and the Social Order," in Jane Burbank and David Ransel, eds., *Imperial Russia: New Histories for the Empire* (Bloomington: Indiana University Press, 1998), 200.

3. RGADA, f. 1209, Elets-Efremov, stlb. 24155, ch. II, 1. 327.

10

From Tsar to Emperor

Portraits of Aleksei and Peter I

Lindsey Hughes

In a groundbreaking work published in 1961 the American historian Michael Cherniavsky juxtaposed two portraits to illustrate the shift between what he termed the "theocratic tsar" and the "sovereign emperor."[1] The first depicted Tsar Aleksei Mikhailovich (born 1629, reigned 1645–76). It came from a bound illuminated manuscript known as the *Great Book of State,* or *Titulary* (*Tituliarnik*), made in the workshops of the Moscow Kremlin in 1672 and comprising short biographies and colored pen and ink portraits of Russian and foreign rulers (fig. 10.1). The second was an engraved portrait of Aleksei's son, Peter I ("the Great," born 1672, reigned 1682–1725). It was made on Peter's orders in 1717–18 by the Dutch engraver Jacobus Houbraken from an original oil painting by Karl (Carel) Moor (Amsterdam, 1717; fig. 10.2).

Cherniavsky believed that the contrast between the two pictures "speaks for itself," but I doubt whether many modern viewers can easily interpret the conventions of formal European portraiture, still less the imagery and historical context of early Russian portraits. In revisiting these well-known images I hope to put into perspective the cultural "leap forward" associated with Peter the Great's reforms and the associated changes in conceptions of rulership in Russia. Only forty-five years separate these portraits of father and son, both in their mid-forties when they were depicted, both shown half-length with their heads turned slightly to the right, but most viewers will be struck initially by how much more modern Peter's portrait looks than Aleksei's. A little context is needed here. The art of lifelike portraiture from living subjects reached Russia some two hundred years after the artists of the Italian Renaissance pioneered it in western Europe. By the seventeenth century reproductions of likenesses of rulers and other celebrities were widely available for sale in the West. To take a British example, we have multiple images of King Charles I from every year of his life, from childhood to his execution in 1649. By contrast, not one authentic portrait survives of his near contemporary Tsar Mikhail (1613–45), Peter I's grandfather. The mere existence of Aleksei's portrait, then, points to changes in Muscovite culture in the second half of the seventeenth century that some historians have dubbed a belated Russian "Renaissance."

These changes were precipitated by war, trade, and diplomacy. For example, Russia's wars with Poland-Lithuania in the 1650s–60s and associated territorial acquisitions encouraged ele-

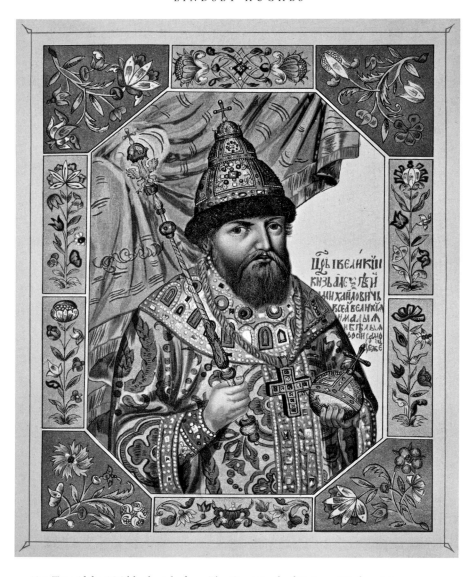

10.1. Tsar Aleksei Mikhailovich, from The *Great Book of State,* or *Titulary,* Moscow Kremlin, 1672.

ments of Polish baroque art to filter through Ukraine and Belarus. Foreign artisans came to work in the royal workshops in Moscow. Portraits of foreign rulers in the *Titulary* were copied from foreign prints that began to circulate in Russia. The Russian Cyrillic inscription on Aleksei's portrait reads: "Tsar and Great Prince Aleksei Mikhailovich, Autocrat [*samoderzhets*] of all Great and Little and White Russia [*Rosiia*]," a shortened version of the more grandiose titles included in diplomatic correspondence. The titles testify to Russia's growing presence and pretensions in world politics.

Despite this modernizing context, Aleksei's image is archaic by Western standards; it is a

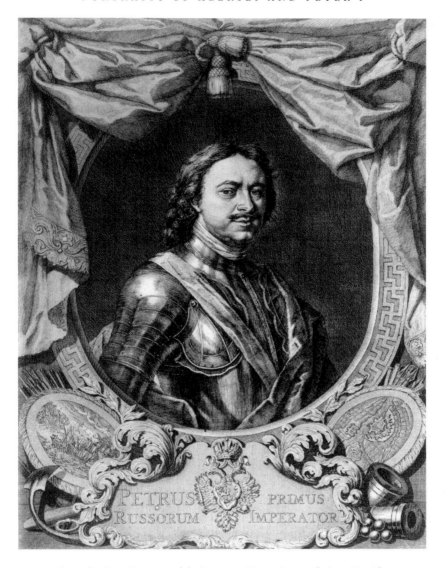

10.2. *Peter the First, Emperor of the Russians.* Engraving made in 1717–18 by
Jacobus Houbraken from an original oil painting by Karl (Carel) Moor, 1717.

stiff, notional likeness, probably only loosely based on portraits of the tsar painted from life.
The Russian rulers in the *Titulary* all have similar facial features, suggesting an unbroken chain
of dynastic descent from Riurik, the semilegendary founder of the Russian realm. In the 1670s,
Russian secular portraiture had not separated from the art of religious iconography. Artists still
worked within the confines of Orthodox sensibilities and Muscovite aesthetic conventions. It
is significant that the only surviving dated image of Aleksei to be signed by an artist appears
in the lower left-hand corner of an icon, *The Tree of the Muscovite Realm* (1668), by the court
icon-painter Simon Ushakov.

In virtually all known portraits, as here, Aleksei appears in the guise of a Byzantine emperor. His regalia include the Crown or Cap of Monomakh, reputed to have been sent to an eleventh-century prince of Kievan Rus from Constantinople (see fig. 7.1 [color section]). The *barmy*, or broad collar, decorated with gems and pearls, and the brocade robes spun with gold thread were also based on Byzantine prototypes, as was the double-headed eagle motif on the scepter, adopted by Ivan III (1462–1505) in the awareness that it was also the emblem of the Holy Roman Empire of the Habsburgs. Such trappings signified Moscow's self-identification as rightful successor to Byzantium and the center of true Christianity. There are four crucifixes in the picture, including the large pectoral cross on a gold chain. The tsar is fully bearded, for, as the Moscow Church Council of 1551 declared, "the sacred rules to all Orthodox Christians warn them not to shave their beards or moustaches or to cut their hair." Shaving was "a Latin [i.e., Catholic] and heretical bequest" and men who shaved rendered themselves "unrecognizable as Christians."[2]

The Muscovite "monarchical myth" was based on the notion of exclusive royal power rooted in divine right. The realm could prosper only under a pious Orthodox tsar. (The flourishing of this blessed earthly kingdom is suggested by the borders of stylized flowers on Aleksei's portrait.) Yet such concepts were hardly expressed at all in theoretical texts. The evidence of portraits is therefore invaluable for historians, to be read alongside the detailed records of court ceremonies, where the tsar acted out his part as the center not only of court and religious life but also of Russia itself, God's chosen kingdom. Portraits give embodiment to the idealized ruler.

Peter I seemed destined to perform a similar ceremonial role to that of his father. Indeed, the first known image of the future emperor is as an infant, clad in Russo-Byzantine robes; it appeared in a supplement to the *Titulary*. Things turned out differently, however. In 1697–98, Peter undertook a Grand Embassy through western Europe, where several artists painted his portrait. Western images that emphasized the Muscovite tsar's "exoticism" and "otherness," with fanciful headgear, Oriental robes edged with furs, and Tatar swords, gave way to portraits wholly in the Western idiom. When Peter embarked on his second major European tour in 1716–17, now with an impressive reputation for foreign conquest and domestic reform on Western models, painters competed to capture his image, including Karl Moor in Amsterdam, who produced what was said to be Peter's favorite portrait of himself.

An initial examination suggests that Peter's portrait is indeed more realistic than Aleksei's. Certainly it conforms to the accumulated evidence of the many likenesses of Peter made from life. The manner in which the engraver imparted an illusion of three dimensions to the fabric swathes, the hair, and the armor contrasts with the flat two-dimensionality of the 1672 image. Peter's jowls and the wrinkles around his eyes suggest life experience rather than transcendent qualities. His portrait is also more secular than his father's. There is no apparent trace of religious imagery, including a beard; as is well known, Peter forced elite Russians to shave their beards off. Peter does not wear a crown or hold an orb and scepter; his authority is rooted in military exploits. Peter himself approved of this portrayal, but it was not just Peter's "Westernized idea of himself" that he liked, as Cherniavsky claimed. The portrait also captured Europe's vision of Peter, confirming the success of one of the goals of the Great Northern War against

Sweden (1700–1721), which was to obtain Russia's inclusion in the ranks of civilized "political" nations. Note the Latin inscription: "Petrus Primus Russorum Imperator" (Peter the First, Emperor of the Russias). Peter did not adopt the imperial title officially until 1721, but by 1717 he was confident of getting it. Whereas only Russian speakers could read the titles on Aleksei's portrait, Peter's aspirations were clear to any educated Westerner.

The portrait of Peter may emphasize military rather than religious symbols, but military leadership had its own conventions and its ceremonial context, no less than did the role of pious tsar reenacted by Aleksei. Seventeenth-century artists developed the stereotypical image of the armor-clad conquering hero-monarch for rulers who led their troops in person, such as William III of England ((1688–1702) and Charles XII of Sweden (1697–1718). However, no eighteenth-century ruler went to war in the sort of archaic armor depicted in such portraits; rather, the armor has a symbolic function. Military emblems surround the oval frame of the engraving. To the left, an anchor rests against a medallion containing a scene of Russia's naval victory at Cape Hangö in 1714; to the right, cannon muzzles and cannonballs rest against a medallion of the Peter-Paul fortress in St. Petersburg, founded by Peter in 1703. The ornamental scrolls, swags, and borders are all conventional enhancements for Western formal portraits.

Peter discarded virtually all Byzantine-based ceremony and imagery, with the exception of the double eagle, replacing them with ceremonies originating in imperial Rome, including the military parade through triumphal arches decorated with classical allegories. Although he reduced the political and economic independence of the Orthodox Church and ended its virtual monopoly on culture, he made good use of a new selection of religious motifs. In our portrait the ribbon draped over Peter's shoulder is the sash of the order of St. Andrew, founded in 1699 to reward gallantry. Andrew was one of several saints whom Peter promoted as protectors of his new empire.

So, for all the differences in detail, our two portraits fulfill a similar purpose: they represent the power and dignity of the ruler of all Russia. In such formal compositions naturalistic realism was inappropriate. The Renaissance theory still held good: "Emperors above all other Kings and Princes should be endowed with majesty, and have a noble and grave air which conforms to their station in life . . . even though they be not naturally so in life" (Georgio Lomazzo, *Trattato dell'arte della pittura,* 1598).

Both our portraits functioned beyond their subjects' lifetimes. In the seventeenth century Aleksei's original portrait in the *Titulary* manuscript could have reached only a very restricted audience. Like the tsar's short-lived court theater (1672–76) and the interiors of his residences, it was accessible only to an elite public. Other images of the tsar reached foreign viewers—for example, in engravings published in Vienna in the 1670s—but not ordinary Russians. Not until the eighteenth century was there a wider demand for pre-petrine dynastic portrait series to decorate imperial palaces and public buildings. In the nineteenth and early twentieth centuries such portraits were one of many devices that the authorities used to inculcate respect for orthodoxy and autocracy. Royal portraits, including the *Titulary* images, appeared in a wide variety of contexts, in history textbooks or in cheap printings on paper for public distribution. Peter's portrait by Moor/Houbraken was probably the most reproduced of all his likenesses, appearing in miniatures and in prints against various backgrounds. In 1912 the engraving was

used on the new 500-ruble banknote (see chapter 28). Peter's armor-clad form was intended to reinforce confidence in the currency and to provide a reminder of the Petrine roots of Russia's prosperity in the expansion of empire and military might: modernization tempered by national pride. This and a few other positive images of a ruler associated with the glory of Russian arms still largely determine both popular and official perceptions of Peter the Great, while Aleksei remains fixed in time, the pious tsar elevated above earthly passions.

NOTES—1. Michael Cherniavsky, *Tsar and People: A Historical Study of Russian National and Social Myths* (New Haven: Yale University Press, 1961).

 2. *Stoglav,* chap. 40; see the text in E. B. Emchenko, *Stoglav: Issledovanie i tekst* (Moscow: Indrik, 2000), 302–3.

11

The Russian Round Table

Aleksei Zubov's *Depiction of the Marriage of His Royal Highness, Peter the First, Autocrat of All the Russias*

Ernest A. Zitser

Aleksei Fyodorovich Zubov's (1682–1751) justly famous etching of Peter the Great's second wedding has been reproduced so often in Russian history textbooks and has become such an emblem of the cultural revolution under way at the court of Russia's first emperor that it appears to speak for itself (fig. 11.1). Once we have explicated its charged political context, identified the key protagonists, and pegged it as a contemporary depiction of the long-term historical processes of westernization, secularization, and female emancipation, there seems very little else left to say.[1] Yet if we take a closer look at this print, its history, and its heretofore-unacknowledged carnivalesque aspects, we will see that neither its canonic status nor its meaning can be taken for granted.

Zubov's engraving was commissioned by Alexander Menshikov (1673–1729), Peter's royal favorite, in anticipation of the event itself—primarily so it could be distributed to visiting foreign envoys and important Russian dignitaries, both as a sign of royal favor and as a programmatic explication of the new dynastic scenario enacted during the royal nuptials. The engraving depicts the elaborately choreographed performance of Peter's controversial plan to legitimate the children of his low-born foreign mistress in what was at once a typical royal wedding, along the lines of those staged at other European courts, and a visual apotheosis of the tsar's God-given power to turn the world upside down, if necessary, in order to institute a radically new dispensation. Even though the details of the interior are executed with remarkable skill and Peter's face is clearly recognizable, realism as we understand it today was not high on Zubov's agenda. Indeed, what is most interesting in the etching is the way the artist used contemporary visual conventions—both European and Muscovite—to direct the viewer's eye to unconventional practices and meanings. So, what from our point of view appears to be a stylized depiction of a staid court ceremony could, from the perspective of Zubov's patron and other knowledgeable insiders, appear to be a carnivalesque political allegory.[2]

Zubov's depiction of Peter's wedding to the recently baptized Catherine Alekseevna (née Marta Skavronskaya, 1683–1727) presents the tsar, his bride, and his guests as knights and ladies of a modern, distinctively Russian Round Table. The tsar is seated at the center rear and

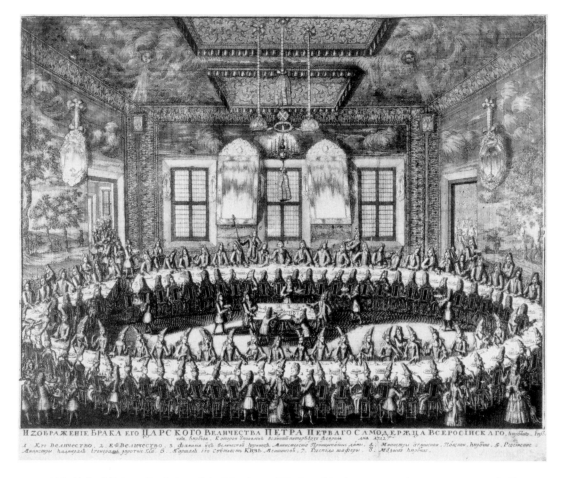

11.1. Aleksei Zubov, *Depiction of the Marriage of His Royal Highness, Peter the First, Autocrat of All the Russias*, 1712. Copperplate engraving.

appears to be pointing in the direction of Menshikov, who stands behind Peter's chair holding the wedding marshal's staff.[3] The chivalrous reference to the Round Table is underscored both by the tsar's outfit—he appears not in royal ermine or Muscovite royal regalia but in the uniform of a rear admiral of the newly formed imperial Russian navy—as well as by the prominent presence of the sash and cruciform medal of the knightly order that he displays across his chest.[4] The insignia of that knightly order—the very first Russian order of chivalry, instituted in 1699 by Peter himself and named after the patron saint of Russia and of sailors (St. Andrew the First-Called)—echoes the insignia on the medallion hanging above the wedding wreath that connects the two crowns on the canopies suspended over the heads of the wedding guests. In fact, the parallelism between the medal on Peter's chest and the medallion above the Petrine Round Table deliberately draws our attention to the relationship between the upper and lower halves of the visual universe depicted by Zubov. This spatial and metaphorical relation is based on an optical illusion according to which the top half of the room appears as if it were the same

size as the bottom half—a combination that in reality was precluded by the squat physical lay-out of Peter's recently completed Winter Palace, in which the wedding banquet actually took place.[5] In Zubov's engraving, however, the baroque interior of the main dining hall is split into two more-or-less even halves by a horizon line going through the figure of Peter himself, who is also the central vanishing point for the entire engraving. In effect, Peter's body marks the boundary between two planes—the light, airy, window-filled top half representing the realm of religious icons and painted cherubim and the glitzy, crowded, bottom half representing the realm of power and gallantry. Here Zubov employs the device of three-dimensional perspec-tive and the technique of copperplate etching—both relatively new developments in Russian visual culture—to render the ineffable quality of the tsar's "two bodies" and to reinterpret for his contemporaries a very old trope of Muscovite royal panegyrics, one that depicted tsars as divinely appointed intercessors between heaven and earth.[6]

For all of the technical innovations and chivalric references, Zubov, ever the icon painter's son, not only hangs on to this very fundamental bit of tsarist visual politics but also uses the trope to structure his image of the royal wedding feast.[7] The top half of the engraving is domi-nated by a representation of the lighting fixtures in the reception hall—large glass windows, reflective side mirrors, and, most prominently, an ivory candelabrum that Peter himself turned for the occasion on his own lathe.[8] As the visual center of the top half of Zubov's engraving, this lighting fixture serves a much more important function than it would seem at first sight. Viewers familiar with the rhetorical conventions of the baroque would be more likely than we to see this candelabrum not as a mere source of illumination or as a demonstration of Peter's skill at one of his favorite pastimes but, rather, as a symbol of the tsar's true vocation. With gentle coaching, they could be led to understand that much like the incognito king (in Russian, *tsar*) of the Gospels, Peter had assumed the form of a humble artisan to better demonstrate his divine calling, which the Archbishop Feofan (Prokopovich) of Novgorod, the tsar's chief panegyrist, would later describe as bringing the Russian political nation "from the darkness of Ignorance into the Theater of the World, so to speak from nothingness into being."[9] At the time of Peter's second wedding, a reference to this exalted calling appeared in a more classical guise on Peter's personal seal ring, which depicted the royal Pygmalion hewing a statue of the New Russia from the rough stone of old Muscovy under the watchful, all-seeing eye of God. It was also embodied in the candelabrum that Peter produced for his wedding and which Zubov reproduced in his engraving. In both cases, the act of polishing the rough material on the tsar's workbench served as an allegory for the redemptive mission of transfiguring his chosen people into the polite denizens of a well-ordered "paradise."[10]

If the image of Peter as divinely inspired light-giver dominates the top half of the Zubov engraving, the arrangement of guests below evokes the chivalrous table-fellowship of the elect.[11] These new chosen people are seated at the Petrine Round Table, which is depicted as a fore-shortened circle, whose circumference is defined by the royal couple's line of vision. Peter's direct stare from the top of the ellipse, like Catherine's coy, over-the-shoulder glance from the bottom, perform a kind of triangulation, reaching outside the frame of the engraving to the prospective viewer of this work. By making eye contact with the two royal figures, the viewer of Zubov's print is invited to catch a glimpse of the exclusive world of the Russian court, in all

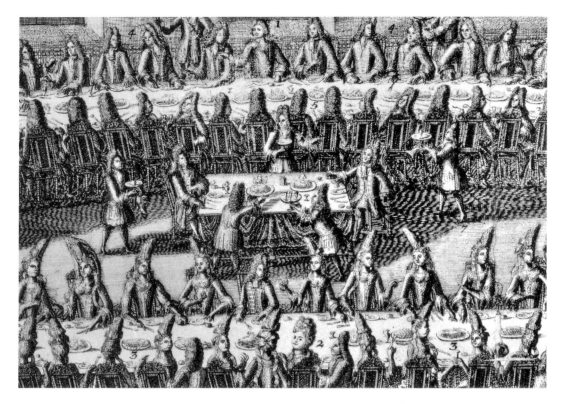

11.2. Detail of fig. 11.1.

its new, European-style finery and refinement. Most interestingly, however, the actual center of this terrestrial plane is not the round table of the royal bride and groom but rather the little square table occupied by three unidentified bewigged figures (two seated and one standing), one of whom holds a large goblet in his right hand while gesticulating with his left, as if in the act of proposing a toast (fig. 11.2). Thanks to the official list of guests kept by Peter's personal secretary, we know that these individuals were none other than the mock archpriests of the so-called Most Comical and All-Drunken Council—that is, the chief participants in the sacred parodies that served as an important element of the countercultural play-world that the tsar first elaborated at the end of the seventeenth century on the royal estate of Novo-Preobrazhenskoe (New Transfiguration) and which he continued to stage throughout his long, turbulent reign.[12] Participation in the Bacchanalian mysteries of this "Transfigured Kingdom" not only delineated the boundaries between those courtiers who belonged to Peter's select company and those who remained hostile to the tsar's vision of reform but also polemically highlighted the fundamental differences between the old Muscovite dispensation and the new Petrine one.[13]

Just as the placing of civil servants, foreign naval officers, and décolleté ladies around the main banquet table offered a visual demonstration of the chivalrous code of conduct that bound the guests to the Russian monarch and his bride, so the prominent presence of the "Prince-Pope" and the leading members of his "Unholy Council"—not to mention the conspicuous

absence of Peter's son from his first marriage—proclaimed the tsar's intention to celebrate his wedding in the company of his own creation, independent of the traditional demands placed by family or faith. Whereas the first of these meanings was relatively obvious to anyone familiar with Peter's new scenario of power, the second meaning—like the second table—remained prominently in sight but just out of reach of most guests. Of the many that were called to the royal wedding banquet, only a select few could, without external coaching, identify the three "clerical persons" at the center of the Round Table or appreciate the seriousness of this inside joke. Consequently, only those courtiers who had helped the tsar to maintain the illusion—the word literally means "in play"—of royal charisma and who had abetted his carnivalesque inversion of the old dispensation could understand the full political significance of the etching created by the preeminent Russian engraver at the court of Peter the Great.

By placing royal play at the very center of his allegorical depiction of the Russian Round Table, Zubov offered not only a prime example of baroque wit but also one of the most sophisticated visual formulations ever made of the intimate connection between chivalry and travesty at Peter's court. Unfortunately, Zubov's insightful depiction of the carnivalesque mystery of state at the heart of Peter's "Transfigured Kingdom" never received a fair viewing. Even though the Russian artist did manage to complete his commission, his etching was never printed and passed out to the tsar's wedding guests, as had originally been intended. Nor was it ever mentioned in the sales receipts of the St. Petersburg Typography. In fact, for reasons that are still unclear,[14] all that survives of Zubov's original work is a single copperplate—the ultimate source for every existing print of this engraving, all of which actually date from the late eighteenth–early nineteenth century, more than thirty years after the artist's death.[15] By the time these later prints were produced, however, very few people cared about—or could even appreciate—the baroque complexities of Zubov's design or the controversial political project that they were meant to represent. Instead, most viewers treated Zubov's engraving as a more or less realistic depiction of the new, secularized, Western habits—in both senses of the word—introduced by Russia's first emperor, who was by then the universally acknowledged progenitor of the civilizing policies pursued by the self-described beneficiaries and inheritors of his legacy. In that respect, Zubov's new status as an important and increasingly collectible Russian artist went hand in hand with the contemporaneous canonization of Peter the Great as an Enlightenment monarch—an image that necessarily removed (or downplayed) all references to Peter's foundational antinomian acts.

Uncovering these references in Zubov's depiction of Peter's Round Table thus not only brings us closer to the engraving's original purpose but also gives readers of this book an opportunity to think about one particularly instructive example of the ideological consequences of canon formation in Russian visual culture. Indeed, if this brief re-vision of Zubov's engraving demonstrates nothing else, it is that its very canonic status limits the many possibilities inherent in viewing what is, to all intents and purposes, a baroque panegyric to Russia's own Anointed One—the man personally empowered by God to go against previously existing laws in order to usher in a new, Edenic age. In this view, the true meaning of Zubov's wedding banquet is closer in spirit to the eschatological one contained in the Gospels (Matthew 22:2–14; cf. Revelation 19:7–9) than to the Enlightenment meaning enshrined in textbooks.

NOTES—1. On the charged political context of Peter's second wedding, see Lindsey Hughes, *Russia in the Age of Peter the Great* (New Haven: Yale University Press, 1998), 261, 393–98, 402–11; and Ernest A. Zitser, *The Transfigured Kingdom: Sacred Parody and Charismatic Authority at the Court of Peter the Great* (Ithaca, N.Y.: Cornell University Press, 2004), 117–21, 157–59.

2. Zubov's most immediate model for his carnivalesque vision of political transformation was Adrian Schoonebeck's unfinished triptych (1702–5) depicting the masquerade-wedding of one of Peter's court jesters. Similarly, Zubov's first attempt to depict an interior scene, *The Marriage and Merriment of His Royal Highness' Dwarves* (1710), was also modeled on Schoonebeck's triptych and, like the latter, also had a carnivalesque theme. M. A. Alekseeva, *Graviura petrovskogo vremeni* (Leningrad: Iskusstvo, Leningradskoe otd-nie, 1990), 117, 119–20; James Cracraft, The *Petrine Revolution in Russian Imagery* (Chicago: Chicago University Press, 1997), 182; and Zitser, *Transfigured Kingdom,* 113–17, 121 n. 32.

3. Menshikov's patronage of Zubov and his preeminent position at court help to explain why the royal favorite is the only individual, other than Peter himself, who is mentioned by name in the numbered cartouche at the bottom of the engraving.

4. Rear admiral is a naval rank that Peter awarded himself through the offices of his mock double, the so-called Prince-Caesar. See *Pis'ma i bumagi Imperatora Petra Velikogo* (St. Petersburg: Gos. tip., 1887–), 1:242–43, 342.

5. *Pokhodnyi zhurnal 1712 goda* (St. Petersburg, 1854), 1, 7.

6. B. A. Uspenskii and V. M. Zhivov, "Tsar' i Bog: Semioticheskie aspekty sakralizatsii monarkha v Rossii," in B. A. Uspenskii, *Izbrannye trudy,* 2 vols. (Moscow: Shkola "Iazyki russkoi kul'tury," 1996), 1:205–337.

7. On Zubov's father, see M. A. Alekseeva, "Bratia Ivan i Aleksei Zubovy i graviura Petrovskogo vremeni," in *Rossiia v period reform Petra I* (Moscow: Izd-vo Nauka, 1973), 338; and Cracraft, *Petrine Revolution,* 178.

8. The official contemporary description of Peter's wedding explicitly mentions the fact that immediately before dinner was served, the tsar hung up the ivory candelabrum (*tochenoe panikadilo kostianoe*) that he had begun in the first days of January 1712 and completed on February 19. See *Pokhodnyi zhurnal,* 1–2.

9. Cited in Richard S. Wortman, *Scenarios of Power: Myth and Ceremony in Russian Monarchy* (Princeton, N.J.: Princeton University Press, 1995), 63. Archbishop Feofan was one of the ghostwriters of the 1721 speech in which this phrase occurs. See O. G. Ageeva, "Imperskii status Rossii: K istorii politicheskogo mentaliteta russkogo obshchestva nachala XVIII veka," in *Tsar i tsarstvo v russkom obshchestvennom soznanii* (Moscow: Institut Rossiiskoi istorii, 1999), 113–15.

10. For the tsar's analogy between St. Petersburg and paradise (*paradiz*), see Peter's letter to A. D. Menshikov (April 7, 1706), in *Pis'ma,* 4:209; and the sources cited in Hughes, *Russia,* 211–13.

11. For a reconstruction of the seating arrangements at Peter's second wedding, see G. A. Mikhailov, "Graviura A. Zubova 'Svad'ba Petra I': Real'nost' i vymysel," *Panorama iskusstv* 11 (1988): 25–38; for the official list of weddings guests, see *Pokhodnyi zhurnal,* 1–7.

12. The three "clerical persons" (*dukhovnye persony*) are "Prince-Pope" N. M. Zotov, "Arch-Hierarch" P. I. Buturlin, and "Arch-Deacon" Prince Iu. F. Shakhovskoy. *Pokhodnyi zhurnal,* 5–6.

13. Zitser, *Transfigured Kingdom,* 4–5, and passim.

14. There is still a debate about which palace interior is depicted in Zubov's engraving. Since Peter decided to move the actual site of his wedding banquet to his own Winter Palace soon after the completion of Zubov's engraving, the artist's diligence in depicting the interior of Menshikov's palace quickly became out of date. Worse still, enemies of the royal favorite could use Zubov's engraving as damning visual evidence of Menshikov's self-aggrandizing overeagerness to curry favor with his master. See Alekseeva, *Graviura petrovskogo vremeni,* 123–24, 200 n. 22.

15. Alekseeva, *Graviura petrovskogo vremeni,* 6, 124.

12

An Icon of Female Authority
The St. Catherine Image of 1721

Gary Marker

This essay focuses, quite literally, on the iconography of female political and religious authority in the early eighteenth century, on the eve of seven decades (1725–96) of almost uninterrupted female rule in Russia. For the most part it dwells on a single image, a 1721 icon of St. Catherine from the Alexander Nevsky Monastery in St. Petersburg. Catherine of Alexandria was the name-day saint of both Catherine (Ekaterina in Russian) I (1725–27), Russia's first crowned female ruler, and Catherine the Great (1762–96), Russia's last female ruler.[1]

Both spatially and temporally this icon lends itself to a multidimensional political reading (fig. 12.1 [color section]). Completed in the latter years of Peter the Great's reign, at the conclusion of the Great Northern War and the declaration of empire, it constituted a visual articulation of the commingling of antiquity and modernity, patrimony and empire, faith and state, that were proclaimed in cathedrals and on the streets, through panegyrics, sermons, and fireworks. Its commissioning for the Nevsky monastery, the newly consecrated cloister of the recently established capital, has a significance of its own, one that illustrates the omnipresence of the visual, at least for the monks who lived behind the monastery's closed gates. The commissioned images were chosen with considerable premeditation, and as everyone knew, the guiding hand of the tsar played no small part in the process. When the monks passed by sacred images, they were coming face to face with the will of the tsar, God's Anointed One. When the figure in an image stood apart, or if it sat in a celestially more important place than was typical, the monarch's will was more visible still. When the sacred figure was that of a female outside the holy family, especially one—St. Catherine—who was the name-day saint of the monarch's living consort, nothing short of blindness could have kept the monks from seeing the tsar's commanding presence.

Saint Catherine was a familiar saint in Russian Orthodoxy, and services in her honor appear in the oldest surviving East Slavic service books of the late eleventh century. The standard vita runs as follows: The daughter of high nobility, Catherine lived in late-third-century Alexandria, at the time of Emperor Maxentius. She embraced Christianity, converting many of the emperor's centurions, as well as his wife. The emperor endeavored to seduce her, but she refused, ultimately becoming a bride of Christ, wed in a mystical marriage. The enraged emperor

imprisoned her and commanded his wisest men to debate her publicly to show the emptiness of her faith. Learned and endowed with wisdom and bravery (*muzhestvo,* also translated as "manliness") and protected by grace, she prevailed. Maxentius ordered Catherine chained to an iron-studded wheel, but the archangel Gabriel smashed the wheel, thus saving her temporarily from martyrdom. Maxentius then ordered her beheaded, after which the now-martyred body of Catherine was spirited away by angels to Mt. Sinai, and there her remains lie.

Saint Catherine became an important figure throughout Christendom as a martyred bride of Christ and an exemplar of piety, wisdom, and defiance. These roles shaped her iconography, particularly in western Christendom, for which the so-called Catherine wheel became her emblem. Other common images depict her mystical marriage to the baby Jesus; the triumphant defeat of the pagan philosophers; and faith's conquest of unbelief, symbolized by Catherine standing with her foot upon the neck of Emperor Maxentius.

In the seventeenth century St. Catherine's identification with the women of the new Romanov dynasty grew quite strong. The primary chapel of the tsaritsy, located in the residential palace of the tsar, adjacent to the women's private quarters, or *terem,* was consecrated in her name. Most of the Romanov children (including the future Peter the Great) were either baptized or received regular communion there. In November 1658, Tsar Aleksei had a miraculous visitation from St. Catherine announcing that his wife was about to give birth to a girl (she did) and instructing him to name her Catherine (he did). Finally, in 1687 the Muscovite court became the official protector of the St. Catherine Monastery in Sinai, an important pilgrimage site since the eighth century. These and other gestures, such as processionals of the cross on St. Catherine's day (November 24 in the Russian calendar) established St. Catherine as a patron saint of sorts for the Romanov women. They formed what might be termed an inventory of religiously sanctioned tropes of female power around the name of St. Catherine.

A critical link in adapting St. Catherine to political hagiography was the celebration of name days, which Orthodox tradition honored far more than birthdays. By tradition, a child was named after a saint whose day fell either on the child's birthday or immediately thereafter. The saint was that person's angel ("name day saint" and "angel" are used interchangeably), an example for living a pious life and a personal intercessor with heaven. The individual strove to become the angel's living image (*zhivii obraz*), to merge spiritually with the saint. Muscovite court records show that name days of the ruling family became important and publicly inscribed events. With the advent of written sermons and religious poetry after 1660 or so, name days of the ruling family provided new opportunities for panegyrics, which often drew upon the idea of the saint's living image. These texts constituted artistic exercises intended to glorify the monarch and the royal family and to align them with the forces of heaven.

The emergence of Peter's consort, the tsaritsa Catherine, as a public figure (that is, one whose persona was acknowledged in official records) just prior to the battle of Pruth in 1711 raised the Catherinian stakes. Saint Catherine was openly identified—through sermons, feast days, fireworks, the new Order of St. Catherine (1714), and iconography—with her living namesake. Churches were dedicated to St. Catherine, and her visage appeared on icons and wall paintings in venues managed by those wishing to curry the tsar's favor. The implied agenda, through word and effigy, was to merge the identities of angel and living image, St. Catherine and Tsaritsa

Catherine, so seamlessly that the viewer or listener began to envision the two almost inter-changeably. We can imagine the value of visual representations to this type of hagiography, the interpolation of the tsaritsa into consecrated space under the approving gaze of Christ. Accessible to all, such representations overwhelmed the faithful with God's judgment. How could a sinful mortal, bereft of insight into the holy mysteries, hope to confront the blended image other than through acceptance?

This fusion became a key element in the legitimation of Catherine's ascendancy to the throne in 1725 because it provided two fundaments of Russian kingship that were otherwise unavailable to would-be female rulers: heaven's blessing and Christian lineage. From the moment of Christianization, rulers embodied God's will and righteousness through the patrilineal heritage of godly kings. Peter the Great, for example, was hailed as the new Vladimir, and through him the new Constantine and the new king David. This articulation of divine renewal defined an unbroken chain between the living king and the first biblical king, and a link between Russian kingship and the will of God, all of which was predicated on men and male inheritance. For Catherine—or any female ruler—an alternative and matrilineal link to godly rule evolved from her identity as the living image of her angel, St. Catherine.

This dualism of Catherine / St. Catherine became ubiquitous over the last five years of Peter the Great's reign. The icon in the Alexander Nevsky Monastery is a vivid example. Dating from 1721, it depicts St. Catherine dressed in a regal gown, wearing a crown, and accompanied by the familiar spiked wheel and sword. Behind her and descending from the heavens is the Mother of God holding the young Christ, who reaches out to St. Catherine's hand with a wreath and ring, signifying the mystical marriage. The faces of cherubs encircle mother and child, and in the background looms a town by the sea, seemingly on an island. The town, on a hill and with a river emptying into an estuary, probably represents St. Petersburg, here identified visually as the new Jerusalem. Before the viewer's eyes stood a bold visual argument for the new capital as consecrated space reborn, transposed from the Moscow Kremlin to the Gulf of Finland. Grigory Kaganov has observed that Peter I encouraged the association of Jerusalem and St. Petersburg, making St. Petersburg the new earthly manifestation of heaven, an ascription previously assigned to Moscow. This act of sacralization conveyed the authority of secular power and the tsar, on one hand, and the kingdom of heaven, on the other, as reciprocal and mutually dependent. State power acknowledged the centrality of faith, granting to the church and sacred images the authority to explain transpositions and make them safe in the eyes of God. Faith, in turn, was conceding to the tsar his right to make these changes.

Saint Catherine is adorned with a bride's crown and wedding dress. She stands in front of what appears to be a canopy bed, and she holds a book; on the table next to her lie four others. The lettering on two books, barely discernible, identifies both as prominent Petrine school texts; one is *Arifmetika*, Leonty Magnitsky's compendious 1703 guide to mathematics, and another as *Ritorika* (Rhetoric), a guide to spoken and written language. The book in her hand is open to a page that reveals the words *premudrost"* and *razumnykh otvetov*—"divine wisdom" and "well-reasoned answers"—possibly extracted from Dmitry Rostovsky's vita of St. Catherine. At the foot of the table stands an orblike object, a compass or other measuring instrument.

The presence of the *Rhetoric* evoked a struggle recently fought by court clerics who had lobbied hard—and successfully—to establish an academy in Moscow. For them, rhetoric constituted the heart of modern learning. Conversely, traditionalists had denounced the *Rhetoric* as "superficial wisdom," unrelated and even contrary to the holy mysteries and communion. This icon aligned St. Catherine, the cerebral conqueror of philosophers, with those in the church and in officialdom for whom divine and human knowledge were linked. Simultaneously it embedded the tsaritsa, her living image, within the sacraments of the church.

Perhaps the most noteworthy feature is St. Catherine's visage, which bears a strong likeness to that of the tsaritsa, as displayed in other portraits of the day. Including the face of a living person in an icon had been an accepted practice since the Church Council of 1550. A few seventeenth-century icons also presented tsars as saintly images. Though hardly commonplace, these representations had achieved acceptability well before the 1721 icon of St. Catherine. What does seem new was the representation of a *living tsaritsa* (emphasis on both) as a saint. Catherine and St. Catherine, saint and living image, merged into a single regal presence, possessed of grace, personal wisdom, and triumphant courage. Their mastery of knowledge, via sword, wheel, and book, serves a faith that is at once practical (rhetoric, arithmetic, compass) and sacred (Mother of God, Christ, angels, saints). The image permits no division between salvation and utility, empire and heaven. Worldly knowledge, born of classical Greek wisdom, was now fully domesticated, integrated with and subservient to Christ, the Mother of God, and the state. The midwife for this unbroken chain, the embodiment of the perfect union of heaven and the Russian Empire was, at least on this day and in this icon, Catherine / St. Catherine.

In the end, the new iconic image of Catherine / St. Catherine came to life precisely when Muscovy was refashioning itself as the Russian Empire and was defining St. Petersburg as an imperial metropole. Saint Catherine became inextricably linked with these changes and, at least during the eighteenth century, emerged as an imperial saint, a celestial female patron of Russian political greatness.

NOTES—1. Sources for this chapter include Gregory Kaganov, *Images of Space: St. Petersburg in the Visual and Verbal Arts,* trans. Sidney Monas (Stanford, Calif.: Stanford University Press, 1997); Oleg Tarasov, *Icon and Devotion: Sacred Spaces in Imperial Russia,* trans. and ed. Robin Milner-Gulland (London: Reaktion, 2002); V. M. Zhivov and B. A. Uspenskii, "Tsar' i Bog: Semioticheskie aspekty sakralizatsii monarkha v Rossii." in *Iazyki kul'tury i problemy perevodimosti,* ed. B. A. Uspenskii. Moscow: Shkola "Iazyki russkoi kul'tury," 1987); Richard S. Wortman, *Scenarios of Power: Myth and Ceremony in Russian Monarchy,* 2 vols. (Princeton, N.J.: Princeton University Press, 1995), vol. 1; I. A. Chudinova, *Penie zvony, ritual: Topografiia tserkovno-muzykal'noi kul'tury Peterburga* (St. Petersburg: Ut, 1994); D. D. Zelov, *Ofitsial'nye svetskie prazdniki: Istoriia triumfov i feierverkov ot Petra Velikogo do ego docheri Elizavety* (Moscow: URSS, 2002).

13

Conspicuous Consumption
at the Court of Catherine the Great
Count Zakhar Chernyshev's Snuffbox

Douglas Smith

A common refrain in the accounts of foreign visitors to Russia in the eighteenth century was amazement at the splendor of the tsarist court. This dazzling radiance reached its apogee in the reign of Catherine the Great (1762–96), the opulence of whose court rivaled, and in most areas surpassed, that of all the other courts of Europe. Through the imposing magnificence of the Winter Palace, with its armies of liveried servants and well-built guardsmen in their resplendent uniforms; through the unmatched collections of art and antiquities acquired en masse by the empress; and through the Technicolor brilliance of the great aristocrats, draped in lace and satin and velvet and adorned with ribbons and jewels, the Russian court proclaimed its power, wealth, and taste to the entire world.

These defining qualities of the Russian court are reflected in the snuffbox of Count Zakhar Grigorievich Chernyshev (1722–84). A longtime supporter and former confidant of Catherine's, Chernyshev was a leading courtier. His personal relationship with the empress and his long family history of service to the tsars brought him considerable power and wealth. Chernyshev's exquisite snuffbox served as a handy sign of his lofty status and refined sensibility and possibly even of his ties to the secret world of the Freemasons; it was a physical object that he could keep on his person as he strode the corridors of the Winter Palace or visited the capital's ornate palaces (fig. 13.1 [color section]).[1]

Chernyshev entered court service in 1741 under Empress Elizabeth as an officer in the Life-Guards Regiment. Three years later he was made a gentleman of the bedchamber to the Young Court of Grand Duke Pyotr Petrovich, the future Peter III (reigned 1762), and his wife, Grand Duchess Ekaterina Alekseevna, the future Catherine the Great. The dashing Chernyshev caught Catherine's fancy, and a brief infatuation followed. The empress took note of the budding romance between Chernyshev and the grand duchess and had him sent away to the army. He later fought bravely in the Seven Years' War (1756–63) and led the Russian troops that captured Berlin in 1760.

After seizing the throne in 1762, Catherine appointed Chernyshev vice president of the War

College. In 1773 she promoted him to president with the rank of field marshal. Other important posts followed: member of the Imperial Council, governor-general of Belorussia, and governor of Moscow.

Chernyshev's snuffbox was made in 1773. The timing appears significant. It is possible that Catherine ordered the snuffbox as a gift to mark Chernyshev's promotion to head of the War College. The fact that the portrait miniature atop the box depicts Chernyshev in his green field marshal's coat lends credence to this supposition. What is more, we know that Catherine could be most generous and that she showered her friends and the men in her service with lavish presents, including snuffboxes. In the mid-1760s, Catherine commissioned a gold snuffbox for Grigory Orlov that was decorated with diamonds and enamel miniatures showing scenes of her coup. And during the visit of the Prince de Ligne to Russia in 1780, the empress presented him with an exquisite snuffbox covered with diamonds and the empress's portrait. (Ligne later wrote that Catherine kept with her a snuffbox decorated with a miniature of Peter the Great, which she would reach for when wondering how he would have acted in a given situation.) As a shrewd political animal, Catherine did not give these gifts simply out of the goodness of her heart; rather, she was fully aware of how they served to instill a sense loyalty and obligation in the hearts of their recipients. Largess was one of the tools Catherine used with great success to motivate, reward, and ultimately bind the men in service to her person.

The snuffbox she gave to Chernyshev has elegant gold chasing and radiant blue enamel studded with white stars set over a *guilloché* ground, reflecting the latest French style and the finest workmanship. It is quite small, measuring just 1 $^7/_{16}$ inches high and 3 ¼ inches wide and 2 ½ inches deep. Its petite size and oval shape allowed it to fit comfortably into a pocket. Hinged lids were popular since they made it possible to open the box with one hand, leaving the other free to extract a pinch of snuff.

The underside of the box bears a series of marks that offer some clues about its manufacture. A Cyrillic "Д" indicates the guild mark for 1773. Crossed anchors and a scepter represent St. Petersburg. The initials "G.K." in square—the maker's mark—probably refer to Georg Kuntzendorf, a native of Riga who moved to St. Petersburg around the middle of the century and served as alderman, or head, of the foreign guild from 1760 to 1775. In 1763, Kuntzendorf began fulfilling commissions for the Russian court. His story was similar to that of many other craftsmen and artists drawn to St. Petersburg from all over Europe during the century. The building of the new Russian capital and the burgeoning demand for luxury goods among an increasingly westernized and acquisitive court and noble class created for the first time in Russia a large market for the skills of the finest architects, goldsmiths and silversmiths, portraitists, painters, and engravers.

The miniature depicts a rather demure Chernyshev, his somewhat ruddy face, with its hint of a smile, highlighted by the whiteness of his wig and jabot. The bright blue sash across his chest and the silver star neatly set off against the green background of his waistcoat tell us that he was a Knight of the Order of St. Andrew, imperial Russia's oldest and highest order. Chernyshev had received the decoration from Catherine on her coronation day. The artist has never been identified, although it was earlier thought to have been based on a portrait by Alexan-

der Roslin, the Swedish-born, French-trained portraitist who painted Catherine and several prominent Russian courtiers in the 1770s.

Snuffboxes like Chernyshev's were chiefly used for one obvious purpose: to hold snuff. In the eighteenth century snuff, a powdered tobacco sniffed up the nose, was in vogue among the European nobility, and its adoption by the Russian elite reflected the general process of westernization then well under way as the nobility took up the dress, comportment, and overall lifestyle of their peers in London and Paris. Smoking did not become widespread until many years later, at which time fine cigarette cases replaced the once ubiquitous snuffboxes.

This utilitarian aspect was not the only function of such boxes, however. Equally important was the intense aesthetic pleasure these objets d'art provided. The men and women of the age were captivated by all manner of elegant decorative objects, and craftsmen were kept busy catering to this craze. Boxes, perhaps because of the frisson generated by the promise of secret treasures hidden within, were particularly fashionable, and bonbonnières, comfit boxes, and toilet boxes were also common. For those of a more prurient sensibility there was the so-called smut box: a small case decorated with innocent pastoral scenes that could be magically transformed with the slip of a latch to reveal randy shepherds and shepherdesses in lewd poses.

Given their expense and craftsmanship, objets d'art served as advertisements for their owner's wealth and taste. When received as a gift from the sovereign, they also functioned as signs of royal favor, helping to mark one's relative position in the immense, ever-shifting constellation of courtiers, ministers, and grandees who made up the court. Gifts of this nature might be viewed as quasi-decorations received for faithful service and singling out personal achievement. We can imagine Chernyshev removing his snuffbox with rehearsed nonchalance, making certain those around him took note so that they would compliment him on it and, if he were lucky, inquire into its provenance. The inquiry would have given him the opportunity to share the story behind the imperial largess—show-and-tell for the court set.

Snuffboxes and the like were also popular because they constituted ready and highly portable liquid assets. Russian nobles, like their counterparts in the rest of Europe, typically swam in a sea of debt and at times struggled to keep their heads above water. An elegant snuffbox was a nest egg of sorts, a source of funds in the event of hard times. Down-on-their-luck nobles not uncommonly hocked gifts received from crowned heads to get themselves out of tight spots. Instead of selling the entire box, sometimes a noble pried off a diamond or other precious stone from its lid and sold it. Europe's kings and queens, Catherine among them, knew of this practice and apparently had no complaints.

We do not know whether Count Chernyshev ever had to sell his snuffbox, nor do we know for certain that it was a gift from Catherine. Indeed, art historians have suggested a different story behind its making. The basis for this alternative history is the inclusion of numerous Masonic symbols on its lid: the white enamel six-pointed stars of David and the compass, square, and hammer chased beneath the miniature.

The secret society of Freemasons was the largest, most influential voluntary society in Europe in the eighteenth century. It counted among its members the political, social, and intellectual elite of the day, men like Frederick the Great, George Washington, Voltaire, Mozart, and

Goethe. Freemasonry arrived in Russia before 1750 and reached its high point in the reign of Catherine the Great, when thousands of Masons gathered in a network of lodges that stretched across nearly the entire Russian Empire. The lodges played a significant role in the cultural life of Catherinian Russia, helping to spread Enlightenment ideals as well as more general ideas about moral philosophy and even the occult sciences.

Chernyshev's membership in the Masonic order is well documented. While serving on the staff of the Russian ambassador in Vienna in the 1740s, Chernyshev joined the lodge Aux Trois Canons. Around the time his snuffbox was made, he belonged to St. Petersburg's Nine Muses lodge, frequented by several prominent courtiers. As governor of Moscow in the early 1780s, Chernyshev patronized the local lodges and employed some of his Masonic brothers on his staff. In addition, his personal physician, Johann Kölchin, was a Mason, as was one of the managers of his estates, a former serf by the name of Ivan Strazhev.

It is possible that Chernyshev, as a prominent Masonic figure, had several of these snuffboxes decorated with his likeness and the order's symbols as gifts for brother Freemasons. Decorating snuffboxes, watches, and other personal items with Masonic hieroglyphs was rather common at the time, making this not unlikely. With such objects Russian Freemasons could simultaneously communicate their membership in the order to fellow brothers and pique the curiosity of outsiders.

The connection between Chernyshev's snuffbox and Freemasonry points to another important aspect of eighteenth-century Russia—namely, the birth of a civil society. As in other parts of Europe, so, too, in Russia, new social institutions (Masonic lodges, learned societies, clubs, salons, theaters) and forms of intellectual life (newspapers, magazines, a book market) were being established that marked the beginning of the gradual shift away from a world dominated by monarchs and their courts.

Yet as important as membership in the Masons was to Chernyshev and men like him, Freemasonry and, in fact, civil society as a whole could not rival the tsarist court in dominance. Service to the tsars continued to be the chief avenue for attaining power, wealth, and social status. It is perhaps only fitting, then, that what first catches our eye when gazing upon Chernyshev's snuffbox are not the Masonic symbols nor even the portrait of Chernyshev but those unmistakable signs of royal favor—the brilliant green, yellow, and red field marshal's coat and the regalia of the Order of St. Andrew.

NOTES—1. Anne Odom and Liana P. Arend, *A Taste for Splendor: Russian Imperial and European Treasures from the Hillwood Museum* (Alexandria, Va.: Art Service International, 1998). The snuffbox is now in the museum's collection. See also Mikhail B. Piotrovsky, *Treasures of Catherine the Great* (New York: Harry N. Abrams, 2001); Katrina V. H. Taylor, *Russian Art at Hillwood* (Washington, D.C.: Hillwood Museum, 1988).

14

Moving Pictures

The Optics of Serfdom on the Russian Estate

Thomas Newlin

Everywhere before me are moving pictures . . .
Everywhere traces of satisfaction and labor.

Alexander Pushkin, "The Countryside" ("Derevnia"), 1819

Among the rich trove of unpublished manuscripts in the Russian National Library is a partially filled album spanning the forty-year period from 1781 to 1821.[1] One of the many long-term projects of the multitalented memoirist, landscape designer, and agronomist Andrei Timofeevich Bolotov (1738–1833), the album was initiated at Bogoroditsk, the crown estate where he worked as bailiff from 1776 to 1797, and continued to garner new contributions from various acquaintances and family members for several decades after he retired to Dvoriani-novo, his estate and birthplace in northern Tula Province. As a literary artifact the volume is unremarkable; consisting of several decades' worth of bland encomiums in prose and verse to Bolotov himself as a friend, father, and all-around good fellow, it has none of the polyphonous verbal banter and give-and-take common to many other domestic albums of the late eighteenth and early nineteenth centuries. It is striking, however, in the way it highlights and exaggerates, in a very persistent and self-conscious fashion, the element of visual play so characteristic of the genre. Interspersed among various obligatory watercolor flowers and pseudo-classical rustic tableaux are numerous optical jokes and "ruses" (*obmanki*) that work, momentarily, to trick or lead on the peruser of the album and that explore and accentuate, in a gently jocular way, the slippery disparity between appearance and reality (fig. 14.1).

The album is in many ways a visual and conceptual mirror and miniature of the elaborately arranged "natural" landscape—likewise replete with various jokes, surprises, and ruses—that Bolotov began fashioning at Bogoroditsk in the mid-1780s. Among the many playful contrivances that he designed to dumbfound (*frapirovat'*), delight, and pleasantly alarm his fellow nobles were the following: a grassy hillock that could be instantaneously turned into an island by means of a hidden sluice-gate, leaving the startled visitor momentarily stranded; a shell-lined grotto containing two false doors fitted with mirrors instead of glass, so that visitors politely doffed their hats at their own reflection before realizing they had been duped; and an

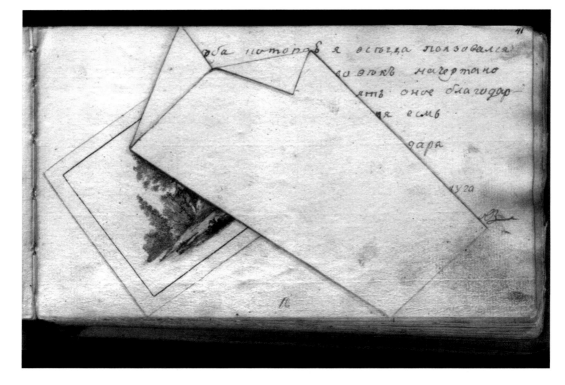

14.1. Watercolor from the domestic album (1781–1821) of Andrei Timofeevich Bolotov. Here, a trompe l'oeil painting of a folded-back page partially reveals a card depicting an arcadian scene; on the "folded" page we see snatches of another "entry" in a conventionally eulogistic vein.

echoing wall that repeated words so exactly that one of Bolotov's suspicious guests insisted a peasant was hiding nearby and providing the echo, and was persuaded otherwise only when the wall answered him back in French. Perhaps most ingenious and pleasingly perplexing of all were the vast trompe l'oeil Gothic ruins that Bolotov "painted" on the side of a steep hill using various types of colored sand and bits of coal, brick, and limestone; at a distance the two-dimensional assortment of stones and rubble metamorphosed magically into a three-dimensional architectural extravaganza, and, as seen from the main road that skirted the estate, it tricked many gullible travelers into thinking they had stumbled onto some sort of long-lost corner of medieval Europe.[2]

For all its frivolity this landscape, like the cheerful album, had a serious agenda, and it accurately reflects (albeit in somewhat exaggerated form) a broadly and consciously enacted poetics—and politics—of visual (mis/non)representation on the Russian estate in the late eighteenth and early nineteenth centuries. Tracing the historical origins of the playful side of eighteenth-century Russian landscaping, the cultural historian Dmitry Likhachev commented that "the illusionism of imaginary architecture, pictorial illusionism, the substitution of reality with various 'shams,' optical tricks—all are typical features of rococo gardens, which drew from both the Italian Renaissance . . . and the Dutch Baroque." He then adds—and here we come to

the heart of the matter—that this "rococo style in general *created the overall illusion of 'happy' rural life*."³ In the Russian context we can put it even more bluntly: the joky, happy illusionism of the landscape (and albumscape) covered over and distracted viewers from the much less happy reality—serfdom and serf labor—that made all the fun (and the picturesque, "natural" vistas) possible in the first place. Indeed, the history of the visual representation of serfdom, both as a social and as an economic system, is by and large one of absence and omission: what is most significant is what we do not see, what is hidden, glossed over, or left out entirely.

The series of two dozen watercolors that Bolotov and his son Pavel painted in the mid-1780s of the various "views" (*vidy*) at Bogoroditsk are highly typical in this respect: we see strolling and chatting noblemen and noblewomen at every turn, but no sign of any peasants or any actual peasant labor; it is as if the landscape somehow magically created and maintained itself (fig. 14.2 [color section]).⁴ For all its supposed playfulness, this landscape—at least as it comes across in these pictures—appears oddly static and sterile. The real life charm of these views, it would seem, was predicated on more or less continuous peripatetic and visual movement—or what we might describe, in less neutral terms, as a subtly relentless ocular (and ideological) shiftiness. Bolotov's basic modus operandi as a landscape artist was to create a series of inviting set pieces, or "scenes"—often formal in nature, with statues, edifying inscriptions, and benches and grass settees—that both surprised and stimulated the visitor and allowed him or her the opportunity to rest and reflect. These scenes, even if relatively static in and of themselves, were laid out "so that one place, inasmuch as it was possible, hid the next, in order that one's vision encounter new and unexpected objects at every step."⁵ By carefully maintaining a certain thematic and philosophical lightheartedness and by encouraging a steady but superficial sense of curiosity—that is, a desire to move on (or turn the page) to see what would come next—Bolotov dissuaded the stroller (and likewise the reader or potential contributor leafing through his album) from ever lingering too long, looking too closely, or reflecting too deeply. This was a realm, in short, where an almost overbearing optic optimism conjured up a magic lantern show of pleasantly peasantless *podvizhnye kartiny,* or "moving pictures" (to evoke the presciently cinematographic turn of phrase used by Alexander Pushkin in his youthful poem "The Countryside"), and where there was little time or space for doubts or genuine contemplation.

For the most part the "horrible thoughts" that later haunted Pushkin (and that abruptly turn a conventional, painterly paean to an idyllic rural landscape into a searing indictment of serfdom) do not intrude on the happy landscapes and albumscapes of the late eighteenth century: serfdom was kept out of sight and (it would seem) out of mind.⁶ But once in a long while the skillfully maintained veil of illusion was briefly pulled aside. These moments of startling and seemingly accidental revelation are all the more striking and resonant for their infrequency. Bolotov's domestic album provides one especially interesting and emblematic instance of clarifying disillusionment. About two-thirds of the way through, on page 113, we come across a moving picture of another sort, one that gives an unexpected and unsettling twist to the heretofore carefully controlled thematics of Bolotov's cheerful enterprise. Before us is a delicately executed watercolor (almost certainly by Bolotov himself) of two pink roses on a double stem, accompanied by a deliberately enigmatic two-word inscription: "NARUZHNOST' [above] OB-

MANCHIVA [below]"—"APPEARANCES ARE DECEIVING" (fig. 14.3 [color section]). The roses are painted on a small piece of pasted-in paper, of fine quality, that has been meticulously filigreed with tiny slits so that we can lift it up from the center and peek below. What we discover there provides graphic confirmation of the terse caption's truth: beneath the roses lurks a coiled and hissing serpent (fig. 14.4 [color section]).

To a modern sensibility the ploy may seem merely quaint, yet it still retains, across more than two centuries, an odd and very real power to surprise and disturb, and when experienced in the larger context of the album—with its fulsome praise of Bolotov and its unfailingly rosy depiction of rural life—it opens up a veritable Pandora's box of unpleasant questions. Were Bolotov's many admirers as sincere as they seem? Was Bolotov himself, the universally loved, jolly good fellow of the album, what he seems to have been? And, most disturbingly of all (especially given the nobility's all too vivid memory of the bloody Pugachev rebellion of the mid-1770s), was life on the Russian country estate as beautiful and happy as the album suggests—or was there a serpent (or serpents) in the Russian Eden? Significantly, no contributor chose to inscribe anything opposite this page. It was as if Bolotov had touched too directly and problematically upon a truth that was everywhere evident yet curiously hidden throughout the album—and throughout the landscape of the Russian estate.

Bolotov was no Pushkin, and it would be wrong to ascribe any sort of radical or subversive intent to his rose ruse. Deeply conservative and politically timid, he would certainly have balked at the idea that serfdom (whether considered broadly as an institution or in its various troubling manifestations: the inscrutable and murderous muzhik, the smiling and sentimental tyrant-master) was the serpent in the rose-filled garden of estate life. Nonetheless, unwittingly and no doubt somewhat naively, he gave richly provocative expression here both to the elaborately maintained lie behind the landscape of the estate and to the complex sense of anxiety and paranoia (social, political, even epistemological) that the Russian nobility experienced during the post-Pugachev era. Bolotov and his fellow nobles apparently wanted to have it both ways: they manipulated the poetics and politics of illusionism to their own advantage on their estates, even as they consistently denied and repressed the dangerous truths lurking beneath that benign-looking paper rose. On the Russian estate appearances were indeed deceiving.

NOTES—Parts of this essay appeared in somewhat different form in my article "Rural Ruses: Illusion and Anxiety on the Russian Estate, 1775–1815," *Slavic Review* 57, no. 2 (Summer 1998): 295–319; and my book *The Voice in the Garden: Andrei Bolotov and the Anxieties of Russian Pastoral, 1738-1833* (Evanston, Ill.: Northwestern University Press, 2001).

1. A. T. Bolotov, "Al'bom ego s risunkami i avtografami otdelnykh lits. 1781–1821," Rossiiskaia Natsional'naia Biblioteka, St. Petersburg, f. 89, d. 57.

2. A. T. Bolotov, *Zhizn' i prikliucheniia Andreia Bolotova, opisannyia samim im dlia svoikh potomkov*, 4 vols. (St. Petersburg, 1870–73; supplement to the journal *Russkaia starina*), 3:1155–56 (island); 3:1189–90; 4:26, 43 (grotto); 4:50 (echo); 3:1147–51, 1173–74; 4:21, 34 (Gothic ruins).

3. D. S. Likhachev, *Poeziia sadov*, 2nd ed. (St. Petersburg: Nauka, 1991), 197. Emphasis added.

4. The album of these watercolors is preserved in the State Historical Museum in Moscow. I have based my observations on twenty-three color reproductions in O. N. Liubchenko, *V Bogoroditske est' park* (Tula: Priokskoe knizhnoe izdatel'stvo, 1984), and five color reproductions in A. P. Vergunov and V. A. Gorokhov, *Russkie sady i parki* (Moscow: Nauka, 1988). The only unambiguous representation of the peasantry that I have discov-

ered in these watercolors is a bearded fishmonger and his partner in the foreground (lower right-hand side) of Bolotov's *Vid ostrovkov na srednem nizhnem prudke s mostochkami v Bogoroditskom sadu* (1786), reproduced in Vergunov and Gorokhov, *Russkie sady i parki* (unnumbered plate). For an insightful analysis of these watercolors, see Andreas Schonle, "A. T. Bolotov's Horticultural Theodicy: The Aesthetics of 'Disinterested' Wonder," *Russian Studies in Literature*, 39, no. 2 (Spring 2003): 24–50 (special issue on Russian nature, ed. Rachel May).

5. A. T. Bolotov, "Nekotoryia prakticheskiia zamechaniia o sadakh noveishago vkusa," *Ekonomicheskii magazin* 26 (1786): 29

6. On the fascinating history of Pushkin's poem (whose "trick" form seems to draw, appropriately enough, on the eighteenth-century tradition of illusionist landscaping), see Stephanie Sandler, *Distant Pleasures: Alexander Pushkin and the Writing of Exile* (Stanford, Calif.: Stanford University Press, 1989), 23–39; and Newlin, *The Voice in the Garden*, 99–103.

15

Neither Nobles nor Peasants

Plain Painting and the Emergence of the Merchant Estate

David L. Ransel

In the eighteenth century the Russian nobility rapidly adopted European styles, and its wealthier members were soon, in portraits at least, scarcely distinguishable from the nobles of central and western Europe. Their dress and poses resembled the European dress and poses, and their artists were either immigrants from Europe or Russians trained in European academy style and technique. The decision on the part of Russian nobles to commission individual and family portraits was a sign of their Europeanization and, as the nobility emerged as an estate, of their sense of their own importance and dignity. Before the eighteenth century scarcely anyone in Russia except saints and rulers were represented pictorially, and then only in highly conventionalized images. After the westernizing reforms of Peter the Great, Russian nobles were able to think of themselves as persons who deserved to have their likenesses preserved and honored by their families and communities.

Russia's commercial and manufacturing families took longer to form into a self-conscious social estate. In the seventeenth century a small number of wealthy merchants received special government recognition as *gosti*, a designation that gave them trading privileges in return for serving as tax collectors for the state. Apart from an occasional rare portrait of one of the gosti and a few sketches by foreigners, we have little idea of how the commercial people of early Russia looked. With time, however, Russian merchants and entrepreneurs also developed a sense of themselves as forming a social group worthy of portraiture. A delay of about a century occurred between the time nobles began to have portraits made of themselves and the time merchants did the same. Pictures of commercial people began to be painted in the late eighteenth century and grew rapidly in number in the next half-century. Merchant portraits appeared in a genre different from that characteristically used by the nobility. Instead of the European academy portrait, merchants were painted in what Russian scholars refer to as the "domestic primitive" genre. I prefer to use a different label, "plain painting," because many of the portraits are not primitive. Indeed, some are very skillfully rendered.[1]

The painters of the Russian merchant portraits are, with a few exceptions, unknown. They were not academically trained artists. The small number of such professionally trained painters in the Russia of this era were fully occupied with commissions from the court and wealthy

nobles. The merchant portraits were done by artisans, talented serfs, and icon painters, people with whom merchants were in contact through their work and their regular involvement with the local clergy and religious philanthropy. The lack of formal artistic training can be seen in the poor execution of details in the merchant portraits—in the hands and the draping of clothing and coverlets. The hands, and especially the fingers, are often out of proportion and even lumpy. The most conspicuous characteristic of plain painting is its linear and flattened, almost two-dimensional appearance; it lacks the shading or chiaroscuro of the academy style. The principal objective was to capture the face in a stiff frontal pose. Here, some Russian scholars have suggested, we may be seeing influences from icon painting. But other, more likely models for plain painting were close at hand. The genre was well developed in Poland, for example, in what are known as Sarmatian paintings.

Plain painting offered a clear contrast to the academy style adopted by the wealthy Russian nobility. Merchants were not usually presented in the relaxed, leisurely poses that nobles were. Nor did the merchant portraits contain many excess compositional elements. Space, created by the use of perspective, was only occasionally present in the portraits of merchant men and was minimally indicated in the portraits of merchant women. In the case of males, the pose was often supplemented only by an object or two indicating profession or status. In the case of women, attention went primarily to dress and often to richly appointed headdresses: symbols of wealth.

The set of features that became characteristic of merchant portraits did not appear all at once. The artistic form started in the late eighteenth century with a varied creativity and moved toward a canonical form by the middle of the nineteenth century. An early example of the genre may be seen in a picture of a man with a letter in his hand, sitting by a window with a view of the Admiralty (fig. 15.1).[2] This unusual portrait contains elements of perspective and individuality that later ones lack. As the genre of merchant portraiture evolved, background elements of the sort painted here were excluded, and attention shifted to an object held in the hand or to official medals worn around the neck or on clothing.

Art rests in a set of conventions that reflect the taste and sensibilities of those who commission and those who produce it. Therefore, we should not too hastily attribute the "plainness" of the merchant portraits to the inexperience or lack of talent of the artists. Once the form became established, even skilled and academically trained artists executed portraits of merchants in the same plain and evidently preferred form. The portraits of provincial nobles of modest means also often appeared in a plain form at first, following the available models and the abilities of the artists, who usually lacked academic training. But the form used by provincial and less well-to-do nobles evolved toward the academy form preferred by the wealthier nobles, whereas the merchant portraits moved in the opposite direction. Their renderers retreated from some of the more three-dimensional and varied forms of the late eighteenth century toward a plain model in the decades that followed. In short, the plain form of presentation became an important marker of social status and identity, a statement on the part of the subjects that they wished to be seen as merchants and not as members of another social group.

What can the use of this genre and the appearance of the subjects tell us about the emergent commercial estate? We can see that the men presented themselves well into the nineteenth cen-

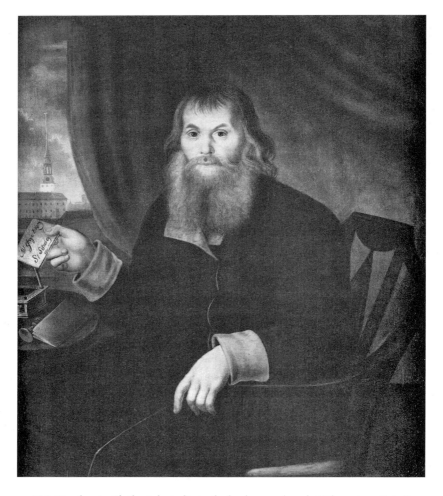

15.1. Merchant with the Admiralty in the background, early 19th century. Painting by an unknown artist.

tury in ways that distinguished them from the nobility. They wore beards and had their hair cut in a fringe (almost as if done with a bowl over the head), styles that placed them closer to the peasantry and clergy than to the nobility. Because merchants often had risen from the peasantry and socialized with and supported their local clergy, it is not surprising to see them looking much like members of these groups. Yet their dress and their choice of accoutrements—abacuses, letters, inkstands, and medals—set them apart from the peasantry by signifying their greater education and from the clergy by underscoring their professional status in the material as distinct from the spiritual realm (fig. 15.2 [color section]).

Even when the attire of the merchant men changed in the nineteenth century, the plain form of painting continued. The change in dress accompanied the increasingly prominent role of nationalism and nativism in the lives of central Russian merchants after the Napoleonic Wars. For one thing, the merchants appeared in portraiture more frequently in uniform. Government

service of virtually any kind carried with it the right to dress in uniform, and the appearance of merchants in this guise bespoke their identification with the state (fig. 15.3 [color section]).

Regardless of individual choice of costume, merchant portraits continued to be executed in the distinctive plain genre associated with the merchant estate, and the male subjects continued to sport the former hairstyle and beard—so different from the style of noblemen, who had short hair swirled up and away from the face and no more than sideburns or a moustache, if they had any facial hair at all.

The portraits of merchant women are remarkable for the adornment of their subjects and for the blend of folk and urban elements. Merchant wives and daughters did not hold either homemaking objects or objects that told of the profession of their families. They just had their hands folded in front of them, often in a way that revealed expensive finger rings. Or they held a flower, fan, muff, or fancy kerchief. That they are rarely shown holding a letter or a book, even a religious book, may indicate that few of the women learned to read, or more likely, it indicates that the subjects and the artists did not think of reading as important to the social role of women of this group.

Women were portrayed in two basic ways. In both, the women's bodies were well covered, and their hair was either wholly or almost wholly hidden under a hat or a kerchief. Russian merchant life was conservative and religious. Most merchants would have bristled at the thought of their wives appearing in public in gowns that bared shoulders or arms, or with their heads uncovered—at least before the middle of the nineteenth century, when some of the wealthiest big-city merchant women began to appear in gowns similar to those worn by noblewomen. Of the two characteristic portrait presentations of merchant women, the first featured a richly ornamented headdress, an element that placed the subjects closer to the peasantry, for women from wealthy peasant families were also portrayed in this way (fig. 15.4 [color section]). In the second, women appeared in conservative urban clothing: a tightly bound kerchief covering the hair, a long-sleeved dress covering the body—the dress was open only at the throat (often to reveal an expensive pearl necklace)—and the whole ensemble dominated by a luxurious shawl. Whichever the style, the portrayal underlined the difference of merchants from the nobility.

What is most remarkable about the merchant portraits is their crystallization in the plain form. Merchant clients insisted on plain painting rather than the fashionable academy portrait style that featured a three-dimensional, expressive representation. Their appropriation of a particular genre of painting was a sign of their emergence as a self-conscious social estate that was defining itself in opposition to the Europeanized nobility. The men portrayed themselves with symbols of their success and displayed their wives in sumptuous costume that at once demonstrated their wealth and affirmed their wives' modesty and morality as different from what they saw as the artificial, imported style and manners of the nobility.

They also sought to affirm their belief that they, and not the nobility, stood for true Russianness. We can see this especially well in the clothing of the merchant women. This belief found political expression in the financial support that the merchants of central Russia were lending to the nativist rebellion of the 1830s and 1840s known as Slavophilism, which sought in pre-petrine (pre-Europeanized) Russia the authentic and natural course of Russia's historical development. Although the roots of plain painting were European, the style had been in use in

Russia for decades, and merchants evidently came to consider it genuinely native. Plain painting became for them an imagined earlier and authentic Russian cultural expression, a form that they could oppose to the supposed artificiality and foreignness of the portrait genre preferred by the elite nobility. Forgetting that the plain style of portraiture came from the West just as much as the academy style did, they imagined it as an older, truer Russian form.

The articulation of cultural difference through the choice of representational genre had parallels in other countries at close to the same time. The popularity of plain painting in colonial New England has been interpreted as an assertion of authentic Americanism and a rejection of the values of the more Europeanized plantation aristocracy of the South, whose portraits were often done by European artists. Much closer to home was another example. In Poland the nationalistic gentry held to the plain portrait form of Sarmatian painting in reaction to the acceptance by the court and high magnates of Europeanized art that arrived in Warsaw with late Enlightenment culture.

With time, the appearance and forms of personal expression of the aristocratic and commercial estates converged; the nobility adopted a more conservative look, and the merchants became more Europeanized. After the mid-nineteenth century, the plain painting genre waned, and nobles and merchants began to appear in much the same dress and poses in both painting and photographs.

NOTES—1. Readings on the style of merchant portraits include Wayne Craven, *Colonial American Portraiture: The Economic, Religious, Social, Cultural, Philosophical, Scientific, and Aesthetic Foundations* (Cambridge: Cambridge University Press, 1986); *"Dlia pamiti potomstvu svoemu . . ." Narodnyi bytovoi portret v Rossii* (Moscow: Galaktika Art, 1993); A. V. Lebedev, *Tshchaniem i userdiem. Primitiv v Rossii XVIII–serediny XIX veka* (Moscow: Traditsiia, 1998); G. S. Ostrovskii, "Primitiv v kontkste russkogo iskusstva XVIII–nachala XX vekov," in *Primitiv v iskusstve. Grani problemy,* ed. K. G. Bogemskaia (Moscow: Rossiiskii institut iskusstvoznaiia, 1992), 21–35; L. I. Tananaeva, *Samarskii protret: Iz istorii pol'skogo portreta epokhi barokko* (Moscow: Nauka, 1979).

2. We can surmise that the subject is a merchant involved in external trade through the port of St. Petersburg and that the letter he is holding is addressed to his foreign partner. Curiously, in this and similar portrayals neither artist nor subject seem to have attached importance to an accurate rendering of the foreign words, which were apparently simply intended to represent the subject's prestigious position as a merchant trading at an international port (the Admiralty building being another such sign).

16

Circles on a Square

The Heart of St. Petersburg Culture in the Early Nineteenth Century

Richard Stites

Viewing edifices in pictures or, if on location, exclusively from the outside reduces the perception to facade, ornament, proportion, fenestration, and the like—pleasing enough on handsome structures but lacking in perceptual depth. To the modern visitor to St. Petersburg, interiors—except for those of hotels, churches, and palaces-turned-into-museums—are secondary or even wholly unseen. The great galleries, like the ones in the Russian Museum and the Hermitage, have interiors unrelated to their original purpose as royal residences. Those interiors that still perform their former function—for example, the Theater School, the Academy of Arts, the back stages of theaters and concert halls—are inaccessible to the general public. To attain something close to a historically authentic, multidimensional visualization of sites, the viewer must see exterior and interior in terms of their function in the era in question and behold all the sights and sounds. Let us go back to the early or mid nineteenth century and "revisualize" St. Petersburg's Mikhailovsky Square, known since 1940 as Square of the Arts.

Saint Petersburg architecture reached an apogee in the late eighteenth and early nineteenth centuries with landmark buildings and ensembles built in the Empire or Russian classical style: the Admiralty, St. Isaac's and Kazan cathedrals, Palace Square, Theater Street, and many more. In architecture, as in theater and other arts, European and Russian classicism stood for order, reason, discipline, stability, and cool reserve—a suitable match to the values of court, aristocracy, regiment, and civil office. Symmetry and harmony in stone and stucco reflected the required conformist comportment of both citizens and men in the ranks, expressed the majesty and gravitas of dynasty and state, and provided yet another cultural link to western Europe.

In the reign of Nicholas I, St. Petersburg's major cultural zone lay along and near Nevsky Prospect and had its center on Mikhailovsky Square (fig. 16.1 [color section]). The land it now occupies, planted in the eighteenth century with thousands of maples in rows, had been used as a dump heap until 1823. Then it was chosen as the site of the new palace and gardens of Grand Duke Mikhail Pavlovich, the tsar's brother. The genial architect, Carlo Rossi, designed it, and the grand duke gave his name to the palace, the square in front of it, and a theater nearby. The other buildings that completed the ring around the square held to the classical design of Rossi.

Symmetry and harmony did not require uniformity. Each building possessed its own shape and facade, but all were compatible. A classical architectural ensemble can be compared to an eighteenth-century drawing room: chairs, tables, highboys, and chaise longues differed from one another but all belonged to the "family" of Chippendale or Louis Quinze. Mikhailovsky Square, however, diverged from the pattern of other grandiose St. Petersburg squares. Unmonumental and intimate, it had no radials or broad thoroughfares but instead a small park, like a carpet that pulls a room together.

Grand Duke Mikhail's wife, Elena Pavlovna (née Princess Charlotte Marie of Würtemburg), added artistic luster to life in the Mikhailovsky Palace. Though Russianized, she retained her German accent as well as a passion for classical music, for which she organized weekly *soirées morganatiques,* socially diverse musical evenings. The mixed company, like morganatic marriages, did not fit the norm of aristocratic gatherings but were necessarily tolerated. Since musically proficient nobles remained in short supply, foreigners or citizens of the Russian Empire with an established European reputation provided the music. Thus it came to pass that two, eventually world-famous Jewish virtuosos, the violinist Henryk Wieniawski and the pianist Anton Rubinstein, played at the palace for the enjoyment of the very highest levels of court society. Wieniawski, son of a Lublin physician, added his talent to the soirées and then went on to a brilliant European career. Rubenstein became the Russian court pianist, appointed to that post by Elena Pavlovna in 1852.

As court pianist, Rubinstein played solo and also served as the professional "stiffener" at the musical evenings when he accompanied the tsar's son, Grand Duke Konstantin Nikolaevich, a talented amateur. The performance venue, the White Hall, lay behind the palace, at its north side, overlooking in winter the brocade of snow in the garden (fig. 16.2). The frosty outdoors matched the icy decor of the hall, with its sumptuous appointments, and the apparent chill of social dynamics at recitals. Rubinstein hints at the atmosphere. Essentially a high-toned servant, he referred to himself sardonically as the royal family's "musical furnace attendant." Although the pianist's Jewish origins evidently caused no problem, this son of a Moscow businessman occasionally felt social discomfort. This did not diminish his contribution to musical life. Rubinstein dedicated several of his pieces from this period, including the once world-famous Melody in F, to Elena Pavlovna. Rubinstein eventually enlisted the willing grand duchess in his campaign to open the first music conservatory in Russia, an event that occurred in 1862. One might say that the institutions of modern Russian musical life were born in the spacious salons of the Mikhailovsky Palace. In 1895 the palace was converted into the Museum of Fine Arts, today known as the Russian Museum.

How different, both in musical offerings and social components, was the two-story flat of Count Mikhail Vielgorsky on the eastern side of the square. The Vielgorskys also had apartments on the opposite side of the square. The brothers Vielgorsky, who were assimilated Poles, achieved some distinction in music: Matvei (1794–1866) as a cellist; Mikhail (1788–1856), a high-ranking court dignitary, as an amateur singer, violinist, composer, and friend of Luigi Cherubini and Beethoven. Count Mikhail Vielgorsky cast a broad social and musical net. As a patron funded by the court, he booked European talent through personal connections. Through the 1830s and 1840s, he and his circle played host to the most celebrated musical visi-

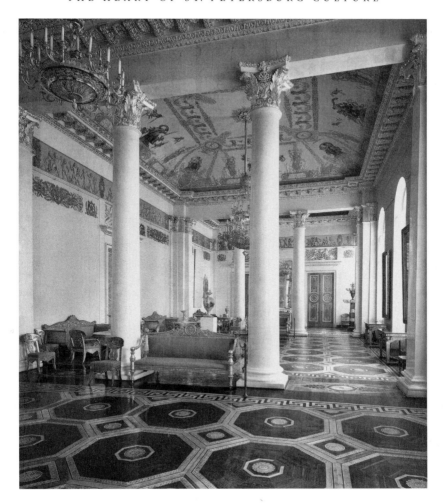

16.2. The White Hall, Mikhailovsky Palace.

tors to midcentury Russia: Franz Liszt, Hector Berlioz, and Robert and Clara Schumann. At the Vielgorsky home, an unofficial concert hall of the capital, as many as three hundred guests could hear the works of the classical Viennese symphonists of the eighteenth and nineteenth centuries. On this modest-looking corner of the square were performed the Russian premiere of Beethoven's Ninth Symphony, portions of Mikhail Glinka's *A Life for the Tsar* in rehearsal, and a Schumann symphony. Because of the attendance of Pushkin, Gogol, Zhukovsky, Viazemsky, Lermontov, Odoevsky, Glinka, Dargomyzhsky, and Briullov, a contemporary dubbed Vielgorsky's home "a lively and original multifaceted academy of the arts." Berlioz called it "a little ministry of fine arts." What set Vielgorsky's home off from that of Elena Pavlovna was its dual character. As a friend of the tsar and a lofty dignitary himself, he entertained the cream of the beau monde. But on musical evenings, he changed out of his spangled court uniform and played music together with friends, some of whom belonged to a distinctly lower social order,

with very unaristocratic enthusiasm. For the wellborn, artistic amateurism was not supposed to escalate into public passion.

A few steps away, on Italianskaia Street, stood the Gentry Club, or Noble Assembly, completed in 1839; the building now houses the St. Petersburg Philharmonia. Its Great Hall ranks among the most eminent in the world for its acoustics, its columned interior, and the musical titans who have performed there. Yet few remember that this concert hall was a ballroom right up to 1917; a dance orchestra played on its balcony. Old woodcuts and photographs capture the former versatility of its private and festive character: potted palms, garlands of flowers, chairs removed for dancing or a charity bazaar. In these pictures we see the Great Hall as the spatial heart of collective gentry life, as an aristocratic playpen (fig. 16.3). At the frequent balls, the gentry arrived in full regalia and opulent gowns, the daughters decked out to attract courtship, the depth of the décolletage depending on the period. Though emulating the court balls, corporate affairs produced greater spontaneity, like a party attended by family. Commoners were excluded, but the nuances of distinction allowed for animation, intrigue, flirtation, and simple sociability.

The power of the capital's gentry class at mid-nineteenth century and the grandeur of its headquarters stand in contrast to the then relative insignificance of the Philharmonic Society that would some day give the hall its name. That society, dedicated from its founding in 1803 to classical choral and symphonic works, had to offer its concerts in the small space of the Engelhardt House, located around the corner at the intersection of Nevsky Prospect and the Catherine (Griboedov) Canal (the Engelhardt House is now known as the Glinka Small Hall of the Philharmonia). The society played host to the most prestigious concert music of the first third of the nineteenth century. But the sale of the Engelhardt House to merchants led the Philharmonic Society to seek a new venue. Enter the St. Petersburg Gentry Club. Carlo Rossi and his colleagues had finished the Hôtel Péterbourg (later named L'Europe) on the southwest corner of the square in 1834 and by 1839 had built the new Gentry Club in a roughly matching style facing it. In 1846 its Great Hall became the new, though irregular home of the Philharmonia. It was only after the Russian Revolution that the brilliant and bubbly, colorful and noisy milieu of the gentry ball gave way forever to the solemnized space of the concert hall.

Completing the circle round the square, on the western side arose the modestly sized Mikhailovsky Theater, one of the five imperial theaters (the others being the Bolshoi Stone and the Aleksandrinsky in Petersburg and the Bolshoi and the Maly in Moscow). In 1833 the architect A. P. Briullov, brother of the famous painter, built this house for French and German productions. Thus, by midcentury the ensemble had reached completion—an architectural gem in the heart of the city but nestled a block away from the bustling Nevsky—each of its buildings, even the hotel, which hosted visiting virtuosos, housing people devoted to some aspect of cultural life.

As visitors proceed around the Square of the Arts today, they are immediately struck by the harmony of architectural design. The design is not symmetrical, as on Theater (now Rossi) Street; rather the buildings complement one another. Although the new, private ownership of the (Grand) Hotel Europa and the 1998 restoration of the Russian Museum have eliminated the uniform pale yellow color scheme of not so long ago, Rossi's and Briullov's elegant sense of en-

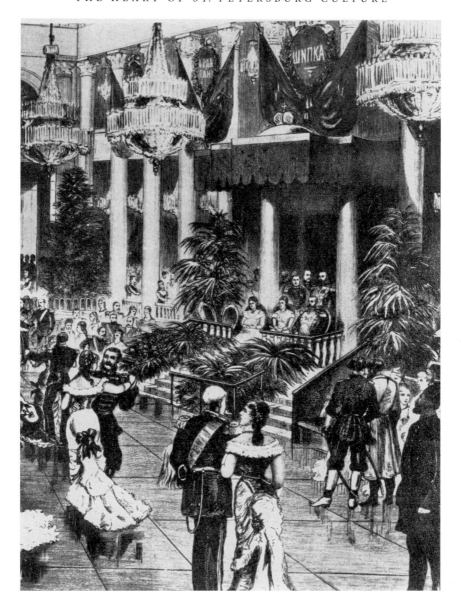

16.3. Ball at the St. Petersburg Gentry Assembly, 19th century.

semble is still on full display in fenestration and Palladian balance. Visitors might enhance their visual experience by pondering the other dimensions of what they see: a long-gone sociocultural system of aristocratic gaiety, candlelit dinners and soirées, the rolling cadences of Racine and Molière, musical performances, and vibrant conversations about all the arts. And, if their imaginations are lively enough, they may also summon up images of the lackeys who served inside the edifices and the coachmen who waited outside in the snows of a winter evening.

17

Alexander Ivanov's Appearance of Christ to the People

Laura Engelstein

Appearance of Christ to the People, a painting by Alexander Andreevich Ivanov (1806–58), covers an entire wall of the Tretiakov Gallery in Moscow. Based on the Gospel according to John, the painting shows John the Baptist (also called John the Precursor), as he fulfills his God-sent mission to prepare for the coming of Christ. Positioned just left of center, he directs the attention of the groups clustered in the foreground to the figure of Jesus, seen high and to the right, diminished in size against the far horizon (fig. 17.1 [color section]).

As in other versions of this scene, Ivanov's canvas depicts not merely the moment of Christ's appearance on earth but the moment at which the light shown by God in the darkness becomes manifest in the person of his Son. Ivanov's subject is therefore the impending transformation of humankind. The Pharisees on the right turn away; the figures on the left follow John's upward gesture. Some tremble, some show signs of joy; some are naked and vulnerable, others are clothed in the garments of social station; youth is paired with old age; the slave crouches in bondage; soldiers represent worldly power helpless before the grace and truth of Christ. The subject can also be said, however, to constitute the event of seeing, which depends on the reception of light. In this sense, the theme touches also on the function of art. Though operating in the domain of vision, pictorial art transmits a meaning beyond the surface forms.

The Russian public had its first view of the painting in 1858. Ivanov had just returned to St. Petersburg from twenty-eight years in Rome, where he had devoted most of his energy to its creation. Along with Karl Pavlovich Briullov (1799–1852), he was considered by contemporaries to be the most talented painter of his generation, but reactions to his masterpiece diverged widely. Despite the controversy that the work continued to arouse and the later tension with Soviet secularism, its status as a key point in the evolution of Russian painting has never been seriously challenged.

Perhaps the staying power of Ivanov's reputation owes something to the larger social issues with which his reception was entangled. The dominant reactions to his person and his work reflect divisions in Russian political discourse rooted in nineteenth-century debates. The first to comment were the Slavophiles. Russian civilization, these thinkers of the 1840s believed, differed from the European, not only in terms of its political and social institutions, but also,

primarily, in the continuity of the Eastern Orthodox heritage. Intent on reviving the native religious tradition, Slavophile intellectuals championed Ivanov's work, which they viewed as the pictorial analogue to their philosophy.[1]

His project was not particularly Russian, however; French and German painters led the way. In Rome, Ivanov had been influenced most directly by the German painter Johann Friedrich Overbeck (1789–1869), a member of the Nazarene fellowship, which turned to the style of the Pre-Raphaelite Renaissance for inspiration.[2] The Nazarenes considered themselves a monastic brotherhood dedicated to artistic creation, which they understood as a secular form of spiritual devotion. In England, the Pre-Raphaelite Brotherhood (1848–53) pursued a similar agenda, rejecting modern life in favor of an idealized version of the preindustrial past while fusing pre-Renaissance aesthetic conventions with realistic techniques of representation.

While acknowledging the European context for Ivanov's endeavor, his Slavophile admirers nevertheless endowed the work with a specifically Russian sensibility. In returning to the style of the early Renaissance, Ivanov, in their view, was able to connect with the Byzantine sources of Eastern Orthodoxy, thus translating what was a contemporary European quest into a re-encounter with Russia's own roots. Among Ivanov's companions in Rome was the writer Nikolai Vasilevich Gogol (1809–52), who, to help his friend supplement a meager pension, wrote a letter that later appeared in the writer's *Selected Correspondence with Friends* (1847).[3] Designed to justify further investment on the part of sponsors who wondered why the work was taking so long, the letter stressed Ivanov's ascetic dedication and the religious inspiration that guided his task.

It was a decade after Gogol's plea, in 1858, that Ivanov finally returned home. By then, Nicholas I had died and Alexander II had taken the first steps toward freeing the serfs and instituting the Great Reforms, which modernized the legal system and expanded the opportunities for civic life. Disappointed by the public's critical response, Ivanov died of cholera soon thereafter, prompting the notion that he had literally fallen victim to bad reviews. Aleksei Stepanovich Khomiakov (1804–60), the Slavophile philosopher, at once hailed Ivanov as a "sacred artist." The canvas was a great achievement, Khomiakov declaimed, because it rejected the post-Renaissance insistence on individual creativity. Conveying the Christian ideal in all its transcendent, impersonal grandeur, it represented the triumph of personality in and through the collective spirit—the mark, in his view, of the Russian Orthodox tradition.[4]

Despite intellectual differences with the Slavophiles, Western-oriented intellectuals also praised the work. Alexander Ivanovich Herzen (1812–70) hailed Ivanov as a martyr to tsarist oppression and the smug cultural establishment. Ivan Sergeevich Turgenev (1818–83) complained that Russia had deprived the artist of a well-deserved welcome. Nikolai Gavrilovich Chernyshevsky (1828–89) not only embraced the artist and his work but insisted that the Slavophile interpretation was mistaken.[5] Describing the period after 1848 as one of transition and himself as a "transitional artist," Ivanov, Chernyshevsky believed, had lost confidence in his great project. In 1851, Ivanov had read a French translation of *The Life of Jesus,* by David Friedrich Strauss (1808–74), and been swayed by its rational approach to the meaning of the Bible. In 1857 he traveled to Germany and England, meeting with Strauss himself, as well as Herzen and Guiseppe Mazzini, and a year later he wrote his brother that he was searching for a new

path in art. In Chernyshevsky's view, Ivanov had undergone a conversion from faith to reason, emerging as a "new man," concerned with social, not spiritual, questions.[6]

This model of the artist developing a secular social conscience was the one codified by the influential culture critic Vladimir Vasilevich Stasov (1824–1906). Stasov praised Ivanov's talent, not as a master of religious sensibility, as Khomiakov had done, but as a gifted and accurate observer. Stasov described the great canvas as a historical narrative, focused not so much on the moment of Christian revelation as on the symbolic moment of transition in the moral life of the human race. The appearance of Christ transferred the task of salvation to human hands and offered redemption to the poor and benighted. Stasov praised Ivanov's realistic representation of human and cultural types—his exact rendition of the Jewish figures, his attention to ethnographic and historic detail. Ivanov's realism, in Stasov's view, was the visual language of progressive social commitment.

Discussion of Ivanov revived in the last part of the nineteenth century with the creative intelligentsia's return to religious themes and the intensified interest on the part of both traditionalists and modernists in the art of the ancient Russian icon.[7] Critics of the modernist Silver Age shared Stasov's distaste for academic art but not his zeal for socially observant realism. Alexandre Nikolaevich Benois (1870–1960) celebrated Ivanov's "angelically sensitive soul, the soul of a true prophet." While praising the preparatory sketches for their mystical sensibility, Benois complained that the great canvas was marred by the traces of Ivanov's academic training and by the cerebral and schematic approach encouraged by the Nazarenes. Benois's views were not, however, generally accepted by other Silver Age critics, who were less convinced of the painter's spiritual gifts.[8]

Not surprisingly, the Soviet art establishment embraced the version of the artist as a master of realistic expression articulated by Stasov and Chernyshevsky.[9] Soviet biographers asserted that Ivanov had been inspired all along by the spirit of social commitment: imbued with democratic values by his father, sensitized by the repression of the Decembrists, confirmed in his hostility to the established order by the revolutions of 1848, and set in his basically rational approach to biblical sources by the encounter with Strauss. His friendship with the Slavophiles was but a passing phase. His true character and intentions emerged in conversations with Herzen and Chernyshevsky. The painting itself depicted the misery of human oppression and the hope of self-liberation. The style was the forerunner of Soviet socialist realism.

Not until the 1970s did Mikhail Allenov, a scholar of the post–World War II generation, depart slightly from the script. Still describing the painting as a historical narrative and continuing to see Ivanov as a secular thinker with humanitarian, not narrowly Christian, concerns, Allenov nevertheless identifies the representational idiom as primarily symbolic. The work can be understood in its totality, Allenov claims, as a commentary on the function of art itself: the pilgrim seated under John the Baptist's upraised arm represents the artist himself as the "all-seeing eye," the facilitator of human vision.[10] With this reading, we return both to the opening scene of the Gospel according to John and to the romantic concept of art as the instrument of modern transcendence.

Although Allenov sees the significance of Ivanov's painting in its ability to join "the historical and the symbolic," even he cannot abandon the Soviet-era view of the work as the visual

translation of a political moment. Ivanov may in fact owe his enduring place in Russian art historical discourse to the rigidly ideological character of the Soviet aesthetic canon. Fixated on nineteenth-century debates and models, Soviet criticism froze the dialogue on art at the pre-modernist moment, retarding the decline into anachronism suffered by objects of Victorian-era fascination that elsewhere had lost their allure.

NOTES—1. S. Shevyrev, "Russkie khudozhniki v Rime," *Moskvitianin,* pt. 6, no. 11 (1841), 150–52; F. V. Chizhov, "Pis'mo o rabotakh russkikh khudozhnikov v Rime," *Moskovskii literaturnyi i uchenyi sbornik* (Moscow: Tipografiia Avgusta Semena, 1846), 49–136; F. V. Chizhov, "Overbek," *Sovremennik* 43 (1846): 17–68.

2. D. V. Sarab'ianov, *Russkaia zhivopis' XIX veka sredi evropeiskikh shkol* (Moscow: Sovetskii khudozhnik, 1980), 93–106.

3. V. V. Stasov, "O znachenii Ivanova v russkom iskusstve," *Vestnik Evropy* (January 1880), in *Izbrannye sochineniia,* 3 vols. (Moscow: Iskusstvo, 1952), 2:72; M. M. Allenov, *Aleksandr Andreevich Ivanov* (Moscow: Izobrazitel'noe iskusstvo, 1980), 40; N. V. Gogol', "Istoricheskii zhivopisets Ivanov" (1846), in *Vybrannye mesta iz perepiski s druz'iami* (1847).

4. A. S. Khomiakov, "Kartina Ivanova (pis'mo k redaktoru *Russkoi besedy,* book 3 [1858])," in *Polnoe sobranie sochinenii,* 8 vols. (Moscow: Universitetskaia tipografiia, 1900), 3:346–65.

5. N. G. Chernyshevskii, "Zametka po povodu predydushchei stat'i," *Sovremennik,* no. 11 (1858), 175–80, in N. G. Chernyshevskii, *Polnoe sobranie sochinenii,* 15 vols. (Moscow: Khudozhestvennaia literatura, 1950), 5:335–40.

6. Stasov, "O znachenii Ivanova," 2:76–77; Chernyshevskii, "Zametka," 340.

7. See "Aleksandr Andreevich Ivanov: Ocherk," *Niva,* no. 12 (1880): 242–44; "A. A. Ivanov," *Niva,* no. 37 (1908): 638–40. See also A. I. Tsomakion, *A. A. Ivanov: Ego zhizn' i khudozhestvennaia deiatel'nost'* (St. Petersburg: Tip. Kontragenstva zhel. dorog, 1894); and N. P. Sobko, ed., *Slovar' russkikh khudozhnikov . . . s drevneishikh vremen do nashikh dnei (XI–XIX vv.),* 3 vols. (St. Petersburg: Stasiulevich, 1893), vol. 1, cols. 5–297.

8. A. P. Benua, *Istoriia zhivopisi v XIX veke: Russkaia zhivopis'* (St. Petersburg: Znanie, 1901–2; reprint, Moscow: Respublika, 1995), 153 (quotation); and Stasov, "O znachenii," 2:38–39; D. Filosofov, "Ivanov i Vasnetsov v otsenke Aleksandra Benua," *Mir iskusstva,* no. 10 (1901): 218–19; Vasilii Rozanov, "Aleks. Andr. Ivanov i kartina ego 'Iavlenie Khrista narodu'" (1906), in V. V. Rozanov, *Sredi khudozhnikov* (St. Petersburg, 1914) and in N. K. Gavriushin, ed., *Filosofiia russkogo religioznogo iskusstva XVI–XX vv.: Antologiia* (Moscow: Progress-Kul'tura, 1993); N. G. Mashkovtsev, "Tvorcheskii put' Aleksandra Ivanova," *Apollon,* no. 6–7 (1916): 1–39.

9. See A. A. Fedorov-Davydov, "Ivanov, Aleksandr Andreevich," *Bol'shaia sovetskaia entsiklopediia* (Moscow: Sovetskaia entsiklopediia, 1933), 27:333–35; "Ivanov, Aleksandr Andreevich," *Bol'shaia sovetskaia entsiklopediia,* 2nd ed. (Moscow: Gosudarstvennoe nauchnoe izdatel'stvo, 1952), 17:272–74 [unsigned]; M. V. Alpatov, *Aleksandr Andreevich Ivanov: Zhizn' i tvorchestvo,* 2 vols. (Moscow: Iskusstvo, 1956); D. V. Sarab'ianov, "Ivanov, Aleksandr Andreevich," *Bol'shaia sovetskaia entsiklopediia,* 3rd ed. (Moscow: Sovetskaia entsiklopediia, 1972), 10:8–9.

10. Allenov, *Aleksandr Andreevich Ivanov,* 130; M. M. Allenov, *Aleksandr Ivanov* (Moscow: Trilistnik, 1997).

18

Lubki *of Emancipation*

Richard Wortman

The spirit of openness and trust that accompanied the era of reforms brought new modes of representation of the Russian monarch and the Russian people. Eighteenth- and early nineteenth-century ceremony and imagery had emphasized the distance between the emperor and the imperial elite, on the one hand, and the people, on the other. In the first decades of the nineteenth century, ideas of nationhood and popular sovereignty prompted changes in the form of imperial representation. The ceremonies and rhetoric of Official Nationality during the reign of Nicholas I (1825–55) defined the Russian nation in terms of the Russian people's voluntary submission and obedience to their sovereign. The formulation in the doctrine of Official Nationality elevated the monarch's unquestioned authority by making it the distinguishing feature of the Russian nation.

The next tsar, Alexander II, adopted these forms of representation, but with an emphasis on the warm sentiment rather than the awed obedience that united sovereign and people. Monarch and people showed a reciprocal affection, expressed by the benefactions bestowed on the people by their ruler and by the people's ardent expressions of gratitude and love. This variant of the Russian monarchical myth, enacted in what I have described as a scenario of love, enabled the tsar to embark on major reforms with the confidence that they would not undermine his absolute power or threaten the distance between ruler and ruled. Alexander's scenario was expressed in the texts, the ceremonies, and the *lubki* that accompanied the emancipation of the serfs. The lubki both anticipated and ordained peasants' response to the reform and the new relationship to arise between tsar and people.[1]

The word *lubki* or its equivalent, *narodnye kartinki,* referred to prints that appealed to the popular taste and were sold to the common people by itinerant peddlers (*ofen'i*), who roamed the towns and villages of nineteenth-century Russia. Lubki were produced by urban craftsmen, and some scholars of popular art have approached them as expressions of an idiom coming from the people themselves, especially in the seventeenth and eighteenth centuries.[2] They illustrated tales of saints, folk and heroic figures, *bogatyri* like Ilia Muromets and Yeruslan Lazarevich, conquerors like Alexander the Great and Yermak, famous generals like Alexander Suvorov, and others. Until 1839 the production and sale of lubki proceeded with little government interference or effective censorship. Indeed, educated society and government officials tended to regard all folk art as crude and insignificant. The government circulated lubki to

propagate certain views only rarely, as when Catherine the Great used them to ridicule monks and Old Believers and when Alexander I found them an effective way to spread knowledge about the horrors of smallpox.[3]

The use of lubki to appeal to popular patriotic sentiment began with the invasion of Russia by Napoleon's army in 1812. Prints by the formally trained artists Ivan Terebenev, Ivan Ivanov, and Aleksei Venetsianov characterized peasants and others routing a sorry and bedraggled Napoleon and his troops. After the victory several popular prints glorified Alexander I as heroic leader, showing him with the Russian troops and European heads of state in France. These and future works that served the interests of the regime borrowed techniques from the lubki to create an idiom accessible to the people, but also adapted more sophisticated artistic techniques to the market and produced works that, modern critics argue, lacked the authenticity of true lubki. The art historian A. G. Sakovich prefers to describe the new popular pictures as "political graphics" that employed "an eclectic pseudo-popular style of pictures for the people." In any event, the distinction was not observed at the time, and popular prints continued to be referred to as lubki or as narodnye kartinki.[4]

Viewing lubki as an instrument of political and religious subversion, Nicholas I broke with the practice of ignoring the market in popular prints. In 1839 he issued a decree introducing censorship for all prints and print books. The governor-general of Moscow, Count Zakrevskii even ordered old plates to be collected and destroyed.[5] Lubki on traditional themes continued to circulate, but under strict government supervision.

At the same time, print shops began to issue pictures of the emperor rendered in the lubok style, placing him in the heroic space evoked in folk legend. Nicholas was depicted with the stylized features of heroes from the folk epics (*byliny*), stiff and stately, larger or higher than those around him: in the lubki, size and position designated importance. People do not appear in this frame of heroic space; they could gaze on it from outside with proper respect and wonderment. The lubki of the first years of Alexander II's reign (1855–81) adopted the same idiom.[6]

How to present the emancipation of the serfs, verbally and visually, was of great importance because, as officials knew, the statutes fell far short of the expectation, widespread among the peasantry, of a "black partition," the granting of all landlords' property to the peasants. The emancipation was dramatized in Alexander's scenario as the selfless initiative of the nobility to free their serfs. The peasants were expected to respond with shows of gratitude to the tsar and the nobles. The Ministry of Interior sustained the image of mutual affection by printing numerous accounts of peasants gathering to express their gratitude, in the pages of its newspaper, *Northern Post* (*Severnaia Pochta*). One account described their simple touching prayers: "Attentive eyes could note how great was the love of the tsar in the simple hearts of the people."[7] At ceremonies staged in St. Petersburg and Moscow, workers expressed their gratitude directly before the tsar.

The lubki of emancipation were visual confirmations of the narrative set forth in official texts. The captions provided explicit statements of meaning, including quotations of the words of the peasants themselves. The pictures aimed to preclude interpretation, to make divergent readings impossible. At the same time, they exerted the magical "power of images" that lifted

the ceremonies of thanksgiving into the realm of legend and myth and served as exemplary acts for all the Russian people. In this respect, the "peasant monarchism" that has been examined by scholars reproduced the official narrative of a peasantry adoringly grateful to its rulers.[8]

The transposition from text to image raised a difficult problem for the artists who had to place tsar and people within a single frame. This was not a problem for official rhetoric, which could suggest affinity but not closeness or similarity. Artists, however, had to find ways to bring peasants and workers into the heroic space of imperial iconography without breaching the symbolic distance crucial for the elevation of the autocrat. Here I give examples of two devices—one that stressed difference in style and one that stressed difference in size and elevation—which artists employed to emphasize both the distinctions between ruler and people and the bonds that united them.

The initial resolution of the problem was to depict the tsar as a picture within a picture. Several lubki employed this device, including the lubok *Voice of the Russian People* (*Glas russkogo naroda*), which shows peasants gathering before a portrait of the tsar on a dais (fig. 18.1). The tsar is under a canopy, indicating his sacred nature. His military dress, the full imperial regalia, and the numerous two-headed eagles symbolize his imperial and secular transcendence. The faces express rapt wonderment, a childlike devotion for the tsar presented as if in an icon. The verse at the bottom indicates that adoration is the proper response to the tsar's feat of altruism: emancipation of the serfs.

> *We all stand before him,*
> *Burning with ardent love for him. . . .*
> *He gave us all freedom*
> *The great day has come.*

Lubki depicting Alexander's meeting with the Moscow workers (literally, "factory people," *fabrichnye liudi*), an actual event, could not show the tsar as an icon in the midst of the people. Now his figure is rendered with the traits of heroes in the lubok idiom (fig. 18.2). In the lubok *The Bringing of Bread and Salt to the Tsar-Emperor in Moscow. From Almost 10,000 Peasants-Factory Tradesmen-Workers,* distance is expressed by differences of height, dress, and bearing. The tsar is the tallest figure in the picture; his body is stiff, his look impassive, and his eyes stare into the distance while the workers, depicted as befits their official estate designation as peasants, gaze reverently at him. The empress stands on a balcony, a representative of the glittering world of the court. The peasant elder (*starosta*) declares to Alexander, "We thank YOUR IMPERIAL MAJESTY and all YOUR Most August House! God is in the Heavens and YOU are on earth! We take on the obligation to pray to God for YOU We thank you for remembering us." The emperor replies with thanks, then adds, "Remember only that now your first duty is to obey the law and to fulfill religiously the established obligations." After showing "visible signs of satisfaction," the emperor passes through the rows of workers, who fall to their knees and shout a rapturous "Hoorah!" When the empress appears on the balcony, they again fall to their knees and shout "Hoorah," the moment captured by the lubok.

The artists thus dealt with challenge of reconciling distant worlds by rendering them in the same artistic frame while emphasizing and even exaggerating the difference between them.

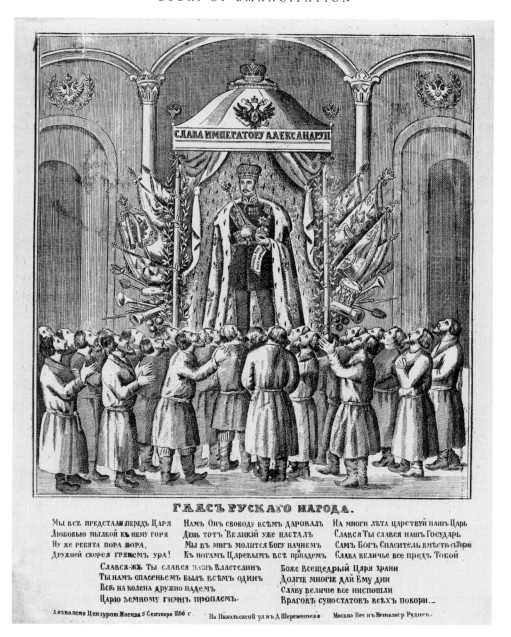

18.1. *Voice of the Russian People*, 1861. *Lubok* print.

The clash of styles reveals the incongruity of a display of affection between a majestic emperor and his abject subjects. Art in this respect trumps text, which could invoke rhetoric and trope to finesse the strain and improbability of such scenes. We have no evidence about whether these lubki succeeded in inducing feelings of submission and gratitude. But it appears that the peasants received their emancipation, if not with joy and gratitude, at least with resignation,

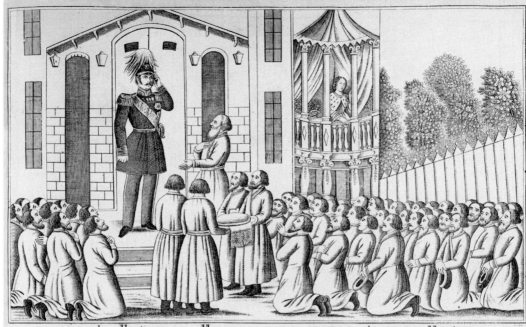

18.2 *The Bringing of Bread and Salt to the Tsar-Emperor in Moscow. From Almost 10,000 Peasants–Factory Tradesmen–Workers*, 1861. *Lubok* print.

and few disturbances took place. The lubki of emancipation give us insights into official expectations of the peasants' response to the reform and the hopes for a future popular autocracy.

NOTES—1. On the changing representation of the monarch, see Richard S. Wortman, *Scenarios of Power: Myth and Ceremony in Russian Monarchy,* 2 vols. (Princeton, N.J.: Princeton University Press, 1995, 2000), vol. 1, chaps. 9 and 12; vol. 2, chaps. 1 and 2.

2. On the many different names for lubki and the different views on whether they were merely produced for the people or represented the expression of a genuine popular art see E. A. Mishina, "Terminy 'lubok' i 'narodnaia kartinka' (k voprosu o proiskhozhdenii i upotreblenii)," in M. A. Alekseeva and E. A. Mishina, eds., *Narodnaia kartinka XVII–XIX vekov: Materialy i issledovaniia* (St. Petersburg: Dmitrii Bulanin, 1996), 15–28.

3. Dmitrii Rovinskii, *Russkie narodnye kartinki* (St. Petersburg: R. Golike, 1900), 2:489. The themes and development of lubok prints are discussed in M. A. Alekseeva, "Russkaia narodnaia kartinka. Nekotorye osobennosti khudozhestvennogo iavleniia," in Alekseeva and Mishina, *Narodnaia kartinka XVII–XIX vekov,* 3–14.

4. A. G. Sakovich, "Moskovskaia narodnaia graviura vtoroi poloviny XIX veka (K probleme krizisa zhanra)," in Alekseeva and Mishina, *Narodnaia kartinka XVII–XIX vekov,* 139. Lubki and the Napoleonic Wars are dis-

cussed in Stephen M. Norris, *A War of Images: Russian Popular Prints, Wartime Culture, and National Identity, 1812-1945* (DeKalb: Northern Illinois University Press, 2006), 11–35.

5. Alekseeva, "Russkaia narodnaia kartinka," 7; Rovinskii, *Russkie narodnye kartinki,* 1:82.

6. Wortman, *Scenarios of Power,* 2:101, 102. For an example of a lubok of Nicholas, see 1:13.

7. *Severnaia Pochta,* September 16, 1862, p. 805; September 19, 1862, p. 813; September 22, 1862, p. 829.

8. See David Freedberg's comments on the mysterious and supernatural allure of painted images, in Freedberg, *The Power of Images: Studies in the History and Theory of Response* (Chicago: University of Chicago Press, 1989), 35, 49. On "peasant monarchism," see Daniel Field, *Rebels in the Name of the Tsar* (Boston: Houghton Mifflin, 1976); Terence Emmons, "The Peasant and the Emancipation," in Wayne Vucinich, ed., *The Peasant in Nineteenth Century Russia* (Stanford, Calif.: Stanford University Press, 1968), 41–71.

19

Folk Art and Social Ritual

Alison Hilton

Household objects offer insights into ways of life and cultural values that are not always available from written descriptions, photographs, or statistical records. Such domestic items as serving dishes displayed on open shelves and textiles draped around icons and windows have special significance, and their decorations inform on several levels. Choices of ornamental motifs, designs, and colors express the aesthetic preferences of artists and their communities; the motifs also recall a repertoire inherited from the distant past, featuring stylized plants and animals and symbols of water and the sun. Figurative scenes show familiar activities, sometimes in combination with fanciful settings that evoke the wide world of folklore. Certain designs that appear in many regions and in a variety of media, including carved architectural details, domestic implements, and textiles, are evidence of long-standing traditions that artists adapt to their own purposes. The concept of tradition in folk arts does not imply a static timelessness but rather a flexible relationship between present needs and an awareness of past beliefs and customs, between utility and imagination.

Russian distaffs (*prialki*) were among the most finely crafted and decorated household implements. Used continually by girls and women to spin thread from flax or wool fiber, they were personal belongings, cherished gifts, and status symbols. While other household objects, such as breadboxes, bowls, and looms, were also decorated, the large, flat surfaces of distaffs encouraged expanded pictorial compositions and prominent display in the home. During fall and winter evenings, women gathered to spin and men frequently joined them to talk and sing; these gatherings, called *posidelki* ("to sit a while"), were opportunities for socializing and courtship. Many folk songs printed on *lubki* (popular prints) or preserved in early twentieth-century recordings, originated at posidelki. Young people wore their best clothes and sometimes shared the cost of renting someone's home for the evening and providing refreshments. Women made a point of showing off the quality of their distaffs, sitting so that the highly decorated outer side of the blade could be seen to advantage.[1]

Distaff decoration varied widely, with more than forty regional types in central and northern Russia, but the basic elements were an upright blade that held a hank of flax or wool and a horizontal base where a woman sat to steady the distaff. Distaffs made in the heavily forested north were L-shaped, with plain bases and elaborately carved or painted upright blades, which were sometimes topped with a ridged or toothed comb to hold the flax, while those from the

Volga River region were made of a flat base with a socket at one end to hold the relatively nar-
row blade; these came apart and hung on a wall when not in use, to display the ornamented
base.

Artists living in a group of woodland villages around Borok, on the Northern Dvina River
in Arkhangelsk Province, made distaffs with very large upright blades painted with architec-
tural and floral motifs surrounding scenes of people engaged in a variety of activities. Local
traditions of icon painting and manuscript illustration in this area, which was settled by colo-
nists from Novgorod, meant that folk artists already had large repertoires of ornamental and
figurative designs and were skilled in their execution. In Gorodets, north of Nizhny Novgorod
on the Volga, the bases of two-part distaffs displayed intricate designs in carving, painting, and
inlay work, made with thin veneers of aged and tinted oak cut to fit into patterns carved in
the lighter base. Gorodets, located on an active trading route, enjoyed the stimulus of visitors
and products from western Russia, and artists incorporated their observations of new customs
and fashions into their stock of traditional motifs. Although distaffs from these two distinct
regions differ in style and technique, they share crucial elements of content and design. Sig-
nificantly, distaffs from both Borok and Gorodets display a combination of symmetrically ar-
ranged, formal ornaments in the upper section and more flexible, narrative scenes below.

On one of the earliest surviving distaffs, from the early nineteenth century, the Borok
painter Yakov Yarygin, places a row of women spinning and sewing on a bench, as if in a
cutaway interior scene, beneath the boldly checkered and striped wall and roofline of a house
(fig. 19.1 [color section]). Above the peak, a prancing lion and unicorn fill the role of heraldic
emblems, looking much like the carved figures above the roofs and doorframes of many tra-
ditional northern houses. The context broadens in the lower part of the distaff blade, with an
outdoor scene of a three-horse carriage approaching with driver and passenger (not shown
here). On the basis of other Borok distaffs that juxtapose domestic scenes such as tea drinking,
reading, and spinning with riding in sleighs and carriages, herding, and hunting, we can rec-
ognize the local style of illustrating stories and parables in parallel bands of images.

This three-part compositional format persisted a century later in the work of several Borok
artists. Pelegeia Amosova, member of a well-known family of painters, explained her process of
painting to a team of Soviet folk art scholars in the 1950s. Much like Yarygin, she used a heral-
dic arrangement in the two top sections of her distaffs, with a bird perched atop a stylized tree
flanked by paired architectural and floral forms in each register, and a wintry sleigh-ride scene
in the bottom section. Highly conscious of her heritage as a painter in a region with strong
artistic ties to Novgorod manuscript and icon painting, Amosova prepared her distaff blades
in much the same way that icon painters prepared panels with layers of gesso, determining the
colors and the placement of gold-leaf accents, inscribing the main sections and features, some-
times using stencils for conventional forms, but drawing many details freehand.[2] Amosova's
style preserved the local tradition of presenting human activity on an elevated level. Connect-
ing the sleigh ride with elegant architectural forms recalled earlier depictions of a visitor ap-
proaching a house, usually a suitor paying a courtesy call on the family of his intended bride.
Distaffs made as engagement or wedding gifts often featured the facade of a three- or four-story
house ornamented with floral swags and columns that evoked fairy-tale descriptions of the

tsar's palace. Such refinements echoed the formal tone of wedding ceremonies that treated the peasant bride and groom as royalty. The birds in the architectural sections of Amosova's composition, and in many distaffs by Yarygin and other Borok artists, recalled the mythical *sirin* (bird with a female face) or the peacock, both emblematic of happiness in Russian folklore.

In a distaff from Gorodets, the three-register composition contains both the heraldic top section and more elastic images of contemporary life (fig. 19.2 [color section]). Lazar Melnikov, and other Gorodets artists in the second half of the nineteenth century, introduced greatly expanded genre elements into the traditional distaff form. In this extraordinary distaff, the top, largest section shows two mounted figures facing a central stylized tree with a bird hovering above it and two small dogs at its base. The center register, on a striking red background set off by a band of carved and painted flowers, is a variant on the posidelka motif. Just right of center, a woman sits working with a distaff. A man in a military jacket and plumed helmet, accompanied by a very large dog, approaches from the right. To the left of center, another man turns toward two women wearing crinoline dresses and carrying parasols. This combination of a social encounter indoors and a promenade places the emphasis on costumes and accessories—the parasols and the man's pipe—showing the artist's awareness of urban activity and fashions. The lowest band on the distaff base contains another contemporary and asymmetrical scene with three men, a horse, two dogs, and a bird. Although the scene looks like part of a narrative, there are still strong similarities to the heraldic composition in the uppermost section. The apparent imbalance, with three men and a dog on the right side and a dog, a horse, and a bird on the left, seems to reassemble the traditional formula. These three associated images suggest that the artist perceived a connection between contemporary life and customs whose meanings had faded although the forms remained compelling.

The significance of this merging of traditional forms with observations of the artists' own surroundings becomes clear in the context of the other furnishings of a peasant house, especially the woven or embroidered textiles used for tablecloths, bed valances, hangings at windows or around the icons, and decorations for headdresses and garments. Borders of these textiles usually consisted of several bands of abstract patterns containing stylized symbols for the sun, trees, or birds and a large, central register with a heraldic motif that often combined birds, trees, horses or horsemen, and a frontally posed female figure, often with upraised hands.

The central figure has been interpreted as a manifestation of the ancient Slavic nature divinity Mokosh, "Moist Mother Earth"; the same orant pose in an important icon type, the Mother of God of the Sign, may have helped Slavs to accept the Christian imagery. *Dvoeverie*, or "dual faith," is the term used for the process by which pagan belief was absorbed into Christian practice, and examples abound in folk art. Textile borders usually feature a symmetrical decoration in which embroidered patterns visually connect the central and flanking figures. Sometimes the riders' hands are raised in a worshiping gesture, and the horses' manes and tails extend into the forms of trees or birds. The ritual character of the panels was natural for these carefully executed decorations made to set off the most important parts of a costume or a room. As in the case of distaffs that emphasized the traditional and ritual meanings of social activity by embellishing the scenes with lush floral patterns and birds, symbols of plenty and

good fortune, the embroidery motifs related to the purpose for which the piece was made, such as a birth, an engagement, or a wedding.

Can we use the decorations on Russian distaffs and related folk arts to gain a sense of what life was like in the peasant communities? The interior scenes of posidelki and tea parties certainly bear little resemblance to nineteenth-century photographs of peasants working in dark, cramped quarters or to descriptions in travel literature. The folk artists' customary idealization of their subjects does not invalidate the images, however. All the depictions of heraldic creatures and human activity reflect distinct points of view based on the experiences of the artists. The elaborate facades on many late-eighteenth- and early nineteenth-century distaffs from Borok reflected local architectural carving traditions while also suggesting the elegant settings of fairy tales. The depictions of suitors approaching on horseback and of wedding journeys by sleigh related to actual courtship customs but also embellished reality with lavish floral ornaments, birds of happiness, and touches of gold leaf.

Although distaff making declined at the end of the nineteenth century, when manufactured fabric became available, ending the need for these implements, some artists transferred their techniques and imagery to other kinds of objects. In the early Soviet period, for instance, artists from Gorodets and Arkhangelsk Province painted panels with similar decorations intended for exhibition and sale. Even at the beginning of the twenty-first century, a number of young artists from institutes of applied arts still travel to northern villages to apprentice themselves to the few surviving traditional painters. Their decorative plaques, boxes, and reproduction distaffs are now sold as souvenirs. These pieces have little connection with actual rural life, but they convey the Russian fascination with the past.

NOTES—1. Sources for this essay include Alison Hilton, *Russian Folk Art* (Bloomington: Indiana University Press, 1995); Joanna Hubbs, *Mother Russia: The Feminine Myth in Russian Culture* (Bloomington: Indiana University Press, 1988); Ol'ga V. Kruglova, *Russkaia narodnaia rez'ba i rospis' po derevu* (Moscow: Izobrazitel'noe iskusstvo, 1974); Kruglova, *Narodnaia rospis' severnoi Dviny* (Moscow: Izobrazitel'noe iskusstvo, 1987); L. Kaymykova, *Narodnaia vyshivka tverskoi zemli* (Leningrad: Khudozhnik RSFSR, 1981); Serafima K. Zhegalova, *Sokrovishcha russkogo narodnogo iskusstva: Rez'ba i rospis' po derevu* (Moscow, Iskusstvo, 1967); and a virtual exhibition, "The World of Russian Folk Art" (Swashbuckler Enterprises and Georgetown University, 1999), http://www.rusfolkart.ru.

2. Illustrated and discussed in Hilton, *Russian Folk Art*, 52–53; preparation and painting methods are detailed in Serafima K. Zhegalova, "Khudozhestvennye prialki," in Zhegalova, *Sokrovishcha russkogo narodnogo iskusstva*, 128–30.

20

Personal and Imperial

Fyodor Vasiliev's *In the Crimean Mountains*

Christopher Ely

Landscape paintings have a way of hiding in plain view. Finding out what they have to tell us can require concentration and repeated observation. The Russian landscape painter Fyodor Vasiliev produced images that are not flashy or spectacular but insist on, and reward, a second look. *In the Crimean Mountains* is one such unobtrusively insistent work (fig. 20.1 [color section]). At first it may appear to be little more than a vaguely interesting depiction of a remote part of the Russian Empire, a slice of southern mountain scenery intended as a souvenir for a visitor from the flat and cold Russian north. Closer examination, however, reveals a complex image open to a variety of possible readings.[1]

The very conditions of its creation mark this landscape as an intriguing artifact. In an effort to recover from tuberculosis, the twenty-three-year-old Vasiliev sought a cure on the Crimean Peninsula in the Black Sea, where he spent the final two years of his life. Less than a year before his untimely death, he painted *In the Crimean Mountains* under great physical strain. Standing at the edge of the grave, as it were, Vasiliev finished the painting; he shipped it back to St. Petersburg in the spring of 1873.

A first look at the image reveals its reliance on the basic elements of a conventional picturesque aesthetic: the "disorderly order" of the immediate hillside, the towering grandeur of the mountains beyond, the patches of light and shadow, the cart driver and his "exotic" family. All were familiar elements of scenic beauty and its representation in landscape painting in the nineteenth century. It may have been on the basis of its picturesque appeal that the painting received a first prize at the annual exhibit of the Society Devoted to the Arts in St. Petersburg. The painting's continuing appeal today may have as much to do with its artistic merit as with its significance as an artifact of a certain place and time. It remains a work of art, but now it is also a historical document, the reflection of a series of communications in the past between a place, a painter, and his audience.

Because of the initial effect of gentle, pictorial charm, a closer look at the painting proves unsettling. The hillside is not just arrayed in painterly disorder but strangely, even violently, denuded. Four sparse evergreens represent the last vestiges of a forest, remnants of which leave a distorted mirror image as cleanly hewn stumps in front of the remaining trees. Only a few

unprepossessing weeds have sprung up to replace the lost greenery. The landscape's foreground suggests a natural environment uprooted and despoiled by human hands. Clearly, Vasiliev did not wish to produce a pastoral idealization of humanity happily intertwined with nature. He conjured up something like its opposite: the degradation of nature as a result of voracious human need. Nature and culture have acted on each other antagonistically here. The forest has been cleared to make, among other things, the ramshackle road and dilapidated cart we see before us. And yet the figures within the landscape hardly illustrate the enrichment to be gained from the exploitation of nature. Just as the environment has been altered for the worse, its human inhabitants, too, seem to suffer from the negative effects of that alteration. On close inspection, the outwardly picturesque foreground becomes something awkward and unpleasant.

Given Vasiliev's condition, we might reasonably expect his work to contain a sense of despair. Who would blame Vasiliev for offering the world a memento mori at the tragic conclusion of his short and, by all accounts, brilliant life? The foreground may reflect the bitterness of a man watching his life come to an end only a few years beyond childhood. At the same time and more poignantly, the landscape is filled with an achingly youthful hope for redemption. Vasiliev achieves this effect by throwing the foreground into dialogue with the distance. In the classical landscape technique pioneered by such artists as Claude Lorrain, the eye travels a steady path from the foreground into the depths of the scene, carried along by a host of framing devices and visual cues that heighten the sense of distant perspective. Through such techniques a huge expanse appears to blend into a harmonious whole. Here, however, the foreground and the distance are separated into distinct halves. The halves divide along the lines of the painting's unusual (in a landscape) vertical format. In this bifurcated arrangement, the eye is not propelled forward into the distant mountains. Rather, it focuses on the foreground details and then floats up into the sunlit, misty mountain atmosphere, urged upward by the arrowlike trees that point into the sky.

The promise inherent in that distant mountainous expanse and those uplifting evergreens modifies the grim message of the foreground. No matter how despoiled and abandoned the road and its travelers, the distant hills and sky fill the image with hope. As in a Chinese landscape, the painting's verticality raises the eyes from the gritty earth to the bright, ethereal heavens. In the radiant distance the world regains its harmony, brighter and newer in the union of mountainous earth and ethereal sky. Seen as part of this unified space, the central stand of trees does not serve as a reminder of the destroyed forest; it becomes a signpost pointing the way to a better world beyond. Were these lone pines Vasiliev's anthropomorphic last testament? If so, they seem to say that we may be surrounded by trauma and difficulty in the here and now, but in the world above and beyond all will be made whole again. Vasiliev had written home to St. Petersburg that a perfectly rendered portrait of Crimean scenery would tear away one's "criminal thoughts" and reveal the essential, naked humanity beneath them.[2] With one foot in each world, not unlike the dying painter himself, the image stands as a reminder that the eternal and the temporal lie closer to each other than we sometimes assume.

In spite of the deeply personal elements in this work, we must not neglect to examine it from an entirely different point of view. *In the Crimean Mountains* is also one among many

orientalist images produced by European painters in the nineteenth century. Its scenery and figures possess an exotic otherness that marks them off as symbols of the East. The bright and unfamiliar Tatar Muslim dress of the traveling figures unmistakably identifies them as non-Russian representatives of this East (even if, ironically, the painting depicts a location slightly to the *west* of Moscow). The land itself is immediately identifiable as non-Russian, particularly in its mountainous terrain and humid, sun-dappled atmosphere. The painting's "Eastern" attributes no doubt offered yet another appeal for contemporary Russian viewers, invited by the painting to experience visions of a distant and mysterious land and people.

And yet Vasiliev's Orient differs sharply from more overtly exotic depictions created by other Russian painters. Perhaps fundamental to this difference is the closeness of the Crimean Peninsula to European Russia; it was firmly incorporated within the empire, and it was personally familiar to a significant number of Russians from war and travel. By the 1870s the Crimea had long served as a vacation and health retreat for the well-to-do. To a native Russian it was exotic, perhaps, but not alarmingly so. In keeping with the Crimea's colonial status, Vasiliev's landscape included elements of the foreign and the familiar. It offered Russian viewers a vision of a distant and intriguing world but did not announce its otherness in extremes of color, costume, and drama. Indeed, aspects of *In the Crimean Mountains*—the muddy road, the tired travelers amid a great expanse, the browns and grays of earth and sky, and the barren soil—are reminiscent of Russian subjects in the work of Vasiliev's contemporaries, the *Peredvizhniki* (realist painters whose work contained elements of social criticism). At least in certain features, the image was unremarkably familiar.

Vasiliev seems to seek a middle ground here between the known and the strange. In this respect *In the Crimean Mountains* does not conform to the kind of imperial discourse described by Edward Said and others as legitimizing and empowering the idea of the West by defining and producing a distinct East. Insofar as Russia engaged in this orientalist project, the experience of empire was a multifaceted negotiation for both colonizer and colonized. This painting makes use of the non-Russian part of the tsarist empire for Russian purposes, but those purposes seem to have less to do with establishing "western" authority than with achieving personal insight. Use of the imperial domains as spaces for reflection, personal growth, and transformation was already a common theme in Russian literature. Alexander Pushkin's experience of exile to non-Russian regions, for example, helped him extend and complicate his poetry, while the success of Leo Tolstoy's novel *The Cossacks* relied on its description of a lost and confused Russian discovering himself in the seemingly more authentic world of the Caucasus. Vasiliev similarly used the natural environment of the Crimea to confront questions of spiritual importance.

But does Vasiliev's search for higher meaning tell us anything about the painting's expression of empire? We may be tempted to find evidence in this painting that there existed a greater identity and cohesion between Russian colonists and their non-Russian subalterns than we find in western European experiences of empire (especially considering the contemporaneous image of Victorian-era British and French colonialists as staunchly European outsider elites). The painting raises the subject of Russia's own imperial history and its ultimate effect on the colonization process. Russian and foreign subjects of the empire had in common that they

stood far from the centers of state power. Lacking political influence, all subjects of the tsar were, in a sense, colonized peoples. Did similarities in Russia between colonizer and colonized breed sympathy?

Contemplation of an interesting image can raise such immensely complicated questions, but it will not decide them. Pushing the difference between Russian and Western forms of empire too far would risk overlooking the wide spectrum of possibility made available by any imperial enterprise. From another perspective entirely, we might conclude that Vasiliev's painting lacks any special understanding or sympathy for the world it depicts. The vast majority of the Russian population lived at a socioeconomic level similar to that suggested by the figures portrayed here. Leaving aside differences in dress, these Crimean peasants do not appear markedly different from the Russian peasants commonly depicted in paintings of European Russia. Educated, urban, and relatively well-off Russians like Vasiliev often represented Russian peasants as foreign, impenetrable beings. It was no stretch to turn a similar gaze on non-Russians within the empire. Perhaps the similarity between this image and that of so many landscapes of European Russia lay in a similar sense of otherness and superiority projected from center to periphery, whether that periphery was located a hundred or a thousand miles from the Russian capital. The Crimeans depicted here have their backs to the radiant distance; the Russian viewer looks straight into it.

Just as Russian travelers took advantage of warm and restorative southern climates in search of a cure for disease, *In the Crimean Mountains* offered aesthetic relief from the everyday in the otherworldly beauty made available by the existence of a large and diverse empire. Looked at this way, the painting reminds us that Russian elites enjoyed a sense of ownership over, and the ability to profit from, their imperial domains. Such a reading of Vasiliev's landscape defines the empire as a form of Russian opportunity. It conceives of the non-Russian, colonized lands as Russia's backyard. We might condemn the implicit abusiveness of this arrangement but still hope that it allowed the young Fyodor Vasiliev to die a bit more comfortably, far away from home.

NOTES—1. Further readings on this topic include Daniel Brower and Edward Lazzerini, *Russia's Orient: Imperial Borderlands and People, 1700–1917* (Bloomington: Indiana University Press, 1997); Jane Costlow, "Imaginations of Destruction: The Forest Question in Nineteenth-Century Russian Culture," *Russian Review* 62 (January 2003): 91–118; Gina Crandell, *Nature Pictorialized: The "View" in Landscape History* (Baltimore, Md.: Johns Hopkins University Press, 1993); Christopher Ely, *This Meager Nature: Landscape and National Identity in Imperial Russia* (DeKalb: Northern Illinois University Press, 2002); A. A. Fedorova-Davydov, ed., *F. Vasil'ev* (Moscow: Gosudarstvennoe izdatel'stvo izobrazitel'nykh iskusstv, 1937); Cathy Frierson, *Peasant Icons: Representations of Rural People in Late 19th Century Russia* (New York: Oxford University Press, 1993); Nathaniel Knight, "Grigoriev in Orenburg, 1851–1862: Russian Orientalism in the Service of Empire?" *Slavic Review* 59 (Spring 2000); Susan Layton, *Russian Literature and Empire: Conquest of the Caucasus from Pushkin to Tolstoy* (Cambridge: Cambridge University Press, 1994); Faina Mal'tseva, *Fedor Aleksandrovich Vasil'ev* (Leningrad: Khudozhniki RSFSR, 1986); N. N. Novouspenskii, *Fedor Aleksandrovich Vasil'ev* (Moscow: Izobrazitel'noe iskusstvo, 1991); Ilya Repin, *Dalekoe-Blizkoe* (Leningrad: Khudozhnik RFSFR, 1982); Andreas Schönle, "Garden of the Empire: Catherine's Appropriation of the Crimea," *Slavic Review* 60 (Spring 2001): 1–23; Elizabeth Kridl Valkenier, *Russian Realist Art* (New York: Columbia University Press, 1977).

2. Ivan Kramskoi, *Perepiska I.N. Kramskogo: Perepiska s khudozhnika* (Moscow: Iskusstvo, 1954), 48–49.

21

Shop Signs, Monuments, Souvenirs
Views of the Empire in Everyday Life

Willard Sunderland

For a long time the focus in Western writing on imperial Russia fell much more on Russia than on the Russian Empire. Topics with a high Russian content were the norm—the history of the Russian court or the Russian peasantry, for example—and the usual settings were Moscow, St. Petersburg, or the Slavic-dominated "Russian center." Scholars did not wholly ignore the empire's history, but they tended to treat it separately, as if it were somehow detachable from the rest of Russia's past. Questions of Russian expansion and policies toward the non-Russian peoples became the domain of "nationality specialists," while empire itself tended to be seen as a subject whose story took place somewhere far away, in the distant imperial borderlands, rather than at home in "Russia proper."

We now know—owing largely to rethinking precipitated by the collapse of the Soviet Union—that this apparently tidy distinction between Russia and the empire was largely an academic construction. In reality, Russia proper was intimately connected to the non-Russian territories that surrounded it—geographically, economically, politically—and this fact had fundamental consequences for the history of Russian society and culture. Empire shaped the literature of Alexander Pushkin and Leo Tolstoy, inspired the music of Mikhail Glinka and Alexander Borodin, added its hues and forms to Russian architecture, and insinuated itself into everything from Muscovite menus to Volga folktales. And how could it have been otherwise? Western European societies were profoundly changed by Europe's possession of colonies in Africa, the Pacific, and the Americas. How, then, could the Russians *not* be affected by their rule over places like Poland, Siberia, and the Caucasus, all of which were considerably closer and linked to Russia proper by a regular transit of people, goods, and ideas? In fact, rather than being remote, empire tended to be an ordinary, tangible presence in Russian life, something that people could see and feel directly, most obviously in the non-Russian periphery but also in the more uniformly Russian locales of the heartland.

The tremendous ethnic and religious diversity of the empire was especially visible in Russian towns. Depending on the particular confessional mix, synagogues, mosques, and Western Christian cathedrals could be seen poking into the skyline alongside Orthodox churches. Cities also offered views of non-Russian shops and businesses (German bookstores in Saratov,

for example, and Chinese warehouses in Vladivostok), non-Russian markets, and, of course, non-Russians themselves—Greeks in Melitopol, Jews in Nikolaev, Tatars in Nizhny Novgorod, Finns in St. Petersburg—many of whom, because they dressed differently from Russian city folk, provided Russians with a visual reminder of their country's multinational dimensions. Many towns in Poland, the Baltic region, and Central Asia were hardly Russian at all, because they had overwhelmingly indigenous populations, but even "white-walled" Moscow, much extolled by nineteenth-century nationalists for its supposedly pure Russian appearance, contained Tatar and German shops, Western Christian churches, and Caucasian restaurants.

In addition to offering living vistas of imperial diversity, Russian towns, both in the center and in the borderlands, were stamped with monuments that provided a more calculated sort of imperial display. Statues of conquering tsars, military commanders, and governors loomed over central squares and embankments to advertise the permanence and grandeur of Russian imperial rule. Still other monuments took the form of Orthodox churches, underscoring the close link between Orthodoxy, nationality, and Russian imperial power that was widely presumed to exist by tsarist officialdom and educated society. One monument of this sort was the Memorial to the Fallen Warriors (Pamiatnik pavshim voinam) built in the central Volga town of Kazan in 1823. Designed in the then fashionable shape of a pyramid topped with a large golden cross, the memorial amounted to a church whose central nave stood over a deep crypt containing what were claimed to be the remains of Muscovite boyars killed during the Russian conquest of the town in 1552.[1] Kazan had been the capital of a rival Muslim Tatar khanate, and in the early nineteenth century it was still home to a large number of Muslims, most of whom lived in the Tatar quarter (*tatarskaia sloboda*), just to the west of the monument. The Kazan pyramid, in part because of its location near the Tatar quarter, represented an evocative visual reminder of Russia's power over the "Muslim East." For close to a century, it served as a symbolic center for the town's Russian community and became an obligatory stop for visiting dignitaries and tourists.

The empire was on display not only in the cities, however. Cultural panoramas in the countryside could be just as diverse. In parts of the Urals, the Amur region, and the Crimea, for example, Russian and non-Russian villages succeeded one another along postal roads or riverbanks. In other regions, like the Middle Volga, individual settlements could themselves be ethnically mixed, with Russian peasants grouped in huts at one end of the village and Tatars, Maris, Chuvash, or Mordvins at the other. The differences between villages in such locales were hard to miss and were invariably stressed by passing observers and provincial officials. As one high-minded commentator noted after visiting a particularly diverse district near the Sea of Azov in 1816, "The view of all these [non-Russian] settlements, combined with those of the various surrounding Russians, offers a tableau of contrasts that is edifying to both the statesman and the philosopher."[2] Local residents, even those who were not statesmen or philosophers, saw these contrasts as well and relied on them to help structure their interactions with their various neighbors.

Even rural people who did not live in ethnically diverse areas were exposed to visual reminders of empire as part of their daily life. By the late nineteenth century, peasants in central Russia with access to illustrated broadsheets and magazines would tear out scenes depicting the

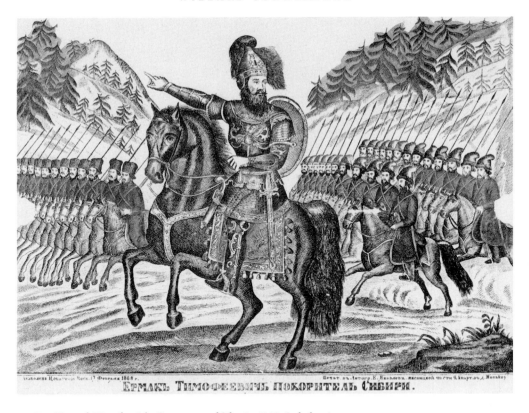

21.1. *Yermak Timofeevich, Conqueror of Siberia*, 1868. *Lubok* print.

conquest of Central Asia or the building of the trans-Siberian railroad and hang them on the walls of their huts. Earlier still they did the same thing with woodblock prints (*lubki*) many of which displayed episodes or personages related to Russia's imperial past. The *lubok* titled *Yermak Timofeevich, Conqueror of Siberia* is one example of this type of popular imperial imagery (fig. 21.1). Yermak, the Cossack leader whose forces defeated the western Siberian Khanate of Kuchum and claimed the territory for Moscow in the late sixteenth century, is pictured here as a shining conquistador, armed with sword, shield, and pistol, pointing the way forward to his ranks of well-organized cavalry. Almost nothing about this image is factually correct, least of all the title, because Yermak's defeat of Kuchum amounted to much less than the complete conquest of Siberia. But the print eloquently reflects the bold, martial image of the empire that often appeared in art produced for peasant consumers.

Visual evidence of the empire was even more commonplace in the material culture enjoyed by the educated classes. As Russian high culture grew increasingly westernized following the reforms of Peter the Great in the early eighteenth century, educated Russians, imitating their counterparts in Europe, developed a vivid ethnographic imagination, which they showed off in multiple ways. Depending on taste and the depth of their pocketbooks, Russian magnates bought Caucasian and Central Asian rugs for their sitting rooms, commissioned canvases of

imperial art to hang in their vestibules, and collected maps of the empire and volumes of ethnographic drawings to display in their libraries. Some noble eccentrics enjoyed the chic of going native and dressing up as local non-Russian peoples, while more ordinary Russian tourists traded ethnographic postcards bought on their excursions to the Crimean coast, Finland, or the spas of the Northern Caucasus. The empire could even appear in children's games. In the early nineteenth century, for example, decks of playing cards portrayed outline maps of the empire's provinces along with colorful ethnographic portraits of regional types so that Russian children could enjoy a visual tour of their country whenever they sat down for a "wonderful and edifying" game of solitaire (fig. 21.2 [color section]).[3]

The presence of such imperial themes in Russian material culture reflected educated society's simultaneous preoccupations with beauty and social status. Colorful drawings of "savage" peoples or objects of native art were at once exotic and intriguing, and to display them was a statement of prestige for their owners. But the possession of these objects also expressed educated Russians' pride in the enormous expanse and cultural diversity of their empire, attributes that were much touted in Russian writing. The self-conscious display of empire in everyday life was thus a way for educated Russians to signal their own national distinctiveness, both to themselves and to others. Porcelain figurines of the empire's peoples are among the most obvious examples of this sort of imperial souvenir. The first collection of ethnic figurines was commissioned by Catherine the Great from the Imperial Porcelain Works in St. Petersburg in the 1790s, and individual statuettes were subsequently used as official gifts for ambassadors and delegations into the early 1800s. Later, as technological enhancements made porcelain products more affordable, figurines of this sort were reproduced in larger numbers to reach wider audiences and could eventually be found in many fine Russian homes. The lively and exquisitely painted figures shown here, represent ethnic Russians as well as types from Siberia drawn from a series produced in the early 1900s (figs. 21.3–21.4 [color section]).[4]

These porcelain miniatures, like many of the other physical embodiments of empire that circulated in Russian life, are interesting, even beautiful artifacts, but they are arguably most important for what they reveal about a side of Russia's imperial past that is often overlooked by historians. For millions of Russians in the tsarist era, the experience of empire was not an issue of understanding or even knowing about formally articulated state policies and ideologies. Instead, it was a matter of the senses. More often than not, Russians recognized and appreciated the realities of empire not because they read about them but because they could see and feel them in everyday life. Travel to the non-Russian borderlands was not necessarily required. Visual reminders of the size, diversity, history, and present power and challenges of Russia's imperial condition were common—as close and as ordinary as the monument down the street or the lubok nailed to the wall of the village tavern. Today this everyday visual context has largely slipped from our view, but in its time it helped make the empire into an integral element of the Russian experience.

NOTES—1. On the history of the Kazan monument, see "O sooruzhenii pamiatnika v chest' ubiennykh pri pokorenii Kazani voinov," *Zavolzhskii muravei* (1833), pt. 2, no. 13, pp. 721–45; A. Artem'ev, "Pamiatnik v chest'

voinov pavshikh pri vziatii Kazani," *Kazanskie gubernskie vedomosti* (1843), no. 40, pp. 231–35; and Il'dus Zagidullin, "Prazdnovanie v Rossii pokoreniia Kazani vo vtoroi polovine xvi-nachale xx v.," in *Kazanskoe khanstvo: aktual'nye problemy issledovaniia* (Kazan: Fen, 2002), 26–45. Pyramids became especially popular in European art following Napoleon's Egyptian expedition in the late eighteenth century. See Peter A. Clayton, *The Rediscovery of Ancient Egypt: Artists and Travellers in the 19th Century* (London: Thames and Hudson, 1982).

2. Prince de Gouroff, *De la civilisation des tatars nogais dans le midi de la Russie européenne* (Kharkov, 1816), 12.

3. For the quotation and for examples of these cards, see *The State Museum-Preserve Peterhof: Playing Cards; The Collection of Alexander Perelman, New Accessions, 2000–2002* (St. Petersburg: Abris Art, 2002), 76–77.

4. On porcelain figurines, see Karen L. Kettering, "The Russian Porcelain Figure in the Eighteenth and Nineteenth Centuries," *Magazine Antiques* (March 2003), http://findarticles.com/p/articles/mi_m1026/is_3_163/ai_98641327.

2.2. Gospel manuscript, on paper, from the third quarter of the 16th century. The wax spots reveal reading practices that might otherwise have remained hidden.

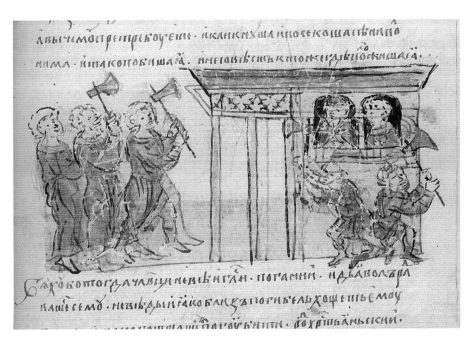

3.1. Illustration in the *Radzivill Chronicle*, 15th century, depicting an attack in Kiev in 983 by pagan Varangians on a Christian landsman in his Byzantine-style house.

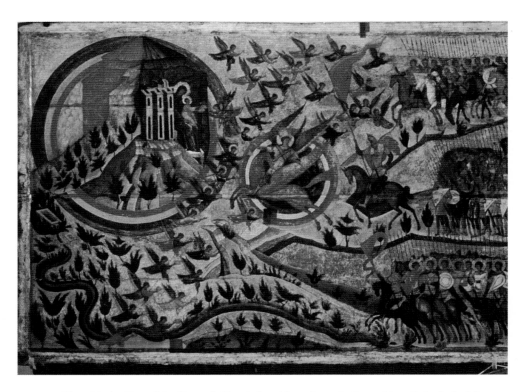

6.1. *Blessed Is the Host of the Heavenly Tsar.* Painted icon from the Dormition Cathedral of the Moscow Kremlin, 1550s.

МНОЖЕСТВОДШЕ ХРТЬЯНЬСКИ Ѡ ПОЛОНИѢ · ИВРАТИ
ШАШ ПЕРЕМ СЛАВЛЬ · ХВАЛА БА Ѡ ТАКОВЫИ ПОМОЩИ ПО
ЛОМЬ Ѡ ПОУГ ТИН ВАРОЖЕН ЕСКОБ; ⁊

ОБ ЖЕ ГИМЫ ПРЕСТАШИ ВОЛОДИ МИРКО · ГАЛИЦКИИ ЕСНЪ ·
ЛБѢ Ѕ ⁊ А ПОСЛАН ЗАСЛАВЪ СНАСВОЕ МСТИСЛАВА НАПО

3.2. Illustration in the *Radzivill Chronicle* depicting the Rus attack on the nomadic Qipchaks in 1152 and showing the Qipchaks in a Rus-style farmstead.

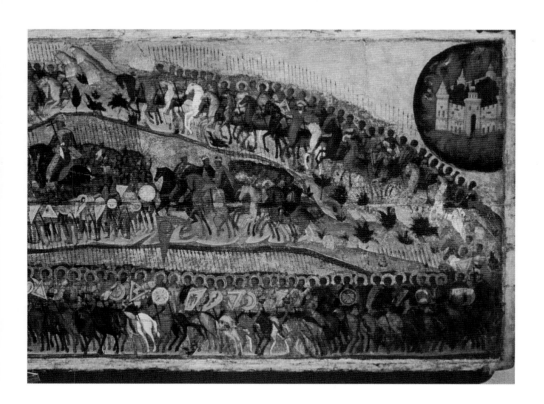

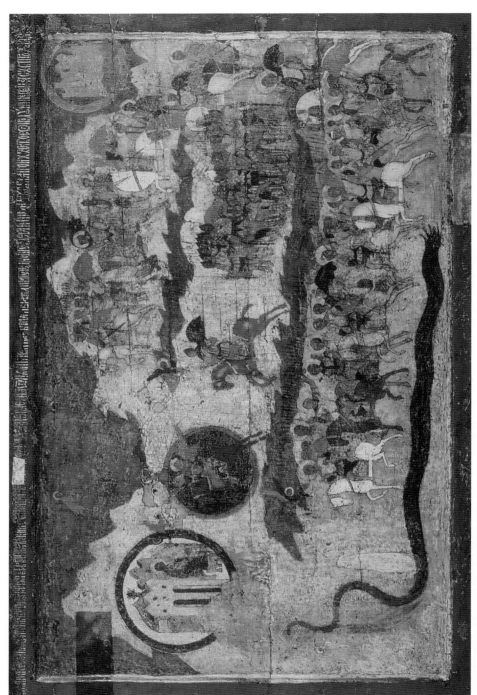

6.3. *Blessed Is the Host of the Heavenly Tsar*, 16th-century copy.

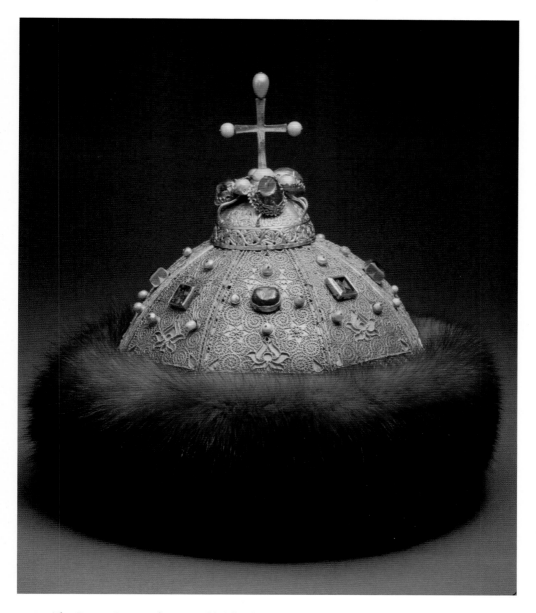

7.1. The Cap, or Crown, of Monomakh (Shapka Monomakha).

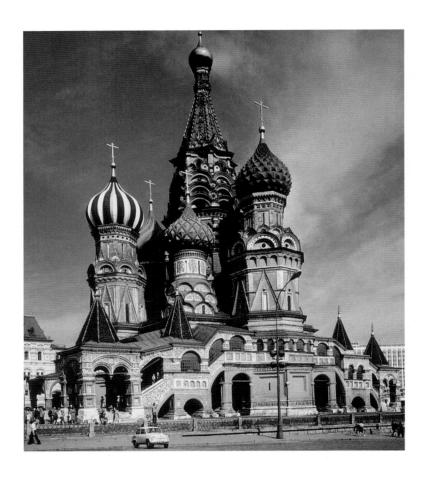

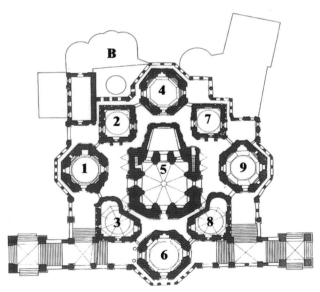

8.1. Church of the Intercession on the Moat / St. Basil's Cathedral,
Red Square, Moscow, 1555–61. Northwest elevation and plan.

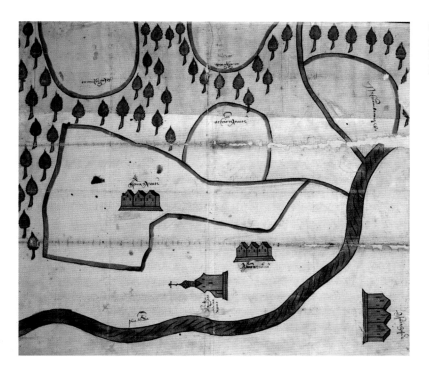

9.1. Property map from Gorotsk District, Uglich Province, 1678.

9.2. Property map from Elets Province, late 1680s.

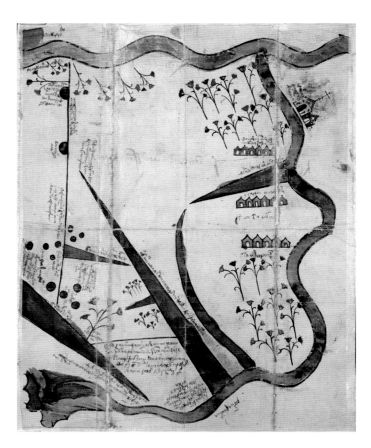

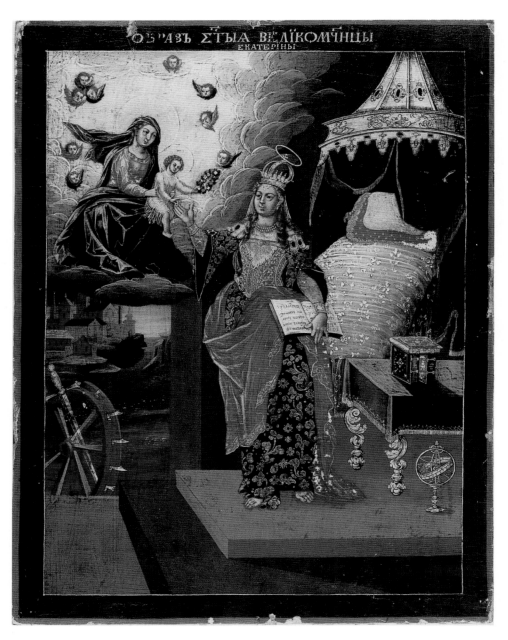

12.1. *St. Catherine of Alexandria*, 1721. Painted icon from the Alexander Nevsky Monastery in St. Petersburg.

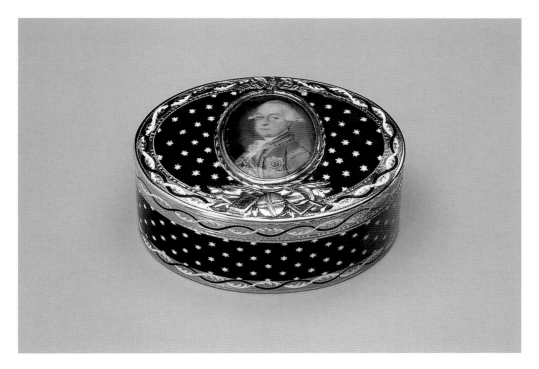

13.1. Snuffbox with a portrait of Field Marshal Zakhar Chernyshev, 1773. Russia: St. Petersburg. Attributed to Georg Kuntzendorf, after Alexander Roslin. Gold, silver, enamel, four-color gold; miniature (on copper?). H. 1⁷/₁₆ in., w. 3¼ in., D. 2½ in.

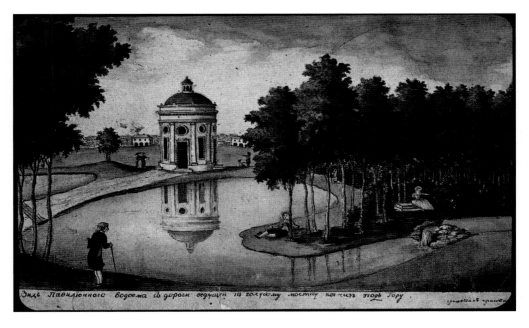

14.2. *View of the Pavilion Reservoir from the Road Leading to the Blue Footbridge and Downhill* from Andrei and Pavel Bolotov's album of watercolors (1786) depicting various scenes at Bogoroditsk.

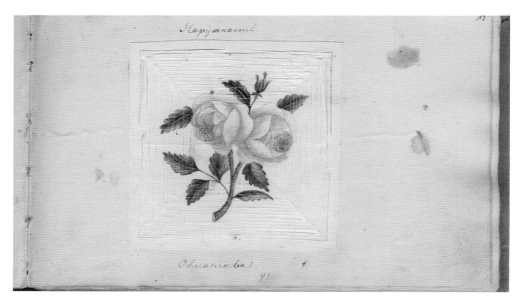

14.3. Watercolor rose from Bolotov's domestic album (closed view).

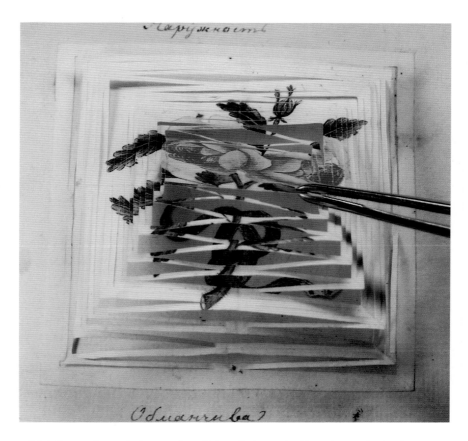

14.4. Serpent beneath the rose from Bolotov's domestic album (open view). The text reads: "Appearances are deceiving."

15.2. Merchant with abacus, 1840s. Painting by an unknown artist.

15.3. Merchant in uniform, 1840s. Painting by an unknown artist.

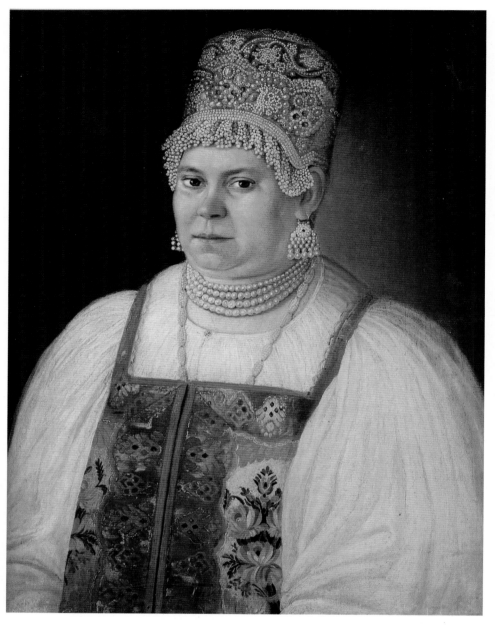

15.4. Portrait of a merchant wife with a pearl necklace, 1820s. Painting by an unknown artist.

16.1. Karl P. Beggrov, *The Mikhailovsky Palace*, 1825. Watercolor.

17.1. Alexander Ivanov, *Appearance of Christ to the People*, ca. 1858. Painting.

19.1 Yakov Yarygin, Distaff blade with spinning scene and journey, Borok area, Arkhangelsk Province, early 19th century.

19.2 Lazar Melnikov, Distaff base, Gorodets, 1866.

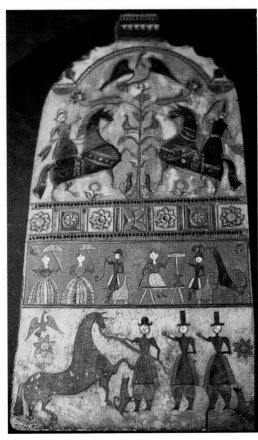

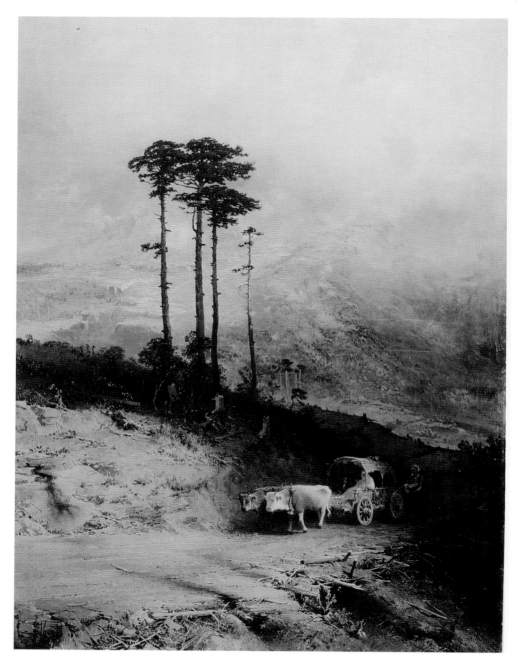

20.1. Fyodor Vasiliev, *In the Crimean Mountains*, 1873. Painting.

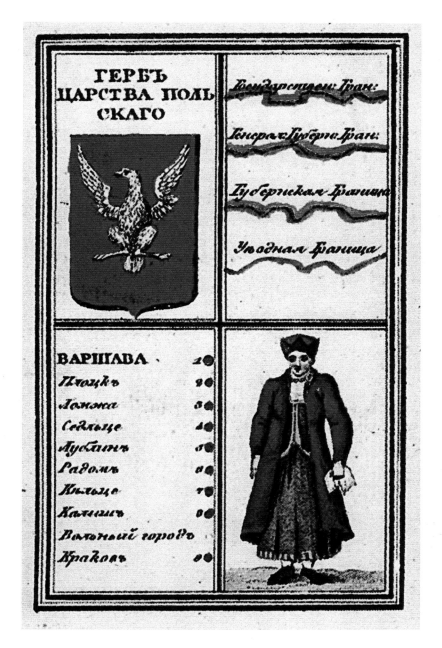

21.2. Playing card, 1830, showing the official emblem of tbe Kingdom (Tsardom) of Poland and a Pole in national dress and listing the major cities and boundaries.

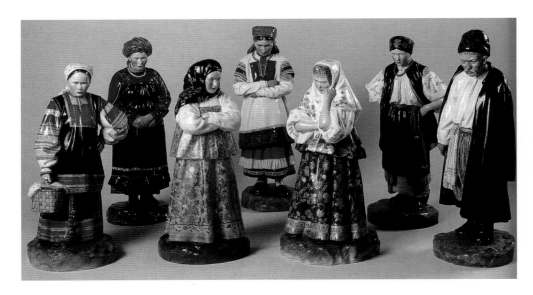

21.3. *The Russians*, porcelain figurines from The Peoples of Russia series, 1909–13.

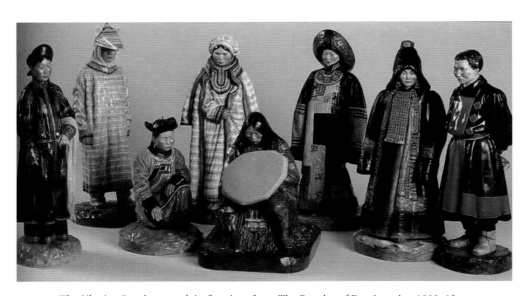

21.4. *The Siberian Peoples*, porcelain figurines from The Peoples of Russia series, 1909–13.

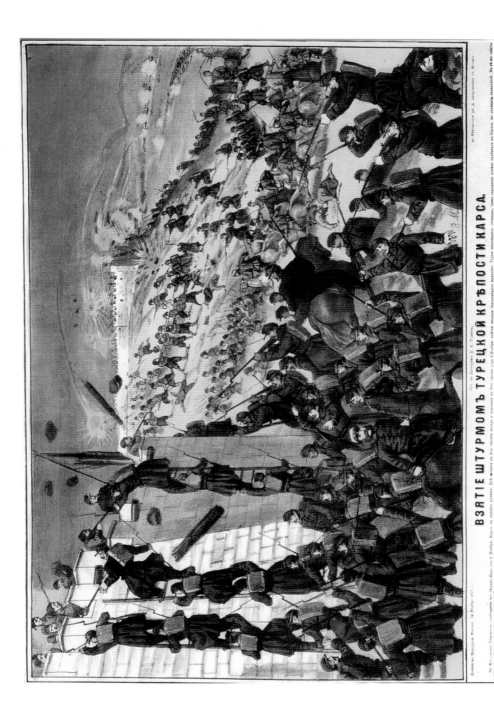

22.1. *The Storming of Kars*, 1878. *Lubok* print (colored lithogrpah).

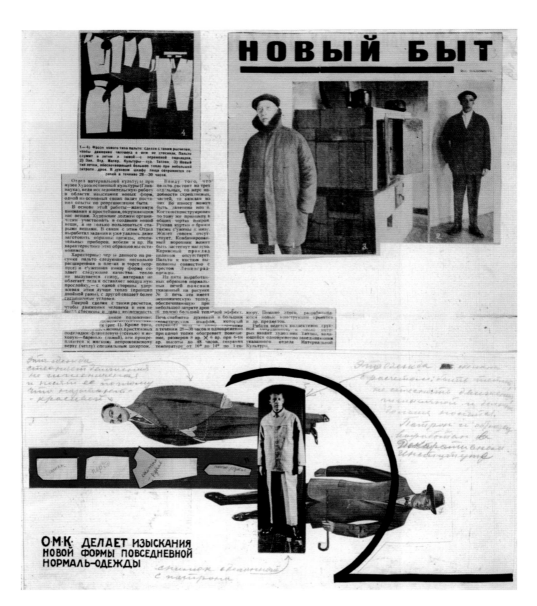

30.1. Vladimir Tatlin, Montage incorporating the article "The New Everyday Life," 1924–25.

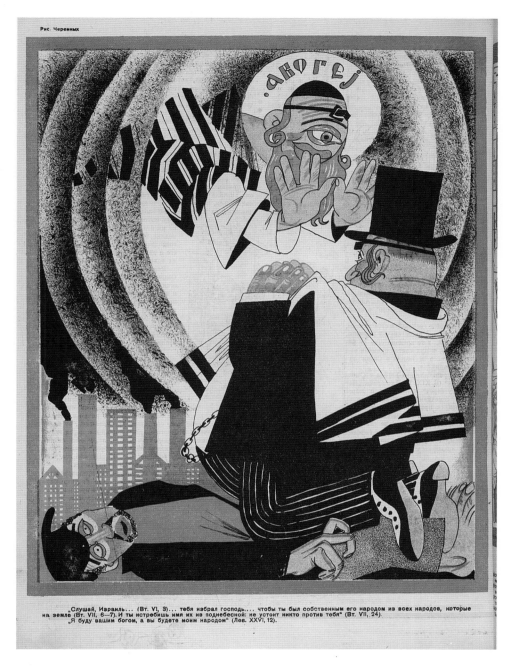

„Слушай, Израиль... (Вт. VI, 3)... тебя избрал господь.... чтобы ты был собственным его народом из всех народов, которые на земле (Вт. VII, 6—7). И ты истребишь имя их из поднебесной: не устоит никто против тебя" (Вт. VII, 24).
„Я буду вашим богом, а вы будете моим народом" (Лев. XXVI, 12).

31.2. Hear, O Israel. Anti-Semitic cartoon from *The Godless at the Workbench* (1923). The text reads: "Hear, O Israel . . . (Deut. 6:3) . . . The Lord has chosen you out of all the peoples on earth to be his people (Deut. 7:6–7). And you shall blot out their name from under heaven; no one will be able to stand against you (Deut. 7:24). I will be your God, and you will be my people (Lev. 26:12)."

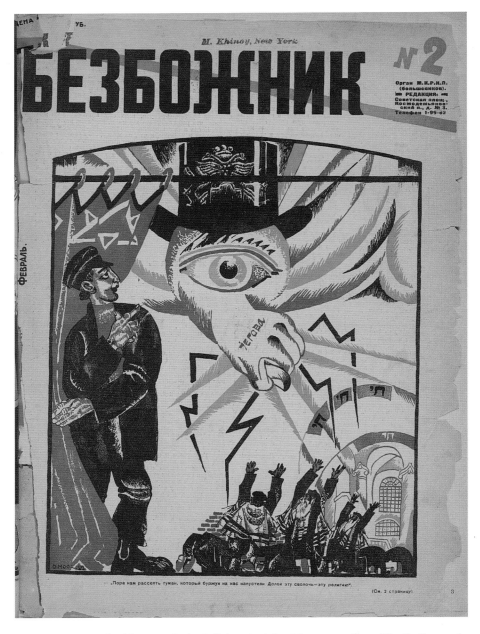

31.3. *Down with This Bastard of a Religion.* Anti-Semitic cartoon from *The Godless at the Workbench* (1923). The text reads: "Now is the time to clear away the fog that the bourgeoisie set upon us. Down with this bastard of a religion."

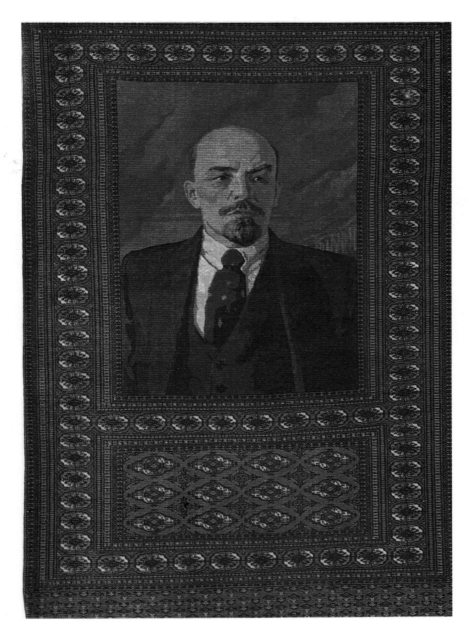

36.1. *Portrait of Lenin.* Carpet by Durdygozel Annakulieva, Aili Taganmuradova, and Nabat Khodjamova, Honored Carpet Makers of the Turkmen Soviet Socialist Republic, Ashgabat, 1955.

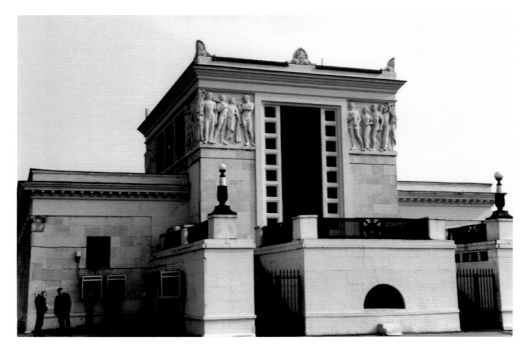

37.1. Dynamo metro station (exterior), 1938. Architect, Dmitry Chechulin.

37.3. Alexander Samokhvalov, *Female Metro Worker (Me-trostroevka) with a Drill*, 1937. Painting.

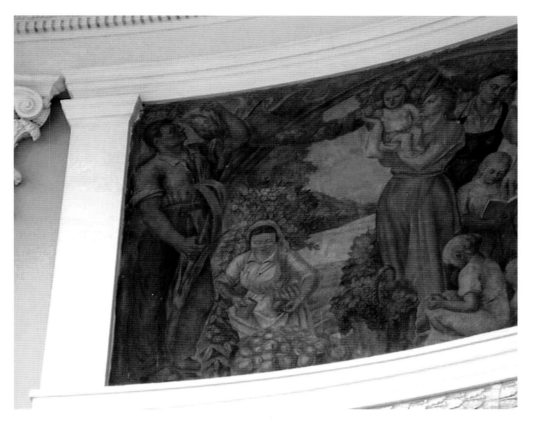

38.4. Mural (detail), All-Union Agricultural Exhibition. Through art, the fusion of socialist abundance with beauty; the fusion of the spectator with "life itself." Photograph by Sergey Nemanov.

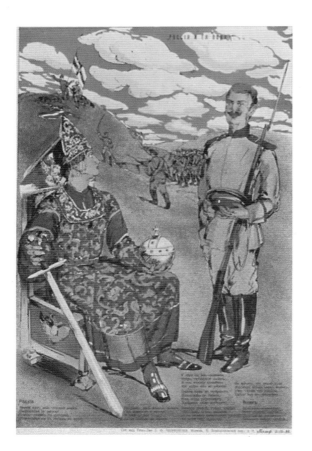

39.1. *Russia and Her Soldier.*
Russian World War I poster.

39.2. I. M. Toidze,
*The Motherland-
Mother Calls*, 1941.
Russian World War II
poster.

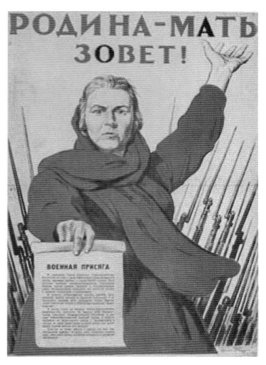

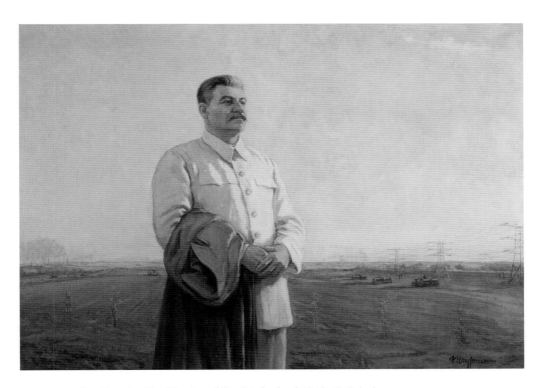

42.1. Fyodor Shurpin, *The Morning of Our Motherland*, 1946–48. Painting.

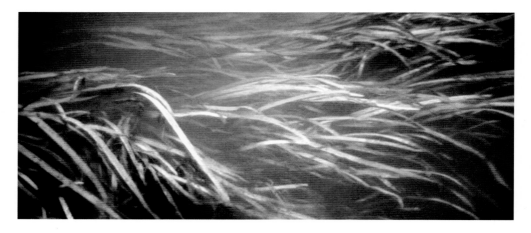

45.1. Underwater reeds in *Solaris* (1972), directed by Andrei Tarkovsky. Film frame capture.

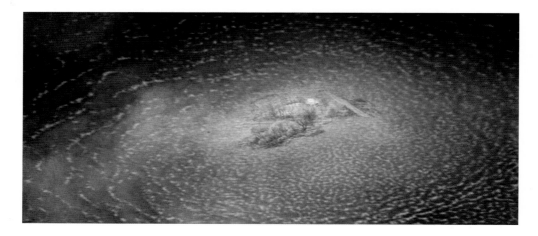

45.2. Solaris Ocean with newly formed islands in *Solaris*. Film frame capture.

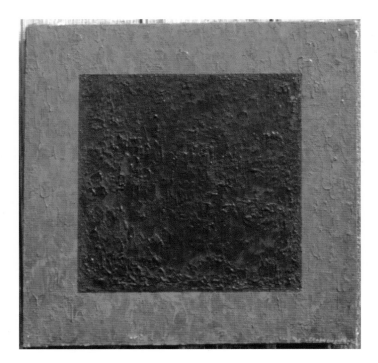

46.3. Igor Makarevich, *Green Square*, 1989. Encaustic on linen.

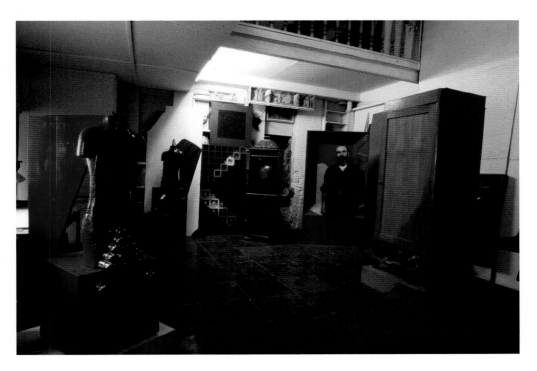

46.4. Igor Makarevich, Photograph of the artist's studio on Bolshaya Bronnaya Street, Moscow, 1989.

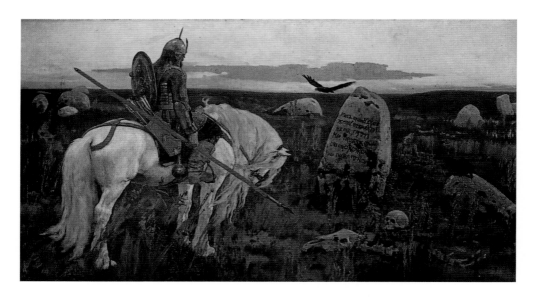

49.1. Viktor Vasnetsov, *The Warrior at the Crossroads*, 1882. Painting.

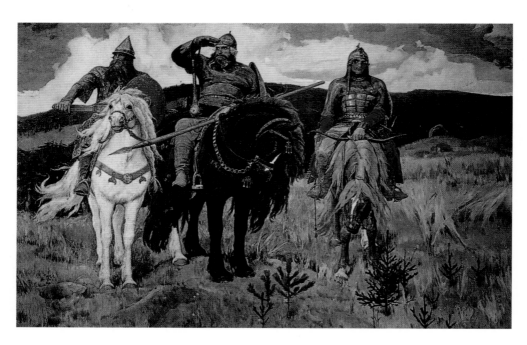

49.2. Viktor Vasnetsov, *Bogatyrs*, 1898. Painting.

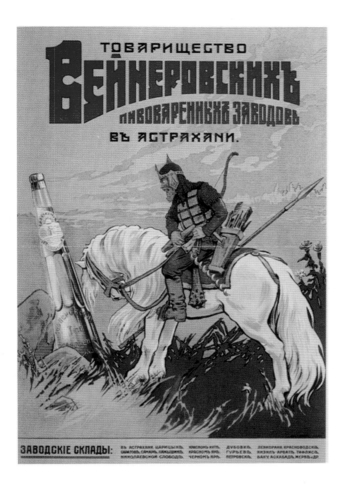

49.4. Prerevolutionary advertisement for Weiner Brewery in Astrakhan, based on Vasnetsov's *The Warrior at the Crossroads*.

49.6. Post-Soviet cigarette box featuring Vasnetsov's *Bogatyrs*.

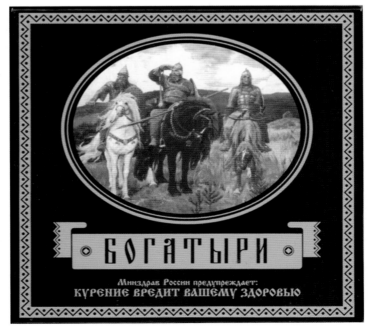

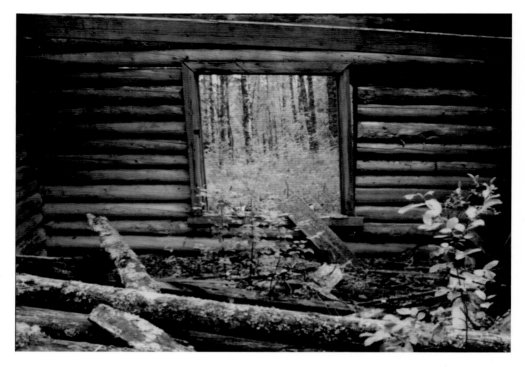

50.2. Window looking out on the birch forest at the site of the former White Sea–Baltic Canal prison, 2001. Photograph by Michael Kunichika.

22

The Storming of Kars

Stephen M. Norris

With war raging in the Balkans between Russia and the Ottoman Empire in 1878, the peasants of Batishchevo, near Smolensk, enthusiastically received a visit from a peddler. The visitor, Mikhaila, carried with him images of the war to sell to the peasants, many of whom had relatives and friends fighting. To entice his customers, Mikhaila pulled a few of his favorite images from his collection and told his eager audience about their contents: "'Here you have,' he explains to the *babas* and day laborers who have gathered around him in the dining room, 'here you have Skobelev, the general, he took Plevna. Here's the same Skobelev standing and pointing to the soldiers with his finger so that they'll run faster to take the gates to Plevna. Here, you see, are the gates, here are our soldiers running. Here they're taking the Osman pasha by their hands—look how he's hunched over!'"

Given the long, bloody struggle to take Plevna, the Turkish fortress, as well as the heroic deeds of General Mikhail Dmitrievich Skobelev, who became a revered figure throughout Russia during the war, Mikhaila's choices proved to be good ones. The peasants of the region eagerly awaited news from the front and discussed the war with great interest. The Russian owner of Batishchevo, Alexander Nikolaevich Engelgardt, had been so surprised that the peasants who lived near his estate seemed interested in the war that he wanted to find out how they obtained their news. He discovered that they did so in part through pictures, and through the scene he witnessed with Mikhaila, which he later published in his *Letters from the Country*.[1]

Engelgardt's *Letters,* published between 1872 and 1887, contain invaluable insights into the workings of the Russian post-emancipation village. Engelgardt, sentenced to internal exile at his family estate, set out to record events in his region for the Russian public. Although most of his letters dealt with the problems of the Russian peasantry and the difficulties of gentry-peasant relations, his sixth letter gave his impressions of the impact of the Russo-Turkish War (1877–78). The whole district, according to Engelgardt, became acutely interested in the events of the war. At one point, the wife of Engelgardt's steward burst into his study and announced, "We've taken Plevna!" obviously joyous at the news. When Engelgardt inquired how she knew of Plevna's conquest, he encountered Mikhaila and his pictures. He observed that "Mikhaila knows all the pictures in great detail, and just as he previously explained the merits of his cottons and scarves [the same peddler had appeared earlier in the war with patriotic scarves], so he now describes his pictures."

Engelgardt may have been surprised by the extent to which Russian peasants understood historical events through popular prints, but the Russian form of image known as the *lubok,* the type that Mikhaila attempted to sell to his audience, had established itself by 1877 as an important information source for illiterate and barely literate Russians. These popular prints, as Jeffrey Brooks has written, can best be described as lively illustrations similar to posters or European broadsides with short texts, usually at the bottom of the picture. The term itself, as well as its adjective, *lubochnyi,* derives from a Russian word meaning "bast," which is the soft layer of wood taken from trees in the spring, then used to make baskets, shoes, and other containers. In early modern Russian culture, artists often used pieces of bast in place of expensive parchment, and thus the crude woodcut images painted on them became known as *lubochnye kartinki,* or "bast pictures." Russians eventually came to refer to these cheap prints as lubki and even as *narodnye kartinki,* or "popular pictures." Originally produced as cheap icons in the seventeenth century, the lubok was transformed by Peter the Great's reforms (reigned 1682–1725). Beginning with Peter, lubki illustrated government reforms, folk-tales, and historical events.

By the turn of the nineteenth century the lubok had established itself as an important medium for understanding Russian national identity and wartime culture. Prior to 1812, Russian elites and artists had started to form a sense of national consciousness. Over the course of the eighteenth century, antipathy toward foreigners (particularly the French and their manners, which many Russian elites embraced), beliefs that authentic Russianness lay in the peasant village and the Russian soul, a renewed interest in national mythology and history, and a belief that Russia possessed its own national character developed among Russian artists and cultural figures. It took an event like Napoleon's invasion, however, to crystallize this early national consciousness. The war against Napoleon and the emotions that it produced led to a proliferation of the lubok—more than two hundred images appeared between 1812 and 1814. The growth of a national identity and the growth of the lubok as a form of Russian popular culture paralleled each other, and when war began in 1812, the two developments came together.

At the time of the Russo-Turkish War, lubok publishing had developed into a major cottage industry centered in Moscow. The success of the 1812 images, combined with the introduction of the lithographic process in nineteenth-century Russia, led to the explosion of the lubok business. Publishers such as Peter Sharapov ran shops in Moscow and employed hundreds of workers, including peasant women who colored prints, apprentices who helped produce the images, salesmen who set up booths at major fairs, and peddlers who bought prints from the publishers and sold them throughout Russia. Mikhaila, the traveling salesman that Engelgardt observed in Batishchevo, represented one aspect of a major industry that catered to Russians from all walks of life.

When Mikhaila displayed his prints on that day in 1878, he said, pointing to an image titled *The Storming of Kars,* "Here our soldiers are taking Kars; do you see how our soldier has seized the Turkish flag?" Engelgardt spoke up, saying that the two-headed eagle flag held by the soldier on the wall of the fortress was the Russian imperial standard. Mikhaila replied, "No, it's the Turkish flag. You see, there's an eagle drawn on it, and there'd be a cross on the Russian one" (figs. 22.1 [color section] and 22.2).

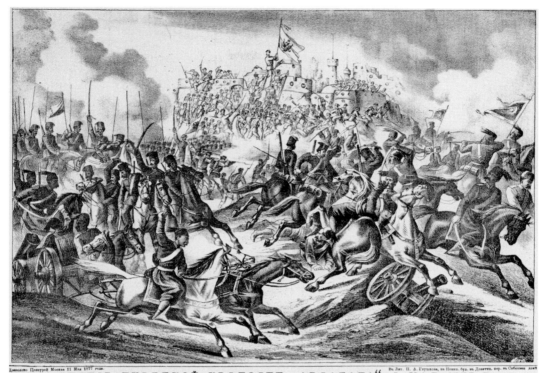

Домашнее Цензурой Москва 11 Мая 1877 года.

ВЗЯТІЕ ТУРЕЦКОЙ КРѢПОСТИ „АРДАГАНА" 5 МАЯ 1877 Г.

22.2. *The Capture of the Turkish Fortress of Ardahan,* ca. 1878. *Lubok* print. The imperial Russian double-headed eagle banner is recognizable.

Engelgardt's account is a wonderful window into how the Russian peasantry viewed the wartime lubki, as well as the role the images played in inspiring the countryside to follow the events of the conflict. Engelgardt expressed doubt about the ability of the peasants to understand the war and later wrote that the peasants believed in rumors about the conflict that were inspired in part by the images. "Knowing how ignorant the peasants are, knowing that they do not possess even the most elementary geographic, historical, and political knowledge . . . you cannot imagine that these people could have any kind of comprehension of current political events." Further, "It seems unlikely that one would be interested in something one does not know, that one could sympathize with the war, understand its significance, when one does not know what Tsargrad [the Russian name for Constantinople] is." To this member of the gentry class, the ignorance of the Russian peasantry about the historical background of the war and its aims excluded them from grasping its true significance.

Yet we could look at the information presented by Engelgardt in a less patronizing way. Engelgardt never doubted that the peasants and villagers in his district expressed a great deal of interest in the war and continued to follow its events, but he clearly responded differently to lubki depicting those events. Mikhaila's belief that a Russian flag should have a cross on it

indicates that he conceived of himself as Russian and that this identity revolved around the Orthodox religion, a point stressed in the war imagery of the time. His lack of knowledge about the double-headed eagle might indicate that this symbol of Russian identity had less resonance for him than the religious imagery also present in the wartime lubki. In fact, the peasant's view may have been more accurate about the meaning of the double-headed eagle—Russian troops went into battle with regimental flags, not with the imperial standard. Engelgardt believed that he understood the iconography of the wartime imagery correctly, but his peasants knew differently. After all, they had to supply the troops for the army and thus knew far more about its workings.[2] At the same time, several wartime prints titled *The Storming of Kars* (as well as images that depicted the storming of such other fortresses as Ardahan and Plevna) featured Russian troops placing the imperial standard on top of Turkish fortresses. Other images depicted Russian troops taking down Turkish flags, while some (including fig. 21.1) were more difficult to read clearly.

Far more instructive in the encounter between the peddler and the landowner is Mikhaila's ability to view himself and his audience as Russian. Peddler and peasants alike had a sense of patriotism and a clear ability to view the Turks as non-Orthodox—and thus non-Russian. Mikhaila's tales of Skobelev's heroism prompted the peasants to later ask him to join them in a toast to the White General. By displaying a keen interest in the war and its events, gathering in the local tavern to discuss their views, and buying Mikhaila's lubki, the peasants of Batishchevo showed that they grasped the basic patriotic views depicted in the popular prints, however different their understanding was from Engelgardt's.

Engelgardt's and the peasants' encounter with *The Storming of Kars* demonstrates the power that visual sources had in imperial Russia. The "act of eyewitnessing," to borrow a term used by Peter Burke, that Engelgardt recorded suggests that Russians from two very different worlds had different views of what it meant to be Russian. Even though Engelgardt and Mikhaila disagreed about what a Russian flag should have on its field, both were able to use an image to think about their sense of national identity. The lubok in particular, as B. M. Sokolov has argued, represents a multifaceted art form, and its importance rests on the openness of interpretation that each image contains. Pictures such as *The Storming of Kars* can show us how national identities are constructed and contested according to the visual worlds in which their audiences live.

NOTES—1. *Aleksandr Nikolaevich Engelgardt's Letters from the Country, 1872–1887*, ed. and trans. Cathy Frierson (New York: Oxford University Press, 1993), 138. The letter originally appeared in *Otechestvennye zapiski* (March 1878): 5–42. All quotations involving Mikhaila the peddler and Engelgardt are taken from this source.

2. I thank Dominic Lieven for bringing this information to my attention.

23

A. O. Karelin and Provincial Bourgeois Photography

Catherine Evtuhov

"Photographs really are experience captured," writes Susan Sontag in her essay "On Plato's Cave."[1] The photographic medium came into its own in the 1870s and 1880s, as technologies became sophisticated enough to experiment, and photographers developed philosophical perspectives on whether their pursuit served the interests of science or of art, or whether indeed photography could become one or the other. The high point in the career of Andrei Osipovich Karelin (1837–1906) came in precisely this period. From 1866 he lived and worked in the provincial town of Nizhny Novgorod, perhaps best known for its yearly trade fair—the biggest in Europe—which made it a point of convergence for East and West. The province's dense forests were also home to many adherents of the Old Belief, as well as to Tatars, Mordvinians, Chuvash, and Cheremiss (Mari). The images presented here are taken from a book of Karelin's photographs, *Art Photography of Life Subjects* (*Khudozhestvennyi al'bom fotografii s natury*), produced in Nizhny Novgorod in the 1870s–80s. Karelin actually took his camera inside the bourgeois household, capturing on film images of families, ladies distributing charity, girls in conversation, loving couples, and other domestic scenes. It is immediately obvious that the pictures are the opposite of "candid" shots: they are painstakingly planned, carefully posed, and elaborately arranged. What, then, is the value of Karelin's images as "experience captured"? Can they function as visual evidence attesting to elements of provincial life in late nineteenth-century Russia?

Even if photographers differed on the question of whether their medium could become an art, Karelin clearly saw himself as an artist and at least some of his photographs as works of art.[2] Trained as an icon painter in his youth, in his native Tambov Province, Karelin received his academic education at the St. Petersburg Academy of Fine Arts; it was there that he discovered photography, or "light-writing" (*svetopis'*). His studio in Nizhny Novgorod bore the title Studio of Photography and Art, and in addition to doing his photographic work, he ran a drawing school. His student F. A. Fomin remarked on Karelin's profound knowledge of the Old Masters and his constant references to their work.[3] Karelin's studio produced the requisite cartes-de-visite and portraits of local notables (some of which won prizes at Paris, Philadelphia, and Edinburgh); the repertoire included ethnographic subjects, landscapes, and views of Nizhny

Novgorod and the fair. I would like to suggest that the photographs included in the *Life Subjects* album are among his most ambitious as art. The very title (*s natury*) refers to painting in which the artist takes his subject from a real-life model. Curiously, at a time when "realistic" photography sought above all to hasten the picture-taking process, Karelin worked on and perfected what he called a "soft" method (following a Frenchman, Desnières or Denier, who worked in Russia), which required the taking of not one but two shots in close succession.[4] The sitters, in other words, had to remain absolutely frozen in their poses during and in between both shots in order not to distort the final image. There can be no question of spontaneity here.

The photographs' proximity to painting has another significant dimension. Unlike portraits, whose goal is to capture the specificity of individual traits, Karelin's pictures portray, rather, a situation. They are genre scenes in which the characters remain anonymous—even though the real-life subjects would naturally recognize themselves. Their publication in a book, rather than their consumption by individuals commissioning their own portraits, enhances the impersonal element. *Family in a Suite of Rooms* depicts a family engaged in leisure pursuits. They are surrounded by the symbols of industriousness, learning, and culture in the form of a sewing machine, a thick book, and a Greek statue (fig. 23.1). *A Scene at the Window* portrays another family (with the artist himself filling the male role) gazing in fascination at a street musician and his companion while busying themselves with reading materials—perhaps an illustrated journal (fig. 23.2). In both cases, the point is to re-create a way of living and being, rather than to portray the particular sitters in order to satisfy their own curiosity about themselves. It is an original genre that has been called "photographic painting," with the goal of "transforming domestic scenes into something meaningful and interesting for everyone."[5] Karelin's art consciously "elevates" and conceptualizes his subject matter. It is worth noting that Karelin's innovations in photography as painting echoed similar efforts by figures in France and England like Nadar (Gaspard Félix Tournachon, 1820–1910), William Lake Price (1810–96), Oscar Rejlander (1813–75), James Elliott (1835–1903), and Henry Peach Robinson (1830–1901). The staging of bourgeois domestic scenes for artistic portraits was a Europe-wide practice.

But does Karelin's artistic intention make the content of his photographs any less "real"? What can we learn about his subjects and the social universe they represent? I would contend that the very care with which the photographs are constructed tells us as much about the provincial world in the late nineteenth century as, or even more than, a hypothetical spontaneous image would. Karelin works with poses and expressions, clothing, frames, and "attributes"— the paraphernalia surrounding the subjects—to create a nuanced and visually articulate picture of a provincial bourgeoisie. In an important 1995 article—a product of many years of collective research on the European *Bürgertum*—Jürgen Kocka proposes that we define the middle classes, first, relationally and, second, culturally. The middle classes, he suggests, gained identity by setting themselves apart from others, "developing cohesion in opposition to people above and below." This negative definition makes it easier to grasp the makeup of a social group variegated enough potentially to include "merchants, manufacturers, bankers, capitalists, entrepreneurs, and managers, as well as rentiers," and their families, and also "the families of doctors, lawyers, ministers, scientists and other professionals, professors of universities and secondary schools, intellectuals, men and women of letters, and academics." In addition, the

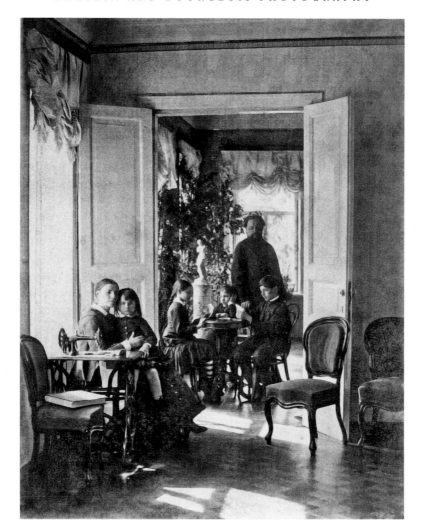

23.1. A. O. Karelin, *Family in a Suite of Rooms,* 1870s–80s. Photograph.

middle classes can be described by their adherence to a common culture. Bourgeois families in nineteenth-century Europe shared "a respect for individual achievement" and "a positive attitude toward regular work, a propensity for rationality and emotional control, and a fundamental striving for independence." The patriarchal family itself was a core cultural value, as was education; "scholarly pursuits were respected, as were music, literature, and the arts."[6] This double definition coincides with remarkable precision with the qualities expressed, through composition and arrangement, in Karelin's two photographs.

Compositionally, the effect of *Family* is linear and hierarchical, from the woman (who may or may not be the mother) and child stretching diagonally back to culminate in the father, who presides caringly over the entire scene, one hand positioned on the back of one of the children's chairs. The serious expressions, while conventional for the time, indicate more than the usual

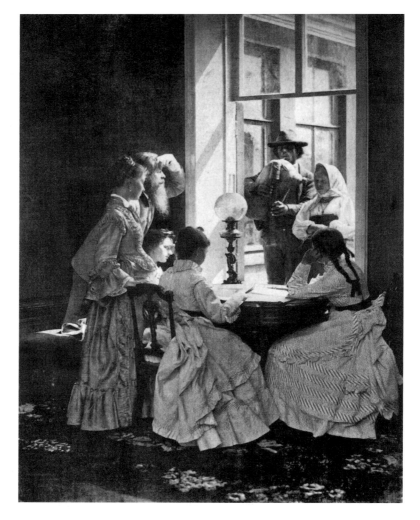

23.2. A. O. Karelin, *A Scene at the Window*, 1870s–80s. Photograph.

degree of anxiety: the woman's face in particular is careworn, while the father's is concerned. Everyone wears simple and austere clothing, cut from rough cloth. Only the Grecian statue is reminiscent of the knickknacks so typical of the studio photography of the time; and even that, like the sewing machine and the book, has symbolic value as a reference to the family's cultural status. Modern and consummately practical, the sewing machine—quite likely a Singer—replaces the idle art of embroidery, while the book underscores the value of reading and education.[7] The image tells us little about the family's actual status within the *soslovie*, or estate system; this may well be a gentry family, but the cultural values expressed are clearly middle class. In *Window*, the girls in crinolines and modest but pretty dresses contrast sharply with the visitors, with their rough faces and worn peasant clothes. Two of the girls have their backs to us, but the other family members look on with curiosity and perhaps a trace of nervousness.

Objects are scarcer here, but the floral rug, ornate chair back and table, and decorative lamp are clear marks of a bourgeois household.

In both photographs, the use of framing is particularly remarkable, and one of Karelin's trademarks. Writing in 1921, José Ortega y Gasset took the opposite view from Sontag, describing *any* photograph, or painting—in short, any work of art—as "an aperture of irreality that opens magically in our real surroundings." A key role therefore belongs to the frame, which functions as an isolating factor, delineating and setting off the imaginary world of the photograph or painting from the stark reality of the wall on which it hangs; a window can serve a similar function, dividing and delineating images.[8] In Karelin's work, windows and doorjambs frequently serve as frames, internal to the picture.[9] In *Window,* the window itself starkly places the street musicians—framed as if in their own separate photograph—in a world distinct from that of the fastidious family inside. It is practically a literal illustration of Kocka's point about delineation and delimitation. In *Family* the use of frames is more anodyne but equally effective aesthetically: the father is doubly framed by the window behind him and, together with the children occupied with their card game, by the open doorway. The cardplayers and the father form one unity, and the woman and child in the front room (also framed by the borders of the door behind them) form a second ensemble, thus perforating the linear compositional structure.

So, must we dismiss Karelin's enterprise as a mildly eccentric experiment in painting with light rays instead of oil colors, and his interpretation of provincial reality as no different from that of any other painter? I think not. An essential element distinguishes Karelin's photographs from painting and makes them uniquely valuable as a documentary source. The photographer, unlike the painter, necessarily works with elements that exist independently of his own imagination. Up to this point, I have focused primarily on the artist and his intentions. However, like Mark Steinberg's workers in suits or Deborah Poole's Andean peasants, the bourgeois families portrayed here are active participants in their own representation.[10] They have worked hard to dress appropriately, hold long poses, and arrange themselves in accordance with the photographer's scenario. It is this cooperation of artist and subject that ensures the "reality" of the images. Even in cases where the sitters are functioning as models (in some photographs, the same individuals appear in different roles, including Karelin himself), they are real people. Their job is to play themselves, not as individuals but as social types. Whatever the theatricality of the posed photographs, the subjects are not characters in a play, but dressed-up, stylized, and "more perfect" versions of their own personae. The very act of posing for the camera in a domestic setting becomes a part of bourgeois existence, and the participants must evince at least some measure of complicity in the cultural values that the photographs capture on paper.

For many decades, historians found it very difficult to talk about a Russian middle class. In a vision dominated by the Revolution of 1917, it became axiomatic that the middle classes were weak, underdeveloped, politically unsophisticated, and unable to hold their ground as radicals and revolutionaries overturned the Provisional Government and constructed a socialist state. Whatever the merits of this perspective,—and this is not the place to resolve the issue—we have, in recent times, become more interested in confronting the documentary evidence to search not only for explanations of why the empire failed but also for explanations of how and

why it worked, which it did with remarkable stability between the late eighteenth century and the early twentieth. Karelin's photographs provide invaluable evidence, in such a context. From Germany or England to Central America, bourgeois families sat for photographic portraits against backdrops of romantic landscapes and with ornate knickknacks surrounding them. The technique of "photographic painting" enables Karelin, and his subjects, to represent to us the vitality of European bourgeois culture deep in the Russian provinces. Instead of merely relying on circumstantial evidence—the books, journals, and newspapers they read, the theatrical performances they attended, the musical and scientific societies they founded—we here have access to the provincial middle classes themselves, productively mediated by the artistic imagination of the photographer. Karelin as an artist is a purveyor of the provincial bourgeoisie, combining representation of his subjects with a carefully orchestrated portrayal of their domestic environment, and providing them with an aesthetic language through which to speak for themselves.

NOTES—1. Susan Sontag, *On Photography* (New York: Farrar, Straus and Giroux, 1977), 3.

2. Mary Warner Marien, *Photography: A Cultural History* (New York: Harry N. Abrams, 2002), 151. The poet Charles-Pierre Baudelaire and the painter Eugène Delacroix, for example, dismissed completely the possibility that photographs could be art.

3. F. A. Fomin, *Vospominaniia ob Andree Osipoviche Kareline* (N.p., 1939), 7.

4. Ibid., 11.

5. V. A. Filippov, "Nizhegorodskii svetopisets," in *Andrei Osipovich Karelin: Tvorcheskoe nasledie* (Nizhnii Novgorod, 1990), 14.

6. Jürgen Kocka, "The Middle Classes in Europe," *Journal of Modern History* 67 (December 1995): 785, 786, 784, 786–87.

7. This emphasis on attributes is reminiscent particularly of Flemish painting, where the subjects are frequently surrounded by objects symbolizing their status or events in their lives.

8. "Thus the frame has some qualities of a window, as the window has many qualities of a frame. Painted canvases are apertures of ideality perforated in the mute reality of the wall, gaps of the imaginary upon which we look through the beneficent window of the frame. On the other hand, a corner of a town or landscape, seen through the frame of a window, appears to separate itself off from reality and to acquire a strange pulsation of the ideal. The same happens with distant objects separated out by the unambiguous curve of an arch." José Ortega y Gasset, "Meditación del marco," in Ortega y Gasset, *Obras completas* (Madrid: Revista de Occidente, 1954–), 8 vols., 2:311–12.

9. It is worth noting the technical difficulties of working with windows, which admit an intensity of light into the room that conventional photographers generally sought to avoid by closing shutters and drawing curtains.

10. See chapter 26; and Deborah Poole, *Vision, Race, and Modernity: A Visual Economy of the Andean Image World* (Princeton, N.J.: Princeton University Press, 1997).

24

European Fashion in Russia

Christine Ruane

Virtually every Russian history textbook mentions Peter the Great's decree of 1700 that Russians abandon traditional dress and wear western European fashions instead. In spite of the importance of this edict, little explanation is offered as to why the tsar issued the order or how his dress revolution was accomplished. Most of us see this act as an expression of the tsar's autocratic authority—Peter was so powerful that he could command his subjects to change their clothes, and they obeyed him. There is more to the story of Peter's dress revolution, however. It offers a visual way of understanding how Russians over the course of the next two centuries created a modern identity for themselves and their nation.

What Peter hoped to achieve through dress reform was to encourage Russians to feel "European." The tsar himself had first donned European clothing as a young man when he began socializing with western Europeans living in Moscow. Peter's outward transformation helped precipitate a shift in his views of himself and his country. Rather than taking pride in Russia's isolation from western European nation-states, Peter wanted Russia to become a part of that world. It was precisely this individual metamorphosis that the tsar required of his subjects. Given that his dress decree was one of his earliest cultural innovations, Peter must have believed that dressing like a European was an essential first step to becoming one.

Peter's initial plan was for all residents of Russia's capital city, Moscow, to adopt western European clothing styles—agricultural laborers and the clergy were excluded from observing the new dress regulations. Not surprisingly, most Russians found the new clothes scandalous. Traditional clothing covered the body with long flowing robes for the elite and equally modest garments for laborers of both sexes. Since women's hair was supposed to be a source of magical power, all women covered their hair. Now men were asked to wear tight-fitting breeches and waistcoats, revealing the contours of their physique. Although eighteenth-century women's dress continued to cover much of the lower torso, the bodices revealed their cleavage. If this was not shocking enough, women had to give up their beautiful traditional headdresses for wigs or simply to leave their hair uncovered. The adoption of European fashions meant that Russians' physicality and sexuality were on display for all to see.

The scandalous nature of the clothes notwithstanding, European dress spread well beyond the limits of Moscow. When Peter the Great moved his court to St. Petersburg, European fashions became the dress code in that city. The military and the bureaucrats adopted Western

uniforms, spreading European dress to all corners of the empire. When the aristocracy began westernizing their country estates, they did so by wearing Paris fashions and building European villas. They often insisted that their house servants wear some form of European dress, thereby spreading fashion's influence to the peasantry.

It is difficult for us to know just how Russians went about adopting European clothing. Few surviving written documents provide such intimate details of what a person wore each day. Eighteenth- and nineteenth-century Russian paintings provide us with more clues, but these must be used with caution. Painters often dress their subjects in clothing that harmonizes with the rest of the painting. However, the invention and dissemination of photography in the second half of the nineteenth century provides us with a different kind of visual evidence. In most photographs, people wear their own clothes, allowing us to see how ordinary individuals used fashionable goods to create an image of themselves. The studio portrait of a young couple, Konstantin and Elena, is a typical example (fig. 24.1). Given their youth the photograph may have been taken to celebrate their marriage. The backdrop of lush drapery and elegant wallpaper, a photographer's studio prop, suggests the kind of comfortable respectability to which the couple aspired. The clothes reveal a more complicated story. Long gone are the wigs, breeches, and décolletage found in Peter's day. The photograph was most probably taken in the early 1880s—Elena's bustle skirt and tailored bodice with form-fitting sleeves were very popular at that time. Konstantin's suit reflects the growing austerity of the male costume—no bright colors, lace, or tight-fitting breeches for men now. Yet, despite their attention to the latest fashions, the clothes indicate that this couple have only modest means. The folds on Elena's bodice and skirt are uneven or rumpled. This suggests shoddy work on the part of her dressmaker. Although gowns in the 1880s were rather simple, fashionable women compensated by wearing elaborate hairdos, headdresses, jewelry, and lace. Elena, however, is wearing little jewelry—a ribbon necklace with a brooch, a small pair of earrings, and a wedding band. Her hair and her head covering follow the latest fashions to only a limited degree. Although Konstantin's neatly trimmed mustache and hair suggest that he was conscious of the image he projected to others, the wrinkles in his coat once again suggest that he could not afford a good tailor, who would have ensured that the coat lay flat.

Taking all of these visual clues together, we can surmise that Konstantin and Elena wanted us to see them as a young, middle-class couple of modest means who aspired to a better life. Konstantin through his grooming and choice of suit wants to project the image of a successful professional or business man. Elena's modest toilette suggests that she is attentive to the latest fashions but not a slave to them. She will help her husband succeed through her judicious use of the family resources, rather than spend frivolously on fashion's latest folly. By adopting the conventions of western European dress and gender roles in a studio portrait, Konstantin and Elena present themselves as a respectable and thoroughly modern couple.

Still, this portrait conceals as much as it reveals. Without knowing the particulars of Konstantin's and Elena's lives, we can assume that their clothing served as a kind of uniform; it was required dress of anyone who wanted to get ahead in modern Russia. As long as the government remained committed to westernization, industrialization, and modernization, ambitious Russians, as well as those who wanted to preserve their existing social standing, had no real

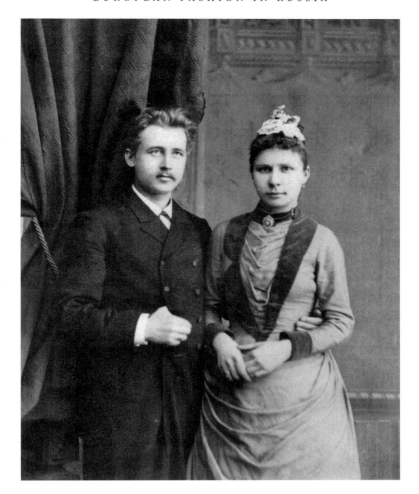

24.1. *Picture of Young Couple,* probably from the early 1880s. Studio photograph.

alternative except to wear modern fashions. But, as the Russian government was soon to find out, just because individuals adopted the modern uniform did not mean that they were compliant and obedient subjects, ready to do whatever their government asked. To give just one example, Lenin, the leader of the Bolshevik party, was often photographed wearing a suit, white shirt, and tie as he worked to topple the Russian government.

Russian commentators usually declared that there were only two forms of dress in that country. "Modern," urbanized Russians wore Western fashions; peasants remained true to traditional dress. However, pictures of Russia's laboring classes suggest that clothing operated along a continuum; peasants and urban workers of both sexes combined elements from both forms of dress in their wardrobes. The photograph of a Moscow market in winter reveals how they did that (fig. 24.2). Typically, sellers were composed of two different social groups: peasants, who came into the city from the surrounding countryside to sell agricultural produce or

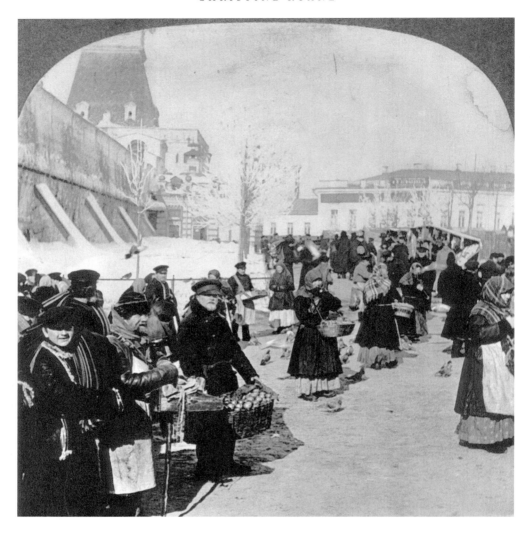

24.2. Moscow market. Photograph.

handicrafts, and petty tradespeople, who were full-time residents of the city. If we look at the three men in the left foreground of the picture, we can see the contrasting styles of the male marketsellers. The man in the middle is wearing elements of traditional dress. His hat, leather coat, and beard were common features among male peasants. The men on either side of him are wearing "city clothes." Woolen caps with short visors quickly came to designate the wearer as a member of the Russian working class. The dark woolen ready-to-wear coats that both men are wearing were also very popular among the city's laboring class, particularly for street sellers who had to spend long hours in the cold hawking their wares. Coats were one of the earliest ready-to-wear items produced in Russia. Made from domestic woolens, they were easy to make because they did not require numerous fittings, and given the country's cold climate, they were an essential element in any wardrobe. Among the Russian Orthodox it was considered a sign of

religious piety for men to wear beards. As the picture reveals, the young man on the left is clean shaven, while the older man on the right has a neatly trimmed beard. This suggests that the younger man may have already abandoned his faith or certainly the observance of its rituals, while the older man is presenting a modern view of an Orthodox Christian.

The dress of the women in the center and the right foreground tells a similar story. All three women are wearing woolen coats. Their very uniformity identifies them as ready-to-wear. However, their head scarves combine Russian and Western elements. The way the scarves are folded was typical of how peasant women covered their hair while working. However, the scarves are made of a woolen plaid material, the design almost certainly having originated in Europe. Russian textile manufacturers initially found it very difficult to produce large quantities of plaid material, but once they mastered the technique in the 1880s, plaids became popular among all social groups. These Russian women, and particularly the woman with her back to the camera, are wearing the Russian style of head scarf but ones with a Western design. Another important feature of working women's dress was the abandonment of the jumper (*sarafan*) and three-paneled skirt (*ponyova*) in favor of a simple blouse and round skirt. The skirts peeking out from underneath the woolen coats appear to be made of factory-produced chintz.

As this picture shows, by combining Western and traditional elements in their dress, Russians laborers embraced the concept of Western fashion as an expression of a modern sensibility. Although some did this out of a desire to look beautiful, others knew that to advance socially and economically, they needed to wear the uniform of modern life. The chief stumbling block that peasants and workers faced was a lack of money to buy Western fashions, but this did not stop them from incorporating elements of Western design into their garments. Wearing factory-made textiles instead of homespun was often the first way in which a peasant participated in the Western fashion system. The next step often involved adopting an item of ready-to-wear manufacture—a coat, a hat, a pair of boots—suggesting that the wearer was becoming more Europeanized and modern. This created a problem for those Russians who had long ago abandoned traditional dress themselves but who wanted the lower classes to continue wearing traditional dress as a way of preserving the old way of life. As one commentator lamented, "In general, in the last few years the streets of Moscow have taken on a more 'Europeanized' appearance. A kind of 'chic' has appeared among the crowds in the street, whereas in old Moscow the population had no understanding of fashion. . . . This collective culture is leveling city dwellers by making them resemble factory-made products."[1]

The sense of loss and nostalgia for Russia's past as workers and peasants adopted Western dress marked the end of Peter's dress revolution. During the Russian Revolution of 1917, a time when imperial cultural traditions faced many challenges, there was no government edict ordering Russians to wear traditional dress. Peter the Great had succeeded in laying a foundation for the creation of a modern Russian identity based on Russia's participation in the European fashion system. By 1917 there was no turning back.

NOTES—1. G. Vasilich, "Ulitsy i liudi sovremmenoi Moskvy," *Moskva v ee proshlom i nastoiashchem* 12 (1912): 6.

25

The Savior on the Waters Church War Memorial in St. Petersburg

Nadieszda Kizenko

From the second half of the nineteenth century to 1917, churches in the Russian style sprang up by the thousands all over the Russian Empire. They represented a new approach to memory, individual expression, and public policy. In a testament to changing goals, however, they disappeared nearly as quickly and completely as they had come. The Savior on the Waters memorial to the Russo-Japanese war exemplifies their story (fig. 25.1).

In the late eighteenth century, the Italianate putti, neoclassical columns, and Germanic spires of the imperial capital exemplified the notion of St. Petersburg as a window on the West and showcased the imposition of Western aesthetic ideals on the "traditional" iconographic forms of Russian Orthodox Christianity. On Russian-style churches, by contrast, the onion domes, the brightly colored majolica tile details evoking embroidered towels and peasant stoves, and the curved *kokoshniki,* arches in the shape of women's traditional head coverings, signaled a rebellion against the tyranny of European pediments and porticoes; they were the architectural equivalents of "Give Russia back to the Russians." But Russian-style churches like the Savior on the Waters Church War Memorial were more than that. Like Gothic Revival in England and *Heimatstil* in Germany, they were also part of a general European, Romantic celebration of the local, the individual, and the particular against the universalism of the eighteenth century. Like the Slavophile movement, they began as a rebellion against the domination of the autocracy, which had often imposed westernization against its subjects' inclination. When the autocrats themselves were canny enough to recognize the potential of the Russian style and officially mandated it, "progressive" thinkers who had initially embraced the Russian style turned on it. Russian-style churches like this one were in the midst of the aesthetic crossfire.

Although all Russian-style churches announced a reclaiming of national traditions, church war memorials like this one carried a particularly heavy symbolic burden. The church as war memorial was a venerable part of the Orthodox Christian experience, dating back to Byzantium. In Russia, precedents included the Cathedral of the Intercession (also known as St. Basil's) to mark the taking of Kazan (1552), St. Isaac's Cathedral to mark Peter I's victory over the Swedes (1721), and the Kazan Cathedral in St. Petersburg to celebrate the victory over Napo-

25.1. The Savior on the Waters Church War Memorial in St. Petersburg, 1911–31.

leon in 1812. In fact, until the eighteenth century, the only war memorials built in Russia were churches.

But this church is different. Unlike most of its predecessors, it was built to commemorate not a glorious victory but an ignoble end to a sorry war. The architects had the challenge of commemorating the brave soldiers killed in the war against Japan, fought in 1904–5, and rationalizing an imperialistic venture that most contemporaries agreed should never have happened. In this sense, it was the Vietnam Veterans Memorial of its time. The builders' choice of location, materials, and style says a great deal about their goals.

The importance of the church was clear from its site. It stood at the main entrance to St. Petersburg, on the Neva River, so that everyone who went in or out of the city by water could see it. The waterfront location reminded those who saw it that it commemorated a naval battle and all those sailors who had been lost at sea without receiving a proper burial.

Its materials and style carried a message as well. The carved white stone facing its walls evoked earlier models in Suzdal, Novgorod, and Vladimir. This pre-imperial, pre-Muscovite association conveyed a possible criticism of the government's aims in pursuing the war with Japan, even as it recognized the ultimate sacrifice made by the sailors it memorialized. The church affirmed the double nature of that sacrifice by being dedicated both to St. Nicholas, historically the patron saint of sailors in Orthodox countries and a symbol of military glory, and to Jesus, with particular reference to his night of lonely agony in Gethsemane. This acknowledgment of the possible tension between private sacrifice and larger goals provided a new and tangible way for Russians to think of their imperial identity and a new way to think as a nation.

The interior carried the commemorative aspect further. Upon entering, one immediately saw a huge mosaic in the dome over the altar apse of the Savior walking on the waters. This, along with the feastday of the church, August 1, the date of the first of the "summer Savior" feasts, gave the church its name. The mosaics for the church's pillars by the artist Viktor Vasnetsov marked a departure from his usual emphasis on folk imagery, depicting instead the notion of voluntary sacrifice for one's brothers, conveyed in two images: the Prayer Over the Cup at Gethsemane and the Bearing of the Cross.

In emphasizing the sailors' sacrifice, the church introduced an innovation in iconography. Instead of a typical wine-red altar-curtain (*katapetasma*) concealing the sanctuary, there was a naval flag of St. Andrew, and the chandeliers hung on real anchor chains. One of the walls was covered with a realistic painting by the academician A. N. Novoskoltsev, *The Savior Blessing Those Perishing on the Cruiser "Svetlana."* The incorporation of military details into church art had not been seen since the neo-Gothic church built by Catherine II in 1777 to commemorate the Russian victory over the Turks in Chesme, and it may have been a conscious attempt to evoke that earlier, and more successful, naval battle.

There were more conventional commemorative forms as well. The walls of the church were covered with bronze plaques inscribed with the names of fallen warriors. Either the original patronal icon and votive oil lamp of each ship lost at sea or its copy hung in front of each plaque. The liturgical utensils were kept in a miniature white marble reproduction of the church on the altar table.

Women played an unusually large role in the building of the church. Olga Konstantinovna, the queen of Greece, was the imperial family member sponsoring the church building committee. The Moscow workshop of O. S. Kokoshkina designed the bronze reliefs for the outside doors. The widows and mothers of lost sailors either embroidered or donated precious filigree Gospel covers, carpets, banners, and gonfalons. The lower church, dedicated to St. Nicholas, was consecrated in 1911 by the celebrated protopresbyter (head chaplain) of the army and the navy, Georgy Shavelsky. Most of the imperial family, including Nicholas II and his daughters, attended the dedication of the main upper church three days later. The Savior on the Waters

remained one of the best-attended churches in St. Petersburg through the Great War and was the site of three annual church processions on holidays connected with the fleet.

Nicholas II's support for this Russian-style church and others like it went beyond the aesthetic policies begun by his great-grandfather. For him, recapturing the pre-petrine past in buildings and ritual was a way of restoring an imagined intimacy between him, his subjects, and his army, without the constraints of modern bureaucracy or politics. This war memorial church was part of that boom. In the first seventeen years of the twentieth century, 165 monasteries opened; between 1906 and 1912, more than 5,500 new churches were built. Along with Russification policies, these Russian-style churches affirmed the Russian and the Orthodox over the voices calling for more overt reflection of the empire's diversity.

It was precisely the attempt to be a link between tsar and people that doomed this memorial church. On April 12, 1918, the Soviet of People's Commissars passed a decree calling for the removal of "Monuments of no historical or artistic interest erected in honor of the tsars and their servants." But who decided what would go? It was not the stereotypical Soviet functionary. Instead, it was members of the Silver Age cultural elite, including the World of Art founder Alexander Benois and the art critic and historian Igor Grabar. To them, this church, and indeed all the Russian-style churches of St. Petersburg, were damned for their association with rulers they disliked—and were, further, an aesthetic crime against the neoclassical elegance and Enlightenment values of the largely eighteenth-century city. Thus, despite many petitions by workers and other laypeople, the Church of the Savior of the Waters was closed and then blown up in 1931, not because of the "new Soviet man" but because of the intellectual modernist elite of the late tsarist era, who finally had a chance to impose their vision. The current petitions to restore it reflect a similar tension. Pious laity and business elite want both a place to worship and a place to emphasize their continuity with the noncommunist past. City authorities, on the other hand, want the prime location for government buildings. Artistic, bureaucratic, and popular goals are in conflict.

If not for photographs like this one, our impression of St. Petersburg would be limited to the rational one that Peter I and Soviet functionaries tried to create. It is only thanks to images that we can restore or imagine the elements now missing from the landscape. Church war memorials, chapels that proliferated on street corners, and the roadside crosses that acted as landmarks for passing vessels set a religious tone in late imperial Russia that we can re-create only with great effort.

Photographs of vanished buildings can do only so much. They cannot reproduce the sounds of religious services, of weeping families, of ship horns. They cannot convey the pressure of the crowds entering on battle anniversaries, the processions to the river, the smells of incense. All of these would have been an integral part of experiencing the church as a war memorial.

As readers of Fyodor Dostoevsky or newspapers of the time know, however, and as this photograph confirms, even the most European of cities in late imperial Russia was more saturated with traditional religious imagery than later accounts or cityscapes would have us think. It also reminds us that city planners build and destroy for a reason: by changing city spaces they change both how people experience a place and how they remember it.

26

Workers in Suits

Performing the Self

Mark D. Steinberg

Four workers stare out at us from a page of a Soviet book on Moscow printers during the revolution of 1905 (fig. 26.1).[1] On the surface, these pictures are simply illustrations of individuals in a narrative text, one of many histories recalling working-class struggles in Russia and especially the rebellion that compelled a deeply conservative tsar to grant limited civil rights and an elected legislature. But these pictures are also expressive as visual objects. The traditional oval shape, as if the portraits were to be held in pendants or framed and placed on a table in visual remembrance of family members, reminds us of the commemorative purpose of this 1925 publication, a book designed to celebrate the past: to focus on the heroic story of working-class mobilization and political radicalism and to leave in the shadows the deviant choices that workers made (including the political passivity of the majority, persistent problems with drunkenness, and the preference of most politicized printers for the Menshevik variant of Marxism, not victorious Bolshevism). These four photographs are, in fact, doubly commemorative. Those pictured were the leaders of an unprecedented citywide printers' strike in Moscow in 1903 and of the underground trade union that emerged to organize the strike, a movement seen to have prefigured greater upheavals to come. Still, noting their commemorative function only begins to let these pictures speak.

We know something of the stories of these individuals, which allows us to look beneath the superficial view of lower-class Russians as faceless masses. Aleksei Medvedev, at the top right, was born into a peasant family in 1874 and began work as an apprentice compositor at the age of fourteen. In 1903, though married, with three small children, and employed in a small printing shop as a senior compositor, he became an instigator and leader of an illegal printers' trade union and of the citywide printers' strike that union organized, for which he was arrested and imprisoned. We know less about Dmitry Komkov, whose portrait appears beneath Medvedev's, only that he was also born into a peasant family, became a compositor, and, in 1903, became a leader of the union and head of the strike committee. Mikhail Popov, to the left of Komkov, was born in 1874, the same year as Medvedev was. His father was a soldier serving in the palace grenadiers and stationed in Moscow. Popov became a compositor and was a member of the 1903 strike committee; in 1905 the workers in his printing shop elected him to the Moscow

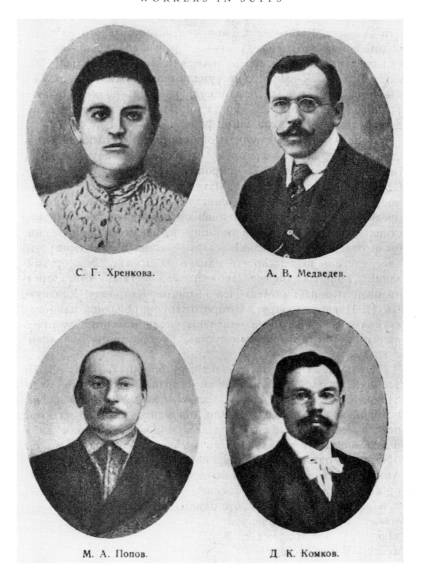

С. Г. Хренкова. А. В. Медведев.

М. А. Попов. Д. К. Комков.

26.1. Portraits of revolutionary workers. *Clockwise from top left,* Sofia Khrenkova, Aleksei Medvedev, Dmitry Komkov, and Mikhail Popov. Photograph from a 1925 work celebrating workers' roles in the revolution.

Soviet, the citywide workers' council. Sofia Khrenkova, a proofreader (proofreading was of the few printing jobs then open to women), helped to rebuild the union after the failure of the 1903 strike and the arrest of many activists. Her apartment became the union's secret home, with a number of worker activists even living there, and the site of a socialist salon where workers met to discuss ideas and plans. Before coming to Moscow, Khrenkova had worked as a school-teacher in the provinces. Misfortune, but also her own daring, led her to Moscow and into the working class: her husband died (leaving her to raise their two young daughters alone), and

she was repeatedly fired from teaching positions in state schools after organizing free evening literacy courses for local peasants and workers. She became a socialist, associated in 1903 with the Marxist Russian Social Democratic Workers' Party and in 1905 with the populist Socialist Revolutionary Party, although she did not join either party.

We are still dwelling only on the surface of these images and what they represent. Photographic portraits (as Roland Barthes, John Berger, and other theorists of the photograph and the portrait remind us) are not innocent reflections of objective reality but deliberate poses, special performances. These photographs appear to capture and freeze moments in time. But they also look beyond that moment, beyond the everyday, and beyond objective facts about workers' lives to suggest something about workers' ideals, illusions, desires, and imagination. Specifically, we can see here evidence of both the experience and the enactment of class. And more deeply, we can see important notions about self and identity. Reading portraits in this way requires not only careful looking but also knowing what lies outside the frame: the referents and resonances, and the languages of meaning available to construct these messages.

At the very least, these portraits of workers dressed up and posing for their photographs remind us of a rapidly changing society: the growth of urban industry and commerce; the expansion of print culture, which gave these individuals jobs but also, along with increasing numbers of literate Russians, access to much new knowledge about the world; the increased social presence and public activism of a working class but also the wide differences among workers in levels of skill, wages, and social and political activism (the individuals depicted here were among the most skilled and the most active—the two traits often went together); the growing place of women in the workforce and in the public sphere; and the development of a public commercial culture in which material objects such as stylish clothes, neckties, watch chains, cosmetics, and spectacles (not to mention photographs) were available to all classes and were widely desired.

We can look still more closely. As a former teacher working in industry and leading a trade union and as a woman organizing men, Sofia Khrenkova had the most ambiguous class position of the four. Unlike middle-class women of the time, who tended to dress fashionably, she deliberately presented herself as a modest, almost masculine worker. Many portraits of women at the time feature stylish coiffures and hats, jewelry, décolleté, and bold makeup. We see none of that here (although we cannot be sure that Khrenkova was not wearing some makeup or perfume). Modesty, respectability, and androgyny are the keynotes. Looking at the men, we notice other telling signs. All three men sport fashionable urban mustaches instead of traditional (and often religiously pious) peasant beards—although Popov's mustache is nowhere near as audacious as Medvedev's handlebars or Komkov's broad mustache and goatee. All have cut their hair in modern styles rather than the longer, under-the-bowl haircuts still common among peasants, although Popov is the least coiffed. And Popov wears only a buttoned-up shirt, evidently embroidered in the Russian national style, and what looks like a topcoat, instead of the more genteel, even dandyish, bourgeois suits worn by Medvedev and Komkov. Popov had a reputation among his fellow workers as such a serious fellow that he was jokingly dubbed "the Pope," while Medvedev was said to resemble a "young lawyer."

In a famous essay, "The Suit and the Photograph," John Berger looks at a 1914 photograph

by August Sander of three young German peasants on the road to a dance, wearing suits. Such bourgeois clothing, he argues, does not for a moment disguise their class. On the contrary, "their suits deform them," for laboring bodies do not belong in clothes meant to "idealize sedentary power," the power of the administrator, not the working man, the power of "talking and calculating abstractly," not making things with one's body and hands. Berger acknowledges the evident "pride" of peasants and workers who wear such clothes, but he judges this a hazardous pride, a pride born of "class hegemony," the result of accepting the standards of those who exercised oppressive power over those who labored, of conforming to norms that had nothing to do with daily experience and hence condemned peasants or workers in suits to always being "second-rate, clumsy, uncouth, defensive."[2] Perhaps.

The work of many historians of working-class culture — and the writings of many workers themselves — implicitly suggests other ways of looking at workers in suits. The metalworker Semen Kanatchikov recalled that workers like himself dressed up on holidays and other special occasions (which would include getting one's picture taken) as a sign of "consciousness of their own worth."[3] Might we think of workers wearing suits — and watch chains and mustaches and spectacles — paradoxically as exhibiting signs of class consciousness and assertiveness? Partly, this was a matter of workers' visibly distancing themselves from peasants — the majority of the Russian population and often their own parents and relatives — a class Marxists considered backward. Urban civilization, the site of the new and the progressive, claimed workers' allegiance. It is noteworthy that the most elegantly outfitted here were those born into peasant families. If anything, these suited workers dressed less in the manner of a respectable bourgeois than in the manner of a middle-class dandy, whose fashion sense marked him as a new man, sensitive to what was new, self-confident to the point of impertinence, and taking visible pleasure in what traditionalists considered frivolous consumerism and vain public displays of self.

We know from workers' own writings that many aspired to a more "cultured" and "conscious" life, which meant in part looking like urban citizens, not transplanted peasants, and spending their leisure time not at the tavern but reading or attending lectures, concerts, and the theater. For many workers, being cultured and conscious meant organizing workers' clubs, unions, and even strikes, perhaps in the company of socialist intellectuals. These behaviors reflected, in large measure, workers' growing "consciousness of their own worth" and their demand for respect. Or, as many workers at the time put it, it was imperative to recognize the natural dignity and rights of every human being.

Notions of human rights and dignity pervaded public discourse and private concern in the nineteenth and early twentieth centuries. The intelligentsia, novelists, poets, songwriters, artists, and journalists were preoccupied with the self: self-knowledge, self-esteem, inward feeling, and the ethical significance of the person as a human being. The words *lichnost'* (person, personality, individual, self) and *chelovek* (the human person, man) were everywhere deployed in moral, social, and political argument. Workers joined their voices to this discourse. When workers collectively protested, which they did with increasing frequency and stubbornness from the 1890s on, they repeatedly demanded "polite address" by foremen and employers (including the use of the formal *vy* rather than the inappropriately familiar *ty*) and material and

social conditions that would allow them to "live like human beings." Workers' writings—essays in the press, letters, poems, reminiscences—continually spoke of human dignity, of the injuries that lichnost' suffered in this world, and of the need to create a society and a polity in which workers were treated as "human beings," not as "machines," "cattle," or "slaves." Ideas about the dignity and equality of all human beings offered workers a powerful knowledge with which to see and demand a life different from the present one. As upheavals like those in 1905 and 1917 showed, when the language of dignity and rights was pervasive, this knowledge could be revolutionary.

A worker wearing a suit, then, could be making a transgressive and subversive gesture, boldly saying, "Look at me. Am I not a human being like any other, with the same dignity and rights?" or even imagining and performing a utopian time yet to be. Concerns about the self often mixed with notions of class. "One day," an anonymous printing-shop worker wrote in an underground trade-union paper in 1903, "all of the oppressions, all of the mockery, all of the insults by the fat cats against the humiliated self [*lichnost'*] of the poor man shall be repaid a hundredfold by the worker conscious of his might."[4] Men like Medvedev and Komkov—who might have written these words and who certainly wrote words like them—look much like labor aristocrats, who were often criticized for concerning themselves only with their own personal advancement. Yet they were also leaders of illegal strikes and unions, suffering arrest for the collective cause.

Our interpretations should avoid becoming too simple, however. We must not be seduced by the heroic narrative of progressively rising working-class consciousness and struggle that blinded many contemporary Marxists to the real complexity of workers' experiences and desires and became canonical for Soviet historians. We know that many Russian workers, disgusted with the lives of drinking and brawling and political passivity so widespread among their fellows, sought not to uplift and unite with the masses of workers but to escape into lives of individual self-improvement and distinctiveness and perhaps earn promotion to better jobs. Some workers traveled both paths. That individual advancement was possible was another sign of changing times and rising expectations. In fact, Khrenkova, Medvedev, Popov, and Komkov vanished from Russia's radical labor movement after 1905. Perhaps they were intimidated and demoralized by the repressive power of the state that threw them in jail and shut down their organizations and publications. Perhaps, for reasons we can never fully know, they chose more individualistic ways of demonstrating their dignity and equal worth.

NOTES—1. *Moskovskie pechatniki v 1905 godu* (Moscow, 1925).

2. John Berger, *About Looking* (New York: Pantheon, 1980), 31–40.

3. Reginald E. Zelnik, ed. and trans., *A Radical Worker in Tsarist Russia: The Autobiography of Semen Ivanovich Kanatchikov* (Stanford, Calif.: Stanford University Press, 1986), 21.

4. *Vestnik soiuza tipografskikh rabochikh*, no. 4 (December 1903): 5.

27

Visualizing Masculinity
The Male Sex That Was Not One in Fin-de-Siècle Russia

Louise McReynolds

Ivan Mozzhukhin, the most popular Russian movie star in the prerevolutionary era, posed for the postcard shot that reproduced his image for his legions of fans (fig. 27.1). Dressed neatly rather than nattily in a pinstripe suit, a wide tie, and a shirt with a stiff collar, he sits on an overstuffed, flowered couch. Directing his tender gaze at the black poodle in his arms, he raises one of the poodle's paws to the camera. At first blush Mozzhukhin appears remarkably feminine for a popular male actor; indeed, this photograph resembles a publicity shot of the famed ballerina Matilda Kshesinskaya in the same period. It is precisely this sexual ambivalence that lies at the heart of Russian masculinity at the end of the tsarist era.

Masculinity is traditionally cast in terms of femininity: each member of this binary relationship defines the other as its opposite. They play different but supporting roles for each other in mutual reinforcement. At the turn of the twentieth century this relationship was thrown into doubt when the so-called new woman emerged, bringing with her the feminism that threatened the male sense of place. However, as Teresa de Lauretis and others have pointed out, masculinity is not itself an inherently stable signifier; rather, it harbors multiple meanings and therefore cannot present itself as a cultural constant. Feminists did not precipitate the crisis of masculinity; it was one of a series of crises rising in response to the questions modernity was posing about proper sexual roles and behaviors.

Men learn how to become masculine by processing stereotypes of manliness produced by their society. Rapid industrialization at the turn of the twentieth century forced Russian males to question their gendered identity because it obligated them to assume new social roles before they were certain what it would take to "be a man" in these changing circumstances. The familiar patriarchy, a masculinist hereditary hierarchy according to which the village elders replicated in the countryside the authority that the tsar exercised from the national political apex, was becoming increasingly less recognizable in urban life. A capitalist economy geared toward expansion and fueled by consumption depended on an entrepreneurial individualism that was anathema to such a static system.

In tsarist Russia, the stock of manly referents derived largely from those who had inherited their authority rather than earned it and from those who were more submissive than competi-

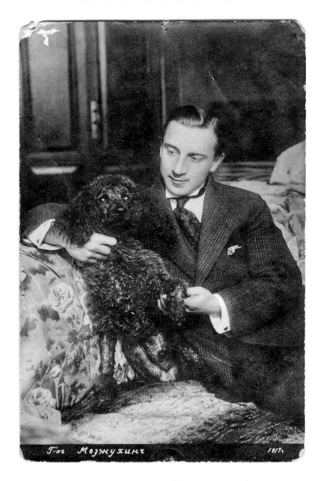

27.1. Movie star Ivan Mozzhukhin, ca. 1911. Photograph.

tive. Sorting through the available store of cultural referents in search of himself, the modern, urban Russian male found too many derived from the social estates that formed the basis of an agrarian economy. The inversion of the classic dichotomy that separates men with brains from men with brawn reflected Russia's masculine dilemma. The appearance of an intelligentsia—men who demonstrated the moral courage to stand up against the tyranny of autocracy—imbued "brains" with virility. As long as the ultimate price for such courage was exile or execution as a revolutionary, however, it was acceptably manly to be physically weak, even neurasthenic. The literary critic Vissarion Belinsky emerged as a role model in the 1840s and served the collective imagination of a physically fragile masculinity by dying young. Significantly, his untimely death signaled a surrender to fatalism rather than a strong show of support for the existing patriarchal status quo.

"Brawn," on the other hand, was associated with the peasantry. Although styling oneself as a peasant became fashionable with a restricted set of intellectuals who hoped for a Slav-inspired national regeneration through the village commune, most people understood identi-

fication with the peasantry more realistically: as a sign of downward mobility, which was not a practicable aspiration. As a result, a distinctly Russian masculinity developed in a culture that idealized ineffectual intellectuals and harbored either romantic or suspicious attitudes toward peasant men, the dominant group of males in the population. All Russian males found themselves deprived of the political power that their counterparts in the West exercised. If their weaknesses engendered sympathy for males, it was sympathy predicated on the acceptance of failure as normative "masculine" behavior.

Modernity demanded the birth of new models of behavior marked by comfort with rapid change and the ability to help others navigate change. Fulfilling the new demands was helped by increasing the possibilities for circulating images of these "new men." Advanced technologies could reproduce visual images on a mass scale, and commercialization ushered in the culture of consumption that inspired experimentation when constructing an identity. Photography changed the expectations for realism, and once images could be reproduced and distributed on a mass scale, reality and representation could stand in for one another. The new images being spread around in unprecedented ways required creative viewing practices, that is, new ways of looking at and making sense of them. Grounded in commercialism, these reproductions were selling the desire for self-imaging, for personal association with the representation at hand. Appealing simultaneously to voyeurism and narcissism, photographs played upon the viewer's sense of subjectivity, of his sense of his place in society.

The invention of the moving-picture camera, which adapted modernity's fundamental reorganization of time and space to the experience of the visual, made the heaviest impact. Movies did not simply project images on the screen; they integrated viewers psychologically into story lines that pulled audiences in at the emotional level, facilitating their ready identification with the actors. Ironically, despite being the most modern of media, the motion picture turned out to be culturally conservative in its narratives of normative masculine behavior.

The movie star Ivan Mozzhukhin made an ideal male model because his image reified the sorts of men he played on screen, where he was best known for scenes in which he shed his celebrated tears. His anguish, however, resulted almost invariably from his regret for his use of violence against a woman, whose function was to stir the man's deepest passions and therefore precipitate a tragic death. The deadly males he played were permitted to regain their humanity through their remorse. In the movie that made Mozzhukhin a matinee idol, *Life in Death* (1914), he plays a husband so entranced with his wife's beauty that he must kill her to preserve that beauty eternally in a crypt. In his last major Russian role, as the mayor in *Little Ellie* (1918), he rapes and murders his underage sister-in-law, and when he can no longer bear the guilt, he shoots himself in the heart.

Just as Mozzhukhin's screen persona captured the essence of the neurasthenic intelligent man, these melodramas echoed themes found in the Russian literary classics in which Mozzhukhin also starred on the silver screen. One of his first roles, for example, was as a violinist whose adulterous affair incites the woman's husband to kill her; this was in the first film version of Leo Tolstoy's *Kreutzer Sonata* (1911). Later he starred as the gambler who suffered a nervous breakdown when jilted, in the film version of Alexander Pushkin's *Queen of Spades* (1916).

Although new women, quasi feminists, could be found in some of these melodramatic

narratives, they functioned, as all Russian women did on screen, to provide the catalyst for male violence. This contrasts sharply with the heroine's role in Western silent movies, which also predictably used violence to resolve conflict, most notably in films produced in the United States. In the Western cinema, however, the female victims had to suffer precisely because their weaknesses underscored the notion that the males who saved them were the true sources of national strength. These films reinforced the liberal patriarchy by giving women the support-ing role. The Russian males watching their own movies, though, did not seek to connect their masculinity with an ability to safeguard virtue or vulnerability; they themselves were too weak to assume any role of protector. To Western eyes, Mozzhukin with his poodle might seem effeminate, but his photograph is better understood as a specifically Russian masculine appro-priation of the feminine. One consequence of this appropriation was that it undermined the kind of mutually reinforcing gender roles that could have contributed to social stability in such unstable years.

Movies enjoyed a phenomenal ability to circulate images. Their related ability to incorporate viewers into cultural narratives made them an especially powerful medium; but they were still only one of the growing number of modern sources of masculine images. Sports, for example, were influenced by the physical culture movement that connected skill and self-discipline to strength. Not only did it allow the rough peasant to metamorphose into the disciplined worker, but it suggested ways to regenerate the male body, threatened by the stresses of urbanization. The booklet *How to Become a Wrestler-Athlete* taught young Russians how to turn themselves into Charles Atlases, while the mass-oriented journal *Hercules* distributed both photographs of popular athletes and historical images of wrestlers to its predominantly male readers. The images fetishized the male body, and the reproductions of seminaked torsos embracing each other offered up the homoerotica that underscored the sexual ambiguity of Russian mascu-linity.

Hercules suggested ways that men could control and even sexualize their own bodies. Other mass-circulation media promoted masculinization through the advertisements that subsidized their publication, selling cures to baldness and telling readers where to buy the latest fashions. Men who developed a personal sense of style now had the means to put themselves on display, even if only for the limited audience of friends and family. Commercial photographers invited clients into their studios and posed them for the camera to make images that conveyed how these men wanted to be looked at, to be seen. Clients purchased cabinet cards, or multiple prints of photographs mounted on stiff cardboard, for purposes of, as Walter Benjamin would impute, private exhibition.

This newly developing commercialized culture of self-representation made visible those males who did not want to be scripted into a social drama of failure and despair. They clad their well-formed bodies in fashionable European-style suits and exuded a jaunty sexiness. The example pictured here, a cabinet card from a prerevolutionary studio, contrasts dramatically with the postcard of Mozzhukin: the latter shows a public figure with a readily identifiable image; the former shows a private man as he presented himself to the world (fig. 27.2).

Although we have no biographical information about the man in the studio portrait, none is needed because what matters here is the manner in which he is posed. The background that

27.2. Studio photograph of an unknown subject.

he selected, with lacy curtains and statuary, including the piece upon which he rests his arm, supposes a bourgeois household. His stance shows an assertiveness, but one without aggression; the hand in his pocket bespeaks a casual confidence. His clothes are especially indicative: the short, narrow tie against the striped shirt and the high, wide waistband, decorated with a noticeably heavy watch chain, make it plain that he wants to be noticed. Like most other males in the animal kingdom, he appears to be priming himself for mating season. Or, placed instead in the civilized city, this fellow is simulating the mannequin in the department store window who demonstrates the newest vogue to the busy street. The opposite sex for him is more than a prompt for a nervous breakdown. More than that, he wants to be an assertive actor in society, not an impotent subject in an autocracy.

The young man in the studio shot, however, like Mozzhukhin's movie characters, lacked an outlet to the larger political world. The patriarch had stood for centuries as the masculine ideal because he represented the cornerstone of social and political relations, but now he had become a source of male anxiety rather than of authority. It was the ineffectual tsar, Nicholas II, rather than the evanescent feminist who troubled Russian males: Nicholas could teach them nothing about how to be men in industrializing Russia.

28

Pictographs of Power
The 500-Ruble Note of 1912

James Cracraft

B etween 1898 and 1912, under the direction of the famous Sergei Witte, minister of finance, the Imperial State Bank in St. Petersburg issued a series of state credit notes in denominations of one, three, five, ten, twenty-five, fifty, one hundred, and five hundred rubles, all of them elegantly, not to say beautifully, designed. The series embodied Witte's monetary reform of 1897, whereby he stabilized Russia's hitherto grossly fluctuating currency, thus facilitating foreign investment in Russia and the empire's ability to float foreign loans (both essential to Witte's ambitious program of intensive industrialization). All previously issued notes were re-called to the Treasury and destroyed, and Russia went on to enjoy, until the outbreak of World War I, the most stable currency in the world, backed by the world's largest gold reserves. But it is not the economic function of the Witte notes that concerns us now. Instead we might see them as an important set of images created by the imperial government for dissemina-tion among its subjects, who naturally received them with the attention and respect that only money can command. Our task, then, is to discover the underlying messages that these impos-ing images, like *all* representations of reality, figural or verbal, strive to convey—the structure of values and interests that informs them.

Let us focus on the acme of the series, the largest in size (10 ¹³⁄₁₆ by 5 inches) as well as denomination, the 500-ruble note issued by the Imperial State Bank in 1912. The obverse (or front) of the note states, on the right, in words emblazoned on a fancy classical escutcheon, that the bank will exchange this note for its full value in gold coin "without limit"; a matching escutcheon on the left proclaims: "1. The Exchange of State Credit Notes for gold coin is guaran-teed by the entire wealth of the State [the Empire]. 2. State Credit Notes have currency through-out the Empire equally with gold coin. 3. For Counterfeiting Credit Notes the guilty will be subject to deprivation of all rights and banishment to hard labor." Above the one escutcheon the familiar Romanov double-headed eagle with crowns and crests is displayed; above the other is displayed the intricate cipher of Nicholas II, the reigning emperor. Both images are trimmed with laurel leaves, fruit, and other symbols of fertility (or natural wealth). Overall, the note is finely engraved and printed in several inks: green, the predominant color, blue, and lavender. Contemporary experts as well as later scholars have rated the series a monetary masterpiece,

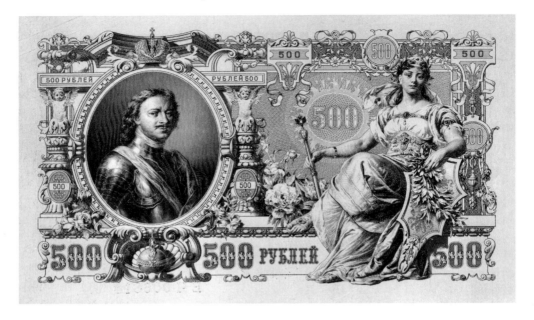

28.1. Reverse of the 500-ruble state credit note issued by the Imperial State Bank, St. Petersburg, 1912.

and the Swiss National Bank of the time took it as a model for improving the aesthetic and anti-counterfeit qualities of its own currency.

The reverse of the 500-ruble note of 1912 is even more impressive (fig. 28.1). Against a background of elaborate classicist architecture and decoration reflecting the highly fashionable *style moderne,* an equally stylish female personification of imperial Russia holds in her outstretched hand a scepter surmounted by the Romanov eagle. The scepter points toward the imperial crown and orb pictured above and below a portrait of Peter the Great, Russia's first emperor (lived 1672–1725). The portrait is easily, and no doubt intentionally, the most striking feature of the entire note. It is also highly specific. It reproduces in fine steel engraving the famous image of Peter first painted from life by Karl (Carel) Moor at The Hague, in Holland, in 1717, during Peter's triumphal tour of Europe as the celebrated reformer of Russia and conqueror of the eastern Baltic provinces, where he had founded St. Petersburg. Moor's painting (later whereabouts unknown) was reputedly Peter's own favorite among the dozens of likenesses taken during his life, and at his order it was copied almost immediately by the well-known Dutch engraver Jacobus Houbraken (see fig. 10.2). The Houbraken engraving was repeatedly reproduced thereafter, in Russia as well as abroad, until it became the single best-known image of Peter in the fullness of his power, as Witte and his subordinates would certainly have known.

Three more notes in the series also carry superbly executed ruler portraits. The first, on the 25-ruble note, is of the recently deceased Alexander III, Witte's own hero and protector as he, Witte, launched his industrialization program; the second, on the 50-ruble note, depicts the majestic Nicholas I, who reigned (1825–55) when the Russian Empire was at the height of its international prestige; and the third, on the 100-ruble note, is an engraving after a portrait in

oil, painted by the incomparable Dmitry Levitsky, of Catherine II, during whose reign (1762–96) Russia became incontestably a great, and splendid, European state. These paper rubles were popularly known, accordingly, as the "Romanov notes" (*romanovskie bilety*) or, for short, the "romanovs." Between 1898 and 1914 they circulated widely in Russia, particularly among influential and affluent groups in society, groups whose support was critical to the empire's continued success.

The choice of rulers for portrayal on these notes—the empire's strongest, ablest, and most successful rulers to date—was surely not accidental, no more than was the choice of means for portraying them. From the time of Peter the Great, the imperial Russian government had sought to project an image of not just enlightened but majestic rule, an image crafted by the most advanced aesthetic and technical means available. Indeed, the basic message that Witte's romanovs conveyed was unmistakable. They said to all who handled them (1) that these exquisitely produced paper rubles were as good as gold and (2) that the system they represented, correspondingly, was as good as its money—at once strong, stable, and benevolent as well as elegant and modern. It was a potent message for the imperial government to send to its subjects and creditors, especially when part 1 of it was, in fact, in true. These beautifully crafted images of power, dignity, strength, and bounty represent, more clearly and succinctly than any known verbal sources from the time, the essential ethos of the Russian Empire's ruling elite, an ethos of enlightened service to the empire's greater glory and prosperity among the world's major powers.

And we can thus see why the precipitous devaluation of imperial Russia's paper money during World War I, caused mainly by the government's equally precipitous increase in the issuance of such money to pay for the war, is an especially telling marker of the empire's sudden collapse (in February 1917). Even then, official documents indicate that as late as August 1917 millions of Russians still clung to their romanovs, evidently convinced that their value would be maintained or, some day, restored.

29

Visualizing 1917

William G. Rosenberg

G reat upheavals like the Russian Revolution of 1917, however complex, are commonly re-
duced to simple political narratives. In the Russian case, the narratives usually describe
how the revolution "began" in the Petrograd food lines late in February, developed after the
tsar's abdication through the dual-power conflicts between the soviets and the Provisional
Government, was challenged by the June offensive and the Kornilov rebellion, and concluded
with the October Revolution (logically, tragically, or triumphantly, depending on who does
the telling). Such one-dimensional stories project an image of the revolution as a struggle for
power. Whether this power is envisioned in political structures, in social or cultural relations
that reflect power hierarchies, or in each of these realms simultaneously, thickens the single
dimension but does not fundamentally change it. Obscured from view are how the revolution
was experienced, how what occurred was perceived, and especially how perceptions and ex-
periences might have acquired meanings that affected the processes of change.

Power is important. Where power was located, how it was acquired, which kinds of force
used it, and what institutions and values it reflected are core issues in any historical exploration
of 1917. The problem is that the ways these familiar narratives are constructed makes it impos-
sible to answer many key questions. Why, for example, did the meaning of "democracy" shift
so rapidly in 1917 away from political processes and structures toward the signification of a
particular social group (one that thought of itself as "workers and peasants") and a particular
kind of social order? Why did political demonstrations and protests occur in certain locations,
and what difference did this make? What was the effect of what people saw on what people
heard and believed? How did memories, accurate or distorted, refract the new experiences and
their consequences?

Attempting to visualize the Russian Revolution is one way to seek answers. Visualization
connects events to experiences and experiences to places. It offers clues about how experiences
themselves take on certain kinds of meanings from their settings that may or may not corre-
spond to those that historians impose on them. Historicizing a sequence of events as part of
a heroic struggle for democracy, for example, embeds a meaning on individual and collective
agonies that might otherwise be understood quite differently. All historical narration, whether
done by professional historians, overworked students, memoirists, or historical actors, un-

avoidably frames events in ways that they may or may not have been understood when they were actually lived.

Visualizing an event is thus an important complementary angle of interpretation. The simulation of appearances also gives meaning to experience, even if these meanings are not written out. Visualizing also encourages historians to probe the meaning of space itself and ask what about a particular site or configuration of sites affected the way an event was understood. Images, in other words, add their own meanings to conventional textual narration.

In complex events like the Russian Revolution, this additional visual meaning can be created in at least three ways. The first kind of visualization is the product of how specific monuments and sites of power are seen and what meanings are created by the feelings that seeing them provokes. The vast Palace Square in front of the Winter Palace in Petrograd (St. Petersburg was given this Russified name in 1914), with its grand column celebrating Alexander I's victory over Napoleon, visually stimulates an awesome sense of power, historical legitimacy, and imperial splendor. On Bloody Sunday, during the "dress rehearsal" rebellion of 1905, the Palace Square was also the site where the tsar's guards regiments fired on a peaceful gathering of workers petitioning him to use his august authority to improve their lives and working conditions. Some people entering this grand space might have felt the majesty of the regime; for others, the site might have provoked anger, feelings of injustice, visions of bloodshed, and a determination to effect change. When the new Provisional Government sought to legitimize its authority in March 1917, its ministers followed the tsarist tradition by ordering army detachments to stand in the Palace Square for review. Whether this identification strengthened or weakened the new regime, however, was literally in the eyes of the beholders.

A second kind of visualization involves the particularities of geography and the meanings of certain kinds of space. All cities, for example, segregate their populations by wealth and social status in varying degrees. How these districts are configured in relation to each other imparts meaning both to the sources of their separation and to their traversal. The stunning neoclassical architecture of St. Petersburg also projected, quite deliberately, a sense of great imperial strength; as Alexander Pushkin, Nikolai Gogol, and Konstantin Aksakov understood, the facades that gave a backdrop to parades intimidated and overwhelmed in their visual assurance of the permanency and power of the state. At the time of the 1917 revolution, the principal working-class districts in St. Petersburg were separated from the city's imperial center and its adjacent elite districts by the wide moat of the Neva River and protected by its drawbridges. The places of wealth and power were on the "other side." As a result, the tsarist "barricades" that were "stormed" when the revolution broke out were actually the spatial distances that reflected social difference. Perceptions of the geography, in other words, gave the assault both real and symbolic power. The conquest of physical space became the means of "seeing" (perceiving) the vulnerability of deeply entrenched social, cultural, and political hierarchies.

Finally, there is the visualization of conflict itself, the sighting as well as the siting of points and moments of political, social, and cultural contestation. The significance of hated foremen being evicted from their plants on wheelbarrows lay as much or more in its witnessing as in its symbolism or its economic consequence. What James Scott has described as the "hidden tran-

scripts" by which subalterns resist domination finds articulation in action more than in words, but actions speak louder than words through the ways they are actually or imaginatively seen. The same is true in contests over how symbols are displayed (the experience of seeing epaulets torn off an officer's uniform was significantly more empowering—or disempowering—than its description) and in contests over space, which are often integrally about power (the peasants' experience in seizing additional land to cultivate also carried the weight of challenging land-owners' property rights and the regime's purposes in defending them).

The three forms of visualization, focusing on sites, geography, and conflict, can help us better understand the events of 1917. First, there are the striking spatial dimensions of the February Revolution itself. Marxist historiography has defined the assumption of power by the politically liberal Provisional Government in early March 1917 as a "bourgeois" revolution because the new regime sought to establish the individual civil liberties and property rights familiar to European and North American political systems. But the first phase of the revolution can also be thought of as bourgeois because the spaces seized in the huge demonstrations of February and early March were not the political centers of power, like Palace Square, but the central location of "bourgeois" wealth and social influence, Nevsky Prospect (fig. 29.1). Moreover, it was not simply the men in this heavily patriarchal world who seized this real and symbolic center of bourgeois gravity but large numbers of women as well, whose demonstrations signaled the deep social and cultural upheaval under way. Among other connotations, "democracy" always implies access. The greater the degree of popular access to political power and social resources, the more democratic the system. As members of "lower class" Petrograd streamed across the Neva moat protecting the imperial social order and occupied not the Winter Palace or principal locations of tsarist authority but what was seen as the principal site of social inequality and difference, the contours of revolutionary contestation were made visible for all who cared to see. Nevsky Prospect finally belonged to "the people."

Marxist historiography aside, we can thus call the first several months of the revolution its bourgeois phase not only because of the civil liberties it brought provisionally to Russia but also because it opened wide the possibility of popular access to socially restricted spaces, resources, and power. Many waiters and waitresses went on strike in the spring to protest *against* the practice of tipping, and laundry workers, mostly female, stopped washing the "bourgeoisie's" clothes until rudeness stopped and conditions of work improved. These were strikes for human dignity and wages based on work instead of deference and were taken again to the core location of bourgeois practices and values (fig. 29.2). No one witnessing these strikes could have doubted that widely different sets of social values were in conflict, as well as the historically more familiar question of who would control whom.

We might argue that this bourgeois phase of the Russian Revolution was superseded in spatial terms by a phase of conflict over who "Nevsky Prospect" belonged to, "us" or "them." The quotation marks signal that by the summer of 1917 "taking Nevsky" had become shorthand for access to property and resources everywhere, especially in the countryside. Peasants could no longer accept the invisible legal boundaries separating individual and collective land, even as wealthy landowners and prosperous peasants tried to mark them with fences. For peasants on

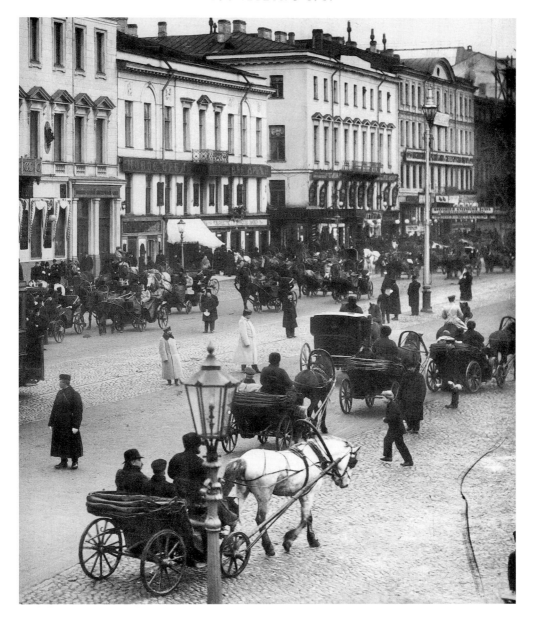

29.1. Nevsky Prospect as a "bourgeois" site, 1917. Photograph.

the cusp of subsistence, the sight of private land held fallow and protected from their ability to use it overwhelmed the invisible abstractions of property law in the same way that the sight of government troops once again on Nevsky Prospect to fend off those who "did not belong there" overwhelmed for many any remaining sense of loyalty to the new regime. One of the best-known photographs of 1917 shows the Provisional Government's repression of demon-

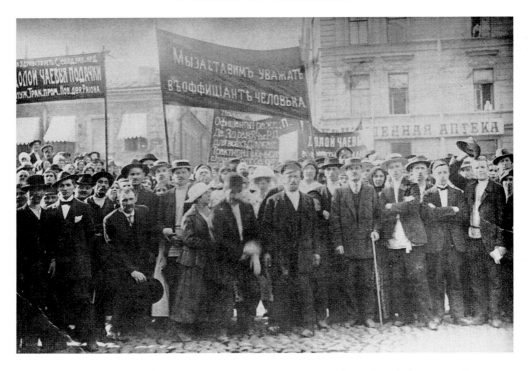

29.2. St. Petersburg restaurant and café workers striking against the undignified practice of tipping, 1917. Photograph.

strations against the regime and the world war during the "July Days" (fig. 29.3). What was seen and felt by the demonstrators, but is missing from most historical descriptions of this scene, is that Nevsky was once again being forcefully ruled off limits, once again being envisioned as a site of restrictions rather than access.

What came next was what in these terms we might call the transition to the revolution's "democratic" phase, the months in the fall when the demand and notion of access began to overwhelm efforts to preserve "legality," to keep Russia socially "stable," and to defend the revolution militarily against the German and Austrian armies. Support for the war weakened enormously after the collapse of the Kerensky offensive in June, and the army itself began to melt away as soldiers rushed home to seize their share of gentry land. Workers took over factories to prevent their being closed, ignoring "bourgeois" economics as well as law. They demanded the democratic state ensure that factories stayed open and workers received their wages. As Lenin and his Bolshevik supporters successfully identified their own political ambitions with increasingly popular notions of democratic access and social equalization, they captured the dominant political discourse, as it were, and rewrote the revolutionary story. Meanwhile, workers' committees and even Bolshevik leaders themselves donned the dress and assumed the affect of the social groups they sought to displace. Students may wonder why the many statues of Lenin dominating principal sites of Russian political memory show the Bolshevik leader in what could almost be a Brooks Brothers suit and tie. Like the similar dress of militant factory

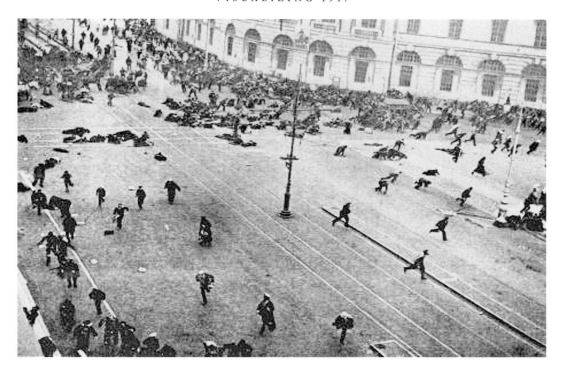

29.3. Viktor Bulla, Suppressing the July Days demonstrators, 1917. Photograph.

committees, Lenin was simply projecting the visual dimensions of revolutionary social conquest and political accession, the improbable taking—figuratively as well as literally—of what the "other" had long held.

Almost overnight, the Russian Revolution turned the world upside down. One literally had to see it to believe it.

30

Looking at Tatlin's Stove

Christina Kiaer

I n December 1924 an article appeared in the popular magazine *Red Panorama* (*Krasnaia panorama*) under the boldface title "The New Everyday Life" ("Novyi byt"). It described the avant-garde artist Vladimir Tatlin's current work in his studio, the Section for Material Culture in Leningrad, and showed photographs of Tatlin with his creations: an overcoat, a men's sportswear suit, pattern pieces, and a large wood-burning stove, all of which were designed as prototypes for industrial mass production although none were ever mass-produced. Tatlin was famous to a broad audience for his spectacular design for the *Monument to the Third International* of 1920, a giant, tilted, open-framework tower of iron and glass that was projected to spiral almost a quarter of a mile into the sky. But the towering form of the *Monument* gave way, in the intervening four years, to the heavy, rooted, boxlike shape of the undecorated and human-scale tile stove.

Shortly after the article appeared, Tatlin made a photomontage that incorporated its text and illustrations, cut out and rearranged on the page, adding below a photograph of himself model-ing a different version of his men's sportswear suit; his photograph is pasted above and partially obscures two horizontal images of gentlemen in fashionable suits cut out of magazines (fig. 30.1 [color section]). The earnest contrast between the images of Tatlin and the images of the gentle-men is amplified by the scribbled texts in Tatlin's hand. On the right, lines pointing to his own image assert the practicality of his sportswear suit: "This clothing is made with the advantage of being warm, not restricting movement, being hygienic, and lasting longer." The reproachful lines on the left point to the fashionable gentlemen: "This clothing restricts movement and is unhygienic, and they wear it only because they consider it—beautiful." The misguided men who covet clothing merely for its visual quality of beauty represent the old, capitalist way of life, now resurgent in the semi-capitalist period of the New Economic Policy (NEP, 1921–28), while Tatlin's visually unremarkable material objects, characterized by utilitarian qualities such as hygiene and warmth, represent the socialist "new everyday life" (*novyi byt*).

This photomontage was displayed in the exhibition room of Tatlin's Section for Material Culture. Yet if Tatlin's everyday objects are about utility rather than visual form, why did he make and display this supremely *visual* montage? What does it mean, in other words, to *look at* Tatlin's stove? The answer proposed here is that this photomontage enacts, with great visual

economy, the tension in the art of the revolutionary avant-garde between the visual and the material—between, that is, the traditions of high art that the artists associated with spectacular bourgeois culture and the ideal of creating a proletarian culture that would be materialist both literally and philosophically. This tension in left avant-garde art was an aspect of the larger tension in the Russian philosophical tradition between a debased and material "everyday life" (*byt*) and a philosophically significant objective reality (*bytie*), which the Bolsheviks attempted to overcome through the invention of the concept of the "new everyday life."

"So what kind of life has been predicted by Tatlin, and what kind of art does it need?" asked the art historian and critic Nikolai Punin, Tatlin's loyal defender, in 1924. "Tatlin's answer to this fundamental question was a stove. Such an answer means above all that the artist's attention is focused with particular fixity on what is usually called everyday life."[1] Tatlin's attention to everyday life challenged the most fundamental categories of Russian culture, in which everyday life was always a category to be transcended. The same urge toward transcendence also motivated Russian Marxist revolutionaries; in their case, however, the transcendence was specifically ideological.

Public debate about the prospect of a higher form of a new everyday life after the revolution was inaugurated by Leon Trotsky's essays on the subject in 1923. "Politics are flexible," he wrote, "but everyday life is immobile and obstinate."[2] For Trotsky, everyday life in its passivity could never be a site for political action but had to be obliterated as a separate sphere of life. His attack on everyday life was an attack on its sheer material weight; he argued that the new everyday life could accomplish equality between women and men—one of its goals—only through the virtual elimination of possessions: the complete rationalization of the material order of domestic life from above, by the state, through such institutions as public laundries, dining halls, and child care. Trotsky's vision of a domestic life emptied of "binding" material objects instances the Bolshevik urge to clear away the detritus of the world of private objects and destroy the materiality of everyday life.

Tatlin rejected this Bolshevik antimaterialism. He produced objects that would be immediately useful in what he called "our simple and primitive everyday life," not in a Bolshevik "new everyday life" of gleaming communal cafeterias.[3] He deliberately mired himself in the devalued order of the everyday. The photographs accompanying the article in *Red Panorama* tied him to his everyday objects, as he modeled the clothing and posed in front of the wood-burning stove. The bold title "The New Everyday Life" at the top of the page is slightly incongruous, given the decidedly gritty and nonfuturistic look of the illustrations; most propaganda posters with that title illustrated a sterile and well-ordered future. His objects are shaped by the demands of everyday life rather than by his visual invention as an artist. Tatlin declared: "Distrusting the eye, we place it under the control of touch."[4]

Tatlin's project found its theoretical ally in the Marxist critic Boris Arvatov. For Arvatov, everyday life was a potentially active force. Writing in 1925, he claimed that proletarian culture would emerge not by transcending the material sphere but by "organically" and "flexibly" working within it in order to transform it in a process of "everyday-life-creation" (*bytotvorchestvo*).[5] "Organic" and "flexible" are the right terms to describe Tatlin's willingness to direct

his artistic practice toward the kinds of things that were needed in the primitive conditions of contemporary everyday life, even though his new practice of art involved a radically different, and less valued, kind of "creation" from that of his previous avant-garde endeavors.

What, if anything, makes Tatlin's stove—as a product of "everyday-life-creation"—look different from other stoves? The large wood-burning stove, plain and rectangular in form, had traditionally organized the domestic space of the home in Russian villages. People even slept on it, since it was the warmest place in the house. In its rectangular form, Tatlin's stove does not in fact look much different from traditional ones. It does, however, appear to be functionally advanced: the tiled exterior is more modern and hygienic; his design efficiently condenses the various parts of traditionally larger stoves into one structure; it provides glass shutters for the opening to the range; and its sophisticated furnace system meant that it would smoke less than the iron stoves in wide use at the time. His design maximized the functional qualities of the traditional stove, making it optimally useful for urban life. Although some critics have suggested that the cubic form of the stove refers to Tatlin's Cubist works of the 1910s, this seems to be stretching things: its form derives from the traditions of stove making more than from geometric modernism. As Punin declared, if the stove could be called artistic at all, then it would be by virtue of having been made by Tatlin the artist, not by virtue of its form. This stove, he wrote, could probably have been "put together by any good stove maker."[6]

The photomontage can be seen as a rejoinder to this nonartistic character of the stove. Whereas the stove's form is distrustful of the eye and geared toward touch, the photomontage offers a specifically visual, graphic composition, especially in the lower half. The narrow vertical photograph of Tatlin modeling his sportswear suit was cut out of a larger photograph showing him surrounded by the four pattern pieces that make up the suit. To the left of Tatlin but now arranged horizontally in a row are the four pattern pieces that had surrounded him in the original photograph. They have been recombined to form a rectangular block with a red background that is answered, on the right side of the composition, by a thick black graphic line in the shape of a large half circle with a kind of horizontal tail. The horizontal block of pattern pieces on the left and the vertical photograph of Tatlin in his suit combine to form a vivid symbolic image: a hammer. This overall image also explains the strange, truncated form of the black graphic line on the right: it forms an abstract sickle, with curved blade and straight handle. Tatlin has created a subtle version of the ubiquitous Soviet symbol of the hammer and sickle.

In this highly visual object, Tatlin and his everyday material objects become a hammer with which to strike the NEPmen in their fancy suits, to smash the old material life in the Russian tradition of transcending everyday life. Like the hammer-wielding proletarians who populated propaganda posters, Tatlin became a savior figure who would rain blows down upon the old everyday life from above, rather than participate in it from within. The photomontage violently reasserted the authorial presence that had been largely repressed from the visual form of the everyday objects, and it marked the vivid return of the "eye" to the "touch" of Tatlin's work in the Section for Material Culture.

On the other hand, although the photomontage may embody an eruption of repressed authorial agency, it also remains fundamentally faithful to the goals of Tatlin's Section. The

content of the hammer, after all, is the sportswear suit, one of the material objects that would meet the demands of "our simple and primitive everyday life" and bring about a socialist "new everyday life." Rather than smashing matter and transcending material everyday life, in the spirit of Trotsky and the entire Russian philosophical tradition, Tatlin proposed to use his own, improved form of a material object to work against the particularly pernicious consumerism of NEP, represented by the fashionable men. His sportswear suit—and his stove and other objects—became instruments of "everyday-life-creation" in the sense evoked by Arvatov when he wrote that under proletarian culture, the thing will function for human beings "as an instrument and as a coworker."[7] Looking at Tatlin's stove allows us to understand the limitations of the Bolshevik ideal of the new everyday life. It also allows us to glimpse the possibility of the egalitarian and creative material culture imagined by the Russian avant-garde.

NOTES—1. Nikolai Punin, "Rutina i Tatlin," in N. Punin, *O Tatline*, ed. I. N. Punina and V. I Rakitin (Moscow: Literaturnoe-khudozhestvennoe agenstvo "RA," 1994), 71.

2. L. Trotskii, *Voprosy byta* (Moscow: Krasnaia Nov', 1923), 40.

3. Tatlin, cited in Punin, "Rutina i Tatlin," 71

4. V. E. Tatlin, T. Shapiro, I. Meerzon, and P. Vinogradov, "Nasha predstoiashchaia rabota," *VIII s'ezd sovetov. Ezhednevnyi biulleten' s'ezda*, no. 13 (January 1, 1921), 11.

5. Boris Arvatov, "Everyday Life and the Culture of the Thing (Toward the Formulation of the Question)," trans. Christina Kiaer, *October*, no. 81 (Summer 1997): 121.

6. Punin, "Rutina i Tatlin," 68.

7. Arvatov, "Everyday Life," 124.

31

Soviet Images of Jehovah in the 1920s

Robert Weinberg

Russian anti-Semites believed that Jews threatened the well-being and stability of Russia because they engaged in capitalist exploitation of non-Jews, subverted the political order by participating in the revolutionary movement, and embraced a religion intent on promoting Jewry's domination of the world.[1] Although scholars have explored Russian anti-Semitism in terms of policies, activities, and the printed word both before and after the revolutionary divide of 1917, they have devoted less attention to visual depictions of Jews and Judaism. Pictorial representations of Jehovah published in the Soviet Union during the 1920s, as we will see, supplement what we already know about the history of anti-Semitism in Russia.

The images examined here come from a periodical titled *The Godless at the Workbench* (*Bezbozhnik u stanka*), published jointly by the Moscow branch of the Communist Party and the Moscow Society of the Godless during the 1920s. Its purpose was to undermine religion's hold on Soviet citizens, and the articles and pictures in *The Godless at the Workbench* provided communist activists with the material needed to promote atheism and secular values among the populace.[2] Along with coercion and repression, antireligious activists used a combination of visual and textual approaches to undermine the hold that Judaism had on most of the nearly two and a half million Jews then living under Soviet power. From the perspective of the communist regime, the production and use of visual images that promoted secular values were an integral part of its broader project to build a socialist culture and society. The message was straightforward: Judaism helped to exploit the vast majority of Jews (who were poor) by serving the interests of the Jewish bourgeoisie. Religion and capitalism worked in tandem to ensure the Jewish bourgeoisie's stranglehold on Jewish society.

The depictions of Jehovah that appeared in *The Godless at the Workbench* tended to draw upon a stock repertoire. The publishers and artists of the journal did not shy away from using grotesque caricatures and traditional anti-Semitic stereotypes to deliver their message. The drawings that appeared in *The Godless at the Workbench* turned Jehovah into a monster and marked Judaism and its adherents as enemies of the socialist revolution. Artists used physiognomy and clothing to convey the message. Certain articles of clothing served as markers of class and religiosity, and even body type was significant. Jewish capitalists, for example, were drawn with tuxedos, spats, big noses, and self-satisfied, overweight countenances. In some drawings the artists depicted the Jewish bourgeoisie as religious Jews: they wear sidelocks,

skullcaps, prayer shawls, and phylacteries.³ Still other drawings underscored the artists' belief in the connection—perhaps a biological link—between Judaism and capitalism. In figure 31.1, Jehovah appears pregnant with a fat-cat capitalist holding two bags of money.

In figure 31.2 (color section) a religious Jewish industrialist prays to a one-eyed Jehovah, who appears as a heavenly visage emanating from the smokestacks of the factories in the background (his name is spelled backwards in Cyrillic in a reference to the fact that Hebrew is written right to left). In this cartoon Jehovah is making the sign of the Priestly Benediction. This suggests that the Jewish bourgeoisie have agreed to worship Jehovah in exchange for protection and status as the chosen people. The caption is drawn from biblical passages that refer to Jehovah's selection of the Jews as the chosen people and Jehovah's promise to help defend them (Deut. 6:3 and 7:6–7 and 24, and Lev. 26:12). Elsewhere in *The Godless at the Workbench,* captions accompanying depictions of Jehovah were taken from the Hebrew Scriptures to underscore how the foundational text of Judaism legitimated the behavior of capitalist Jews who acted against the interests of the Jewish proletariat. In this illustration, the covenant between Jehovah and the Jewish bourgeoisie allows the industrialist to vanquish the downtrodden, barefoot Jewish worker.

It is difficult to ascertain either how readers may have understood such images or what the artists of the drawings intended. Symbols and images may lose their effectiveness if their messages are arcane or opaque. At the same time they can be especially effective if their meanings are ambiguous and subject to multiple interpretations. The general message of these drawings may have been relatively easy to understand to the informed eye, but not all features of these drawings were easily parsed. One function of political art is to provide a visual script designed to lead to new modes of thinking and behavior. Yet no matter how powerful and persuasive these images may be, no matter how deftly they incorporate popular mythologies, viewers' responses can be unpredictable because visual representations are open to diverse readings. The absence of explanatory text that could help decode and demystify the drawings' imagery enhanced the likelihood that the typical readers of *The Godless at the Workbench* would interpret what they saw with the cultural repertoires available to them. The artists of these drawings could select freely from the vast repository of visual imagery in Russian religious, political, and folk culture, although there is no way to tell whether their audiences took away with them the message intended by the artists.

The representations of a one-eyed Jehovah are a case in point. Depicting the Jewish god with a single eye, as in figures 31.1 and 31.2, makes several allusions; what the artists had in mind and how readers interpreted the images are difficult to know with certainty. Russian icon painters depicted the Great Eye (*velikii glaz*) on icons and wrote the word "God" underneath as a way to capture the viewer's attention.⁴ Yet religious images and texts in Russian Orthodoxy were supposed to be open to multiple messages. The single eye could, for instance, refer to the all-seeing and all-knowing Jehovah who watches over the Jews. Since the Jewish god has no physical manifestation, the single eye may therefore represent the unity that Jehovah supposedly embodies. Moreover, on tombstones in Jewish cemeteries and in some European synagogues the depiction of a single eye referred to Jehovah's keeping a watchful eye on his flock.

But the single eye could also be an expression of the evil eye. Russian popular culture was

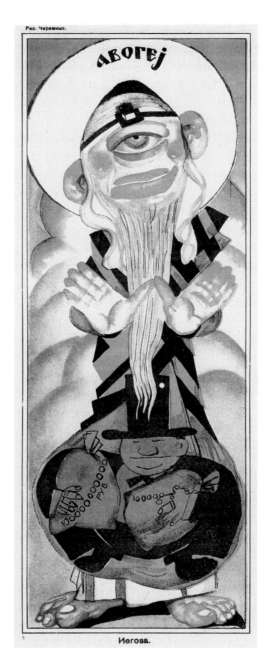

31.1. *Jehovah.* Anti-Semitic cartoon from *The Godless at the Workbench* (1923).

rich with such imagery, and the single eye may have represented the artists' belief that adherents of Judaism wished the worst for the communist regime. The single eye could also allude to the purported association between Jews and Freemasonry, a movement organized in secret societies, that emerged during the eighteenth century and was rooted in Enlightenment ideals. One familiar symbol of the Freemasons was the single eye, best known to Americans as the one in the pyramid on the back of the one-dollar bill. During the nineteenth and early twentieth centuries, both conservative political forces and anti-Semites fostered a belief in a worldwide Judeo-Masonic conspiracy. Opponents of the Freemasons claimed that Freemasons were disguised Jews who worshipped the devil in the form of a goat. Such a belief enjoyed common currency in Europe at the turn of the twentieth century, and some of Russia's educated public undoubtedly shared this sentiment. After 1917 enemies of the communist regime condemned the supposed Judeo-Masonic conspiracy as the cause of the upheaval that had engulfed Russia.

Figure 31.3 (color section) offers a different depiction of Jehovah. Although this Jehovah has one eye like the others, his physiognomy is unusual in other ways, too. A worker, easily identified as such by his boots, cap, and jacket, draws open a curtain, revealing the inside of a synagogue where Jews wearing prayer shawls are genuflecting below the image of a goat's head labeled "Jehovah" (rotate the image 90 degrees to the right to see the goat from another perspective). The Jewish god wears a top hat emblazoned with a double-headed eagle, the seal of the Romanov dynasty. "God" possesses a single eye and a nose similar to a closed fist with the thumb sticking through the second and third digits. Lightning bolts emanate from around the goat's head and hurtle toward the congregants. The caption reads, "Now is the time to clear away the fog that the bourgeoisie set upon us. Down with this bastard of a religion."

What are we to make of Jehovah's resemblance to a goat's head with a fist as a nose? Since medieval times Christian Europe had associated Jews with goats, which were also known as the devil's favorite animal. These associations still enjoyed common currency in early twentieth-century Russia. The presence of a single eye dominating the goat's head might have prompted the viewer to conclude that Jews and Freemasons were one and the same, jointly responsible for evil in the world. In addition, the goat's snout draws upon the long-standing stereotype of Jews as having large noses, and the thumb sticking through the fist resembles the *mano in fica* (the "fig" hand), a gesture commonly employed in Europe to ward off the evil eye. But giving someone "the fig" is also an insulting, if not obscene, gesture. It is equivalent to telling someone to "get lost," but in some contexts it may mean "fuck you," or serve as an obscene sexual invitation, or refer crudely to female genitalia. Undoubtedly, the various meanings of the mano in fica would not have been lost on most Russians, for the gesture enjoyed currency among the general populace. In short, the drawing portrays a cynical and deceitful Jehovah thumbing his nose at his loyal flock of worshippers.

It is impossible to ascertain whether someone looking at figure 31.3 would have deciphered the connection between Jehovah and evil in such literal terms. But the message of this drawing and the other images explored in this essay drew its sustenance from the multiple readings that visual representations of Jehovah could elicit. At the very least, viewers of these illustrations would have been exposed to bizarre and grotesque images of Jehovah that relied on folkloric, cultural, religious, and political traditions of Russian society and that reinforced stereotypes

and prejudices already in place. Moreover, the depiction of a monstrous Jehovah paralleled depictions of the revolution's alleged opponents in Soviet political posters, where so-called enemies of the people were frequently rendered as bloodthirsty monsters engaged in heinous crimes against the world's first socialist society.

Ironically, the depictions of Jehovah in *The Godless at the Workbench* may have subverted the regime's effort to undermine anti-Semitism: they may have fostered suspicion of all Soviet Jews, not just the bourgeois exploiters. Despite the communist authorities' policy of combating anti-Semitism in the 1920s, illustrations such as the ones presented here may have not improved relations between Jews and non-Jews. Indeed, they may have helped keep alive anti-Jewish prejudices The drawings of Jehovah in *The Godless at the Workbench* did not try to sever the distinction between antireligious activity and anti-Semitic diatribe. Consequently, the artists who drew for the journal may have unwittingly nurtured the survival of anti-Jewish sentiments among the Soviet populace.

NOTES—1. On Soviet anti-Semitism, see Zvi Gitelman, *A Century of Ambivalence: The Jews of Russia and the Soviet Union, 1881 to the Present,* 2nd ed. (Bloomington: Indiana University Press, 2001); Nora Levin, *The Jews in the Soviet Union since 1917: Paradox of Survival* (New York: New York University Press, 1988); Yaacov Ro'i, ed., *Jews and Jewish Life in Russia and the Soviet Union* (Essex, England: Frank Cass, 1995).

2. On the Soviet campaign against Judaism, see note 1; and Anna Shternshis, *Soviet and Kosher: Jewish Popular Culture in the Soviet Union, 1923–1939* (Bloomington: Indiana University Press, 2006).

3. Observant Jews are enjoined from shaving their facial hair and often grow long curls along the side of their faces. Two phylacteries—small leather cases containing pieces of paper with passages from the Hebrew Scriptures— are worn during morning prayers.

4. Victoria Bonnell, *Iconography of Power: Soviet Political Posters under Lenin and Stalin* (Berkeley: University of California Press, 1997), 42, 159; and Boris Uspensky, *The Semiotics of the Russian Icon,* ed. Stephen Rudy (Lisse, Belgium: Peter de Ridder Press, 1976), 39.

32

National Types

Francine Hirsch

C an images tell their own stories? How much information or context do we need to make sense of a series of tables or photographs? Take the images of Chuvash, Mishar, and Russian "types," for example, shown in figures 32.1–32.3. What do these images evoke for us? We see three sets of headshots, each set photographed from the same three angles. All of the subjects have serious expressions; all are in fixed positions, holding themselves still for the camera. The photographs are in black and white. There is no date. A pair of calipers, a standard tool used in physical-anthropological research for taking head measurements, is discernible in the first photograph of each set.

Is it possible to look at these images without thinking about Nazi theories of biological determinism and racial hygiene? Do these images make national or ethnic types into racial types? Are all racializing images racist? Can the images speak for themselves, or do we need to know more about them and their origins?

Those of us who can read Russian have some additional information at our disposal. The text underneath the headshots identifies each subject as "Chuvash," "Mishar," or "Russian." It also states each subject's age and place of residence and gives a list of physical traits with corresponding numbers. The twenty-six-year-old Chuvash is catalogued this way: "Skin color—8, hair color—6, eye color—8. Body hair: chest, abdomen, thighs—0, forearms—2, calves—2. Height—164.7, head index—78.53, facial index—83.10, nasal index—68.0. Blood group—III." The twenty-three-year-old Mishar is catalogued this way: "Skin color—10, hair color—7, eye color—7. Body hair: chest, abdomen, thighs—0, forearms—1, calves—2. Height—183.4, head index—82.72, facial index—86.62, nasal index—62.96. Blood group—I." The twenty-nine-year-old Russian is catalogued this way: "Skin color—3 (gray hue), hair—14, eyes—10. Body hair: chest—1, abdomen, thighs—0, forearms—1, calves—2. Height—167.0, head index—80.21, facial index—83.57, nasal index—62.07. Blood group—II."

What have we learned from reading the text under the images? Well, it is obvious that the subjects have some differences. Some have more hair than others, or different coloring. It is not as clear what these differences mean. No additional information is provided on these pages about the indexes that were used or about the significance of the numbers. We also have learned that the individual or organization that published these photographs was interested in the subjects' physical and constitutional traits. But does this help us to figure out what purpose

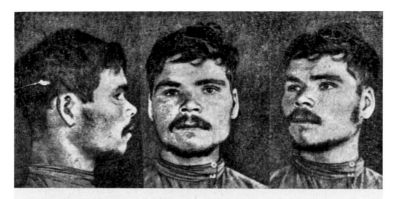

Рис. 1. Чувашин, 27 лет, Батыревской вол. Цвет кожи—11, волос—5, глаз—8. Растительность на теле: грудь, живот, бедра—0, предплечье—1, икры—2. Рост 165.7, головной указ.—78.75, лицевой—83.67, носовой—80.43. Группа крови—II.

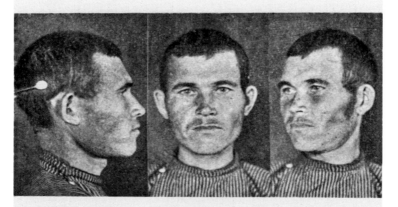

Рис. 2. Чувашин, 26 лет, Батыревской вол. Цвет кожи—8, волос—6, глаз—8. Растительность на теле: грудь, живот, бедра—0, предплечье—2, икры—2. Рост—164.7, головной указ.—78.53, лицевой—83.10, носовой—68.0. Группа крови—III.

32.1. Ethnographic photographs of Chuvash "types," 1927.

the images were intended to serve? Does the inclusion of anthropometric data and information about skin color and blood group suggest that a racist agenda was at work? Some of us might know that similar images of national types appeared in Nazi journals in the late 1930s. Did the Nazi images and these images "mean" the same thing? Do these images reflect the Nazi idea that nature established a division into higher and lower races?

What if it were revealed that these images were the product of a Russian anthropological expedition that had the explicit aim of studying racial traits? What if it were also revealed that the Russian physical anthropologists and physicians who participated in this expedition had strong ties with German colleagues and used German anthropometrical indexes to compare

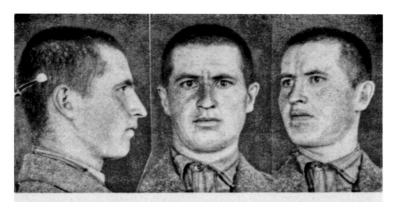

Рис. 1. Мишарь, 23 лет, Шихирданской вол., Батыревского у. Цвет кожи—10, волос—7, глаз—7. Растительность на теле: грудь, живот, бедра—0, предплечье—1, икры—2. Рост—183.4, головной указ.—82.72, лицевой—86.62, носовой—62.96. Группа крови—I.

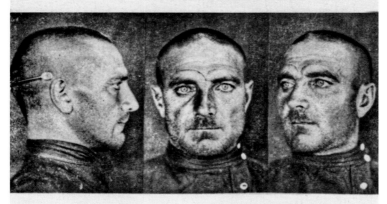

Рис. 2. Мишарь, 33 лет, дер. Биденги, б. Симбирской губ. и уезда. Проживает теперь в с. Шихирданах. Цвет кожи—10, волос—4, глаз—14. Растительность на теле довольно сильно развита: грудь—3, живот—0, бедра—2, предплечье—2, икры—3. Рост 165.4, головной указ.—77.94, лицевой—88.97, носовой 70.18. Группа крови—III.

32.2. Ethnographic photographs of Mishar "types," 1927.

health, illness, blood group, morphological types, intelligence level, and physiological functions among different population groups? Would this information, combined with the visual experience of seeing the photographs, be enough to help us reach an accurate conclusion as to what the images were about? Would it complicate matters if we learned that the photographs were taken in the Soviet Union in the mid-1920s—almost a decade *before* the Nazis spread their own theories worldwide and embarked on their racial-biological revolution?

These images cannot tell their own stories. The photographs were taken in the summer of 1927 during a "complex" (*kompleksny*) research expedition to the Chuvash Autonomous Soviet Socialist Republic (ASSR). The expedition was state sponsored, and received funds from

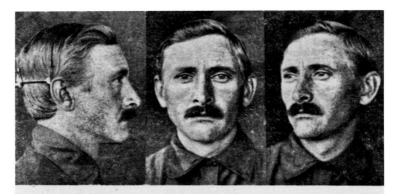

Рис. 2. Русский, 29 лет, уроженец Шамкинской вол., Батыревского у. Цвет кожи—3 (серый оттенок), волос—14, глаз—10. Растительность на теле: грудь—1, живот, бедра—0, предплечье—1, икры—2. Рост—167.0, головной указ.·—80.21, лицевой—83.57, носовой—62.07. Группа крови—II.

32.3. Ethnographic photographs of a Russian "type," 1927.

the State Planning Commission (Gosplan), the Soviet Academy of Sciences, and the Chuvash ASSR government. Its main purpose was to "elucidate the young republic's productive forces" and promote "the development of local industries and agriculture." The expedition's anthropological-ethnographical detachment, which brought together physical anthropologists, ethnographers, and linguists from three Leningrad institutions, studied the republic's population from racial, linguistic, and social-hygiene perspectives. An explicit aim of this detachment was to prove that racial differences among the republic's nationalities existed but were *irrelevant.*

The photographs before us—of Chuvash, Mishar, and Russian "types"—and the accompanying text were published in a 1929 volume about the Chuvash ASSR expedition, titled *Chuvash Republic (Chuvashskaia respublika).* The prominent physical anthropologist Boris Vishnevsky, who participated in the expedition, wrote the last chapter, which described the research program and the findings of the anthropological-ethnographical detachment. We learn from this chapter that Vishnevsky and his colleagues drew blood from and recorded anthropometrical data for a thousand men and women in an effort to examine the correlation between nationality (*narodnost'*) and race; we also learn that the same anthropologists took the photographs of national types. According to Vishnevsky, the anthropologists discovered significant differences between the Chuvash and the Mishars in blood group distribution, as well as in skin, eye, and hair color, and concluded that the two peoples belonged to "different anthropological groups." Vishnevsky also noted that, on the whole, there was a different blood group distribution among the Chuvash than among their Russian neighbors. But he also pointed out that there was a continuum and that notable differences could be found between Chuvash of different regions or between Russians or between Mishars,

What did all this mean? We learn from the 1929 volume that Vishnevsky did not make value

judgments about the different anthropological groups or attempt to link racial traits to particular cultural, behavioral, or psychological traits. Instead, he looked at data about language distribution and migration patterns for the same regions. He determined that the patterns of racial and linguistic intermixing in the Chuvash ASSR were similar—and that this was a result of particular migration and settlement patterns. In the end, Vishnevsky concluded that data about the distribution of physical and constitutional traits, like data about the distribution of dialects, could provide important information about the historical interrelationships between different peoples. Does this information change our opinion of these photographs? Was Vishnevsky a racist? Are the photographs racist?

How might people reading the 1929 volume *Chuvash Republic* have viewed these photographs? How unusual was Vishnevsky's position? To even begin to answer these questions we would have to look at additional Soviet and other sources from the same era. If we undertook this research, we would learn that Soviet physical anthropologists—like their western European and American counterparts—were participating in an international dialogue during the 1920s about the significance of race and the causes of physical and constitutional differentiation. We would also learn that Soviet anthropologists were debating among themselves and also with colleagues abroad whether the physical and constitutional characteristics associated with different nationalities were indelible and immutable, or developmental and dynamic. The same Soviet anthropologists would take on Nazi race theorists in the 1930s and would challenge the Nazi position that racial traits derived from immutable genetic material and that some nationalities were destined for greatness and others for extinction. These anthropologists would do extensive fieldwork with the mandate to prove that all nationalities could flourish when placed in favorable economic and social conditions.

This information may—or may not—change how we view these images.

33

Envisioning Empire

Veils and Visual Revolution in Soviet Central Asia

Douglas Northrop

In Central Asia the Muslim and Slavic worlds met (and sometimes collided) across a broad cultural divide. Literacy levels were low, so the encounter was expressed in a language that was as much visual as textual or oral. Merely by acting or dressing in a certain way, people made nonverbal statements about their identity, about state power, and about the future of Central Asian and Soviet society. They did so, moreover, with specific viewers in mind.

Party policy in the exotic "East" aimed at multiple audiences. It had to reach local men and women but also to inspire the wider colonized world, to accelerate a world socialist revolution by showing the promise of Soviet power to the millions watching from India, Africa, Southeast Asia, and the Middle East. Bolshevik activists thus devised initiatives and policies to *show*—as publicly, even theatrically, as possible—that in the USSR, a backward, primitive hinterland was being transformed and modernized, virtually overnight, thanks to the progressive, emancipatory programs of the Bolshevik party and Soviet state.

Visual images served as a kind of bridge—a way to show that the Central Asian republics were undergoing the same process as revolutionary Russia, perhaps even more dramatically. Pictures worked in getting that message across to an international audience. At the same time, however, these images were not so easily translatable when directed at Central Asian audiences; the resulting visuals could be (and were) read and interpreted locally in wildly different ways.

Consider figure 33.1, an archival photograph of a veiled Uzbek woman taken in 1930. Veils served as emblems—but of what? To a good Bolshevik, such images showed backwardness, primitivism, dirt, and debauchery. They were a metaphor for the despotic character of Central Asian society, and the presence of children only heightened the horror. To a devout Muslim, however, this image of a veiled mother was just as easily read as showing piety and good character—especially three years after the party had launched its *hujum* (assault), the all-out onslaught against the veil that had started in 1927. To many Muslims the campaign looked like a fight by foreign, urban atheists to overturn their world of propriety and decency, even to destroy Islamic society altogether. To such viewers, the sight of children with an upstanding mother had a reassuring, not frightening, tone as veils became a marker of cultural authenticity and national identity—and a primary site of anticolonial resistance.

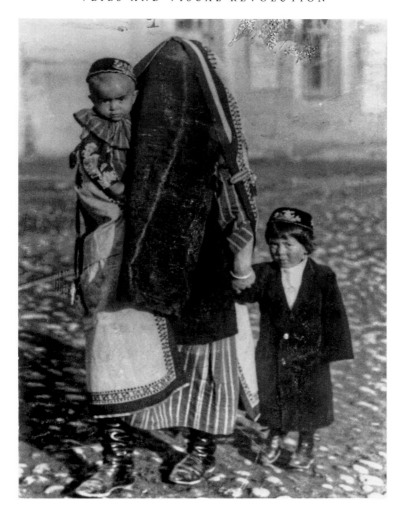

33.1. Uzbek woman with children, 1930. Photograph.

Once such dress had been politicized by the hujum, even capturing images like the one of the veiled Uzbek woman could be a double-edged sword. Although pictures of veils were meant to show local backwardness and thus to justify Soviet reforms, the continuing presence of veiled women in the 1930s and 1940s also showed the untranslatability of this visual "liberation"—by demonstrating that Soviet policies had failed to penetrate and transform Central Asian society as readily as party activists had expected. This photograph—and others like it—remained unpublished.

Why, then, were such photographs produced? For Soviet image makers, Central Asia had to be shown as exotic, as different, as utterly unlike the Bolshevik ideal of a modern, technologically advanced society. In a wide variety of photographs, paintings, and postcards, Russian and other nonnative artists illuminated what they saw as the alien character of Central Asian life. Often they focused on physical objects and material culture; architectural studies were

common. They emphasized unfamiliar patterns of dress and behavior. Dusty streets, ancient buildings, strange clothing, and peculiar rituals all figured prominently — photographers and artists drew on these preexisting orientalist images to capture what they saw as a distant, exotic, static East.

Heavily veiled Muslim women like this one frequently figured as an integral, even definitive part of the Central Asian landscape. Russian viewers had long been exposed to such images. In these pictures the veiled woman appeared as a motif that neatly embodied Muslim society, capturing an indefinable and timeless essence of Central Asia in a way that written texts alone seemed unable to do. Veils both packed an erotic charge and drew a sharp contrast between Russian viewers and Muslim subjects, affirming these Russians' own, sometimes precarious identity as "Europeans" — as bearers of civilization in an area they judged primitive, backward, benighted. Central Asia was a place for them to overcome their own sense of cultural ambiguity and inadequacy. Russian authorities thus insisted — even more forcefully after 1917 — that Central Asia had to be transformed, and as completely and quickly as possible.

After 1917, orientalist images of veiled women and ancient minarets did not stand alone but were also paired with other, very different images that showed the dramatic impact of Soviet power. These pictures likewise aimed at an external audience; but they were also distributed widely within the region as new visual technologies (films, posters, photograph exhibits) circumvented the practical problems of reaching a largely illiterate population. And once again, these images played very differently on these two audiences.

This new Soviet image making aimed to show the sudden and total transformation of Central Asia. By the late 1920s, Soviet activists were working hard to bring about sweeping changes to everyday life, on the streets of local neighborhoods and in the intimate space of the Muslim family. Their evangelical efforts aimed to instill an egalitarian approach to social relationships — especially through the revolutionary message of gender liberation that was aimed at local women through the hujum.

For Russian and outside audiences, the meaning of this campaign was captured by the image in figure 33.2, an archival photograph of a Tajik woman taken in 1936, of a veil being cast aside. Veils were usually removed at large public demonstrations and often tossed into celebratory bonfires. In the official narrative of liberation, veils now served as physical symbols of ancient Muslim tradition. They were the visible detritus of old ways, thrown aside by thousands of heroic women inspired by the party's message of emancipation. The hujum focused on the visual — above all, on changing the way women *looked*. Party activists assumed that these images would inspire viewers, that success in unveiling women would transform, more or less straightforwardly, all the relationships and hierarchies that defined Muslim society.

For wider audiences, the Soviet visual revolution — as embodied in images of unveiling — drew its power from viewers' shared familiarity with the earlier orientalist pictures. Without the cultural resonance of such deeply embedded visual tropes, Bolshevik leaders could not have conceived a Central Asian campaign based on the unveiling of women — nor would unveiling have had its explosive symbolic power. There could be no more effective way to show a global audience the breadth, depth, and drama of the revolution under way in the East than by showing women freeing themselves of veils.

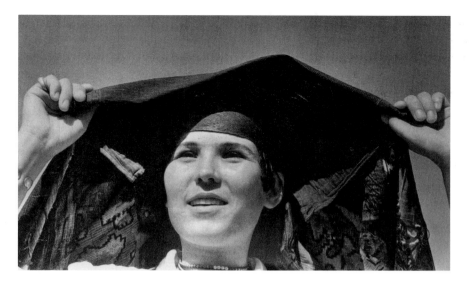

33.2. Tajik woman removing her veil, 1936. Photograph.

Yet these particular layers of resonance did not exist for indigenous audiences, and the officially sanctioned pictures of liberation worked on multiple and contradictory levels even for Europeans. If the pictures illuminate the visual texture of everyday life, they also show how the private sphere was represented and manipulated for public, political purposes. Figure 33.2 is, on one level, an image of female agency; it shows the kind of genuinely heroic choice made by many women who decided to unveil. But it is also staged; it is a piece of political propaganda, a photograph likely intended for publication: a tool for education, inspiration, and persuasion. It may even be evidence of state coercion, an image designed to overcome resistance among viewers by suggesting that they needed to show the same level of political loyalty as this eager woman. (The photograph was shot in 1936, as Stalin's party purges were verging to Terror—and as male party members in Central Asia were being purged specifically for their failure to unveil wives, sisters, mothers, and daughters.) Such pictures, then, are also political products, packaging family life and gender practices for specific purposes and to particular audiences.

Such ambivalences and ambiguities emerge further in figure 33.3, an image captured by the well-known photographer Max Penson. This photograph, taken on a kolkhoz in Uzbekistan in the early 1930s, shows the Soviet vision for Central Asia by depicting a mixed-sex group dedicated to the greater good of the state. These emancipated women do not wear veils. They are gathered alongside men as equals; they are socially involved, politically active, and economically independent. The viewer can tell they are good Soviet citizens: they are raising cotton (as encouraged by Moscow's central planners) rather than food crops for their own consumption.

Ideas of gender liberation, as well as ideas of social egalitarianism, are woven through the composition. Men and women sit together in a group. Everyone at the table is basically equal. One man is reading aloud, which may signal status or hierarchy, and so may the military cap

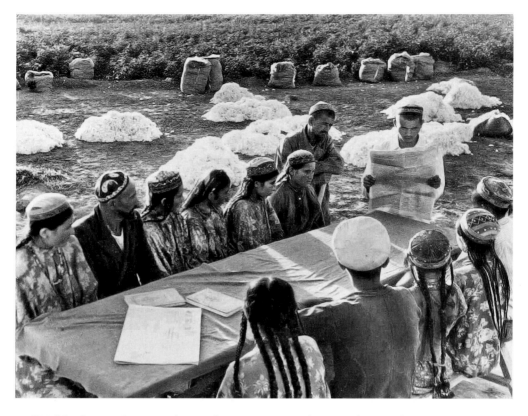

33.3. Max Penson, Cotton workers reading newspaper, early 1930s. Photograph.

worn by another, but there are no other signs of inequality. Here men and women are shown coming together before starting their day's work, convening to hear and discuss the latest news from a wider Soviet world.

Yet in reality such spaces were very rare. This image is better seen as an abstract assertion of Soviet ideals than as an accurate, representative, or transparent view of social interactions in the countryside. In fact, during the 1930s, despite the best efforts of Soviet activists, many women continued to wear veils; many who did unveil were attacked or raped. Hundreds were murdered and some mutilated. This violence represents an important strand of indigenous social response to—an alternate translation of—such images. Whatever the global audience thought of pictures of unveiled women, many Uzbeks were horrified by them.

And not just Uzbek men. Female agency worked in complex ways, and Central Asian women, too, had their own opinions about Soviet power. Consider the women here: they are quietly listening, heads bowed, projecting an air of modesty. Upon closer inspection, several do not appear eager to be in the picture—certainly they do not offer a zealous portrait of enthusiasm like the woman in figure 33.2. Even openly propagandistic images like this one can capture some of the subtle subaltern strategies of colonized peoples, the fleeting glimpses and raised

eyebrows through which men and women could talk back to, and in their own way partly resist, the policies and agendas of an overwhelmingly powerful state.

Finally, everyday scenes like this give an unexpectedly complex glimpse of the myriad quotidian negotiations and power relationships that characterized colonial society. Sometimes one need only look around the edges of a photograph, at the fashions, foods, or furniture that are used as props, to see the emergence of hybrid cultural forms. The tendrils of European material culture in Central Asian scenes—a samovar, a radio, Russian shoes, a military cap—served as emblems of modernity and socialist progress. They were talismans, constituting the thin edge of a wedge of cultural transformation, and were adopted by local men and women who wished to declare an affiliation with this kind of cultural change.

In this image, even the presence of a table and chairs is crucial. They show both the obviously posed character of the photograph (how likely is it that furniture would be arranged in the middle of a field?) and the European framework for Central Asia's transformation. In this period, tables and chairs were specifically Russian objects; given a choice, Uzbek men and women rarely used them. Whether at home or elsewhere, they normally sat on the floor or on the ground, or at most on a raised platform, using pads and cushions for comfort. In the colonial world of Central Asia, even such simple objects as chairs encoded complex cultural meanings and expressed political messages of power, domination, and coercion.

An uplifting message of social transformation in Central Asia could not be captured straightforwardly in the visual medium of photography: unwanted ambiguities trickled through into the images, muddying the intended picture of a grateful population and its bright Soviet future. Photographs did still serve as an effective shorthand way to reach outside and international audiences, working well with foreign viewers who had never been to the Central Asian republics. Within Central Asia itself, however, images of Soviet-style women's liberation served less as a cross-cultural, nonverbal bridge to socialist revolution and more as a site that showed, sometimes all too visibly, the difficulties of cross-cultural translation.

34

The Visual Economy of Forced Labor

Alexander Rodchenko and the White Sea–Baltic Canal

Erika Wolf

In 1933, Alexander Rodchenko extensively photographed Belomorstroi, the construction of the White Sea–Baltic Canal, a forced labor project administered by the Soviet secret police.[1] His photographs appeared in numerous publications, including an issue of the magazine *USSR in Construction* (*SSSR na stroike*) designed by the artist. While other modernists were persecuted by the regime, Rodchenko celebrated the Gulag system of labor camps in slick propaganda. The work of Soviet artists after April 1932, when the Central Committee dissolved all independent cultural organizations, is often dismissed as compromised. Rodchenko's photographs and photomontages of the construction of the White Sea–Baltic Canal have been singled out as proof of the avant-garde's abandonment of their visionary project. However, this work was in accordance with vanguard principles and reveals the constructivist underpinnings of Stalinist visual culture.

After the revolution, the state welcomed the support of artists and commissioned agitational propaganda and monuments. Embroiled in civil war, the Communist Party was not concerned with cultural policies beyond urgent propaganda needs. Because Karl Marx had provided no comprehensive theory of culture, theorists considered the relation of art to the new society being established. The idea of uniting art with industrial production soon emerged. Art was equated with work and was envisioned as merging with production. The goal was not to create beautiful applied objet d'arts but to make scientifically designed industrial products. In 1921 these theories led to the formation of the First Working Group of Constructivists and their proclamation of a synthesis of art and industry.

Rejecting conventional art, the constructivists relegated purely artistic exploration to the "laboratory" and sought to extend the results of artistic experiments into the real environment through industrial production. However, constructivism's practical implementation was negligible. Soviet industry, virtually wiped out during the upheavals, was not receptive to artists with little actual familiarity of production techniques. The constructivists nevertheless found practical work in textile, graphic and theater design. Although graphic design necessitated a return to representation, photography provided a technological source of images without recourse to conventional artistic methods. After exploring photomontage, Rodchenko took up

photography in 1924. He approached the medium as a constructivist, extensively experiment-ing before publishing any photographs. Rodchenko began to photograph from unusual view-points, arguing that conventional shots from "center to center" were an anachronism cultivated by centuries of painting. He equated his extreme angles with a break from tradition, a liberation of vision that would encourage people to see from every point of view.

The constructivists embraced the camera as a technical tool of visual efficiency. Comment-ing on Rodchenko's photographs in 1926, Osip Brik argued that the camera possessed the ability to expand human vision. Because cameras, as machines, function independently, photographs could suggest new ways of seeing. The constructivists recognized the power of photography to create new realities and, consequently, to shape the viewer's consciousness in a hitherto-unrealized manner. In 1928, Rodchenko contrasted the documentary quality of photography to that of realist painting. While the synthetic realist painting, despite its claims for truth, will always remain a fabrication, the photograph is a precise document of a single moment. Paint-ing's search for "eternal truths" had been rendered obsolete by modern, scientific media. Single, unique truths were no longer sought; instead, facts were compiled. This devaluation of truth in favor of the production of facts had ominous implications. Even though Rodchenko envisioned his documentary approach as a tool for making utopia a reality, these principles would soon present a positive vision of an illogical, nightmarish regime.

In 1928, Rodchenko was attacked for plagiarism. His photographs were published along-side similar images by Western photographers, and he was accused of imitating their corrupt bourgeois forms. In response, Rodchenko rejected any claim that he had invented the acute angle shot: "Renger-Patzsch's *Chimney* and my *Tree,* both taken from below, are very similar, but don't the 'Photographer' and the publishers see that I made them similar on purpose? For hundreds of years painters kept on doing the same old tree 'from the belly button.' Then photographers followed them. When I present a tree taken from below, like an industrial ob-ject—such as a chimney—this creates a revolution in the eyes of the philistine and the old-style connoisseur of landscapes."[2]

Rodchenko may have emphasized photography's transformative potential, but his pref-erence for unusual viewpoints was subsequently identified as arising solely from his desire to confront traditional art, and this was deemed an aestheticizing, formalist approach. These debates had little impact on Rodchenko, other than to heighten his sensitivity to Soviet sub-ject matter. He procured photojournalism assignments and became active in the photography section of October, a modernist group dedicated to proletarian cultural revolution. October rejected art photography in favor of professional photojournalism and required its members to participate in industrial construction. In 1931 the October photographers were accused of formalism and distortion of socialist reality during the vitriolic debates of the class war. Rod-chenko was singled out for criticism and expelled from October.

The precise effect of these events is difficult to determine. While it has been asserted that he suffered professionally, Rodchenko continued to find prestigious work opportunities. The dissolution of independent cultural organizations in 1932 mitigated the creative feuding, and Rodchenko's photographs appeared in prominent publications, including *From Merchant Mos-cow to Socialist Moscow (Ot Moskvy kupecheskoi k Moskve sotsialisticheskoi,* 1932), an illustrated

version of a report to the Central Committee by Lazar Kaganovich, a member of Stalin's inner circle.

By 1933 other artists had achieved acclaim for their representations of industrialization. The art historian Alexander Lavrentiev, the artist's grandson, has noted that "Rodchenko also dreamt of showing in his own way some grandiose construction site. Therefore he considered the trip to Belomorstroi honorable, necessary, and socially justified work." In February 1933, Rodchenko went to Belomorstroi on assignment for Worker's International Relief, a German Communist media empire.[3] Sent by an autonomous international organization to record the construction of the White Sea–Baltic Canal, Rodchenko was not coerced into this work by the Soviet government. Arriving for a brief assignment, he realized the immense professional opportunity that Belomorstroi presented and began to document it as a freelance photojournalist. Rodchenko made a series of trips to the canal, where he spent at least three months, and produced more than two thousand negatives.[4] Unlike short-term guests, who were presented with a sanitized version of conditions, Rodchenko was in close contact with the camp leadership and must have been familiar with day-to-day operations. In May 1933 the editors of *USSR in Construction* became interested in Rodchenko's photographs. By enduring severe conditions to document a high-profile project, he secured a niche within this prestigious magazine. Published in Russian, English, French, and German, this deluxe magazine featured photo-essays that showcased the socioeconomic achievements of socialist construction during the industrialization drive.

Although the government generally suppressed knowledge of forced labor, Belomorstroi was an exception. This prison camp was internationally propagandized to demonstrate the progressive claims of Soviet penal policy. At the camp, "nonproductive," "antisocial" individuals were reforged through labor into productive, skilled, contributing members of society, and at the same time a useful public project was completed. The planned canal would strategically connect the Baltic and White seas, providing access from Leningrad to the White Sea in case of war. It was built with virtually no labor-saving, capital-intensive equipment, and the locks were made primarily of wood. Completed in less than two years, in August 1933, the canal was ultimately of minor strategic importance, and the wooden locks required constant maintenance.

Rodchenko's photo-essay begins with a Soviet creation myth about the abstract idea of water and Stalin's leading role in transforming this idea into a concrete reality (fig. 34.1). The narrative elaborates the progress of construction and concludes with the leader's inspection of the new canal. This account celebrates socialist society's achievements: the establishment of a new transportation route, the innovative use of materials, and the transformation of outcasts into members of society.

Rodchenko's compositions propel the narrative, and skillful montage juxtapositions add dynamism. The spread captioned "The attack on the land took place with spades and explosives, iron and fire!" presents a densely montaged landscape of construction as military battle (fig. 34.2). The integration and juxtaposition of fragments from numerous photographs creates multiple viewpoints, shifting scales, and rising and falling horizon lines, which together evoke the constant state of transformation at the construction site.

The photo-essay employs constructivist practices first developed during the 1920s. Numer-

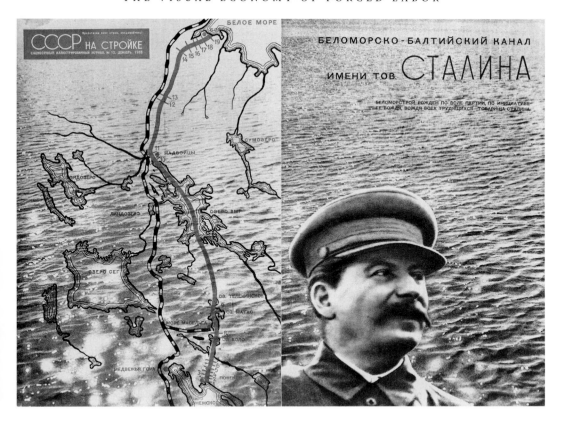

34.1. Alexander Rodchenko, *The White Sea–Baltic Canal Named for Comrade Stalin.* Photomontage title page, *USSR in Construction* (1933).

ous facts—newspapers, maps, documents, statistics—are deployed to make Belomorstroi's achievement concrete. The transformative gaze of the camera is also abundantly present. The narrative is interwoven with themes of transformation: the change of the landscape over the course of the project, the passing of seasons, the conversion of natural materials into technical objects, and the rebirth of criminals as productive members of society. One spread includes a pine tree reminiscent of the supposedly plagiarized photograph of 1928. This subject reasserts Rodchenko's claims about the transformation of vision that could be achieved through photography. Another spread captioned "Mighty dams sprang up where there had formerly been forest" depicts a dam rising above a boulder-strewn, impenetrable forest (fig. 34.3). The inhospitable terrain is becoming a refined, technological landscape. At the far left, an artfully photomontaged pine rises out of the forest and into the realm of the dam. Spanning both realms, the pine calls attention to the canal's construction from local resources; the unruly forest becomes a work of engineering.

There is an additional hidden transformation behind Belomorstroi. No hard currency was provided to purchase excavation equipment, such as the American steam shovels employed at other sites. Men and women, not machines, did the work. Through the same shifting displace-

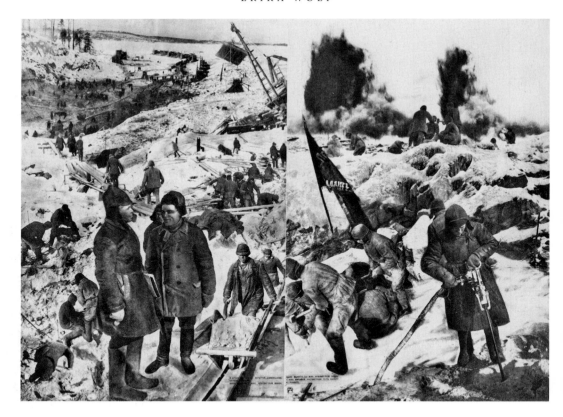

34.2. Alexander Rodchenko, *The Attack on the Land Took Place with Spades and Explosives, Iron and Fire!* Photomontage of prisoners at Belomorstroi, the White Sea–Baltic Canal construction site, *USSR in Construction* (1933).

ment by which trees become locks, the prisoners became machines, the industrial capital behind this engineering project. Mechanized equipment is largely absent in the photomontages. Pneumatic drills are featured in several spreads, but in the panoramic views, only hammers, shovels, wheel-barrels, and wooden derricks are visible. The raw, rocky vistas indicate that digging the canal was no easy chore. The severity of the climate and the difficulty of the task suggest that the cost in human lives was great. While the private slave owner has a capital investment that encourages concern for the continued physical well-being of the slave, forced labor in a controlled economy did not require a major capital investment. With an almost endless supply of labor at the state's disposal, there was no motive for providing the prisoners with minimum care or labor-saving equipment.

Despite the hidden atrocities and factual distortions, Belomorstroi is not entirely romanticized in Rodchenko's photographs. The prisoners do not seem particularly happy about their situation. The harsh nature of the environment is evident, as is the poor quality of the prisoners' garments. Guards are present, and guns are visible. This is, after all, a penal colony. Rodchenko, an active participant in the struggle for a new society, does, however, present an idealized vision

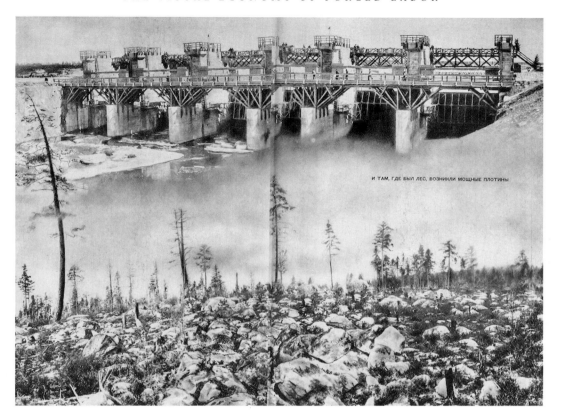

И ТАМ, ГДЕ БЫЛ ЛЕС, ВОЗНИКЛИ МОЩНЫЕ ПЛОТИНЫ

34.3. Alexander Rodchenko, *Mighty Dams Sprang Up Where There Had Formerly Been Forest.* Photomontage of Belomorstroi, *USSR in Construction* (1933).

of a progressive penal institution. He is projecting the transformations that would take place through the enactment of state policies.

The utopian aspirations of this propaganda may be traced to the postrevolutionary period, when the constructivists saw their visionary role as shaping the culture and environment of the future classless society. Rodchenko did not compromise his constructivist ideals. Inherent to his approach was a belief in photography's ability to transfigure reality. By the late 1920s, constructivism's concern for truth to materials had given way to the documentation of facts. The collection of facts casts aside truth; emphasis is given to the factual, regardless of historical validity. This distortion of facts was made in the utopian belief that it could aid in the realization of a society free of the ills plaguing both the capitalist world and postrevolutionary Russia. Rodchenko's idealized transfiguration of a brutal labor camp into a progressive penal colony through the medium of photography was a direct outgrowth of constructivism. Far from abandoning constructivism, Rodchenko utilized *USSR in Construction* to continue the visionary work begun earlier.

NOTES—1. The pioneering work on forced labor in the Soviet Union is David Dallin and Boris Nicolaevsky, *Forced Labor in Soviet Russia* (New Haven: Yale University Press, 1947). For more recent studies, see Michael Jakobson, *Origins of the Gulag: The Soviet Prison Camp System, 1917-1934* (Lexington: University Press of Kentucky, 1993); and Paul R. Gregory and Valery Lazerev, eds. *The Economics of Forced Labor: The Soviet Gulag* (Stanford, Calif.: Hoover Institution Press, 2003). Also see Aleksandr Solzhenitsyn's commentary on Belomorstroi in his *Gulag Archipelago, 1918-1956: An Experiment in Literary Investigation III-IV,* trans. Thomas P. Whitney (New York: Harper and Row, 1975); and see Cynthia Ruder, *Making History for Stalin: The Story of the Belomor Canal* (Gainesville: University of Florida Press, 1998).

2. Christopher Phillips, ed. *Photography in the Modern Era: European Documents and Critical Writings, 1913-1940* (New York: Metropolitan Museum of Art / Aperture, 1989), 247.

3. Aleksandr Lavrent'ev, *Rakursy Rodchenko* (Moscow: Iskusstvo, 1992), 170; Rossiiskii gosudarstvennyi arkhiv sotsial'no-politicheskoi istorii (RGASPI), f. 538, op. 3., d. 158, 1. 76.

4. Aleksandr Rodchenko, "Perestroika khudozhnika," *Sovetskoe foto,* nos. 5–6 (1936): 19; Lavrent'ev, *Rakursy Rodchenko,* 170.

35

The Cinematic Pastoral of the 1930s

Emma Widdis

Igor Savchenko's film-musical *The Accordion* (1934) pictures farm laborers at work and play. In the original film sequence from which the frames shown here are taken, they dance and sing to the merry strains of the accordion of the film's title, scythe the fields, then break for a lunch of simple fare. Meanwhile, the film's hero, Timoshka, continues to work with unflagging energy (figs. 35.1–35.3). The scene is apparently timeless, a glimpse of rural harmony and healthy labor reminiscent of Leo Tolstoy's *Anna Karenina*. Yet it supposedly depicts part of Soviet reality, the collectivized countryside of Stalin's Russia in 1934.

The initial problem posed by these images is clear: they contradict what historians tell us about life in the Soviet countryside during the 1930s. In reality, the rapid and huge-scale social change brought about by the collectivization project, initiated in 1929, left much of the countryside ravaged. The forced consolidation of individual smallholdings into vast collective farms and the elimination of private property often met with violent peasant resistance. Poverty and hunger, resentment and social discord, were common.[1] Yet here we see rural life as a joyful symphony. The difficult peasant is transformed into the happy, all-singing, all-dancing collective farm worker. How, then, are we to read these images?

The Accordion was produced in the year of the first Congress of Soviet Writers, usually seen as the moment at which socialist realism was adopted as the single cultural orthodoxy and the end of the artistic "experiments" of the 1920s. "Life has become better, comrades," Stalin announced. "Life has become more fun." The task of literature and cinema was to celebrate that improved reality, to produce films that were "cheerful, optimistic, and joyous." *The Accordion* was one of the first of what was to become a very popular and successful genre of filmed "musicals" (exemplified in the works of Grigory Alexandrov and Ivan Pyriev). These musicals were aimed to appeal to largely uneducated workers and peasants and were viewed by huge audiences.

Just twenty years ago, a film such as *The Accordion* would have attracted no attention, its images dismissed as "false." The films of socialist realism were long considered unworthy of scholarly notice, of little artistic value, evidence of the ossification of Soviet culture after the so-called end of the avant-garde. More recently, however, the cinema of this period has been recognized as a major resource for cinema scholars and cultural historians alike. Soviet culture was mass culture: its task was to mediate the ideological messages of a powerful (and oppres-

35.1. Farm laborers harvesting hay in *The Accordion* (1934). Film frame capture.

sive) regime. Film, as a medium at once visual and narrative, had a vital role to play: its moving pictures could blur the divide between reality and illusion; its power to remake the world seemed to echo the grand ambitions of the Soviet project itself.

Savchenko's *The Accordion* is a historical document—not because it presents a "real" picture of Soviet rural life but perhaps precisely because it does not. It is the distortion and varnishing of reality that is of interest to us as cultural historians. These are the kinds of images that surrounded ordinary men and women during the 1930s, images that were part of their reality. We cannot see them as "true"—but nor can we write them off as false. Our task is to try to understand how the images disseminated in cultural texts coexisted with reality and to learn how to read them. As a visual text, the film image must be treated with particular caution. Through the camera lens, films offer not just pictures of the world but ways of looking at the world. We can learn as much from the angle of a shot, from the speed of an edited sequence, as from an analysis of the themes and characters of a film. As Sergei Eisenstein's early description of film as "a tractor plowing over the audience's psyche" makes clear, Soviet filmmakers were extremely aware of the power of their medium and mobilized all its resources to convey the appropriate message.

The scene from which these frames come has much to tell. First, we see the villagers dancing

35.2. Farm laborers eating in *The Accordion*. Film frame capture.

and singing, as the hero, Timoshka, plays his beloved accordion. Second, we see them working in the fields, with the folk music still as the soundtrack. Thus labor and leisure are linked. The message is clear: if you work hard, you can play hard. Visually, these two parts of this sequence are linked by an emphasis on rhythmic movement. Just as the peasants dance in sequence, so they work in sequence. The harmonized movement of their bodies is a symbol of their collectivity: they live, dance and work *together*.

The film's visual emphasis on rhythm and harmony is echoed in its representation of nature; here the movement of the scything workers echoes the swaying of the corn in the breeze. The representation of the natural world in Soviet culture of the 1930s was no simple matter. In principle, the ideology of communism seemed to dictate a victory of humankind over nature: the subjugation of the natural world to the power of reason, science, and the machine. Notable, then, is the total absence of machinery in Savchenko's images. Instead, we have a pastoral vision in which man, woman, and nature appear as a single organic entity. Nature, moreover, is pictured in poetic terms. The camera lingers in close-up on individual sheaves of wheat and corn, still shots framed against the broader landscape, and such images periodically interrupt those of human endeavor. These shots are carefully balanced, however, by an emphasis on the robust energy and productivity of Soviet labor, as the workers harvest nature to their own ends.

As the film continues, the workers are called to lunch, and they sit to enjoy a bountiful feast of simple fare, with bowls of vegetables laid out along a wooden table. The iconography of

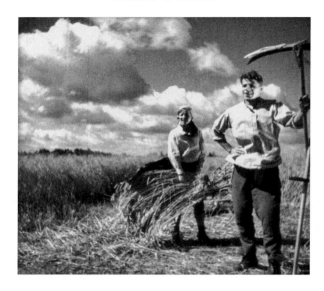

35.3. Timoshka in *The Accordion*. Film frame capture.

plenty is significant here—a far cry from the hungry reality of collective farm life in the 1930s. The camera dwells with almost fetishistic attention on faces, on mouths eating. The workers, shot from below, are endowed with a statuesque quality. Nameless, they become representative of more than their individual selves, images of an iconic peasant. All generations—grandparents, younger adults, and children—are represented; sharing their feast, they are an idealized microcosm of Soviet collective politics.

This stylized iconography has further significance. The visual codes of the sequence are largely timeless. The music, costumes. and style of dance are that of the folk tradition. Lunch is cooked in pots on an open fire in the fields, and the workers themselves seem visually drawn from an earlier tradition of the representation of rural Russia. These allusions to the folk past hide the real problems of contemporary reality, endowing Stalin's collectivized countryside with an eternal context and a nostalgic emotional impact. The landscape of the Soviet Union is still that of the eternal motherland, Russia.

Alongside traditional symbols we have the image of the heroic labor of the hero, Timoshka. Not joining his comrades for lunch, he continues to work, stopping only when he has cut a long path through the field of corn. As he completes his work with a flourish, he is rewarded by love: the local beauty praises him, and together they run joyously along the recently opened path— toward the shining Soviet future. As Timoshka completes his work, moreover, he proudly uncovers railway tracks, incongruous in this pastoral paradise. This curiously discordant moment is the film's essential nod to modernity: Timoshka's remarkable labor is part of the great Soviet path, the drive toward the future, of which the railway track is a symbol. Thus the apparently timeless space of the village is linked, via the railway, to the modern world. Labor and technology are linked to nature and timelessness in a careful balance typical of representations of the village during the 1930s.

It is clear, then, that we cannot take these images to be historical documents of life on the collective farm. We can, however, read them as historical documents of the iconography of the collectivization project during the 1930s. In this, one of the first examples of a film genre that might be called "Stalinist pastoral," three points are key: the link between labor and leisure (or joyfulness), images of plenty and collectivity, and the careful balance between nature and modernity.

Thus far, we have two preliminary readings of this sequence. The first writes it off as false, as mere propaganda. The second analyzes the iconography of that propaganda, examining how cinema remade historical experience as visual experience. The impact of that "visual experience" on Soviet society should not be underestimated. Both readings are inadequate, however. For both imply a straightforward relationship between state policy and cultural product, a view of the film as an expression of the ideology of the regime. In practice, the process was surely more complex. Any film of this period was, in a sense, a testing ground, where the director sought images appropriate to the rapidly changing political demands. The stakes were increasingly high: the arrest and assassination of the high-ranking Bolshevik Sergei Kirov in 1934 (the year that *The Accordion* was produced) is often seen as the beginning of the Stalinist Terror, and "enemies of the people" ran the risk of the most brutal of punishments. When we look at any Stalinist film, therefore, we need to understand it as part of a complex process of ideological negotiation.

How do such considerations affect our reading of these particular scenes? Certainly, *The Accordion* can be read as an attempt to conform and can be seen as part of a broader trend toward a new Stalinist pastoral. On another level, however, Savchenko's overtly stylized poetics could be seen as subtly subversive. On the one hand, they are excessive, explicitly not "real," acknowledging their own falsity even as they present it. On another, the use of folkloric iconography, and the almost total absence of the key symbols of Soviet modernity, such as the tractor, could be seen as a rejection of the much-vaunted ideals of Stalinist agricultural transformation. What is absent from the images may speak as much as what is present. Ultimately, of course, no single reading of the film can be authoritative. We cannot know what Savchenko meant. Nor do we need to. We should, however, view this visual document within its own context and enrich our reading by exploring the film's reception. How was it understood in its own time?

Soviet film reception worked on two levels: "official" (state) and "unofficial" (public). At the first, official level, we have some evidence, and individual case studies reveal censorship to have been a more arbitrary process than views of the monolithic Soviet administration might suggest. Stalin himself was an avid film spectator and an eager censor. The head of the cinematic administration, Boris Shumiatsky, organized almost daily film screenings for him in the Kremlin, and the Great Leader's comments carried enormous weight, for Shumiatsky and others attempted to translate them into official policy. Stalin and Shumiatsky viewed *The Accordion* on June 9, 1934. Although Shumiatsky praised the film's "merriness," and Stalin apparently approved of the "positive heroism" of Timoshka, Stalin did express doubt about the film's excessive pastoralism, and in particular about its failure to show that the Soviet countryside was "mechanized." Although the film passed the barriers of censorship and made it to the screen, it was not considered a success.

The final—and perhaps most important—level of reception for us to consider is also the most elusive: What did ordinary men and women think of the film? How was it "read"? How did fantasy and reality, ideal and practice, coexist in its spectators' minds? In the 1930s, this question is largely unanswerable. We are left, therefore, with the challenge of reading the visual text ourselves and recognizing its ambiguities, as well as its certainties. The images shown here formed part of the visual environment of the 1930s. Alone, they cannot prove anything. As part of a sustained analysis of many films of the same period, however, a reading of this filmed vision of the Soviet countryside may enable us to create a more nuanced and fluid understanding of Stalinist history.

NOTES—1. On collectivization and rural society, see Lynne Viola, V. P. Danilov, N. A. Ivnitskii, and Denis Kozlov, eds., *The War against the Peasantry, 1927-1930: The Tragedy of the Soviet Countryside*, vol. 1 (New Haven: Yale University Press, 2005); and Sheila Fitzpatrick, *Stalin's Peasants: Resistance and Survival in the Russian Village after Collectivization* (New York: Oxford University Press, 1994).

36

Portrait of Lenin

Carpets and National Culture in Soviet Turkmenistan

Adrienne Edgar

U ntil the collapse of the Soviet Union in 1991, the carpet titled *Portrait of Lenin* occupied a prominent place in the collection of the Turkmen State Museum of Art in Ashgabat (fig. 36.1 [color section]). Handwoven in the rich colors and delicate patterns characteristic of Turkmen carpets, it portrays a stern-looking Lenin framed by a traditional carpet border. It may seem incongruous to see the face of a Russian revolutionary leader peering out of a Central Asian carpet. If we look more closely, however, this image can tell us a great deal about the nature of the Soviet multinational state and the Bolsheviks' relationship with their non-Russian citizens.

The Turkmen were one of more than a hundred ethnic groups making up the population of the Soviet Union. Before the Soviet era, these Turkic-speaking Muslims did not form a unified or cohesive group; rather, the Turkmen population consisted of a number of tribes that spoke different dialects and were often politically at odds with one another. Historically nomadic and stateless, they inhabited a large, arid territory between the Caspian Sea and the Amu Darya along the southernmost frontier of the Russian Empire. In the eighteenth and nineteenth centuries, the Turkmen tribes gradually fell under the control of neighboring states, including tsarist Russia. After the Bolshevik revolution of 1917, some of these tribes were incorporated into the Soviet Union while others remained across the border in Persia and Afghanistan.

Like many Middle Eastern and Central Asian nomads, Turkmen were skilled weavers of carpets. Lightweight and easy to transport on the back of a camel, carpets constituted the ideal form of home furnishings for a nomadic (and later seminomadic) people. Turkmen families slept, ate, and sat on carpets, using them to cover and decorate the floor and walls of their portable felt tents, or yurts. Woven carpet material was also used to make a variety of other everyday objects, including saddle bags, storage containers for household goods, and adornments for camels and horses in wedding processions. Useful and durable, these colorful artifacts—traditionally woven by women—were an important source of beauty and artistry in a harsh environment.[1] Carpets also served as identity markers for the various Turkmen tribes, each of which was associated with a specific carpet design. (The pattern on *Portrait of Lenin* is typical of the Tekke tribe, which inhabits the central areas of Turkmenistan near the capital

of Ashgabat.) Moreover, weaving was an important source of cash income for the Turkmen, whose carpets—known as Bukharans after the city where they were traded—were prized by connoisseurs throughout the world.

Carpet weaving retained its importance in Turkmenistan after 1917, but customary ways of producing and viewing carpets were reinvented under Soviet rule. First, the Soviet state encouraged the formation of carpet-weaving cooperatives, which received raw materials and other assistance from the government and sold their carpets directly to state agencies. Cooperative workshops were billed as a way of promoting women's emancipation by encouraging female economic self-sufficiency within Turkmen villages; the workshops were also intended to eliminate the "capitalist middlemen" who had hitherto dominated the carpet trade. Second, carpets ceased to be merely objects of everyday use and came to be valued as works of art in their own right. The most beautiful were placed in museums, and their creators were acknowledged as "honored artists of the Soviet Union." These "artistic" carpets were removed from their functional context and transformed into objects to be viewed, not used. Displayed on the walls of the republic's museums, they were intended to inspire visiting schoolchildren and workers with reverence for the artistic genius of the Turkmen people. Finally, and most importantly for understanding the genesis of the *Portrait of Lenin,* carpets became an important element of the new Soviet Turkmen "national culture."

One of the surprising things about the Soviet multinational state was that the Bolsheviks did not try to impose Russian culture on the non-Russian periphery; instead, they promoted the indigenous languages and cultures of all Soviet peoples. Lenin and Stalin believed that Soviet citizens could best be reached with the Bolshevik message in their own languages. Moreover, they argued that the Soviet state could hasten the eventual merging of all Soviet nations into a single socialist family by encouraging the development of each nation's special character. A key aspect of this Soviet nationality policy was the creation of national territories for each ethnic group. In 1924–25 the Soviet regime divided Central Asia into five national republics, one of which was the Turkmen Soviet Socialist Republic. Within each territory, the indigenous nationality enjoyed preferential access to education and jobs, and the Soviet leadership promoted the establishment of books, newspapers, and schools using the native language.[2]

Soviet authorities also promoted the development of a distinct national culture within each republic. Because Soviet nations were supposed to be modern and socialist, however, the communist leaders in Moscow took it upon themselves to decide which customs and traditions were acceptable and which were "backward" or "exploitive" and therefore destined for elimination. Aspects of indigenous Central Asian cultures that were deemed oppressive to women, such as veiling and polygamy, were banned. Religion was targeted for elimination in accordance with the Soviets' atheist and materialist philosophy. The works of prerevolutionary writers and poets who allegedly possessed a "class-alien" or "anti-Soviet" orientation were banned.

The aspects of national culture vigorously promoted by the Soviets included folk arts, such as handicrafts and folkloric dancing. The state also encouraged the development of a national literary and musical culture in each republic, as long as it was free of the taint of "feudalism." These national cultures, however much they might differ from each other superficially, were all supposed to be infused with "Soviet" or "socialist" ideology. As Stalin famously declared

in 1925, the cultures of the Soviet nations would be "national in form, socialist in content." Often this meant that they were to become more similar to Russian culture, which was deemed more modern and socialist than that of Muslim Central Asians. Thus, Central Asian writers were encouraged to abandon their indigenous traditions of epic poetry for Russian genres like the novel and short story. Indigenous traditions of musical performance were to give way to European-style operas and symphonies (albeit with Central Asian musical motifs and instruments). From the early 1930s, Central Asian music and literature were also expected to adhere to the socialist realist style and to incorporate socialist themes and ideas. Like other Soviet peoples, Turkmen, Tajiks, and Uzbeks began writing odes to tractors, factories, and Lenin in their own languages.

Turkmen carpets became a key aspect of the folk culture promoted as the basis for Soviet Turkmen nationhood. Even this seemingly most apolitical of national forms was destined to absorb a certain amount of socialist content. While the female artisans of Turkmenistan continued to produce carpets in traditional styles, in the 1920s some began to incorporate Soviet themes into their designs. (Naturally, the Soviet authorities strongly encouraged this development.) These new "theme carpets" and "portrait carpets" portrayed the most important communist leaders — Karl Marx, Friedrich Engels, and, of course, Lenin — or celebrated Soviet holidays, such as Lenin's birthday, and Soviet policies, such as the friendship of the Soviet peoples. The link between carpets and socialism was even memorialized in stone in the 1920s, when a monument to Lenin erected in the center of Ashgabat placed the leader on a pedestal decorated with Turkmen carpet motifs. In the words of a Soviet Turkmen commentator, this statue demonstrated the "real continuity of new socialist artistic traditions with the achievements of the old national culture."[3]

Portrait carpets in subsequent decades honored the Russian writers Alexander Pushkin and Maxim Gorky, the eighteenth-century Turkmen poet Mahtïmgulï, the Communist Party secretary Leonid Brezhnev, the cosmonaut Yuri Gagarin, and such foreign communist figures as Fidel Castro. Well into the postwar period, Lenin remained a favorite subject for depiction, as in the example here from the 1950s. These carpets provided a perfect visual representation of the Stalinist principle that national forms should contain socialist content. In the *Portrait of Lenin,* the leader who became the human embodiment of socialism and the Great October Revolution was literally woven into the fabric of Turkmen culture. Displayed in museums and exhibits in Turkmenistan and throughout the Soviet Union, such carpets were intended to show that the formerly nomadic and tribal Turkmen had successfully absorbed socialist ideas and practices. They declared — wordlessly but with perfect clarity — that the Turkmen had consolidated their national identity under Soviet rule while also acquiring a Soviet identity that they shared with other citizens of the USSR.

How did the Soviet Turkmen themselves respond to the *Portrait of Lenin?* It is impossible to know with certainty, since only positive views of this new art form could be expressed in the Soviet era. Yet we can imagine a range of responses, depending on the viewer's standpoint. Devoted Turkmen communists would have regarded *Portrait of Lenin* with pride as a uniquely Turkmen contribution to Soviet socialist culture. Anti-Soviet nationalists might have been angry at the sullying of a traditional carpet pattern with the image of a Russian communist.

Devout Muslims would have been offended by the carpet's violation of the Koranic injunction against visual representation of the human form. And it is entirely possible that some citizens of this remote republic would have failed to recognize the famous revolutionary leader.

In the post-Soviet era, themed carpets such as the *Portrait of Lenin* have become historical curiosities, of interest mainly to Western tourists in search of Communist kitsch. Although carpets remain important as a national form in independent Turkmenistan (the country celebrates Carpet Day along with more conventional state holidays such as Independence Day), the socialist content of the Soviet era has been abandoned. The *Portrait of Lenin* no longer graces the walls of the National Museum, and Turkmen couples no longer pose for photographs in front of the carpet-themed Lenin monument on their wedding day. Instead, an imposing statue of the late Turkmen president Saparmurat Niyazov, self-proclaimed national hero and leader of the Turkmen until his sudden death in December 2006, has become the preferred backdrop for wedding snapshots.

NOTES—1. For more information on Turkmen carpets, see the trilingual book *Türkmenistanïng Halïlarï* (Ashgabat: Turkmenistan Publishing House, 1983); and Robert Pinner and Murray L. Eiland, Jr., *Between the Black Desert and the Red: Turkmen Carpets from the Wiedersperg Collection* (San Francisco: Fine Arts Museums of San Francisco, 1999).

2. On the Soviet nationality policy, see Ronald G. Suny, *The Revenge of the Past: Nationalism, Revolution, and the Collapse of the Soviet Union* (Stanford, Calif.: Stanford University Press, 1993); Terry Martin, *The Affirmative Action Empire: Nations and Nationalism in the Soviet Union, 1923–1939* (Ithaca, N.Y.: Cornell University Press, 2001).

3. *Türkmenistanïng Halïlarï*, 7.

37

The Moscow Metro

Mike O'Mahony

The Moscow metro is one of the most spectacular engineering, architectural, and design achievements of the Stalinist era. Begun in the 1930s as part of the plan for the reconstruction of the Soviet capital, the Moscow metro continued to expand throughout the Soviet era and by the late 1980s consisted of over 120 miles of track and 138 stations. There can be little doubt, however, that it was during the early stages of the project, and in particular in the 1930s, that the most dramatic developments occurred and that some of the most beautiful stations were designed and built. Between 1935 and 1938 two key sections of the metro system were completed in record time and publicly opened amid much pomp and ceremony.

Such haste, however, did not result in the neglect of the visual appearance of the metro. Rather, the Soviet authorities specifically set out to make the Moscow metro the most beautiful metro system in the world. No expense was spared on materials. Rich marble and granite were brought in from all corners of the Soviet Union to line the walls of the stations, and huge chandeliers were constructed from cut glass and precious metals to illuminate the subterranean tunnels. Each of the stations was individually designed and given a unique appearance, so the city of Moscow was gradually filled with an assortment of dramatic public interiors, frequently described as palaces for the people. To fulfill this task, many of the Soviet Union's most famous architects, designers, and artists were called upon to contribute to the metro project. Some of the stations, like the Red Gates (Krasnye Vorota), were designed in a highly modern style emphasizing geometrical forms and modern materials. Others adopted more traditional architectural vocabularies drawn from a whole host of historical sources.

One of the most striking of these was Dynamo (Dinamo) station, designed by the architect Dmitry Chechulin (fig. 37.1 [color section]). Dynamo station has the appearance of a Greek temple in miniature. Built from light-colored stone and surrounded by classical columns, the two exterior pavilions have a sculptural frieze on the upper walls. Here reference is clearly being made to the Parthenon, in Athens, then, as now, the most famous example of ancient Greek architecture. This protoclassical building also carries overtly modern references. The capitals of the columns, for example, far from conforming to the classical orders, are alternately decorated with Soviet star and Soviet hammer and sickle motifs. Further, the frieze that runs around the exterior of the building depicts not the battles of ancient Greece but the sporting activities of modern Soviet citizens participating in boxing, weight lifting, swimming, tennis, and

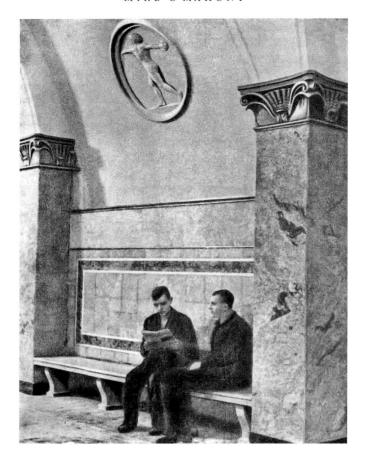

37.2. Dynamo metro station (interior). Metro riders on a bench
below a rondelle of an athlete by Elena Yanson-Manizer.

other athletics. Many wear the sports costume of the Dynamo sports society, whose stadium is adjacent to the Dynamo metro station, and all exude strength, fitness, and team loyalty.

The conflation of visual references to the past (the Greek classical tradition) and the present (modern sport) establishes a link between the power and authority of ancient Athens and modern Moscow (fig. 37.2). Because ancient Greece was inextricably linked with the practice of sport, not least of all the Olympic Games, the sports activities at the Dynamo stadium were thus recorded as a continuation of a grand historical tradition. Here visual culture was deployed explicitly to reinforce the power and authority of the Soviet state by reference to a grand, heroic past.

Similar strategies were deployed throughout the metro stations, some of which alluded to Gothic or Romanesque cathedrals, others to Renaissance and baroque palaces. Every conceivable form of decoration, from mural painting to sculpture, from mosaic to ceramic, was employed to emphasize the richness of the project and thus to represent symbolically the glory

of life in the Soviet Union. Linking the whole diverse ensemble, was the idea that this visual extravaganza was designed explicitly for the masses and not for a tiny elite.

The building of the metro was a huge-scale construction project and, as such, expressed the aspirations of the Soviet leadership toward competing with the major industrial and engineering advancements of the West. However, to complete this project, a massive labor force was required. Most of the laborers were young volunteers, many of whom were peasants coming to the city for the first time. To entice Soviet youth into helping to build the metro it was also necessary to present labor as both a civic duty and a fun leisure activity. Visual imagery was widely deployed to get this message across. Countless posters promoting the metro project were produced and distributed throughout the city, and special journals were published informing the public of the latest developments. Many of the journals were lavishly illustrated with photographs of attractive, smiling young men and women purportedly having a great time in the metro tunnels. Artists, too, were called on to promote labor on the metro project, as can be seen in Alexander Samokhvalov's *Female Metro Worker (Metrostroevka) with a Drill,* painted in 1937 (fig. 37.3 [color section]).

Originally hailing from the tiny hamlet of Bezhetsk, Samokhvalov became one of the best-known Soviet artists of the interwar years. During the 1920s he was a key member of The Circle (Krug), a group of artists dedicated to developing a new painterly style based on the traditions of Russian icon painting. In the 1930s, Samokhvalov gained several major state commissions, particularly for his works representing young female workers and sportswomen. A key visual document of the era, Samokhvalov's *Female Metro Worker* offers fascinating insights into notions of the heroic female worker in the Soviet Union of the 1930s. The painting is more than six feet in height and represents a larger-than-life figure sketchily finished in muted earth tones and posed underground against a background of recently excavated tunnel walls. The figure's body is turned toward the viewer, though leaning somewhat to the left, whereas the head is seen in profile. From the evidence of scars on the tunnel walls the metro worker would seem to be focusing on the area of excavation, poised in a moment of concentration just before commencing labor. The body type is notably stocky, with a thickset neck, wide shoulders, and broad hips. In her left hand she is holding an electric drill, the forefinger raised in a triggerlike fashion, giving the tool the air of a weapon. The costume is also noteworthy. The lower body is clad in loose-fitting overalls, but the top half of the garment has been stripped from the upper body and is tied at the waist, suggesting that the labor about to be undertaken demands intense physical effort and exertion. Beneath the overalls, the metro worker is wearing a tightly fitting sports vest. A small red cap neatly contains what appears to be fairly short cut hair.

The metro worker presented in this work could be read as gender ambiguous. In one sense, both body type and costume are masculinized to express the physical power and labor potential more conventionally ascribed to male workers. Yet simultaneously Samokhvalov is deploying a number of devices more familiar in traditional images of the female body. Much emphasis is placed on the disrobed upper torso, with the black horizontal band of the athletics vest running across the breasts. Similarly, the roundness of the hips is highlighted by the fall of the tied overalls, which resemble classical drapery. The low-level direct lighting and turn of the worker's

head away from the viewer also imply a potentially unobserved and unchallenged voyeuristic (male) gaze.

Here Samokhvalov's visual construction of a metro worker sets up a dual appeal. On the one hand, the viewer is presented with a strong, powerful, and independent working woman in control of her own destiny and contributing her labor for the good of the collective. At the same time, however, she is potentially glamorous, even sexy, and the thinly veiled eroticism can easily be seen to call on basic instincts. For newly arrived peasant migrants, many still coming to terms with the new and alienating experience of urban culture, this image of the heroic metro worker thus addressed the notion that work on the metro could be prestigious and liberating for women while still offering a potential for social interaction and even romance.

But Samokhvalov's work alludes to a more complex idea, too—namely, that participation in labor programs such as the building of the metro could in itself be a transformatory experience. Throughout the early postrevolutionary era Soviet theorists were obsessed with the notion that the new conditions brought about by the Bolshevik revolution would lead to the emergence of a new type of citizen, the "new Soviet man" or "new Soviet woman." Here, Samokhvalov's visual articulation of a mythical metro worker suggests that the very process of working on a grand labor project has contributed to the formation of a new body type, with both strength and sensuality. Ultimately, Samokhvalov's work makes explicit reference to one of the key events of his era, the building of the Moscow metro. Rather than simply recording this event, the artist has here used visual culture to construct an idealized archetype of the new Soviet woman, who, in turn, symbolizes the progress and advancement of the Soviet state.

38

The Soviet Spectacle

The All-Union Agricultural Exhibition

Evgeny Dobrenko

The All-Union Agricultural Exhibition (AAE) can justifiably be considered one of the brightest examples of Stalinist architecture. Originally opened in Moscow in 1939, then rebuilt and reopened in 1954, the exhibition was again transformed in 1958 into its late-Soviet incarnation as the Exhibition of the Achievements of the People's Economy of the USSR. The Soviet state enlisted culture to produce socialism through what might be called the de-realization of life. As the philosopher Mikhail Ryklin asserts, "From the beginning, the Exhibition was planned to be a gigantic, agitational, theatrical operation realized by architects, builders, directors, actors, and tour guides supervised by the Communist Party, which would not only create a joyous mood but would also liquidate the irreconcilability of reality with the image."[1] The exhibition was designed to display the fruits of Soviet fertility and productivity in the absence of actual fertility and productivity and thus turn the visual illusion into conceptual reality, to make people believe what they saw (fig. 38.1). At issue, as Vladimir Papernyi suggests, is the Platonism of Stalinist culture. The agricultural exhibition that opened in 1939 was "not simply an exhibition about agriculture; it was the ideal type (in Platonic terms) of agriculture. . . . The creators of the All-Union Agricultural Exhibition . . . were convinced that the artificially preserved blossoming of agriculture at [the exhibition] would inevitably lead to the real blossoming of agriculture in the USSR."[2] It is not simply that the Soviet state wanted to fool the public into thinking that Soviet agriculture and industry were more productive than in reality they were; the exhibition was designed to use the imagery of abundance to bring real abundance into being.

This Soviet project and the discourse that arose to explain it have roots in the bourgeois museums and great exhibitions of the late nineteenth and early twentieth centuries. Beginning with the first Great Exhibition in London in 1851, massive public architectural ensembles were erected to stage images of modern national identity through the display of the products of modern industry, technology, and imperial conquest. One significant aspect of London's Great Exhibition was the spectacle of progress—the national future was asserted as a task whose path of realization the exhibition displayed. The AAE transformed the capitalist spectacle of modernity into a spectacle of socialism, and the rhetoric of progress into the rhetoric of socialism. The

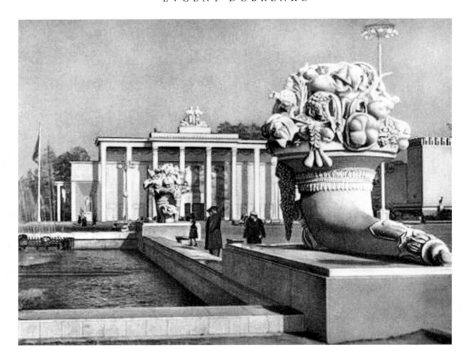

38.1. Siberian Pavilion, All-Union Agricultural Exhibition (exterior). Abundance was not only displayed in the exhibit halls but featured in every architectural element on the grounds: fountains, bas-reliefs, columns, and archways overflowed with images of fertility.

socialist spectacle had no need of a rhetoric of progress because history began anew in 1917, and the Stalinist future had been transformed into a persistent present.

Socialist modernity had no need to arouse in visitors a desire for capitalist consumption, but the AAE did function in a similar way, linking the cultural identity of the mass of spectators with the mass of goods on display and offering a visual-conceptual basis for the construction of a Soviet identity. However symbolic or sublimated, the nature of the exhibition was undoubtedly commercial. Thus when Ryklin concludes that certain goods on display were produced especially for the exhibition and that they were produced "not for consumption but for contemplation," we must make a correction: consumption and contemplation were in no way opposed in socialist realism; contemplation in this culture *is* consumption.[3]

The basic function of the exhibition was the creation and maintenance of a Soviet identity. The spectator (who was also a participant) was supposed to form a connection, to fuse, with all this abundance, with that ideal life in which the abundance of products and goods for the people's consumption was contained. The interior of the exhibition's pavilions presented a single, continuous picture of Soviet abundance (fig. 38.2). However, without artistic arrangement and embellishment, viewers would see nothing more than a mountain of abundance without context (fig. 38.3). The task of socialist realism was not reducible to the depiction

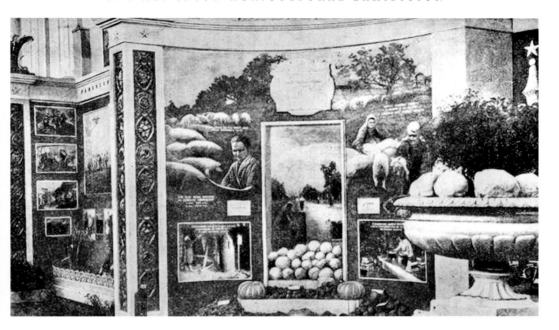

38.2. Exhibit Hall of Moscow Province, All-Union Agricultural Exhibition, with displays of cabbages, flax, squash, and other vegetables before murals of women tending livestock. Note the floral motifs on the columns and urns.

and production of a world of abundance; it also included the creation of a coherent socialist reality.

The role of art in constructing Soviet identity and the specific operation of the process were discussed in many published reviews of the exhibition in the 1940s and 1950s. As Osip Beskin, editor in chief of the journal *Art* (*Iskusstvo*), wrote on the occasion of the AAE's opening: "If these immense sheaves of grain, weighed down with enormous kernels, Southern fruits and vegetables raised in the North, bulls of unheard-of strength and weight, if these new and extremely complex agricultural machines—if all of this were presented at the exhibition just as it was, without the help of art, then we would certainly be witnesses of a stunning spectacle, reflecting the enormous achievements of our kolkhoz construction. . . . But [without art], the organic, vital connection that unites visitors at the exhibition with the triumph of socialism in our country . . . would not appear with such visual, emotional, and perceptual vividness."[4]

At the same time, some critics heightened the achievements of socialism by noting the "powerlessness of art" to describe all this splendor, using words that themselves formed Gogolesque roulades :

Mountains of fruits, unheard-of and amazing in their magnificence, lay in the display cases and on the floors of the pavilions. Cheeses rose in towers like heavy millstones. Wine grapes surrounded bottles of the season's wines on which played reflections of the distant South. Precious animal pelts filled the stands of the Northern pavilions. Huge cucumbers, water-

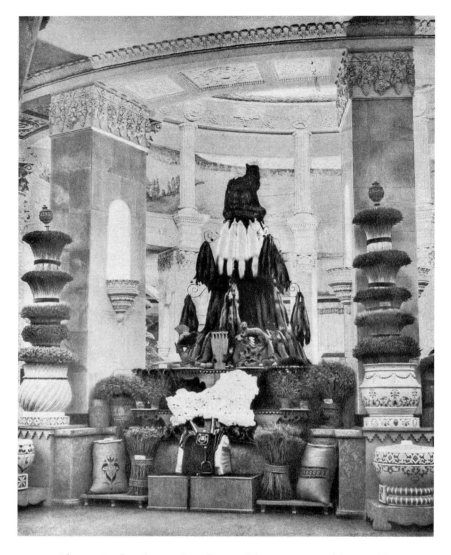

38.3. Siberian Pavilion (interior), with an artful arrangement of flora and furs.

melons, muskmelons, splendid furs, delicate silks, sheaves of choice wheat bending under the burden of the grain—all of this immeasurable wealth of the country of socialism literally overwhelmed the senses. The masterpieces of Snyders would pale alongside this real, living splendor.

On the other hand, as even this writer recognized, it was only thanks to Soviet art that the spectator and reader were in a position to distinguish the exhibition's displays from the overflowing still-lifes by such baroque painters as Frans Snyders, because it was precisely Soviet art that transformed Gogolesque abundance into socialism:

Beyond the whimsical linking of the displays, behind the unusual, extremely diverse pavilion styles, one constantly felt something bigger, something that fused and unified, so it seemed, the disparate parts. And this fundamental, all-encompassing, and pervasive principle was *socialism — the fundamental and main theme of the exhibition.*

Everything the spectator saw, everything displayed in the brightly lit halls of the pavilions and in the shade of the Michurin gardens, everything on the stands and in the stables, appeared solely as the expression of this fundamental theme. Only because socialism has triumphed do these splendid fruits and vegetables grow in the far North. Only because socialism has triumphed are the fields of Uzbekistan covered with millions of splendid, high-quality cotton plants. Only because socialism has triumphed have such remarkable people, the producers of Stakhanovite harvests, grown up. Only because socialism has triumphed has this endlessly rich and versatile culture of the peoples of the Soviet Union flourished.[5]

The goal of the exhibition was to represent the masterpieces of Snyders as obsolete through the use of socialist art, which in this case meant the synthesis of all the arts and the fusion of spectator and spectacle. As one reviewer wrote, "The great process of merging all types of art with the constructive realization of the people's dream of a sunny, joyous abode has begun. On the experimental field of the All-Union Agricultural Exhibition, in the capital of the Soviet peoples, Moscow, the multinational art of our Motherland has brought forth its first fruits, saturated with the juices of life."[6] The fruits of art, then, are comparable (in terms of their "juiciness") to the unparalleled cucumbers, watermelons, and muskmelons.

Art brings socialism together here with beauty. As another reviewer put it, "An important feature of the exhibition is that accomplishments in the area of agriculture and industry are directly linked, in the consciousness of the Soviet people, to a sense of the beauty of what they have made with their own hands." But this beauty was esoteric. It was a "reflection" of reality itself while simultaneously possessing a sort of light invisible to the naked eye. Another reviewer wrote that everyone tried "to reflect the beauty of our socialist activity," but he asked, "Do all the works at the exhibition possess these features of the new beauty? Of course they all do not to an identical degree, but in almost every element of the setup . . . the gleam of the truly visible beauty of our life peeks through" (fig. 38.4 [color section]).[7]

In the anxiety with which the "reality" of the exhibition was asserted, we can read the culture's concern with the naturalization of art. A reviewer of the International Exhibition of 1939 in the journal *Art* praised the authenticity of the Soviet pavilion in comparison with the artificiality of the others. "Here visitors accustomed to all manner of imitations, of plaster for stone, veneer for marble, etc., see what granite, marble, and bronze are really like, both outside and inside." The authenticity of the All-Union Agricultural Exhibit was praised in the same way by one reviewer after another. "How strikingly this city of palace-pavilions differs from the recent foreign exhibitions! There they have undistinguished architecture, compositional cacophony, a preoccupation with the effects of technological window-dressing. Here we have a durable construction base, harmony of the whole, a life-affirming and expressive architecture . . . Here there is not even a hint of window-dressing: the building materials are durable and of high

quality."[8] The naturalism and high quality of the pavilions was important not in and of itself but as a sign of the permanence and durability of the whole Soviet world.

Thus, the exhibition's space was primarily an artistic space and the exhibitionary discourse of the modern art museum came together with characteristic Soviet megalomania. The exhibition expanded to the scale of the entire country, so that ultimately it no longer reflected the country but rather the country was simply an exhibition expanded many times: its macro reflection. The fusion of life and art and the fusion of the spectator with the spectacle occurred through the denial of the artificiality of the exhibition, a denial made via emphasis on its artfully constructed "realism," "mimesis," and "naturalism." A metaphor of Soviet identity can be seen in this: while "fusing" with what they have seen there, viewers "fuse" with life itself, which has already become equated with the exhibition.

At first art was ascribed a rather representative-instrumental function. The material to be exhibited "necessarily required a certain artistic treatment in order to be 'read' by the spectator, since hundreds of thousands of photographs in their 'raw' form, with their tiresome monotony, could completely paralyze perception." Such documentary photographs did not have the qualities necessary to fulfill the tasks imposed on them in distilling reality into socialism. In other words, it was art that made this content more real (more "natural") than reality itself: "No 'natural' display, no number, map, or diagram possesses the kind of strength of generalization that works of art possess."[9]

An editorial on the exhibition in the journal *Art* in 1954 conveyed with maximum clarity the meaning of what was seen and the mechanics of the artistic process that occurred between spectator and display there: "The exhibition is splendid in its riches. How could it fail to gladden the visitor! Like a magic tablecloth, it has spread out before the people all the generosity of our land. And all of this is for the people, for the simple Soviet person—so that our home will be filled with prosperity, so that we can live here happily and freely."[10] In this fairy-tale discourse (a magic tablecloth!), abundance does not so much *reflect* as it *conjures*. The simple Soviet people only have to see such riches spread out before them, and they will suddenly begin to live in prosperity, happily and freely. The very achievements of Soviet progress and the discourses of socialist modernity are subordinated to, and only realized through, the miraculous and fantastic. The socialist spectacle arises from the transformation of Soviet reality by socialist realist art.

Translated by Jesse Savage

NOTES—1. Mikhail Ryklin, *Prostranstva likovaniia: Totalitarism i razlichie* (Moscow: Logos, 2002), 101, 102, 106.

2. Vladimir Papernyi, *Architecture in the Age of Stalin: Culture Two,* trans. John Hill and Roann Barris (Cambridge: Cambridge University Press, 2002), 236 (translation revised by Joan Neuberger).

3. Mikhail Ryklin, *Iskusstvo kak prepiatstvie* (Moscow: Ad Marginem, 1997), 186.

4. O. Beskin, "Monumental'naia zhivopis,'" *Iskusstvo,* no. 1 (1940): 103.

5. I. Sofenov, "Vystavka kak khudozhestvennoe tseloe," *Iskusstvo,* no. 1 (1940): 85. Stakhanovites were workers who were celebrated and rewarded for using modern innovations to increase their productivity. Their individual exploits were then used to force higher productivity among all workers.

6. A. Bassekhes, "Khudozhestvennyi obraz Vsesouznoi sel'skokhoziaistvennoi vystavki," *Teatr,* no. 9 (1952): 12.

7. V. Tolstoi, "Leninskii plan monumental'noi propagandy v deistvii," *Iskusstvo,* no. 1 (1952): 60; A. Zhukov, "Arkhitekturno-planirovochnyi ansambl' Vsesoiuznoi sel'skokhoziaistvennoi vystavki," *Arkhitektura SSSR,* no. 7 (1954): 14.

8. N. M. Suetin, "Iskusstvo na Vystavke," *Iskusstvo,* no. 5 (1939): 103; A. Bassekhes, "Arkhitekturnyi ansambl' Vystavki,'" *Iskusstvo,* no. 6 (1939): 59.

9. Sosfenov, "Vystavka," 86.

10. "Slava narodnomu trudu!" (editorial), *Iskusstvo,* no. 5 (1954): 3.

39

Motherland Calling?

National Symbols and the Mobilization for War

Karen Petrone

In the first half of the twentieth century, the poster came into prominence as a modern medium of mass communication. Posters promoted commerce, educated the public, and mobilized citizens for war. The heyday of the poster coincided with the era of total war, during which a victorious outcome was determined not only by military strategies but by the effectiveness with which a government mustered its economic and social resources. During the two world wars, Russian and Soviet propagandists designed posters to motivate the population to make personal sacrifices for the sake of the nation.

A key aspect of war propaganda is its attempt to stir emotions such as loyalty, dedication, love, pride, anger, hatred, contempt, and the desire for revenge against enemies. Visual propaganda can be especially effective in appealing to emotions, and posters, which tend to focus on discrete images that convey a single powerful idea, are an ideal medium for eliciting emotional responses. During the world wars, visual propaganda sought to create a strong emotional attachment to the country for which Russian and Soviet soldiers were fighting and dying. Political posters encapsulated the meaning of "Russia" or the "Soviet Union" into a single symbolic maternal image to draw on powerful familial emotions. Propagandists used this image to encourage viewers to love their country as they loved their mother and to protect "her" against attack as staunchly as they would protect their own mother from danger.

The depiction of gender difference is an important part of the visual repertoire of Russian and Soviet war posters. The ideals of Man as warrior and defender of the nation and Woman as its nurturer and progenitor were deeply embedded in early twentieth-century social values, making the visual language of gender difference particularly suitable for stimulating strong emotions. By visualizing the actions and relationships of ideal men and women, posters conveyed powerful messages about how viewers should behave during wartime and how they should feel about their nation.

In both world wars the country was symbolized by a female allegorical figure; male images dominated during the Civil War. A comparison of how these symbolic figures related to Russian and Soviet soldiers reveals differences between Russian and Soviet visual interpretations

of the nation, as well as the ways the Russian and Soviet states both used emotion, gender relations, and familial metaphors to mobilize their citizens.

The World War I poster *Russia and Her Soldier* depicts the relationship between the Russian motherland (*rodina*) and the loyal soldier (fig. 39.1 [color section]). Implicit in the imagery and explicit in the accompanying text of the poster is the notion that the motherland gave birth to the citizen-children, whose duty it was to protect her. The poster shows the relationship of Russia to her soldier through a series of oppositions, including female versus male, sitting in repose versus standing at attention, sword down versus rifle up, ornamental dress versus functional uniform. The differences in posture, dress, and weaponry reinforce the idea that female Russia expects her male citizens to fight for her. Russia remains passive but in command as the male soldier demonstrates his allegiance and respect through his posture and his hat in hand. The combat scene in the background of the poster illustrates the ideal future actions of the soldier. Having proclaimed his loyalty to the motherland, the soldier would engage in valiant combat on her behalf. The division of the visual space into foreground and background enabled the artist simultaneously to depict the emotional act of commitment to the motherland and its actualization on the battlefield.

The male and female figures exemplify the ideals of male and female beauty in 1914. The female embodiment of Russia possesses a fine profile, although her features are obscured because her face is turned in rapt attention toward her beloved son. She holds a sword and an orb, symbols of monarchical rule. Her clothes and headdress hark back to traditional Muscovite dress. This turn away from Europeanized St. Petersburg and toward the ancient and native virtues of Moscow was a hallmark of the personal style of the court of Nicholas II. Her dress thus connotes a particular kind of patriotism that embraced autocratic rule as a native virtue. The warrior, with his erect stature and handsome mustache, represents the soldierly ideal. Yet while Mother Russia gazes expectantly toward him, he does not meet her gaze. Is he awed by this solemn moment of declaring loyalty? Is he following the strict discipline of standing at attention? Or is he looking past the needs of Mother Russia? The very moment of emotional connection central to the poster's meaning is partly hidden from view. Because neither the soldier nor Mother Russia looks directly at the poster's audience, their expressions are less readable and more open to interpretation. Mother Russia can be seen as demanding, determined, vulnerable, concerned, and the soldier as obedient, protective, stoic, detached.

As scholars have pointed out, the poster's telegraphic form leaves it open to multiple interpretations. Although the creators of propaganda strive to produce a single and unambiguous meaning, the task is impossible due to the malleability of images and the multiplicity of viewers. Because it is very difficult to know how viewers interpret any particular poster, it is necessary to read the poster itself with sensitivity to alternative and contradictory meanings. Tensions may be identified by attending to the context in which the image was created, as well as by scrutinizing the compositional elements of the poster for internal consistency. In 1914 the Russian Empire was in the midst of redefining and modernizing its notions of citizenship and nationhood. *Russia and Her Soldier* is a representation of a key moment in the relationship of citizens to the modernizing state. Would the newly defined citizens evince their patriotism by

taking up arms in the state's defense? The poster's background of soldiers in battle suggests an affirmative answer. The Slavic citizen-soldier standing at attention, however, who was likely intended as a symbol of resolute obedience, has a facial expression that can be read as lacking enthusiasm or any emotional connection with Russia. This detail suggests that despite the artist's intentions, the idea of distance between Russia and her soldiers is also available to viewers of the poster. This image of the ideal soldier also implicitly excludes those who are not young, male, and Slavic. The analyst of visual sources must identify where elements of the poster contradict and undermine each other, and show the possibility of multiple readings grounded in the poster's historical context.

The image of the motherland was also strikingly evident in Soviet World War II posters. Shortly after the Nazi invasion in 1941, I. M. Toidze's poster declared in so many words that the "Motherland-Mother calls" her children to battle (fig. 39.2 [color section]). In the foreground of the poster, a somber middle-aged woman dressed entirely in the color red, holds one hand up in the air in a commanding gesture and clasps in the other a sheet inscribed with the Soviet military oath. In the background, we can see a large number of rifles with bayonets attached, but no other human figures. Unlike *Russia and Her Soldier,* this poster presents no visual depiction of the soldier answering the motherland's call. Whereas the 1914 poster depicts a specific relationship between Russia and a young male Slavic soldier, this poster allows men and women of any age and ethnicity to imagine themselves responding to the maternal call. Even though the Soviet Union still figures as the mother of citizens who are obligated to fight for her, the image of the ideal fighting citizen allows for the broadest possible definition of the nation in arms. Likewise, the nature of fighting is not concretely depicted; although the citizen soldiers were expected to arm themselves and take the military oath, the nature of their future military endeavors remained undefined. These generalized images were consistent with a Soviet ideology that promoted an inclusive vision of the nation and the war effort. In fact, hundreds of thousands of women volunteered to serve in the Soviet military, millions of non-Russians fought the Nazis, and civilians engaged in armed resistance behind enemy lines.

The image of Mother Russia is also starkly different from the one in the 1914 poster. While she is still a European woman, the Soviet mother actively calls her citizens to her side with a dramatic gesture rather than remaining passive in her chair. She does not symbolize womanly beauty; rather, she wears the realistic and careworn expression of a mother in distress. She looks the viewer full in the face and demands help, showing her own strength but also evoking concern among her viewers. The simplicity and bright color of her dress reflect her austerity and directness but also her lack of connection to any specific cultural and national traditions. She is adorned only by the color that symbolized communism. By omitting details about the specific nature of the motherland, her soldiers, and the fighting, this poster minimized the potential for compositional tensions and alternate readings that might lead viewers to decide that the motherland was not calling *them.* The 1941 poster thus offered a more dynamic message to a wider audience than the 1914 poster did.

When analyzing images, it is critically important to take into account what is absent as well as what is present. Despite the seeming continuity of the image of the motherland from World War I to World War II, this image was conspicuously absent from the lively poster tradition of

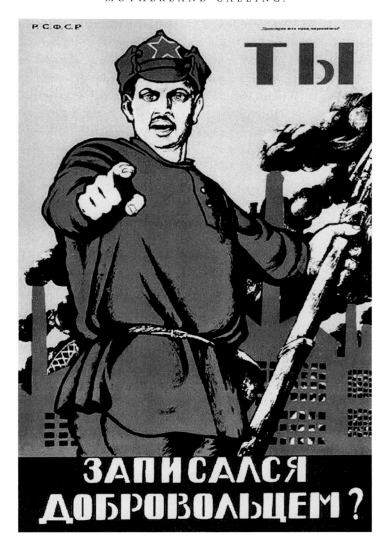

39.3. Dmitry Moor, *Have YOU Enlisted?* 1920. Russian Civil War poster.

the intervening period of the Soviet Civil War, 1918–21.[1] In that conflict the image of the nation was masculinized. The 1920 poster by Dmitry Moor, *Have YOU Enlisted?* (the "you" is in the familiar form) shows a giant Red Army soldier standing against the backdrop of a factory and pointing his finger accusingly at the viewer (fig. 39.3). This poster is a Soviet version of *Uncle Sam Wants YOU;* the soldier is both the symbol of the Soviet Union and the model of the soldier to be emulated. This mustachioed figure with large eyes bears a certain resemblance to the 1914 soldier, but now he both serves and represents the country. Rather than exhibiting obedience, this soldier demands a response from the viewer.

The Civil War poster presents a more generalized image than the World War I poster does, but a more specific image than the World War II poster presents. The national characteristics

are represented by the color red and by the Red Army uniform; what must be protected is a factory rather than a careworn or vulnerable woman. The specificity of the soldier's face and uniform and the grammatical construction of the slogan limit the poster's audience, however. The slogan calls familiarly to other Soviet men to join the army. The mother-child relationship between state and citizen has been replaced by a fraternal one, and the nation is symbolized by production rather than reproduction. The masculine revolutionary ethos left little space for the female or the maternal in the imagining of the nation. Despite the striking similarities of the World War I and World War II posters, the story of gendered national images in Russia and the Soviet Union is not one of unbroken continuity.

Gender is a crucial category of analysis for decoding the meanings of Russian and Soviet war posters. By paying attention to male and female symbols in posters and their relation to each other, to the actions that men and women take in posters, and to the definitions of ideal masculine and feminine traits, we can learn how meaning is produced in visual sources and also gain insight into gender and power in specific historical contexts. Posters also allow us to investigate the ideal relationship of Russian and Soviet citizens to their country, the characteristics of "enemies" and "patriots," and representations of those included and excluded from the national community. The poster analyst can pinpoint changes in visual vocabulary over time that reveal transformations in ideology—transformations that both reflect changes in social reality and bring them about.

NOTES—1. Victoria Bonnell, *Iconography of Power: Soviet Political Posters under Lenin and Stalin* (Berkeley: University of California Press, 1997), 72.

40

Visual Dialectics

Murderous Laughter in Eisenstein's *Ivan the Terrible*

Joan Neuberger

When Stalin commissioned Sergei Eisenstein to make a film about Ivan the Terrible in 1941, it was widely assumed that the film would follow the prescribed historical thinking on Ivan: it would glorify the sixteenth-century tsar (and his twentieth-century counterpart) as the founder of the Russian state and justify his use of mass terror against the boyars who opposed him. Eisenstein had little interest in making that film, but Ivan's story offered him the possibility to experiment with his evolving ideas about filmmaking, psychology, politics, and aesthetics. He resolved to make a film that would be acceptable to the ruling political elite but that would also contain a complex and challenging examination of Ivan and his legacy. Such contradictory ambitions made *Ivan the Terrible* difficult to interpret, and controversy continues to this day over *Ivan*'s politics—and Eisenstein's.

Although the film's contradictions partly arise from the narrative strategies employed to tell the tsar's story, the complexity of Eisenstein's thinking is primarily conveyed visually. Eisenstein's chief departure from the screenplay (previously approved by Stalin) can be found in the film's strange and unconventional visual universe. Eccentric acting, disorienting spaces, obsessive attention to physical objects, recurrent images, mirror reversals, and disruptive camera work contribute to the unique visual method that Eisenstein invented to convey cinematic meaning: to displace ordinary viewing habits, to challenge prevailing socialist realist styles, and to construct Ivan's persona.

Eisenstein came to view Ivan as a man tragically divided—a dialectical unity of opposites—torn between, on the one hand, his commitment to unite Russia against both its predatory neighbors and its own aristocratic elite and, on the other, his remorse over the violent means he chose to accomplish this glorious task. Eisenstein undoubtedly approved what he saw as Ivan's "progressive" duty to consolidate Russian power, but the film never justifies his violent methods, and ultimately violence destroys Ivan and decimates Russia. Such a profile, Eisenstein understood, would hardly appeal to Stalin or to the cultural bureaucrats overseeing production of the film. For both political and artistic reasons, he made *Ivan the Terrible* difficult to decipher. Both Part I (completed 1944, released 1945) and Part II (completed 1946, released 1958) received mixed responses; Part III was never completed.

40.1. Chaldean guards in *Ivan the Terrible,* Part II, directed by Sergei Eisenstein. Film frame capture.

Eisenstein's visual method is vividly displayed in his pivotal scene, the re-creation of *The Fiery Furnace,* a liturgical play-within-a-film. Midway through *Ivan,* Part II, the Orthodox Church leader, Metropolitan Filipp, stages *The Fiery Furnace* to humble Ivan and persuade him to renounce his violent ways. Based on an episode in the book of Daniel, *The Fiery Furnace* was regularly performed on church holidays during Ivan's reign. It recounts the martyrdom of three Jewish boys who refuse to pay homage to a golden idol of the tyrant Nebuchadnezzar. Thrown into a burning furnace by Chaldean guards, the boys are miraculously rescued by an angel. In Eisenstein's version the boys are not saved, a spectator laments that "nowadays, there are no such angels," and other Stalinist parallels abound. Ivan rejects Filipp's lesson and, at the scene's end, finally realizing the extent of the boyars' resistance to his political will, he embraces the epithet by which he is known: "I will be just what you say I am. . . . I will be Terrible."

Although the narrative in this scene supports the Stalinist justification for Ivan's turn to terror (to eradicate the boyars), its visuals tell a different story. With visual parody and comedy, Eisenstein transforms the liturgical play into a circus-carnival, undercutting the official narrative, dramatizing Ivan's inner divisions, exposing the tsar's willingness to embrace naked, brutal despotism, and identifying Ivan's motives as personal vengeance and despair (rather than the needs of state).

The first visual clue that *The Fiery Furnace* will not be a straightforward liturgical performance is the garb of the Chaldean guards who lead the boys to their doom: they are dressed as circus clowns, complete with makeup and costumes that parody the boyars in the audience (fig 40.1). In the original Muscovite play, the guards were dressed as jesters, which must have appealed to Eisenstein's lifelong fascination with the circus. Like his contemporary Mikhail Bakhtin, he associated masquerade and comedy with reversals of social hierarchies, and he be-

lieved that comedy offered an escape from modernity's suffocating power structures. One thing that is "always funny," he wrote, is "the *one* thing that dares to deny the leading philosophy of the time."[1] He attributed the enduring and seemingly universal popularity of the circus to its ability to tap into people's earliest, instinctive, foundational experiences. Taming ferocious animals and laughing at clowns who haplessly fall down but always get up again mimicked our childhood fears and our drive for mastery.

In the visual experience of circus Eisenstein also perceived a universal anxiety about the relationship between depiction, the actual physical characteristics of a visual image, and its underlying essential meaning (which Eisenstein confusingly called the image). Comedy arises from the explicit decoupling of depiction and and meaning. Eisenstein describes how this decoupling operates in a scene from Charlie Chaplin's *The Great Dictator*: "On the little bar-ber's storefront, Nazi storm troopers have written the terrible, damning word 'Jew.' The shell-shocked (!) Chaplin . . . erases this word, taking it for a series of abstract white streaks, devoid of meaning. The comic mechanism is clear: essence and form are dissected. . . . And the comi-cality of the effect resides in the fact that their representational co-membership is persistently emphasized."[2] This is funny, in other words, because the tension triggers our anxiety about the imperfect concurrence of visual image and meaning. We laugh at clowns because they look as if pain is not painful. In a literal sense, nothing is what it seems. And that dialectic, which plays a sinister role in both *The Great Dictator* and *Ivan the Terrible*, lies at the heart of Eisenstein's sense of humor. It is no coincidence that Eisenstein's favorite example of comedy is a joke about Nazis.

One does not have to accept Eisenstein's theory (or sense) of humor to appreciate its ap-plication in *The Fiery Furnace*. In this scene we see Eisenstein's characters as if in disguise; their visual representations are severed from the meanings we usually associate with them. The effect, Eisenstein hoped, was to force us to engage actively with the film by visually exposing the slippage between depiction and significance.

In Eisenstein's screenplay, the Chaldean guards make no special impression; only the words "clownishly grimacing" suggest the role devised for them. Their significance changes entirely when we see how Eisenstein dresses them, directs their gestures, and crosscuts their shots with other images. The Chaldean guards accompanying the young martyrs to the flames are an unsettling amalgam: grotesque and sinister in their role as prison guards and executioners yet recognizable as clowns and as parodies of boyars. Their pointed caps, caftans, and beards of straw mirror the boyars' appearance, blurring the line dividing the actors from their boyar audience.

Despite the Chaldeans' clownish gestures and makeup, their grimaces and facial contortions are unfunny, visibly heightening the decoupling inherent in the clowns' circus role. As the Chaldeans discuss throwing the boys into the fire, Eisenstein cuts to faces in the crowd, laugh-ing as this brutal execution and sacred martyrdom is turned into a circus routine. But instead of showing the audience at the play, Eisenstein inserts shots of the grinning women we saw much earlier gazing up in rapt approval at Ivan during his coronation. By doing so, he explic-itly links Ivan with Nebuchadnezzar and turns the Russian audience into demonic Chaldeans merrily applauding the torture of the young boys (fig. 40.2).

40.2. Ecstatic spectator in the audience of *The Fiery Furnace* as the boys chant: "Why do you bewitched Chaldeans serve a demonic tsar, a blasphemer and tormentor?" *Ivan the Terrible,* Part II. Film frame capture.

The effect is creepy and disorienting when viewers of a liturgical performance identify with the pagan torturers instead of with the sacred martyrs. The boys push these reversals a step further, linking the spectators in the Muscovite cathedral with the spectators in the Soviet movie theater. Chanting lines that Eisenstein added to the liturgical text, the boys ask the cathedral audience, "Why do you shameless Chaldeans serve a lawless tsar?" Ivan turns and listens for the first time as the boys continue. "Why do you bewitched Chaldeans serve a demonic tsar, a blasphemer and tormentor?" Ivan turns back to Filipp for his blessing, which Filipp defiantly refuses, and the boys chant, "Why do you torment us with fire? Why do you burn us?"

The decoupling of clowns from their ability to make us laugh at pain redoubles their subversive effect: Eisenstein cues us to question the conventional meaning of the clowns' role, prompting us to think about how that meaning is constructed. The process of unmasking the tsar—revealing him as truly Terrible—begins with the unmasking of the clowns and their audiences. Even if film viewers could only sense the disorienting contradiction between circus and liturgical play while watching the film, Eisenstein's clowns destabilize all conventional meanings associated with martyrdom and political murder. Their disguise-dualism leads us not to an unambiguous political judgment but to a more challenging position: they prompt us to consider how we are cued to respond to such public events as spectacles of terror.

But there are no simple masked/unmasked binaries in *The Fiery Furnace;* nor are there simple, deceptive surfaces that conceal true meanings: every unmasking reveals yet another field of ambivalence and division. Eisenstein shows us how truth itself is masked, how pain can be made to seem funny, and how comedy can be used to depict the deadly serious.

Escape from the spiraling world of seemingly endless reversals and masquerade comes with

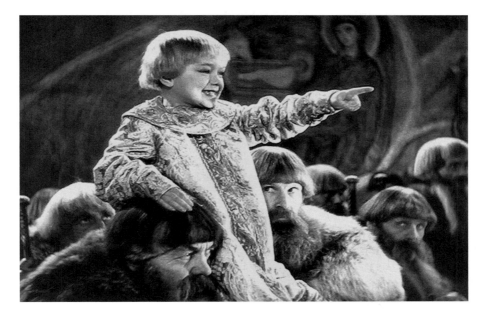

40.3. Child laughing as he says, "Look, Mama, *there* is the terrible, pagan tsar!" *Ivan the Terrible,* Part II. Film frame capture.

another form of laughter, which Eisenstein associated with both Chaplin and the circus: "Chaplin's distinctive feature" is that "he has retained a 'child's eye view' and a direct way of perceiving phenomena." This gives him the "ability to see the funny side of something that makes other people's flesh crawl." In this, Eisenstein says, "lies his greatness. . . . To see the most terrifying, the most pitiful, the most tragic phenomena . . . as a child looks at them, in a burst of laughter." Eisenstein is not recommending this point of view for everyday life ("In an adult such a trait is called 'infantilism'"), but he uses it to break out of the stalemate that occurs when good and evil threaten to become an indistinguishable mirrored pair.[3] As Ivan continues to demand Filipp's blessing and Filipp repeatedly defies him, a child's voice rings out. Laughing and pointing at Ivan, the child says, "Mama, *there* is the terrible, pagan tsar" (fig. 40.3). Whereas the unfunny clowns set the audience laughing, the infectious laughter of the child evokes fear and silence; it is immediately clear that even though the child thinks Ivan is an actor, he has penetrated the tsar's mask to see the naked truth. In so doing, the little boy destroys the illusion of fiction and the line between the fictional and the real.

Angered by the child's accusation, Ivan looks into the boyar audience and becomes truly enraged when he realizes what we have known all along—that it was his aunt Efrosinia who murdered his wife. He recognizes that no one here supports him and that everyone sees him as the "terrible, pagan tsar." At that point—all masks off—Ivan abandons his remaining human attachments and declares that he "will be Terrible."

The final, revealing irony of the "Fiery Furnace" scene resides in the mirrored laughter with which it begins and ends. When Ivan enters the cathedral, where the play has already begun, we hear his laughter before we see him. With a hearty but forced theatrical laugh, the tsar

announces his supremacy by disrupting the sacred atmosphere of the play. If laughter defies power, then a confident, laughing Ivan should have had no trouble defying Filipp, the church, and the play's moral lesson. Indeed, the scene ends with the tsar embracing his terrible power. Yet Ivan's strategic laughter pales in comparison with the ecstatic, Chaplinesque laugh of the small boy. In a typical Eisensteinian dialectic, the Terrible Ivan asserts his claim to submit to no one just when he has been forced to submit to a child's laugh.

NOTES—1. Russian State Archive of Literature and Art (Rossiiskii Gosudarstvennyi Arkhiv Literatury i Iskusstvo), f. 1923, op. 2, ed. khr. 1175, ll. 6–6ob (April 18, 1946).

2. *Eisenstein on Disney,* ed. Jay Leyda, trans. Alan Upchurch (Calcutta: Seagull Books, 1986), 58.

3. S. M. Eisenstein, "Charlie the Kid," in Eisenstein, *Selected Works,* vol. 3, ed. Richard Taylor, trans. William Powell (London: British Film Institute, 1996), 244, 254.

41

Soviet Jewish Photographers Confront World War II and the Holocaust

David Shneer

On May 9, 1945, Mark Markov-Grinberg, a photographer for the Soviet army newspaper *The Fighter's Word* (*Slovo boytsa*), entered the grounds of the Stutthof concentration camp with the 48th Regiment and took a series of photographs that were some of the most graphic images of war he ever created. In addition to *This Cannot Be Forgotten* (*Eto ne zabyvaetsia*), a haunting and seemingly staged image of an arm in a crematorium, Markov-Grinberg photographed gas chambers, zyklon B canisters, and other relics of Nazi atrocities (fig. 41.1). In interviews, he describes this series as the war photographs that touched him most deeply.

Markov-Grinberg was just one of many photojournalists, to this day relatively unknown outside the former Soviet Union, who built their careers documenting Soviet victories and Nazi atrocities on the eastern front of World War II. He was also just one of many Soviet photojournalists who were Jewish. From Max Alpert, the lead photographer for *TASS* and former photo editor of *Pravda,* and Semen Fridlyand, special war correspondent for *Ogonyok,* the *Time* magazine of the Soviet Union, to Abram Shterenberg, Evgeny Khaldei, Arkady Shaykhet, Mikhail Trakhman, Dmitry Baltermants, and Georgy Zelma, Jewish photographers were the foremost journalists creating the popular images of the war for the Soviet population.

As war photographers, they had the job of both documenting the latest news from the front and using photography to help win the war. Most of their photographs depict Soviet heroism or German atrocities. Markov-Grinberg's Stutthof photographs fit the atrocity category. Because they were taken on the last day of the war, they were not published at the time. In May 1945 there was no longer any need to demonize the Germans. In the category of Soviet heroism, one of Markov-Grinberg's best-known photographs shows soldiers huddled in a trench with a tank driving right over them during the Kursk Tank Battle of 1943, the biggest tank battle in history. The photograph shows the heat of battle and reminds the viewer of the conditions that soldiers and war photographers faced at the front. Unlike the Stutthof photograph, which shows Soviet victimhood, this photograph celebrates Soviet soldiers defending Russia from the Nazi invaders.

All Soviet photojournalists took pictures meant to show Red Army soldiers in a heroic light—as they raised the Soviet flag, for example, or defeated German soldiers. The most fa-

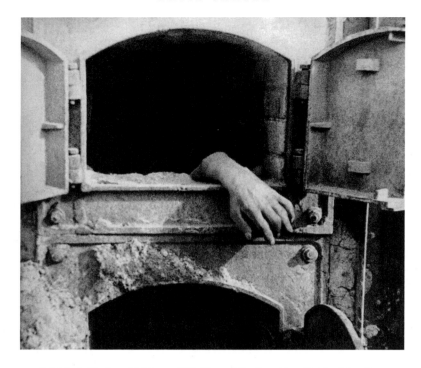

41.1. Mark Markov-Grinberg, *This Cannot Be Forgotten.* Stutthof death camp, 1945. Photograph.

mous such photograph of heroism, Evgeny Khaldei's *Raising the Red Flag over the Reichstag,* became as famous in the Soviet Union as Joe Rosenthal's image from Iwo Jima became in the United States (fig. 41.2).

Like Markov-Grinberg and Khaldei, other photographers took pictures of the evils of the enemy against whom they were fighting. The Soviet press had been publishing Nazi atrocity photographs since the beginning of the war and always framed them as documents of crimes against the Soviet people. *Pravda, Izvestiia,* and other publications circulated these photographs to show the nature of the enemy and to raise the fighting spirit of the population. Photographers took pictures of hangings discovered upon a city's liberation, bodies exhumed from mass burial pits, and, in some cases, mass executions, making them the first liberators to capture Nazi atrocities on film.

Several Soviet Jewish photographers, including Zelma, Trakhman, Samary Gurary, and Viktor Temin, photographed the Majdanek concentration camp in Poland shortly after its discovery in July 1944. Majdanek was the most widely photographed camp in Eastern Europe. These photographers captured images of empty buildings, silent landscapes, and piles of ash and bones. The Soviet press published these Nazi atrocity photographs widely, and the accompanying captions and stories identified the victims as a polyglot collection of European victims—from Soviet prisoners of war to French Communists. Although the victims at Majdanek

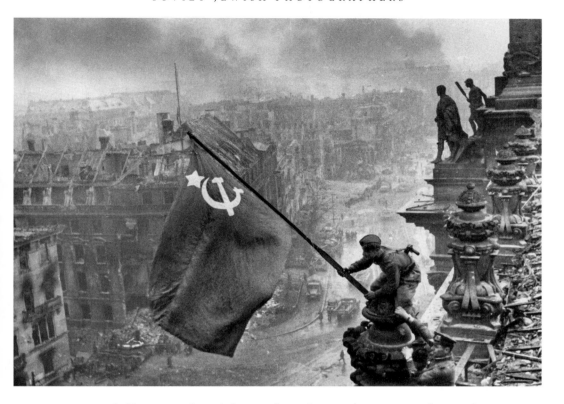

41.2. Evgeny Khaldei, *Raising the Red Flag over the Reichstag*, Berlin, May 1945. Photograph.

included prisoners of war, Communists, and other "peaceful citizens,—as news editors labeled the victims in the photographs—most of them were also Jews.

Today, this fact probably seems obvious. Most readers see photographs of concentration and extermination camps and immediately conclude that they document the Nazi war against the Jews, not the broader war against the Soviet Union and Europe. The photographs are what might now be called Holocaust photographs. Somewhere between the news editors who saw peaceful citizens and those who see murdered Jews lie the Soviet Jewish photographers who took the pictures. What did they see at Majdanek?

Ideologically and politically, the Soviet Union did not officially memorialize the Holocaust, meaning that it did not foster a particular memory of the persecution of European Jews by Nazi Germany and its allies. Very specific political and ideological policy shifts erased from popular Soviet consciousness particular Jewish suffering during and shortly after the war. The Soviet Union also had a hard time recognizing a Jewish tragedy during the war precisely because Nazi atrocities and mass destruction took place extensively on Nazi-occupied Soviet territory. The murder of two million Jews on Soviet soil could easily be absorbed into the staggering twenty-five million to thirty million Soviet war deaths overall, many of them the deaths of civilians.[1]

Soviet Jewish war photographers saw themselves first and foremost as Soviet journalists

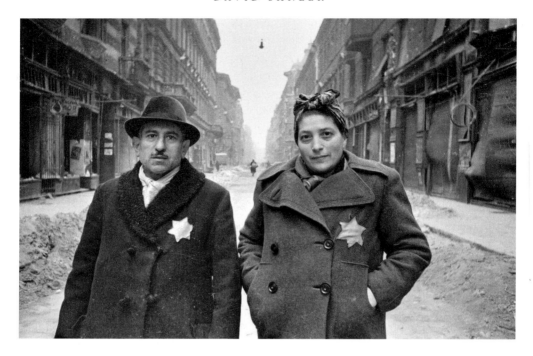

41.3. Evgeny Khaldei, *Jewish Couple*, Budapest, January 1945. Photograph.

photographing a Soviet war. In interviews, most of the photographers recognized that Jews, and thus they themselves, were targeted. But all said that they photographed the war as Soviet citizens, not as Jews. Most of them took pictures that could become part of the general narrative of Soviet atrocities, rather than taking pictures specifically of Jewish victims. After all, they wanted their photographs to get published. But this line of reasoning presumes that Soviet Jewish photographers were externally compelled to universalize the story, to erase the Jewishness of the story. For some this may have been the case. But for many others, they themselves wanted to be seen not as Jews, but as Soviet citizens. In other words, the universalization of Nazi atrocities was both official policy and something many Soviet Jewish photographers willingly contributed to.

Some Jewish writers and photographers in the Soviet Union did, however, produce texts and images specifically about the Nazi persecution of Jews. Ilya Ehrenburg and Vasily Grossman, two of the best-known Soviet print journalists, compiled the *Black Book* (*Chernaya kniga*) that documented Nazi atrocities against Jews on Soviet soil. Khaldei, the photographer of the famous Reichstag image, entered Budapest in January 1945 with the Red Army after a fierce several-month-long fight against German troops. One afternoon he turned down a small alley and entered the former Jewish ghetto of Budapest. Among his many shots of bombed-out buildings was a photograph titled *Jewish Couple* (fig. 41.3). In an interview Khaldei said: "There was a Jewish couple wearing Stars of David. They were afraid of me. There was still fighting going on in the city, and they thought I might be an SS soldier. So I said *Sholem Aleichem* [Yid-

dish for "hello"] to them, and the woman began to cry. After I'd taken the picture, I pulled their stars off and said, 'The fascists are beaten. It's terrible to be marked like that.'"[2]

The photographs from the Budapest ghetto today garner more attention than many of Khaldei's other photographs because of their emotional power and because the victims are marked as Jews by the yellow six-pointed star. Most Soviet editors chose not to publish these powerful images because of the obvious Jewish markings, which rendered them too "particular"—unlike Markov-Grinberg's image of a hand in a crematorium, which could have belonged to any victim of fascism. The only place Khaldei's photographs of the Jewish couple were published was in the Soviet Yiddish newspaper *Unity (Eynikayt),* which captioned the photograph *Jews with Stars of David on Their Chests That the Nazis Forced Them to Wear.* What compelled the editors was not the Jewishness of the victims but the Nazis' crude and violent marking of one ethnic group, something that even Khaldei noted in his story.

The photographic record of the war shows that Jewish photojournalists bore witness to and aesthetically represented several events simultaneously: the Soviet victory over evil, Nazi atrocities against humanity, and the particular destruction of European Jewry. Their editors, often Jews themselves, published and fostered the first two narratives, but the final narrative was not told widely in the Soviet Union. Photographs of Majdanek and Stutthof—which tended toward images of bones and emptiness rather than the vividness and presence of survivors' faces—were understood as Nazi atrocity photographs and officially had nothing to do with Jews in particular. Some readers might have known that the bodies in, for example, Dmitry Baltermants's famous picture *Grief* were massacred Jews, even though they were not marked with stars (fig. 41.4). Many other readers, however, would not have known that they were mostly Jews, or they would have read something else into the photographs.

The key point for these journalists was that bodies were *Soviet* bodies. Therefore, the original question must be restated: Did the Jews who were responsible for documenting the war for the Soviet public also document the Holocaust? Were they seeing what viewers today see in these images? How does the power of these images shift if the viewer learns that a photograph of rows of bodies at Majdanek, for example, depicts Polish Catholics and not Jews? Does that exclude the images as documents of the Holocaust? Khaldei's photographs of bodies with Jewish stars, such as *Murdered Jews in Budapest,* are easy to mark as explicitly Jewish photographs, and for that reason they were published only in the Yiddish newspaper. But what about atrocity photographs without explicit Jewish markings? Does the fact that they were situated in a pan-Soviet context mean that the photographers, or the readers for that matter, failed to read a Jewish narrative into these images? No, it does not.

When Baltermants, Khaldei, and others took Nazi atrocity photographs, especially images of extermination camps, they were bearing witness to several tragedies simultaneously. As Jews, at least according to their passports, which marked Jews as a separate nationality in the Soviet Union, they saw their own personal and national tragedies in these images, and many of them used their role as journalists to document this story, even if the Budapest ghetto photographs and the *Black Book* were not published as part of the larger Soviet narrative.

Photographs, like memorials, are contextual. They are created and seen at particular times

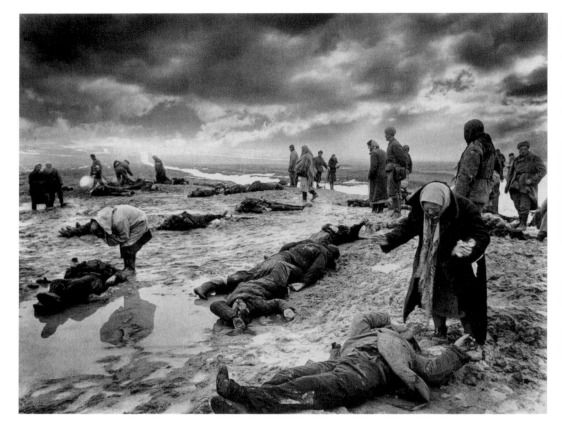

41.4. Dmitry Baltermants, *Grief,* Kerch, January 1942. Photograph.

and places by particular people with particular biases and prejudices. Once a photograph is taken, it is up to the viewer invest it with meaning. According to the Holocaust scholar James Young, "Memorials are dependent on visitors for whatever memory they finally produce."[3]

Some of the photographs presented here already have a long history of being read—by the photographers who took them, the editors who selected and captioned them, the newspaper readers who saw them, and, more recently, by museum and gallery visitors. Other photographs published here were only living in the private collections of these photographers, having never been published before.

Hung on a wall at the United States Holocaust Memorial Museum, Markov-Grinberg's *This Cannot Be Forgotten* becomes a Holocaust photograph. On the editor's layout table during the war it was a Nazi atrocity photograph. In the hands of individual Soviet readers, it meant many different things. But even at the time, when the Holocaust did not exist conceptually, these Soviet Jewish photographers understood that their photographs were not simply newspaper filler, there to accompany stories. Their photographs were documents of a crime, memorials of personal and collective tragedies, and important pieces in each photographer's body of work. Even if the editors of major Soviet wire services and newspapers avoided a particular Jewish

reading of Nazi atrocity photographs, even if Markov-Grinberg did not expect his photograph to be read "Jewishly," these Soviet Jewish photographers did take Holocaust photographs, even if we understand them to be so only today.

NOTES—1. Zvi Gitelman, "Politics and the Historiography of the Holocaust in the Soviet Union," in Gitelman, ed., *Bitter Legacy: Confronting the Holocaust in the USSR* (Bloomington: Indiana University Press, 1997), 14–42.

2. United States Holocaust Memorial Museum Photo Archives, #27208, text taken from Magyar Nemzeti Muzeum Torteneti Fenykeptar. There are several versions of this story, some told by Khaldei on tape, others reproduced in various publications.

3. James Young, *The Texture of Memory: Holocaust Memorials and Meaning* (New Haven: Yale University Press, 1992), xiii.

42

The Morning of Our Motherland

Fyodor Shurpin's Portrait of Stalin

Mark Bassin

*T*he Morning of Our Motherland is one of the most popular and important examples of socialist realist painting from the period of late or "high" Stalinism, which extended from the end of World War II down to Stalin's death in 1953 (fig. 42.1 [color section]). Its creator, Fyodor Shurpin (1904–72), was part of a generation of young Soviet "peasant" painters who came from rural backgrounds and emphasized themes of agriculture and country landscapes in their work. Completed in 1948, Shurpin's painting was immediately hailed by critics and the viewing public alike as an outstanding achievement, and in the following year it was awarded the highest honor for artistic accomplishment in the Soviet Union: the Stalin Prize.

Socialist realism was a not a particular style or genre but rather a highly generalized perspective or philosophy. Its basic tenet was that all cultural production in the Soviet Union—literature, painting, sculpture, architecture, and music—should in some way both reflect and advance the principles of progressive social organization and economic development that formed the basis of official state ideology and party policy. In practice, this imperative meant two rather different things. Soviet art was supposed to depict the ongoing radical reconstruction of all aspects of Soviet life in a positive and celebratory light. At the same time, however, socialist realism demanded that Soviet culture deliver vivid literary and visual representations of what the glorious communist future, once achieved, was actually going to look like. This latter task was critical, not least because so much of the lived reality of the USSR stood in utter contrast to the conditions of material abundance, social harmony, and personal happiness that socialism was supposed to deliver. Effectively, socialist realism had to bridge this critical disjuncture; thus, despite its "realist" pretensions, it necessarily took on a distinctly utopian dimension. The objective was not merely to encourage Soviet citizens to use their imagination in thinking about the conditions of their life; beyond this, and more fundamentally, socialist realism had to teach them exactly *how* they should use their imagination, by providing tangible models of what their future would look like. In a real sense, the challenge was to provide a means by which radiant ideal and sober reality could be brought into some kind of apparently logical perceptual correspondence. For the purposes of mobilizing popular support for the regime and its many policies it was imperative that such a correspondence be sustained, and as it turned out, the

realm of cultural production was one of the most effective means for achieving it. This latter fact is fundamental in explaining the high political priority that the state consistently assigned to it.

Shurpin's painting is both a portrait and a landscape. The symbology that he develops within each of these genres is discrete and, to a significant extent, self-contained. The scene is dominated by the commanding figure of Stalin, standing in a open field at the break of day. His massive figure is resplendent in his trademark white tunic, which brightly reflects the intense sunshine of the dawn. Presented faithfully in the deifying spirit of the Stalinist cult of personality, the artist's message is one of the simple magnificence and grandeur of the Great Leader. Stalin's relaxed bearing and expression of serenity and peace suggest a lordly humility mixed with self-confidence, determination, and unquestionable authority. Significantly, Stalin's back is turned on the landscape and by association on all of its worldly affairs. Instead, he gazes intently out of the frame of the picture, over the shoulder of the viewer and into the distance. The object of his attention seems to be the source of the morning light, but viewers can imagine that he is really looking at—or into—the alluring communist future of the Soviet motherland. The unmistakable implication is that this future is destined to be as radiant as the sun, which has brought the dawn and shines so dazzlingly upon him.

Some practical indications of exactly what this future might look like are provided in the landscape that fills the space behind the figure of Stalin, directing the attention of the viewer—in contrast to that of the Great Leader himself—to more worldly matters. One of the most important aspects of the Soviet canon was the belief that material abundance and social harmony would come as a result of the radical modernization of Russia's backward prerevolutionary order. Backwardness was characterized by low levels of technological development, which prevented the Russians from controlling and exploiting the forces of the natural world around them and ensured, among other things, that economic development would remain on a primitive level. The Soviets ambitiously resolved to overcome this unhappy legacy by the rapid industrialization of all sectors of the economy, a program that involved the far-reaching introduction of modern technology. As a result, Russia would finally be in a position to lift itself out from under the chaotic domination of the natural world and instead press its own principles for rational organization and exploitation upon it. This intention was expressed through the notion of *preobrazovanie,* the literal "reshaping" or "transformation" of the natural world through a human agency empowered with the resources of modern technology and the most progressive form of social organization. The spirit of what we might call transformism reverberated powerfully throughout the Stalinist period, and it provided inspiration for artists no less than anyone else.

The landscape that Shurpin depicts as a backdrop to Stalin represents a veritable tableau of the Soviet transformist project, and the inherent complexity of this panorama provides a creative contrast to the straightforward simplicity of the portrait itself. Four key transformist motifs are depicted here using standard socialist realist iconography. The theme of industrialization is signaled by the row of factories that stretches out across the horizon in the furthest background to the left behind Stalin, with a lone outcast on the far right. The factory buildings themselves are obscured by their remoteness, but their character and function are indicated

unmistakably—and typically for socialist realism—by the great billows of dirty smoke that pour out of their smokestacks. The row of factories is balanced visually by a row of pylons filling the middle background to the right of Stalin. The high-tension cables that they carry mark the second motif—namely, the electrification of the countryside and by extension the entire country. This particular project was of such inordinate symbolic value to the Soviets that Lenin famously went so far as to define communism itself in terms of it. Electrification was one of the most pervasive themes in socialist realism. It could be signaled iconographically in various ways, either with pylons, as Shurpin has done here, or alternatively—and more powerfully—through the depiction of hydroelectric dams. The third transformist theme is shown by the string of agricultural vehicles (apparently seeders) crawling resolutely along the oblique line marked out by the pylons. These represent the mechanization of agriculture, which was a key element in the transformation of the countryside, achieved through the collectivization campaigns of the 1930s. The fact of collectivization is marked more subtly by the straight furrows in which the seeders are moving. The strictly linear geometry was made possible by the consolidation of individual peasant allotments into extensive collective fields that could be exploited industrially, as it were, in a genuinely rational fashion.

Paradoxically, however, Shurpin's landscape is striking above all by virtue of its emptiness, for the artist's fields are devoid of crops. This particular pictorial strategy was characteristic of Shurpin's work, and he deployed it here and in other pictures to great effect. Most immediately and obviously, the lack of crops locates the scene sometime in the early spring, in the first stages of the agricultural cycle, thus echoing the theme of dawn—a propitious new beginning—already evoked in the Stalin portrait and, indeed, in the very title of the painting. The various iconographic markers of industrialization that the artist has provided guide the viewer to envision the eventual agricultural bounty as the product not so much of the forces of nature as of human agency—specifically, of Soviet planning and labor. This point is brought out by the row of saplings stretching across the length of the canvas in the immediate background, directly behind the figure of Stalin. These represent the fourth transformist motif. The meaning of this particular symbology is lost today, but it would have been readily apparent to audiences at the time that the picture was produced. In 1948 the Soviet government promulgated the "Great Stalin Plan for the Transformation of Nature," which represented an apotheosis of sorts for this dimension of the Soviet project. Inspired by the conviction that climatic patterns could be significantly altered through human intervention, the plan aimed to ameliorate the aridity characteristic of the southern regions of the USSR by increasing available moisture and thereby greatly enhancing agricultural potential. This was to be accomplished by the planting of shatterbelts—linear rows of trees that would change the movement of surface winds and thereby stimulate precipitation—across the vast Soviet countryside. In the row of saplings, Shurpin has brought this plan into his painting. With their uniform size and precisely even spacing, they provide a clear demonstration of the natural world organized and controlled by human agency.

For all of Shurpin's exemplary ideological conformity and the apparent clarity of his imagery, there remains a palpable ambiguity in the message that *The Morning of Our Motherland* is supposed to deliver. The theme of anthropogenic control and transformation of the natural world

is counterbalanced, in a vaguely unsettling manner, with the hint of a desire to penetrate into and merge with that very natural world in order to achieve a sort of harmonious union between Soviet society and nature itself. Thus, while the figure of Stalin dominates a landscape which the artist wants us to believe the Great Leader has created and controls, the figure becomes at the same time an organic part of this very landscape. This is signaled mainly by Shurpin's use of the sun's rays to illuminate his hero: Stalin is a sun god, but being a sun god suggests a oneness and harmony with the sun, with the cosmos, and the natural world—the very same natural world that the Soviets were so single-mindedly striving to subjugate and reshape. And if Stalin was to be naturalized in this manner, then so, by extension, was all of Soviet civilization.

These nuances were important to the critics of the day, who enthusiastically picked up on them in their accolades for the artist. In Shurpin's landscapes "people are always harmonized with nature," wrote one approvingly, and another specifically commented on how Stalin "organically blended" into the natural landscape in *The Morning of Our Motherland*.[1] Indeed, the artist himself was at pains to stress the point. At a talk in the Tretiakov Gallery in Moscow in May 1949, he explained his most basic motivation for his celebrated painting as a desire "somehow to extend our conceptions about Stalin in a somewhat different manner, [to show how] Stalin is connected to Nature, [how he] loves Nature, loves the dawn . . . , the sun, and the spring."[2] This marked ambivalence, it should be noted, was not Shurpin's alone but characterized much of the landscape art of socialist realism.

NOTES—1. K. Stepanova, "F. S. Shurpin," in *Fyodor Savvich Shurpin* (Moscow: Sovetskii Khudozhnik, 1954), 16; O. Sopotsinskii, "Vsesoiuznaia Khudozhestvennaia Vystavka 1949 goda. Peizazh.," *Iskusstvo*, no. 3 (1950): 19.

2. Tretiakov Gallery, Moscow: Manuscript Division, f. 18, d. 483 (May 13, 1949).

43

The Pioneer Palace in the Lenin Hills

Susan E. Reid

You could be forgiven for never noticing the Pioneer Palace in Moscow's Sparrow Hills. Or you may have dismissed it as just another of those postwar prefabs that remind you of your high school. Yet when the Pioneer Palace was built, between 1958 and 1962, at the height of the Thaw, this complex of glass and reinforced concrete structures, nestling unassumingly in a wooded hillside, inspired enormous enthusiasm. Even the First Secretary of the Communist Party, Nikita Khrushchev, pronounced the palace a "fine example of good taste" (fig. 43.1).[1]

The Pioneer Palace was a palace for children. Built in an unabashedly modernist style that contrasted starkly with nearby monumental Stalinist architecture, it was meant to embody the spirit of youth and modernity and to incubate the radiant future. Sponsored by the Komsomol, the Communist youth organization, it was designed by a collective of young Moscow architects—Igor Pokrovsky, Felix Novikov, Viktor Yegerev—in close collaboration with a group of young artists to accommodate the extracurricular activities and rituals of the Pioneers, the Communist Party's organization for children. More broadly, it was intended to nurture collectivist communist values. In accordance with the principles of "communist upbringing" espoused under Khrushchev, the palace was to promote self-regulation and mutual help, to temper children's will and physique, and to develop their initiative. The architects had to find an appropriate form to foster this new approach to the formation of the Soviet person—to arouse children's curiosity, imagination, and aesthetic sensibility. And when the Pioneer Palace was completed, contemporaries exuberated: it was the palace of happy childhood, a great box of presents, a gift to children, a dream come true, a city of the future, the City of Happiness, a Pioneer Republic, the Land of Red Ties, the Pioneer Wonderland. One magazine likened the palace to "a ship under full sail, sailing off into the future."[2]

Why did the building arouse such enthusiasm? What hopes for the future did its patrons and designers intend it to embody? And what can its visual appearance and spatial organization tell us about aspirations at this time of fundamental change?

The design for the Pioneer Palace abjured what had been a defining characteristic of Stalinist architecture, the search for imposing effect and monumentality, of which nearby Moscow University was a prime example. The university's tower, which looked down over the whole of Moscow, was an assertion of triumphal power and permanence. With the carelessness of convention permitted to youth, the children's palace ignored the expectation that public archi-

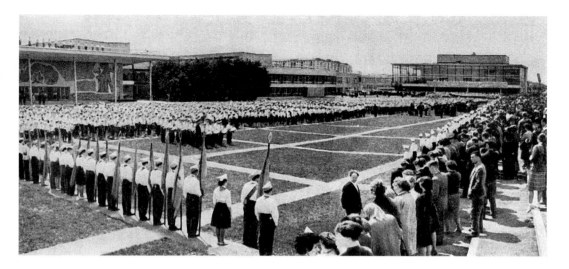

43.1. Ceremonial parade for the opening of the Pioneer Palace, June 1, 1962. Photograph.

tecture should impose itself upon its surroundings and its human users. Indeed, the architects and their supporters emphasized that their whole conception was founded in the nature and culture of childhood. Skeptics who doubted that this modest glass structure could really be a palace were told to "come like children."[3] Let us, then, approach the palace from the point of view of children, as the architects intended, imagining that we are going there for the first time, soon after its opening.

Starting out from the center of Moscow, our metro train suddenly emerges from its dark tunnel, and we are struck by the bright sunlight and the thrill of crossing the Moskva River by a new road and rail bridge—a wonder of modern construction technology. Our destination is the newly opened station, Lenin (now Sparrow) Hills. We surface on a wooded hillside rising above the rest of Moscow. The air is markedly fresher, as if our short journey has taken us far from the city. Indeed, we probably associate this place with family picnics in summer or with skiing in the winter, for it was a favorite leisure resort among Muscovites. The area also had positive associations with Russian liberal culture of the past. It had exemplified the pictur-esque for the nineteenth-century historian Nicholas Karamzin, and for Alexander Herzen, one of the founders of the Russian revolutionary movement, it had represented the site of moral awakening and youthful, romantic dreams of freedom, fondly remembered in exile. This quarter of Moscow had recently taken on additional meanings. Beginning with the postwar construction of Moscow University and continuing in the Khrushchev era with experimental mass housing schemes, it was marked as a place where the radiant future was being prepared through concrete work in the present day. By the early 1960s the region was firmly identified with youth, modernity, and the construction of communism. Contemporary commentators emphasized the significance of locating the new Pioneer Palace in the Lenin Hills. Set apart from the city by the river, it was a distinct new settlement, between countryside and city. To travel there across the river, to walk along its broad, tree-lined streets surrounded by the new

architecture that spoke of the post-Stalin regime's commitment to giving the people a better life, was to shake off the past and enter the brave new world. As contemporary accounts made clear, the trip across the new bridge to the Lenin Hills served as a form of time travel into the future, distancing the visitor to the Pioneer Palace from the ways of the past, whose material traces were inescapable in the city center.[4] As we emerge from the metro we can see the tower of Moscow University. . . . But where is the Pioneer Palace?

Our first impression is of a picturesque, lushly wooded park. In its midst, way off in the distance, across a meadow and below the level of the road, various low, loosely connected pavilions, some low domes, and a flagpole are to be seen. Has someone struck camp in this favored spot? No grand facade looms; no eloquent massing of volumes coheres into an imposing image. There is only an array of shapes and rooflines, seemingly informally distributed, without symmetry or apparent order, which eludes the attempt to grasp it visually. But we are children, and this does not bother us! We just want to get there: to explore, not only with our eyes but with our bodies; to experience its spaces, look around corners, and discover what interesting things there are to see and do inside. Such at least were the architects' expectations.

One of the most innovative and controversial aspects of the design was the architects' decision to eschew a grand facade and tuck the main building into a downward slope, well away from the main city thoroughfares. Khrushchev expressly welcomed the way the architects had used the natural relief of the plot, freely deploying the buildings in the heart of the park rather than reshaping and dominating the hillside and surrounding woodland. The architects had argued that a palace for children should not try to compete with Moscow University. On the contrary, its representative functions should be subordinated to its purpose as an "inner environment" for children's social, intellectual, physical, and creative development. The end result "seems to dissolve into nature. The parade ground and greenery become an inseparable part of the building, and the building looks like an organic element of the surrounding landscape."[5]

The scale of the palace was Lilliputian by comparison with Stalinist complexes, which tended to dwarf their occupants. The palace was "a separate Pioneer's world with its own, scale," "commensurate with the little person, its future master." Here, as in the fictional world of children's stories, children were the masters. "Enough, the reign of adults has ended!" a family magazine declared. "From now on, you are fully entitled masters of everything around you."[6]

The palace was also quite unlike Stalinist buildings such as Moscow University in its striking openness and transparency. Instead of entrances set back in courtyards and attained through narrow, guarded gates, which induce a sense of sanctity, deference, and privilege, the Pioneer Palace gave built form to Khrushchev's commitment to "democratism" (fig. 43.2). An important principle of the Pioneer organization was that access was not dependent on privilege or talent but that the organization was open to all children; the architecture of the palace expressed this principle through its emphatic horizontality, its continuous glass walls, and the presence of numerous doors on all sides. It "hospitably and warm-heartedly opens itself to children," wrote one enthusiast. "It invites them to come in and actively interests them in the most varied activities and objects."[7] Thus, modernist architectural form served to represent the modernization and democratization of the project of constructing communism. "Socialist democratism" was also expressed by the remarkable transparency and openness of the structures and their

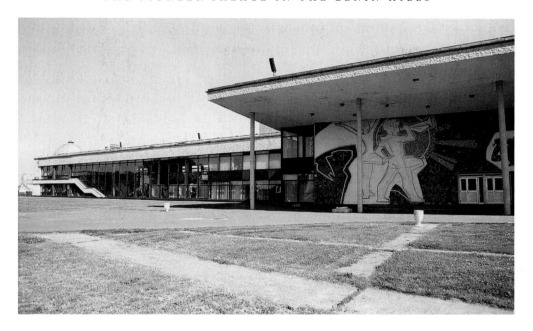

43.2. Pioneer Palace, main entrance. Photograph by Georgy Arzamasov.

fluid, picturesque plan, which were almost unprecedented in a permanent public building in the Soviet Union. The Concert Hall was staggeringly modern for its day (fig. 43.3). Great walls of glass soar high above the visitor. A low, broad flight of steps leads up to its entrance, placed off-center under a heavy cantilevered lintel. The lintel bears a deep semiabstract monochrome relief representing music. The insistent weightiness and materiality of this incised block of rough, raw concrete emphasizes, by contrast, the apparent immateriality of the transparent walls.

Large expanses of glass also rendered the interiors very bright. This answered health specialists' requirement that children's educational buildings have maximum natural light. It also served symbolic functions: in Soviet iconography, sunshine and the corresponding motif of the "shining path" represented the radiant future. Sunlight was specifically associated with childhood and with the happiness that was supposed to be its inalienable attribute under socialism, as in the song every schoolchild knew, "Let There Always Be Sunshine" ("Pust' vsegda budet solntse").[8]

The openness of the palace, its use of modern, industrial materials, its designers' intention that its function determine its form, and their refusal to mask its technological modernity with a historicist facade all firmly connected the palace to the international modernist movement, as in the work of Frank Lloyd Wright, Le Corbusier, and Mies van der Rohe, as well as to the Russian constructivist legacy. Contemporaries legitimated this audacious rapprochement with international modernism, hitherto repudiated as the expression of bourgeois capitalist ideology and still not officially acknowledged, by reference to the specific character and needs of children. The open plan of the modernist palace kept children close to their "natural" habitat

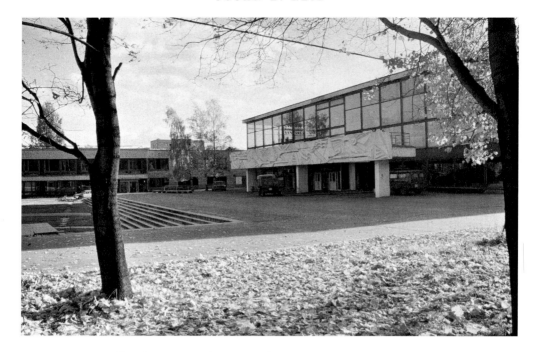

43.3. Concert Hall in the Pioneer Palace ensemble. Photograph by Susan E. Reid.

and corresponded to the specific ways children related to space and to their material environment. The press described the initial encounter with the palace complex as an active, spatial experience for a young body moving through it: it aroused the child's need to explore. It could even have a rejuvenating, stimulating effect on adults, reviving their long lost excitement of childhood.[9]

"Children need things that are simple, contemporary, graceful, and convenient," declared the Komsomol newspaper. "This is precisely how the Moscow Pioneer Palace looks. It has been built by people who clearly know children well and love them."[10] Aiming to stimulate the child's imagination rather than to indoctrinate, to encourage spontaneous activity within a purposeful framework, the Pioneer Palace was child-centered architecture, a design for the future not only with a human face but with a child's face. Turning toward the future, it rejected the styles of the past and embraced the modern.

NOTES—1. N. S. Khrushchev, Opening Speech, June 1, 1962, Pioneer Palace Archive, Historical Section of the Pioneer Palace, Moscow (no catalogue or file numbers); "Vystuplenie N. S. Khrushcheva," *Komsomol'skaia pravda* (hereafter *KP*), June 2, 1962, pp. 1–2; V. Egerev et al., *Moskovskii Dvorets pionerov* (Moscow: Stroyizdat, 1963), 5–6.

2. S. Soloveichik and E. Bruskova, "Kliuch ot strany romantikov," *KP*, June 2, 1962; Soloveichik, "Eto Vam, schastlivye!" *KP*, June 1, 1962, p. 4; "'Zolotoi kliuchik' Pionerskoi strany," *KP*, May 17, 1962; V. Lebedeva and V. Lebedev, "Gorod schast'ia," *Sovetskaia kul'tura*, April 8, 1962; Iu. Kotler, "Strana krasnykh galstukov," *Sem'ia i shkola*, no. 1 (January 1959): 28; Russian State Archive of Literature and Art (Rossiiskii Gosudarstvennyi Arkhiv Literatury i Iskusstvo, RGALI), f. 2943, op. 2, ed. khr. 82, l. 30; Moscow Central Municipal Archive (Tsentral'nyi

Municipial'nyi Arkhiv Moskvy), f. 959, op. 1. d. 452, ll. 1–3; f. 959, op. 1, d. 47; f. 959, op. 1, d. 32, l. 2; f. 959, op. 1, d. 54, l. 2; "Pokolenie tovarishchei," *Ogonek,* no. 24 (June 10, 1962): 3.

3. RGALI, f. 2943, op. 2, ed. khr. 82, l. 52.

4. RGALI, f. 2943, op. 2, ed. khr. 82, l. 52; D. Sarab'ianov, "Real'nye plody sinteza," *Tvorchestvo,* no. 9 (1962): 1.

5. N. S. Khrushchev, Opening Speech, June 1, 1962; "Vystuplenie N. S. Khrushcheva"; Egerev et al., *Moskovskii Dvorets,* 5–6; E. Dzhavelidze, A. Riabushin, and M. Fedorov, "Dvorets pionerov na Leninskikh gorakh," *Stroitel'stvo i arkhitektura Moskvy,* no. 7 (1962): 17 (quotations).

6. Egerev, *Moskovskii Dvorets,* 6; RGALI, f. 2943, op. 2, ed. khr. 82, l. 52 (Pokrovskii); F. Novikov, *Formula arkhitektury* (Moscow: Detskaia literatura, 1984), 105; Igor' Pokrovskii, interview with the author, Zelenograd, 1994; Kotler, "Strana krasnykh galstukov," 28.

7. L. Zhadova, "Probuzhdat' khudozhnikov," *Dekorativnoe iskusstvo SSSR,* no. 4 (1963): 7.

8. "Pust' vsegda budet solntse," *Sem'ia i shkola,* no. 6 (1961): 5; A. Zhukova, "V solnechnom dome," *Ogonek,* no. 25 (June 17, 1962): 8–9.

9. Soloveichik, "Eto Vam"; compare M. V. Osorina, *Sekretnyi mir detei v prostranstve mira vzroslykh* (St. Petersburg: Piter, 2000), 119.

10. Soloveichik, "Eto Vam," 4.

44

Mikhail Romm's Ordinary Fascism

Josephine Woll

The film *Ordinary Fascism* was conceived in response to the power of images. In 1963 the critics Maia Turovskaia and Yury Khaniutin watched thousands of yards of film footage from Weimar and Nazi Germany, much of it captured by Red Army forces from German archives. "We were amazed," they later wrote, "at how much the face of Germany had changed. Life became completely standardized. The whole country was a faceless mass, raising its hand and hysterically shouting 'Heil!'"[1] They originally intended to show that transformation in a blend of documentary footage, which would convey the passage of time, and clips from German fiction films of the 1920s. Following the sociologist Siegfried Kracauer, they believed that these films demonstrated the psychological vulnerability of the German petit bourgeoisie, which created a hospitable environment for Nazism.

From its inception, then, *Ordinary Fascism* was meant to be neither a documentary chronicle of the Second World War nor a visual account of what was only beginning—and not yet in the Soviet Union—to be called the Holocaust.[2] Turovskaia and Khaniutin wanted to explore the metamorphosis of an entire society, and the historically factual images of conventional documentary, albeit essential, could not in themselves do the job. They therefore took their project to Mosfilm, the Soviet Union's premier feature film studio, and to Mikhail Romm, one of its premier directors.

The idea of scrutinizing the instincts and motives of people who ceded their individuality to become part of a mindless social mass intrigued Romm. He had already scathingly satirized the dehumanizing narcissism of petit bourgeois mentality in *Pyshka* (1934), *The Dream* (1940), and *Person #217* (1944). And he had long understood the flexible potential of documentary footage, integrating newsreel images of German prisoners of war, for instance, into the opening of *Person #217*. Like many of his colleagues, Romm admired Italian neorealist cinema precisely because its presentations of unadorned "real life" transformed chronicle into an aesthetic principle, one clearly opposed to the inflated monumentalism of Benito Mussolini's fascism (and postwar Stalinism). In short, when Turovskaia and Khaniutin came to Romm, he agreed to direct their film.

As the three worked, they significantly modified their original plan. First, the feature film clips disappeared entirely. With mise-en-scène and dialogue aesthetically shaped for entertainment, the artifice of feature films undercut the credibility of the documentary images. Besides,

separating the "authentic" world shown in the documentary footage from the invented world of the actors required too much effort; even the actors' voices proved a distraction.[3] In the end, the team retained a few staged segments, such as the consultation between a doctor and a newly betrothed pair to discuss the Aryan purity of their offspring: such segments, staged by the Nazis themselves for domestic consumption, became one more documentary source for Romm, Turovskaia, and Khaniutin.

Second, they subordinated the loosely chronological structure of *Ordinary Fascism* to the fundamental device of contrast: image against image, image against text. Montage creates visual contrast in the film, and Romm's voice-over narration creates aural montage, a dialogue both with the viewer and with the screened images. Together, montage and voice-over allow *Ordinary Fascism* to challenge the viewer intellectually—to "force the viewer to work," as Romm later explained—and, equally important, to avoid the nearly inevitable dulling of emotional response elicited by a steady stream of Nazi footage.[4]

Instead of juxtaposing German documentary footage with feature film clips, Romm and his team juxtaposed the German material with footage they themselves shot, in concentration camps in Poland and in contemporary Moscow, Berlin, and Warsaw, the latter footage shot mainly via hidden cameras. After the title credits roll, to an ominous musical background, the film shows us no swastikas, no corpses, no goose-stepping SS men, no Führer. Instead, we see children's drawings of cats—a cheerful cat, a hungry cat, a sly cat—and then young people waiting for examination results in Moscow, mothers pushing prams in Berlin, affectionate couples, more drawings, this time of children's "most-beautiful-in-the-world" mothers. After something like sixty shots, not one of them archival, not one connected with fascism, Romm cuts from a mother holding her child on a Moscow street to a mother holding her child as a Nazi soldier shoots them (fig. 44.1). Romm first celebrates the diversity of human beings and the fundamental creative human impulse; only then does *Ordinary Fascism* turn to its primary subject, the rise of Nazism.

From the start Romm wanted to engage the viewer of *Ordinary Fascism* in a dialogue. His constant consciousness of that viewer determined the images selected for inclusion, the content and tone of the voice-over narration, the formal division of the film into "chapters," and the relative autonomy of each chapter to make the film as a whole easier to absorb. He, Turovskaia, and Khaniutin agreed to avoid Grand Guignol: their audience had seen enough horrors over the years. Instead, they sought to inflect the images with sarcasm, irony, anger, humor—partly by montage and partly by Romm's scripted commentary, his improvisations, and the modulations of his voice. Editing transformed the photographs of Hitler frozen in one or another pose and of Hitleriana such as a swastika-iced birthday cake—iconographic representations for their original intended audience—into a theatrical, absurd montage, and Romm's voice directs our eye over the screen, explaining what we see, indicating on occasion the provenance of the images, offering an ironic or sardonic comment. As the cinematographer German Lavrov's camera pans cases of prosthetic limbs, children's potties, and the brick walls and ovens of Auschwitz, Romm deliberately eschews pathos: his voice betrays anger, not grief.

Recalling Sergei Eisenstein's advice that a good director, like a good boxer, never hits twice in the same spot, Romm assumes an active, aggressive, "even occasionally crude" stance to

44.1. Mothers holding children in *Ordinary Fascism* (1965), directed by Michael Romm. Film frame captures.

compel the viewer's attention and involvement.[5] Sometimes the images speak for themselves. When Mussolini harangues the crowd from his balcony in Rome, Romm explicitly tells us to pay attention to the image, not the words, in order to appreciate the farcical element of Il Duce's public persona. Chapter II, "Mein Kampf, or How Calfskin Is Reworked," shows us the steps involved in manufacturing a unique exemplar of Hitler's book in 1939—from skinning the calf for the most supple leather for binding to reverently hand-etching the Gothic lettering on the

front cover—until the completion of the monument that is meant (as the Nazi soundtrack tells us) to endure one thousand years. Romm's voice remains neutral as he describes what we are watching, only once interpolating, "If all Germans had thought about the contents of the book as they should have, Germany's fate might have been different."

In line with the structural principle of contrast, Romm's team sought footage of Germans who were not seduced by Nazism. They found very little: a few images of workers, old footage of Rotfront demonstrators, mugshots of individuals who resisted the Nazis and ended up in camps. As for "ordinary" life, in modest or opulent apartments, in schoolrooms or parks and cafés, the filmmakers found virtually no footage: such images, which contradicted the ideology of "One People, One Führer," did not interest the Nazis.[6] Rather, Turovskaia and Khaniutin repeatedly saw Germans in uniform and helmet, marching with arms outstretched, swaying in unison to a song, or "squashed like caviar by the borders of the frame" in crowd scenes.[7]

Flaming torches—in nighttime parades, in a gigantic swastika, lighting the pyre of burning books at Berlin University—demonstrate the metamorphosis of German society under Nazism, as do the uniforms that transform representatives of various academic institutions into soldiers of the state. Romm inserts non-Nazi footage only once, interrupting a sequence on the Nazi "science" of measuring "Aryan" skulls with a series of head shots of Pushkin, Tolstoy, Marx, Chekhov, Mayakovsky, and Einstein. Here contrast emerges less from the actual footage than from the collision between what we see and the common sense of a reasonable individual, as Romm's voice-over presumes the viewer to be. In the last chapter of Part I, titled "Art," Hitler attends a sculpture exhibit, its hyperbolized romantic portraits of him and gargantuan statues of Aryan perfection providing a grotesque visual contrast to (and mute comment on) the diminutive examples of living Aryans who trail from room to room.

Ordinary Fascism's focus shifts in the six segments that deal with the war itself. Romm reprises one of his fundamental images, the child as prism of moral judgment and as symbol of innocence. We see children playing hopscotch and clustered around a barrel organ grinder pumping out the "Horst Wessel Song," the Nazi Party anthem; their drawings, in addition to "mama" and "papa," depict tanks, knives, and swastikas. As these children of Nazi Germany practice their handwriting, we see the goal of their meticulous repetitions—a birthday card for Hitler. We watch the child metamorphose into the soldier.

And we see the war, condensed into a dramatic montage constructed of sharply contrasting pieces. Romm cuts from airplane shots looking down on ant-sized people (shot by Nazi cameramen) to people running down the bombarded streets of Madrid (shot by Soviet cameramen), from German prisoners at Stalingrad to victory celebrations in Red Square, from Joseph Goebbels's speech about "total" war, received with ecstatic applause, to deathly silence, then bomb blasts and lines of captured soldiers. Romm wanted viewers to feel that the war had passed before them, but without depicting the war at all. With an image of Auguste Rodin's *Thinker,* Romm contests the nightmare of war with the wonder of art; with shots of a small Moscow girl who wriggles and wiggles and dances restlessly away from her mother, he opposes the pursuit of death to the freedom-seeking energy of a child.

The principle of contrast culminates in the chapter titled "Ordinary Fascism." In souvenirs treasured by some German soldiers, snapshots of parents are juxtaposed with a photograph of

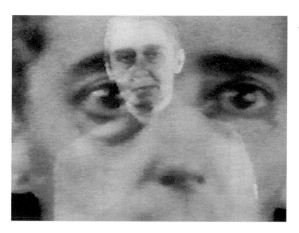

44.2. Auschwitz prisoners in *Ordinary Fascism*.
Frames from a film sequence of photographs.

a victim hanging from a noose, a smiling German soldier posed next to him; we see German soldiers run naked into a river, laughing and splashing, and we see the smoke rising from the Lvov (L'viv) ghetto. In one still photograph a person is pressed face down into the ground while a German soldier poises an axe overhead.

Ordinary Fascism showed Soviet viewers of 1965 the faces of fascism—the infamous familiar faces, often in contexts or accompanied by commentary that defamiliarized them, and the unknown faces of perpetrators and victims. Some observers argue that it might be naive to zoom in on the eyes of the perpetrators, as if to suggest that we can somehow recognize in their gaze what drove people to Nazism. But when Romm presents a sequence of photographs taken from the walls of the Auschwitz museum, of prisoners so starved that their faces often lack gender, the eyes of the prisoners scour and burn and brand our own gaze, rendering analysis superfluous (fig. 44.2).

Ordinary Fascism draws no explicit parallels between Nazi Germany and Stalinist Russia, referring to recrudescent fascism only in images from the Federal Republic of Germany, the United States, and other antagonists of the USSR. While conventions of allowable thought may have constrained Romm from implying resemblances, viewers still recall making the obvious connections between Nazi parades and Soviet parades, between Nazi sculpture and socialist realist sculpture, between the apotheosis of the Führer and the Stalinist cult of personality. The novelist Boris Strugatsky remembered that when Romm's film appeared, "both I and the majority of my friends properly understood the director's hidden design—to demonstrate the dreadful, unconditional, infernally profound resemblance between the two regimes."[8] Soviet interpretation had traditionally regarded fascism as horrifying, as morally threatening, but never as familiar or "ordinary." In *Ordinary Fascism,* using images and words, Mikhail Romm, Maia Turovskaia, and Yury Khaniutin set out to change that perception, and to a remarkable degree they succeeded.

NOTES—1. Maia Turovskaia and Iurii Khaniutin, "Romm, kinokamera i my," *Iskusstvo kino* 3 (1988): 94 (written in 1968).

2. On the changing representation of the Holocaust as a historical event, see Lawrence Langer, *Admitting the Holocaust* (Oxford: Oxford University Press, 1995); Tim Cole, *Selling the Holocaust: From Auschwitz to Schindler: How History Is Bought, Packaged, and Sold* (New York: Routledge, 1999); Peter Novick, *The Holocaust in American Life* (Boston: Houghton Mifflin, 1999).

3. Mikhail Romm, "Akter—kino—zhizn,'" *Izbrannye proizvedeniia v trekh tomakh* (Moscow: Iskusstvo, 1981), 1:353.

4. Mikhail Romm, cited in Miron Zak, *Mikhail Romm i ego fil'my* (Moscow: Iskusstvo, 1988), 247.

5. Romm, cited in Zak, *Mikhail Romm i ego fil'my,* 247.

6. Mikhail Romm, "Obyknovennyi fashizm," *Izbrannye proizvedeniia v trekh tomakh,* 2:302.

7. Romm, cited in Zak, *Mikhail Romm i ego fil'my,* 247.

8. Boris Strugatskii, "Zheleznaia ruka, kostianaia noga i prochie prelesti poriadka," *Literaturnaia gazeta,* October 11, 1995. The critic Lev Anninskii believed that internal as well as external censorship prevented Romm from identifying Stalinism as Nazism's mirror image, but as a young man watching the film he saw the parallels. Lev Anninskii, *Shestidesiatniki i my* (Moscow: Kinotsentr, 1991), 187–88. The film historian Julian Graffy, studying in Voronezh, saw the film with fellow students, all of whom discussed the parallels. (Conversation with the author, London, July 2004).

45

Solaris *and the White, White Screen*

Lilya Kaganovsky

One of the premier filmmakers of the post-Stalin period, Andrei Arsenevich Tarkovsky (1932–86) completed only five feature films in the Soviet Union and two in the West, before his death in Paris in 1986. His films, which began with *The Steamroller and the Violin* (*Katok i skripka*, 1960) and *Ivan's Childhood* (*Ivanovo detstvo*, 1962) and ended with *The Sacrifice* (*Offret*, 1986), are each in their own way masterpieces of world cinema. In each Tarkovsky strives to combine the visual and formal possibilities of filmmaking with an intensely personal web of memory, history, and art. The films drew criticism from Soviet critics and were highly praised abroad: some of Tarkovsky's highest awards include the Golden Lion in Venice for *Ivan's Childhood* and the Donatello Prize (1980) and several different prizes at Cannes for *Andrei Rublev* (1966, USSR release in 1971), *Solaris* (1972), *Stalker* (1979), *Nostalghia* (*Nostalgiia*, 1983), and *The Sacrifice*. In 1984, after failing to negotiate an extended stay in the West, Tarkovsky announced his "defection," citing motives of artistic freedom and economic necessity. He died of cancer shortly after completing *The Sacrifice*. Tarkovsky's theoretical and critical writings are collected in his diary, published in English as *Time within Time* (1991) and *Sculpting in Time* (1986). In his writing, Tarkovsky maps out the origins of his films and dwells on the possibilities and limitations of cinema as art.

Tarkovsky's third full-length feature film, *Solaris,* is a lengthy science-fiction project based on Stanislaw Lem's 1961 novel of that name (the original cut was supposed to be longer than three hours but was released in the Soviet Union and abroad in several shortened versions). Although Tarkovsky was never happy with the final result, the film nonetheless captured many of his perennial concerns: the relationship between memory and history, the relationship between art and science, and the consequences of confrontation with an incomprehensible and alien Other. The film, which unlike Lem's novel includes a long opening sequence set on Earth, opens and closes with an extreme close-up of underwater reeds (fig. 45.1 [color section]). From the reeds the camera pans through the water up to the hand and the face of Kris Kelvin (Donatas Banionis). Yet the underwater reeds are not part of a shot-reverse shot sequence, nor are they the object of Kelvin's gaze; rather, they seem to capture the camera's attention precisely in their inhuman, alien form as pure non-anthropomorphic nature. Swaying gently in the water, giving off the feeling of time slowed but not completely halted, the blue-green reeds are the first in a

series of images of organic, disturbingly inhuman life, culminating in the shots of the seething Solaris Ocean glimpsed through the portholes of the space station that orbits the planet.

The image of the reeds is surprising because *Solaris* is a film about the conflict of nature and technology, humanity and science, that appears at first glance to reject the cold and inhuman in favor of the personal, the tragic, and the emotional. Made as a kind of response to Stanley Kubrick's coolly scientific *2001: A Space Odyssey* (1968), *Solaris,* with its prolonged Earth sequence, nearly nonexistent space flight, dilapidated space station, and mahogany library filled with works by Brueghel and Cervantes, shows us the power of love, memory, and history lost in the world of scientific and technological progress. Yet, as the swaying underwater reeds of the opening sequence suggest, *Solaris* also tells another story, offering a glimpse into the truly unknown and unknowable that attracts and repels us at the same time.

Writing about his use of Leonardo da Vinci's portrait *A Young Lady with a Juniper* in *Mirror* (*Zerkalo,* 1975), Tarkovsky explains that the picture affects us simultaneously in two opposite ways. "It is not possible to say what impression the portrait finally makes on us," he writes. "It is not even possible to say definitely whether we like the woman or not, whether she is appealing or unpleasant. She is at once attractive and repellent. There is something inexpressibly beautiful about her and at the same time, repulsive, fiendish."[1] Indeed, Tarkovsky's films are filled with images whose power lies precisely in the twofold nature of their inexpressible beauty that is at the same time frightening and repellent. *Mirror* ends its documentary sequence with shots of the atomic bomb exploding over Hiroshima, and this image of nuclear annihilation likely informs the vision of monstrous beauty found at the heart of all of Tarkovsky's films. The image of the Solaris Ocean, produced through shots of oil and mercury superimposed on water, creating an impression of a richly hued, thick, viscous liquid that seems recognizable but is completely alien, is itself a product of a Hiroshima/Nagasaki vision of post-apocalyptic life, similar to the landscape of *Stalker.*

Even the placement of the images of the Solaris Ocean helps to create an impression of an alien presence because the shots are preceded by a complete de-saturation of the screen space, when the film screen temporarily goes white. As Gilles Deleuze tells us, it is precisely at moments like this that the viewer is forced to confront the image itself. All narrative and other devices are removed, and the experience of looking becomes primary. In other words, the all-white screen and the removal of all recognizable visual or narrative support prepare us for the image of the truly alien and incomprehensible Other. The image of the Solaris Ocean first appears out of this moment of de-saturation, out of the nothingness that precedes it, that "white on white, which is impossible to film."[2] We first see this white space on a video screen during the pilot Berton's debriefing, and it is the image that closes the film, dissolving the underwater reeds and the teeming Solaris Ocean.

In the context of *Solaris,* the Ocean represents a possible alien intelligence, responsible for generating physical manifestations of the dreams and memories of those on board the space station. In the historical-cultural-political context of the film and of Tarkovsky's work, however, the image of the Ocean—the seething alien mass that fills the screen—seems representative of the end point of humanity's scientific advance: the aftermath of technology's antihuman drive

but also of humanity's inevitable confrontation with the truly incomprehensible and uncomprehending Other. Filmed in part in Japan (at a time when Tarkovsky had been hoping to make his autobiographical and intensely personal *Mirror,* the original version of which was titled *White, White Day* [*Belyi, belyi den'*, 1973]), *Solaris* seems to speak to the tragedy of the human race pushed toward its farthest technological frontier. The images of the de-saturated screen and the seething tides of the Solaris Ocean force the viewer into a momentary confrontation with what Jacques Lacan had termed the Real—with that which is inassimilable and which cannot be placed within narrative or other symbolic structures, but of which Hiroshima's atomic explosions are one blinding manifestation.[3] Science taken to its limits is the magnificent and incomprehensible beauty of nuclear holocaust (as the ending of Stanley Kubrick's *Dr. Strangelove* [1964] similarly suggests), and Tarkovsky's all-white screen and the seething images of non-anthropomorphic life are the closest visual representation of this terrifying, repulsive, incomprehensible Other.

Despite the ostensible rejection of the technological in favor of the human in Tarkovsky's film, we are nevertheless able to perceive humanity only through the matrix of cinema, by means of its mechanical generation. Technology—film technology in particular—can visually represent notions of timelessness and immortality: the older Berton can watch his younger self; the dead Gibarian can speak to Kelvin; Kelvin can see his mother, his younger self, and Hari, his dead wife. Indeed, when Sartorius tells Hari that she is merely a "mechanical reproduction, a copy, a matrix," he is speaking about the nature of film itself and its multiple iterations. As the camera moves away in a helicopter shot in the final moments of *Solaris,* it reveals the father's house from the opening sequence gradually becoming obscured by clouds. The final shots show us the Solaris Ocean with its newly formed islands—one of them contains the dacha, the pond, the trees, and the highway—a view made possible precisely through cinema's ability to see the world from inhuman vantage points and to superimpose one image over another (fig. 45.2 [color section]). As the camera continues to move away through the clouds, the screen fades to white. This final white screen of nothingness is also the white screen of what is and what is not given to us to be seen, enclosing the seething mass of Solaris.

NOTES—1. Andrey Tarkovsky, *Sculpting in Time* (Austin: University of Texas Press, 1986), 108.

2. Gilles Deleuze, *Cinema 1: The Movement Image* (Minneapolis: University of Minnesota Press, 1986), 12–13; 18.

3. On "the Real," see Jacques Lacan, *The Seminar of Jacques Lacan: Book XI,* trans. Alan Sheridan (New York: W. W. Norton, 1978); Lacan, *The Seminar of Jacques Lacan: Book VII,* trans. Dennis Porter (New York: W. W. Norton, 1992); and Slavoj Zizek, *Looking Awry: An Introduction to Jacques Lacan through Popular Culture* (Cambridge, Mass.: MIT Press, 1992).

46

After Malevich—Variations on the Return to the Black Square

Jane A. Sharp

Kazimir Malevich's *Black Square* (1915) and its legacy in the visual arts in Russia had unique significance for avant-garde artists in the Soviet era, particularly after the Thaw (1953–62). For this generation, the painting, an irregular rectangle (nearly square) on a white ground, embodied both the myth of creative work in the prerevolutionary period and its real impact on their own work (fig. 46.1). Launched at "0.10: The Last Futurist Exhibition" in St. Petersburg in December 1915 as a spontaneous and intuitive (though historically self-conscious) act, the square was presented by Malevich as the founding element of suprematism. This new utopian visual language, geometric and abstract, aimed to defy traditional concepts of representation— and to transform society.

Artists tend to mark their place in art history by making complex references to preceding traditions—through their returns to the *Black Square* in the case of many; both the painter Lydia Masterkova and the conceptual artist Igor Makarevich have actually "repainted" the square, or restaged its reception. Such returns can be compelling creative strategies for artists from later generations. The question is, How can a work of art such as the *Black Square* evoke diverse responses from artists who matured in the same decade and milieu—Moscow in the 1950s and 1960s—and why do later artists return to it?

In the visual arts, it is often least rewarding, even misleading, to interpret a return to the past as evidence of causation in the present or, in art historical terms, as evidence of influence. To do so implies that artists are passive recipients of meanings or values that we confer on their sources rather than active agents who shape their culture and history. Typically they are motivated to reclaim an artist, an object, painting, or era. We, as viewers, seek to understand how and to what end. Some artists insist on deliberate and self-conscious historical continuity with the avant-garde past. Others ironically underscore a rupture; they recognize both the need for and the impossibility of realizing modernism's utopian message. To interpret the significance of each reworking of the *Black Square* requires us to move in two directions. As we learn what Masterkova and Makarevich selectively understood in Malevich's progression toward abstraction, we gain a new insight into Malevich's work, as well as a new perspective on contemporary practices. In the cases discussed below, the artist's recognition of his or her place in the present

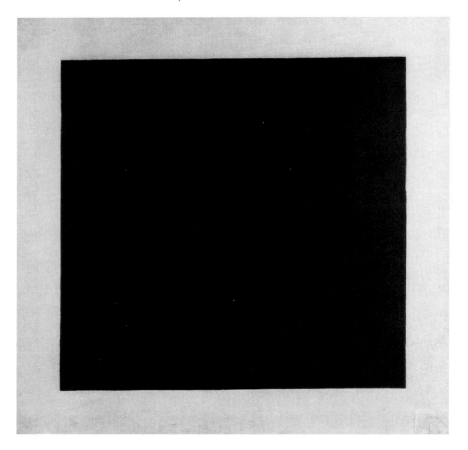

46.1. Kazimir Malevich, *Black Square*, 1915. Oil on canvas.

is embodied in a dialogue with the past—one that makes such art especially poignant to contemporary viewers. In reconstructing this dialogue and its reception we may come to better understand how art constitutes history instead of merely illustrating it.

As we recognize the *Black Square*'s plural meanings in contemporary art we add to (as we may reinforce or alter) the many different values that Malevich himself assigned to the painting. When Malevich repainted that primary form over the course of nearly two decades, he proposed plural philosophical systems through it (four different versions of his *Black Square* are known to exist, spanning the years 1915 to 1932). They all express Malevich's conviction that nonobjective art was to generate, in a manner similar to the role of the word/logos in religious thought, a profound attitude of self-awareness in relation to the environment and spiritual world in which we exist. In his various redactions of *Suprematism: The World as Nonobjectivity*, which he wrote between 1923 and 1926, the artist argued that the material realization of any concept, including through useful objects, is both anticipated and demonstrated by the abstract conceptualization of the art object, although he acknowledged that this relationship would be interpreted variously at different moments in time and in different cultural contexts.

A reconsideration of the impact of Malevich's thought and work on the art of subsequent generations must address the artistic context of the Soviet period. The notion of painting as the preeminent form of creative expression in the visual arts was critical to the perpetuation of the Soviet worldview. The tradition of realism, which enjoyed official status as the style of Soviet art, mystified the connection between painted representation and the object or idea being represented. Socialist realist paintings both authenticated the reality they depicted and constituted the mythic narratives through which that reality was perceived. Abstract painting that critically engages such authoritative claims—which is where Malevich's square has led artists—allowed those who doubted socialist realism's premise (that image equals reality) to question, on that same discursive plane both the realities of Soviet life and, equally important, its myths.

By invoking the Russian avant-garde, artists of the 1960s like Masterkova linked their own quest for personal accountability through form with a prior search for *authenticity* that contrasted with the production of a counterfeit socialist reality. But artists differ in the kind of tribute they pay to an avant-garde predecessor. Masterkova doubted Malevich's singular authority as spokesperson for the Russian avant-garde, but she still found the urge to repaint the *Black Square* and thereby explore the notions of self-transformation that had always been associated with it. Masterkova approached abstract painting as a revelatory experience, as a conversion similar to Malevich's own, following, in her case, an encounter with American and European abstract expressionist paintings that she had seen at the Sixth Festival of Youth exhibition held at Gorky Park in Moscow in 1957. Although Masterkova does not admit to an attraction to suprematism, she admires the objectless (*bezpredmetnyi*) art that followed, particularly the work of Liubov Popova and Mikhail Matiushin. As recently as 2002 she stated that for these early twentieth-century abstractionists "painting is like breathing." Her observation suggests that the organic character of their painting reinforced the structural and expressive concerns of her own abstract language.[1]

Masterkova's *Black Square* (1967) is of this moment; she transforms Malevich's austere yet irregular geometry into a haunting image of her inner life (fig. 46.2). She has characteristically layered the form with delicate tracings of ancient lace, fragments of which are embedded in the pigment. Their authenticity as materials overlaying and interacting with her own handwork suggests the parallel integrity of her individual voice as she faces her present culture by turning inward, away from the insistent social demands of Soviet life. Fragments of antique textiles that were cut from Orthodox liturgical garments and various other cloths pervade her abstractions of the 1960s and early 1970s. They record her fascination with eras known for their rigorous professionalism and depth of culture, evidenced by traditions of individual handicraft (such as embroidery and lacework), that preceded the hollow rhetorical era in which she found herself. A return in this sense suggests a bypassing or overcoming of one authorized history with a different one, imagined or reconstituted, in which she may choose to participate as a creative individual. A more complete appraisal of her dialogue with the historical avant-garde would illuminate the complex appreciation of abstract painting in her era—and enable us to press beyond the limits of our own.

A contrast to Masterkova's adaptation of Malevich's image is provided by Makarevich's

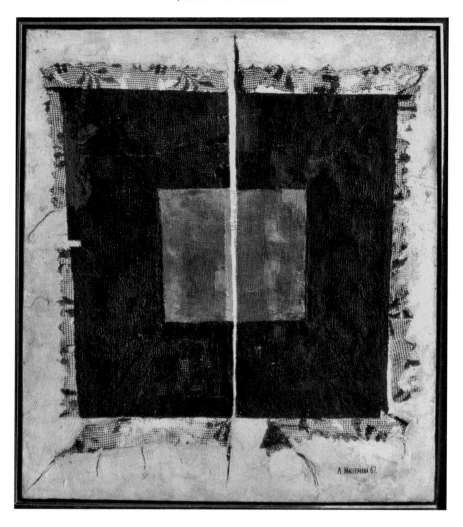

46.2. Lydia Masterkova, *Untitled,* 1967. Oil on linen.

Green Square of 1989. This is the second of two squares the artist painted, and, like Malevich, repainted in a different context. Makarevich recently has suggested that the utopia proposed by Malevich's square is realized most fully in his and Elena Elagina's large conceptual installations based on the theme of Buratino (the Russian Pinocchio) from Aleksei Tolstoy's novella The *Golden Key or the Adventures of Buratino* (1935).[2] Although several other conceptual narratives form part of Makarevich's re-presentation of that story, the one most dependent on Malevich's paintings is *Life in the Snow,* co-created with Elagina and installed in the Russian Museum in St. Petersburg in 1994. In this work we find direct links between narrative modes of display and histories of abstraction. In one room Makarevich included his own renditions of Malevich's, Georges Braque's, and Pablo Picasso's paintings, with, as the culmination, his own three black squares, monochrome paintings displayed on a shelf like the other objects in the room. Each

painting projects the principle of abstraction—demonstrated to varying degrees by Malevich's progression from cubism to suprematism—to a meta-narrative of progressive historical reasoning. The paintings trace the derivation of nonobjective from figurative art, while the insertion of Buratino within them breaks the relentless flow of one move to another. The image of the puppet stands as the artist's surrogate, too, reminding the viewer of the ambition and futility—but also the poignancy for Russians—of the utopian dreams that Malevich's oeuvre embodies.

These thematic concerns are also realized in Makarevich's *Green Square* (fig. 46.3 [color section]). Here, Makarevich casts Malevich's categorical rejection of conventional mimetic forms of representation as a statement of doubt; the certainty of figure and ground in Malevich's work is suspended by Makarevich's monochromatic rendering. But there is a more profound sense in which Makarevich uses the medium to distinguish his project from Malevich's and marks it as one of our own era. Makarevich has explained that he used green in this and other paintings as the opposite, rather than complement, of red; the color denies red its symbolic role and dominance within the Soviet environment, "freeing" the artist from its assigned values.[3] This divergence is supported by others: whereas Malevich's suprematist paintings suppress the artist's hand or brushwork, Makarevich has exaggerated it. Makarevich's very legible brushwork is registered as a self-expressive imprint. If it is recognizably his, it is also materially of a different order of subjectivity from the modernist one he quotes because he counts on the viewer to recall its suprematist source. Yet he has painted the work in encaustic (a wax-based medium), evoking not only a different artist, the American Jasper Johns, but also a different place in time—America of the 1950s. Makarevich refers the viewer to Johns's most famous works, his *Target* series (one work is green), especially *Target with Plaster Casts,* all painted in 1955 and in collage and encaustic paint on canvas. Both are singular, if "found" (preexisting) forms, appropriated to new expressive ends. Thus, the square (both Malevich's and Makarevich's) enters into a different stream of history, of postmodernist gestures and ethical stances.

Neither Masterkova nor Makarevich present their squares as originals in the sense proclaimed by Malevich, as unique inventions. Rather, both offer us a surface onto which we might project our own musings as we hold accountable both the artist and her or his stake in the creative gesture. At the same time, they are in no simple sense a deconstruction of the modernist fetish of originality. This distinction is underscored by Makarevich, who photographed his *Green Square* himself; it is positioned in his studio atop works that resemble such forms as curiosity cabinets, reliquaries, and sarcophagi (fig. 46.4 [color section]). In his *Traveling Gallery of Artists* and *Permanent Gallery* of 1981 (both of which contain various representations of Makarevich's generation of artists, including the *Portrait of Bulatov,* at the right edge of fig. 46.4) he abandons his personal style to underscore the historically momentous character of the era of unofficial art: "The idea itself contained a reflexive concern that was very necessary at the time. It was, in its own way, an attempt to create an infrastructure that Russian art so desperately needed."[4] A similar personal investment in a moment of great historical change may explain Malevich's efforts to universalize his project in Vitebsk through the repetitious studio practices of his students, who mastered suprematism by creating variations on the square, breaking open the square, and so forth, and later in his charts and their demonstrations. But

in repainting Malevich's *Black Square,* Makarevich acknowledges the impossibility of a similar index of validation in his particular location and time.

If an engagement with Malevich's work and statements helps us to appreciate the multiple meanings of late or postmodernist art, then clearly the reverse is also true. As artists return to the primary language that suprematism represented, their glosses also return value to that originary moment. The *Black Square* is not significant to the history of Russian art solely in the sense proposed by Boris Groys—as a singular expression of ambition and symbolic, collective authorship. Today it may be a better index of Russian modernism's true plurality. The many suprematisms that arise from the square as repainted by contemporary artists suggest facets of an exponentially expanding crystal, to use an image invoked by Malevich himself. In this way, as a figure poised between past and present, memory and anticipation, the *Black Square* should not be seen as a structure that collapses into solipsism, as so many have argued, for it is constantly renewed and altered in the art of all those who have, in various, often contradictory ways, reclaimed it.

NOTES—1. Author's interview with the artist, Saint Laurent sur l'Othain, France, May 30, 2002.

2. Several of these installations from concept to realization were produced in collaboration, or cocreated, with his wife, the artist Elena Elagina.

3. Author's interview with the artist, Moscow, November 24, 2004.

4. Igor' Makarevich, as cited in *Moi Kabakov / My Kabakov,* exhibition catalogue, Stella Art Gallery (Moscow, 2004), 56.

47

Imagining Soviet Rock

Akvarium's *Triangle*

Polly McMichael

A strip of carpet runs along the polished floor of a corridor. A man wearing a dark suit and pale shoes, with a strange circular object attached to the back of his head, steps away from us, toward a window where a figure stands on a radiator, partly hidden by a translucent curtain (fig. 47.1). In 2002 this image was used on the front cover of the compact disc re-release of *Triangle* (*Treugol'nik*) by the rock group Akvarium, founded by the singer and songwriter Boris Grebenshchikov in 1972.[1] The design used for this compact disc was based on the photography and design of the homemade "tape-recorder album" (*magnitoal'bom*), recorded by Akvarium in Leningrad during the summer of 1981. The image takes as its theme rock's Soviet incarnation, playing on the aspirations and exclusive nature of the culture surrounding the music, and de-familiarizing its habitual settings.[2]

In the 1970s and early 1980s, Soviet rock musicians' creative activities—and their material viability—centered on giving concerts. These were unofficial or semiofficial events to which admission was charged, and tended to be organized in Houses of Culture, school halls, and cafés or often simply private apartments. Yet the small-scale, parochial rock scene was gradually becoming home to notions of professionalism and publicity as musicians sought wider audiences and more effective means of disseminating their music. Reel-to-reel tape had long been the response of the Soviet rock scene to rock's being denied official channels for recording, mass production, and broadcasting. Fans collected and disseminated recordings of Western groups and artists, recorded from contraband LPs or hissing Western radio signals. And now Soviet musicians sought to make recordings of their own. The Soviet tape-recorder album was a curious hybrid, part object of publicity, part commercial undertaking, and part collectible work of art. It was never a true supplement to the unimaginative releases produced by the Soviet record company Melodiia, because its recordings were of inferior quality and had no access to a means of mass production or distribution. The tape-recorder album was seen, however, as a way of emulating the albums of Western rock musicians and encouraging a homegrown version of rock. Writing in the Leningrad samizdat rock magazine *Roksi* in 1978, Boris Grebenshchikov urged his fellow musicians to action. "What are you waiting for?" he wrote. "At any concert— even a very good one—a song will be absorbed only after the third or fourth time it is heard.

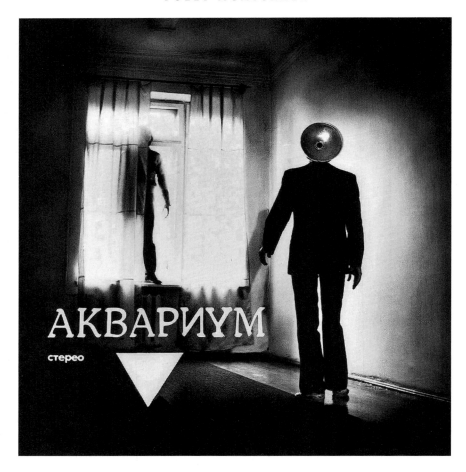

47.1. Photograph by Andrei Usov used as cover art for the *Triangle* album by the rock group Akvarium, 1981.

If recordings are already changing hands, people will know the song from its first chords, so you'll make life easier for yourself and for the fans. And you'll leave something after you, maybe nothing like the imported records in quality—but at least something that's OUR OWN."[3]

Grebenshchikov made these comments shortly after finishing work on an album with another Leningrad singer-songwriter, Maik Naumenko. *All Brothers Are Sisters* (*Vse brat'ia—sestry*) was recorded in the open air on the banks of the Neva. By the time *Triangle* was recorded, however, Grebenshchikov and his group had access to a studio of sorts. Andrei Tropillo, a radio and recording enthusiast with a background in physics, was employed in the House of Young Technicians (Dom iunogo tekhnika), near the Okhta River, to teach local Pioneer groups about acoustics and sound recording. Here he set up a private recording studio, making professional recording equipment available for the first time to the nonofficial musicians of Leningrad.

The author of the photograph reproduced here, Andrei Usov, is among those who regard

Triangle as a point of departure in the development of the tape-recorder album. This departure occurred not merely in auditory terms, through the superior and more experimental sounds that Tropillo's studio made possible; crucially, *Triangle* also confirmed the importance to Soviet rock musicians and fans of the album as a tangible artifact, complete with specially designed cover art. Usov came up with the idea of using a Liubitel-make camera to produce prints of 2 ¼ by 2 ¼ inches, which were suitable to be glued straight onto boxes of reel-to-reel tape. He produced a symbol for Akvarium, a letter "A" with a small circle above it, as well as a logo for Andrei Tropillo. The significance of these symbols is demonstrated by the fact that the title by which the album became known, *Triangle,* was never its official name; rather, it was dubbed this because of the white triangle that Usov placed in the bottom left-hand corner of the cover.

Usov's earlier album cover for Akvarium, used on *The Blue Album* (*Sinii al'bom*, 1980), depicts a lineup of the musicians featured on the album, all staring straight into the camera lens. *Triangle,* made a few months later, shuns this direct method of representation. The photograph shows two members of Akvarium, Grebenshchikov (stepping toward the window) and violoncellist Seva Gakkel (standing on the radiator). Neither man is identifiable. The figure in the foreground has its back to us and its head obscured, while the figure in the window has the light behind it; Usov suggests that the latter could be perceived as a hanging body. The inscrutability of the image is intentional. Usov recalls Grebenshchikov's commentary during the photograph session: "Don't explain anything. Let it make everyone think. Let them ask questions all the time."[4] The photograph therefore makes manifest Grebenshchikov's desire to present himself as a rock star in the Western mode—defiant, unfathomable, and otherworldly.

Yet both the recording and its design emphasize their Sovietness. *Triangle,* says Grebenshchikov, was conceived and realized as "an album of pure and irresponsible absurdity."[5] Tropillo delighted in using a sound library of animal and nature noises to create unexplained interludes between the songs. The songs, meanwhile, hint at the absurdity of everyday life by poking fun at genres and ideas that were recognizable to a Soviet audience, including a faux-operatic nonsense aria ("Hookshapedness"—"Kriukoobraznost'"), a drunken military march ("March"), and a celebration of Sartre-reading tractor drivers ("Two Tractor Drivers"). Visually, too, the album draws on its background in the Soviet everyday, which is represented by the setting and paraphernalia shown in the photograph. The corridor with the carpet, radiator, and window is the one in the House of Young Technicians, where Tropillo's studio was located. The circular object on Grebenshchikov's head is the reflector from a heater, an everyday object presumably found lying around in the building. The impression given to an audience, therefore, is of the contemporary, local, and everyday as transformed by exposure to rock music.

In autumn 1981, Grebenshchikov arrived in Moscow with ten tapes of his group's latest recording. Each box of tape had been painstakingly decorated with the prints of Usov's photograph. Grebenshchikov recalls that, heart in mouth, he handed the boxes out to prominent members of the Moscow rock scene, seeking their approval with the aim of promoting Akvarium among rock fans and encouraging concert audiences. The capital's influential rock critics told him: "No one is ever going to listen to this."[6] The initial critical failure notwithstanding,

the original release of *Triangle* is regarded today as a pioneering artifact in the development of the Soviet tape-recorder album, thanks in part to its arresting cover art, which testifies to the serious concerns and ambitions of the Soviet Union's burgeoning rock culture.

NOTES—1. Akvarium, *Treugol'nik* (Soiuz, 2002), recorded in Leningrad in 1981.

2. On Soviet rock culture, see Thomas Cushman, *Notes from Underground: Rock Music Counterculture in Russia* (Albany: State University of New York Press, 1995); Aleksandr Kushnir, *100 magnitoal'bomov russkogo roka 1977–1991: 15 let podpol'noi zvukozapisi* (Moscow: LEAN, 1999); Alexei Yurchak, *Everything Was Forever, Until It Was No More: The Last Soviet Generation* (Princeton, N.J.: Princeton University Press, 2006).

3. Boris Grebenshchikov, "Kolonka redaktora," *Roksi* 3, samizdat publication available at http://handbook .reldata.com/handbook.nsf/Main?OpenFrameSet&Frame=Body&Src=1/3E0B4451C03EEF28C3256B09003 384A4%3FOpenDocument", accessed on December 29, 2005.

4. Andrei Usov, "Strannye ob"ekty mezhdu svetom i zvukom," *Fuzz*, September 2003, 30.

5. Boris Grebenshchikov, "Kratkii otchet o 16-i godakh zvukozapisi," in Grebenshchikov, *Ne pesni* (Moscow: ANTAO, 2002), 177.

6. Ibid., 178.

48

Keeping the Ancient Piety
Old Believers and Contemporary Society

Roy R. Robson and Elena B. Smilianskaia

In Russian literature and history there is a stereotypical view of Old Believers: old men with beards and women in headscarves spending countless hours in church and arguing over mundane points of theology. To some extent, the stereotype is true. Old Believers have tried to retain the ancient piety of seventeenth-century Russian Orthodoxy, convinced that the old rituals offer the path to salvation. Mostly, rituals are liturgical in form, showing the correct ways to stand, read, sing, and pray. Rituals, however, can also affect secular activities, guiding Old Believers in the dos and don'ts of their lives. Such rituals often run afoul of modern life, forcing the faithful either to accommodate or to confront a rapidly changing world. Indeed, consciously maintaining unchanging tradition while simultaneously adapting to new conditions is an important motif in Old Believer history.[1]

THE MEN OF KUNICHA

Study the photograph of old men standing in church that is reproduced here (fig. 48.1). Taken during the 1980s in Kunicha, Moldova—one of the more prosperous Old Believer communities in the former Soviet Union—it reveals much about the Old Believer religious experience. Most obvious are the people—aged men standing in a row, in dark suits with candles in their hands, beards long and tangled. Note their posture—standing, not kneeling or sitting, lined up according to age, with neither youths nor women present. Three men look forward, toward the front of the church. Two eye the photographer warily, one scowling.

Each of these details tells us something about the way Old Believers use visual markers to establish their claims to unwavering tradition and piety. Old Believer men and women stand apart from one another. Separation by gender not only discourages young people from flirting but also visibly reinforces communal identity rather than familial connections. Likewise, the men of Old Believer communities are often given prominent places of respect in church, spatial reminders of their liturgical and spiritual leadership.

The men's dramatic beards dominate the photograph. Peter the Great decreed that all men (except peasants and clergy) should shave in the style of western Europeans. Old Believers,

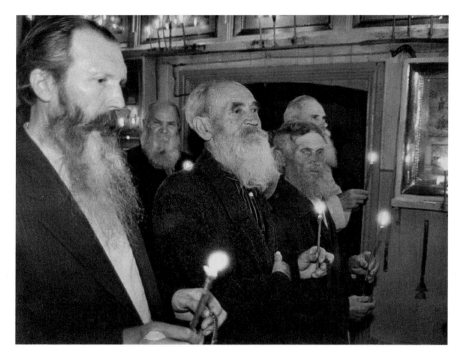

48.1. Yury Brodsky and Mark Milov, The men of Kunicha. Photograph.

however, saw their beards as outward manifestations of having been made in the "image and likeness of God." Moreover, Old Believers questioned the need to cut beards—why be vain, shaving in the Western style? Why follow European traditions rather than Russian ones? Under Peter, those who refused to shave had to pay a "beard tax" if they wanted to take part in Russian commerce, government, or refined society. As a result, beards became a visible hallmark of Old Believers—a shorthand way to show their distrust of change, their defiance of the government, and their adherence to the old ways.

Note that none of the men wears a necktie. This, too, marks the men's stance against Western styles—neckties, according to Old Believers, arrived in Russia simultaneously with shaved chins. Stories abound in Old Believer lore about neckties turning into serpents as unsuspecting Christians stand in judgment before God. That being said, the men are wearing Western-style suits, a far cry from the traditional clothing maintained by earlier generations of Old Believers. Fear of vanity also makes many Old Believers dislike having photographs taken during church services—why wasn't the photographer concentrating on God instead of men? Their scowls may register their suspicion of the photographer, although they appear to have acquiesced to the picture taking and to have played their part in full.

Each of the men holds a candle in his right hand. Illuminating their faces, the candles resemble those placed in front of icons, like those that line the walls of the church, visible in the background. Candles are not unique to Old Believer practice, although here the effect is remarkable—the men seem to be three-dimensional versions of icons. This is no accident. Old

Believers believe that they should visibly replicate the image and likeness of God, whose holy prototypes are depicted on icons. All Orthodox Christians adorn their churches with holy images and interact with them by kissing, holding, and gazing at them. Old Believers, however, take their icons particularly seriously—they must adhere to visual styles extant before the church schism of 1666. The icons here stand on shelves instead of being housed in wooden shrines, as they would in other Orthodox churches. Candles have been stuck to the front of the shelves rather than put in elaborate candelabra. This reminds Old Believers of their outsider status in Russian society: long persecuted, they have often worried that their icons would be taken away or burned by agents of the Russian state.

The careful composition of the photograph suggests that the men of Kunicha cooperated with the photographer. In underscoring the parallel between the men and the icons, the photograph fulfills the Old Believers' vision of themselves, as well as the expectations of the photograph's target audience back in Moscow and elsewhere. Both the Old Believers and many of the ethnographers who study them have an interest in showing that the Old Believers conform to the role they play in the Russian historical imagination, as occupying a place outside of time and apart from the pettiness and materiality of the modern world. Some elements in this photograph are easily communicated, but others require more arcane knowledge to decode. The man in the foreground grips a kind of prayer rope, called a "ladder" (*lestovka*) or "branch" (*vervitsa*). Ubiquitous among Old Believers (especially when sitting for formal photographs), the ladder symbolically represents all of Christian history. The leather triangles (just visible at the bottom right of the photograph) signify the four Gospels—the foundation of all prayer. The main part of the prayer ladder starts with twelve steps (beads or wooden dowels covered with leather) representing the apostles, then thirty-eight more to remind the prayerful of the thirty-six weeks and two days of Jesus' time in the womb. Then come thirty-three steps, each a reminder of a year in Jesus' life, and finally seventeen more, representing the sixteen Old Testament prophets and John the Baptist, the last prophet before Christ. In all, the lestovka has a hundred steps.

Traditionally, the faithful are admonished to "pray a ladder," that is, to say a prayer and to prostrate themselves on the ground for each rung of the ladder. It is not uncommon for spiritual fathers, the equivalent of priests in some Old Believer communities, to tell members of their flock to pray the ladder multiple times. During Lent, Old Believers might pray ten ladders—a thousand prostrations over the course of one evening. The ladder reminds them of Christ's life and work. Likewise, it shows the faithful that prayer is sometimes a physically punishing activity; like all good works, prayer for Old Believers is not supposed to be easy. Finally, the ladder helps differentiate Old Believers from other Orthodox Russians: the ladder is a sign that its holder keeps to the old ways and prays by the old traditions. Like the beard, it makes a statement about community self-definition, faith, tradition, and the importance of retaining rituals from century to century.

THE WOMEN OF SEPYCH

The scene portrayed in the second photograph reproduced here gives clues to Old Believer life in rural Russia (fig. 48.2). The two women are Old Believers from a village in the foothills

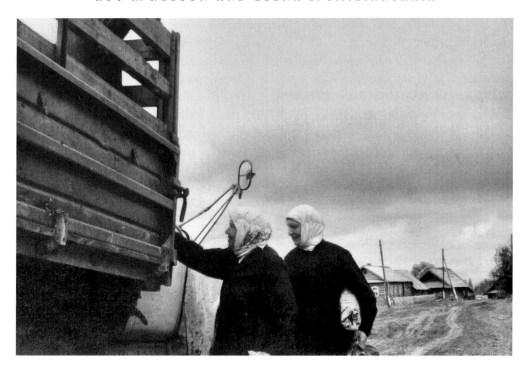

48.2. The women of Sepych. Photograph.

of the Ural Mountains. They are among the most traditional Old Believers in Russia, trying to maintain what they see as ancient piety during the modern age.

First, note the composition of the photograph. The camera angle seems haphazard—the picture is dominated by the gray, cloudy sky and the side of a truck. The women, ostensibly the main focus, are centered but not very large. These elements suggest that the photograph was taken from hip level, a technique used by photographers to take pictures without calling attention to themselves. The photographer probably hoped not to be obvious, remembering that some Old Believers distrust photographs as a form of vanity.

The two women's clothes signify adherence to the Old Belief. Most obviously, their heads are almost completely covered, a sign of humility and a reminder of St. Paul's injunction against women praying with their hair uncovered. Yet these are not the ordinary hats or headscarves still worn by many women in rural Russia; the women of Sepych follow a local ritual, twisting and tying their headscarves in a particular way. The women also wear matching black overcoats that completely cover their bodies.

These ritual clothes identify the women in the photograph as holding to a particularly stringent form of the Old Belief. In some parts of this region, Old Believers distinguish between those who are "of the council," who strictly follow the old rituals, and those who are "worldly," or live according to secular norms. The women of the council pictured here are distinguished visually from their worldly neighbors by their clothes, which remind people of their spiritual leadership. Interestingly, the woman's coats are similar to the caftans worn by male Old Believer

preceptors and priests—the spiritual fathers of each Old Believer community. Although men took on such leadership positions in the villages during the nineteenth century, few today are willing to give up drinking alcohol, sharing meals with outsiders, having sexual relations—all activities barred in the nearly monastic lifestyle taken on by those of the council. Instead of being blocked from spiritual leadership—as is typical in mainstream Russian Orthodoxy—the women of Sepych have found themselves taking on those traditionally male roles.

Finally, the picture shows these two spiritual leaders about to climb into the large truck. This, too, has significance in Sepych. How appropriate it is for people of the council to use automobiles has been sorely debated among the region's Old Believers. No one has denied that the worldly laity may use powered transport—tractors and motorcycles are common on the roads—but the stricter Old Believers have debated whether anything was so urgent that an Old Believer of the council would need to travel so quickly. Were these expensive machines appropriate for humble Christians? The leaders of the community said no; travel by car or truck puffed people up with idle vanity. Though cognizant of Old Believers from other parts of the region who might disagree, these women have chosen to embrace some parts of modern life while standing firm against others. Or, perhaps, their decision was less resolute, and their unwillingness to be captured on film in flagrant violation of their own precepts might explain the photographer's resort to surreptitious shooting from the hip. In either case, these photographs capture the complex interplay between the Old Believers' desire to retain their distinct identity and their claim to adhere to unchanging tradition, on the one hand, and the demands and temptations of the modern world, on the other. Similarly, the photographs record the negotiated interactions between Old Believers and the scholars and photographers who record and study them, where both sides are strongly invested in constructing and preserving an image of timeless faith. And finally, the photographs convey information at distinct levels: the general viewer sees different information than does the adept practitioner or student of the Old Belief.

NOTES—1. On the history of the Old Believers, see Robert O. Crummey, *The Old Believers and the World of Antichrist: The Vyg Community and the Russian State, 1694–1855* (Madison: University of Wisconsin Press, 1970); Georg Bernhard Michels, *At War with the Church: Religious Dissent in Seventeenth-Century Russia* (Stanford, Calif.: Stanford University Press, 1999); Roy R. Robson, *Old Believers in Modern Russia* (DeKalb: Northern Illinois University Press, 1995); Douglas J. Rogers, "An Ethics of Transformation: Work, Prayer, and Moral Practice in the Russian Urals, 1861–2001" (Ph.D. diss. University of Michigan, Ann Arbor, 2004).

49

Viktor Vasnetsov's Bogatyrs

Mythic Heroes and Sacrosanct Borders Go to Market

Helena Goscilo

As the redoubtable protector of national borders and Orthodox Christianity, the Russian *bogatyr* looms large in multiple cultural genres throughout the ages. From medieval epic songs (*byliny*) and legends to fairy tales, poems, posters, and opera libretti, the bogatyr embodies the ethos of medieval Russia, with its sui generis embrace of both pagan and Christian rituals. The hyperbolic image of this divinely ordained incarnation of valorous masculinity has practically vanished from contemporary verbal texts, whether written or oral. Visual representations of the bogatyr, by contrast, continue to thrive.

PROPHYLACTIC IDEALS. Within this iconography, no image of the bogatyr matches two related paintings by Viktor Vasnetsov in status and instant recognizability: *The Warrior at the Crossroads* (*Vitiaz' na rasput'e*, 1882) and *Bogatyrs* (*Bogatyri*, 1898) (figs. 49.1-49.2 [color section]). Known to all Russians irrespective of their geographical roots, intellectual training, political affiliation, or attitude toward art, these figuratively executed images reflect Vasnetsov's retrospective preoccupation with heroic legends and legendary heroism. Contextualized more broadly, *Warrior* and *Bogatyrs* belong to the huge repository of artworks produced by the World of Art group of artists (*Mir iskusstva*) as part of the international late-nineteenth-century impulse to invent endemic traditions. In a concerted drive to define a unique national ("folk") identity, artists such as Vasnetsov, Mikhail Vrubel, Ivan Bilibin, Maria Iakunchikova, and Elena Polenova illustrated fairy tales, painted scenes from Russia's (largely imagined) past, and, at Abramtsevo and Talashkino, produced handicrafts featuring folkloric themes. Tellingly, the 1890s also yielded Sergei Maliutin's Abramtsevo-inspired design for what during the Soviet period would reign as the quintessential Russian/Soviet souvenir—the stacked wooden doll called the *matryoshka*. For unimpeded "true Russian minds," an ideal marriage of symbolic complementarity would unite matryoshka with bogatyr: healthy fertility and resolute, virile custodianship.

Sedimented in the nation's collective unconscious and, under Soviet rule, reinforced by a uniform educational system dedicated to the selective preservation of national history, Vasnetsov's bogatyrs are Russia's heroic border guards of the empire, functioning as a reassuring emblem of indomitable strength and invincibility. Whereas the hyperbolically feminized

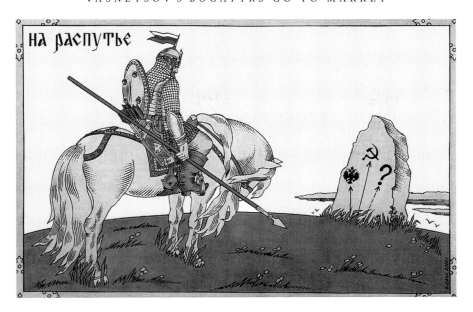

НА РАСПУТЬЕ

49.3. Efim Tsvik, *At the Crossroads.* Post-Soviet poster.

matryoshka—whose shape and containment of ever-smaller dolls within her belly allegorize female fecundity, hence national robustness and generational continuity—Vasnetsov's bogatyrs showcase Russian masculinity. Their subsequent incorporation into multiple cultural genres, whether conceived in a solemn or a comic spirit, invariably places them in an emphatically male context and targets a male audience.

CHOOSING ONE'S FUTURE. Vasnetsov's *Warrior* depicts that locus classicus of Russian folktales, the momentous stage in the hero's quest when he arrives at a crossroads only to confront a stone inscribed with three consequence-laden choices: to follow the left road, the right road, or the road directly ahead (see fig. 49.1 [color section]). The fate of the hero, hence of the community, hinges on his decision, which determines future events and, ultimately, the triumph of the very qualities he exemplifies. The identification between the hero's choice and the well-being of the nation immortalized by Vasnetsov here receives a cleverly ironic treatment in Efim Tsvik's post-Soviet poster titled *At the Crossroads* (2000; fig. 49.3), where three symbols concisely indicate the three routes facing Russia today: on the left, tsarist Russia's official emblem, the two-headed eagle summarily discarded upon the installation of the Soviet regime; in the middle, the hammer and sickle that represented the Soviet state, in its turn jettisoned for the reinstated tsarist eagle once the Soviet Union disintegrated; and, to the right, a large question mark, signaling the existential uncertainty of Russia's future while simultaneously evoking the verbal clichés of "whither Russia," Gogol's troika, "What is to be done?" and sundry other timeworn variations.

CHOOSING ONE'S BEER. Tsvik's interrogatory quotation of Vasnetsov raises profound politico-philosophical issues, its pointed irony starkly contrasting with the playfulness of another *At the Crossroads:* an undated prerevolutionary poster advertising the Weiner Brewery

in Astrakhan (fig. 49.4 [color section]). In modifying Vasnetsov's original, the unknown artist replaced its ominous, penumbral landscape with vivid, cheery colors, reversed the bogatyr's stance, and introduced an outsized bottle of beer, impudently propped against the stone, that conventionally bears messages enumerating the hero's options. Basing its sales strategy not only on the safe assumption that Russian machismo equals alcohol intake but also on viewers' familiarity with Vasnetsov's painting, the advertisement eliminates choices, its visual confidently asserting that for drinking heroes, Weiner beer "is the only way to go."

THE TOWERING TROIKA. Co-optation for political and marketing ends likewise has been the fate of Vasnetsov's *Bogatyrs*—a grandiose, static rendition of the three major epic heroes in Russian folklore: in the center, the supreme warrior, Ilia Muromets (broadest, tallest, holding a half-cocked lance), flanked by the lesser stalwarts Dobrynia Nikitich and Alyosha Popovich, the armored body of each boasting larger-than-life proportions. Outsize dimensions and trebling project physical unassailableness, cohering into a fortress against attack. Moreover, the trebling simultaneously hypertrophies the concept of power, conjures up the Orthodox Trinity, and cleverly evokes the number three, cemented into Russian folklore, which engages in the naturalizing, universal "threefold articulation underlying all created things," particularly "the three temporal stages of all growth (beginning-middle-end, birth-life-death, past-present-future)."[1]

THE TROIKA ON BILLBOARDS AND BODIES. Post-Soviet Russia has extensively mined the long-embedded associative ore of Vasnetsov's painting along both political and commercial lines. During the summer of 2003, as part of its electoral campaign, the People's Party plastered billboards along Moscow's highways with a reproduction accompanied by a text transparently tapping into voters' collective unconscious: "For truth and justice. The People's Party." Calculated to activate the populace's association between mytho-historical icons and the fight for ethical probity, the poster cast the People's Party in the role of Russia's moral custodian. A no less fanciful, if more aggressive and radically unofficial, use of Vasnetsov's painting appeared in a fascinating volume titled *Prisoners' Tattoos.*[2] Distinctive yet consonant with sundry reproductions of misogynistic and anti-Semitic prison tattoos derived from folklore, the relevant tattoo, created at the peak of Stalinism, scrupulously translates Vasnetsov's *Bogatyrs* into graphic form, with a geographically embattled message that anticipates one of President Vladimir Putin's few glaringly imprudent public statements (fig. 49.5). Beneath the three heroes on horseback, the criminal artist—sentenced to twenty-five years for stealing state property—inscribed the following imperative on his body: "Chase out, flush down the toilet, all non-Russians from the southern coastal lands to Russia!" The jingoism advocated by countless Soviet prisoners in the Gulag found historical legitimation in the medieval Military Trinity's struggle to preserve boundaries and ethnic distinctions under the aegis of Russian Orthodoxy.

THE TROIKA'S SCREEN BROTHER. Approximately half a century later, the Gulag inmate's xenophobia resonated in Alexander Balabanov's blockbuster film *Brother* (*Brat,* 1997), released during Russia's protracted war in Chechnya. At the height of male impotence, national anxiety vis-à-vis U.S. political supremacy in the international sphere, and the influx of swarthy citizens from former Soviet republics into Russia, Balabanov's *Brother* struck a sympathetic

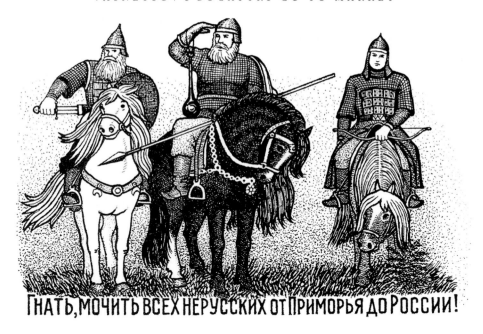

49.5. Stalinist-era prisoner tattoo based on Vasnetsov's *Bogatyrs*. The inscription reads: "Chase out, flush down the toilet, all non-Russians from the southern coastal lands to Russia!"

chord with mass audiences. Its intrepid ex-soldier protagonist Danila, in fact, became a cult figure. The "wrongs" avenged by this gun-toting latter-day paladin include the rape and beating of a young woman, carried out against a background showing a wall rug depicting Vasnetsov's *Bogatyrs*. Heavily significant interior decoration argues for a dubious distinction: unlike the personally and pragmatically motivated violence of hoodlums and abusive husbands, Danila's multiple killings, like the bogatyrs', are sanctioned by the sacred nation. The "black-assed scum" and money-hungry criminals whom he disciplines and punishes constitute a contemporary equivalent of the nomadic Asian tribes whose incursions into Kievan Russia the bogatyrs of old repelled.

TOBACCO TROIKA. Whereas earnestness and solemnity mark ideological appropriations of Vasnetsov's painting for political purposes, product advertising tends to handle its source with a twist of humor and panache. The least self-conscious and most retrograde of three recent market-driven borrowings faithfully duplicates *Bogatyrs* on the cover of a black cardboard box containing twenty-five *papirosy* (fig. 49.6 [color section]). Outdated relics of the Soviet era, today these harsh, inconvenient quasi-cigarettes cannot attract buyers apart from veterans, nostalgia buffs, and such "subversive" rock groups as Leningrad, whose song "Kosmos" exploits papirosy's connotations of rough-and-tough virility. Still, a certain poignant retro charm colors the implicit endorsement: ancient bogatyrs are promoting smoking as a profoundly he-man habit, a troglodytic notion, but one irresistible to devotees of self-serving irreconcilable gender divisions.

MACHISMO IN BEER AND SPORT. A kindred appeal to macho consumerism, but in a

decidedly post-Soviet vein, animates a series of self-reflexive television commercials for Three Bogatyrs beer, named after the popular misconception of what Vasnetsov titled his painting. One tongue-in-cheek scenario presents a trio of rowdy, tastelessly dressed men enjoying a boisterous exchange over beer. Periodically the three vociferously shout to Zinka, the blowsy middle-aged cook cum waitress, for more brew. Zinka, whose appearance—pendulous breasts, grotesque makeup, dyed hair, headphones—matches the tacky retro setting, obligingly delivers it to their table. Two contrasts structure the sequence: one historical (between the epic heroes of yore depicted on the prominently displayed bottles and today's hapless threesome), the other gendered (between men, who "order," and woman, who "serve"). Like the prerevolutionary poster discussed above, the commercial defines beer drinking as a masculine prerogative, on a par with cigarette smoking. The acquisition of both habits denotes a rite of passage into manhood.

The marketing of Three Bogatyrs beer bifurcates along the contrasting vectors of visual and physical consumption. Although television advertisements, being evanescent, can risk irony directed at sexist machismo, the labels on the bottles of beer sold in stores opt for a safer sales strategy. The front label simply portrays the three bogatyrs' helmeted heads and shoulders, while the rear label repeats the image in miniature, linking it to three hockey sticks by means of a banner bearing the toast "To our hockey!" The text below proudly declares the brand "The Official Partner of the Russian Hockey Federation." Real men, in other words, drink beer, play hockey, and support "our" teams in both sports and politics, for the former is merely an engaging manifestation of the latter, both of them offering lucrative careers. By having it both ways through differentiated approaches to their advertisements, the producers of Three Bogatyrs beer court a wide clientele.

L'AIR DE L'HOMME, OR A WHIFF OF MACHISMO. In atypicality and irreverence, however, no recent treatment of Vasnetsov's *Bogatyrs* matches an advertisement, pasted inside subway cars in Moscow during July and August of 2003, promoting Roxena men's deodorant (a brand originating in Australia). Approximately half of the advertising space is occupied by the visual—a radically altered *Bogatyrs* in a showy frame that underscores its high-culture provenance. Though a perfect copy as far as it goes, this version omits both Dobrynia Nikitich and Alyosha Popovich, leaving Ilia Muromets alone in the saddle, between two riderless horses. Beneath the solitary hero the first stage of explanatory text reads, "Does it seem as though your friends have started avoiding you?" It is followed by the image of three deodorants and the brand name Roxena, next to which bold letters announce, "Protects from perspiration and unpleasant odor." At the bottom appears the exhortation, "It's time to use Roxena for men!" Indeed, the Moscow metro during the hot summer confirmed as much.

What distinguishes this advertisement is the subversive use of a revered national image to market a (foreign) item designed for the body and, moreover, for its rank excretions. Furthermore, in the Russian context the idea that men should pay attention to hygiene and eliminate their malodor verges on the revolutionary, for during the Soviet era such concerns preoccupied only women. The pleasurable shock value, at first glance, of three epic heroes reduced to one through noxious smell combines with the idea that huge, strong men perpetually engaged in physical combat emit huge, strong whiffs of machismo—tusk, not musk—the protector in

need of protection! Though witty and sassy, the advertisement allows for an interpretation that focuses on heroic strength, subordinated, however, to the overall humorous popularization and depopulation of Vasnetsov's painting.

VASNETSOV NAVEKI VEKOV? Precisely because Russia's sense of national unity and strength has eroded since perestroika, Vasnetsov's two "historical" paintings have functioned as a compensatory rallying point for both politicians and entrepreneurs. Post-Soviet Russia teems with personal bodyguards, but what it yearns for is the reassurance of Cerberean heroes prepared to safeguard the nation against perceived enemy invasion, whether military, ethnic, or commercial. Just as Roxena deodorant staves off the body's alienating smells, so within Russia's Imaginary, Vasnetsov's bogatyrs guarantee safety from foreigners allegedly taking advantage not only of Russia's diminished political status but also of the assaultive market economy imposed after de-sovietization. Yet, paradoxically, Roxena itself belongs to the capitalist invasion from the West, just as Vasnetsov's creation of a purely Russian heroic past transgressed borders by participating in the international western European movement to forge inspiring national myths through artistic means. The periodic revival of this iconography, whereby sundry configurations retain the basic structure and elements of Vasnetsov's two canvases while subscribing to the dominant aesthetic and doctrines of specific-interest groups, stems from political and financial exigencies. As long as these factors remain operative, the recycling of Vasnetsov's two paintings as ideological ready-mades probably will continue.

NOTES—1. Erich Neumann, *The Great Mother,* trans. Ralph Manheim (Princeton, N.J.: Princeton University Press, 1983), 228.

2. D. S. Baldaev, *Tatuirovki zakliuchennykh* (St. Petersburg: Limbus Press, 2001).

5 0

Landscape and Vision at the White Sea–Baltic Canal

Michael Kunichika

A network of camps encompassing thousands of square miles in Karelia, in the northwest of Russia, housed the prisoners who labored on the construction of the White Sea–Baltic Canal (Belomorsko-baltiiskii kanal) in 1931–33 and who later maintained it or worked in timber production in the area around it.[1] Located throughout the region's terrain of forests, marshes, and fields, the barracks constituting this site of the Gulag are now in varying states of ruin. Some are barely discernible: we see rectangular pits in the ground, posts jutting out in a field, or just bare foundations. Others remain with buckling or freestanding walls, with collapsed roofs, or with their floors covered by debris and sometimes overgrown. Still other barracks have proven so resilient to over a half-century of weathering that they remain virtually intact and are sometimes used by local fishermen and woodsmen. The two photographs shown here were taken during an expedition in the summer of 2001 (fig. 50.1 and fig. 50.2 [color section]).[2] I chose to record these particular images because they capture the historical interrelations of vision and nature at the canal, as well as the stark incongruity between a knowledge of the canal's history and the actual visions supplied by its landscape today.

One "fine serene June day" in 1966, Alexander Solzhenitsyn visited the canal and marveled. Recording his impressions on that day in his *Gulag Archipelago,* Solzhenitsyn writes, "But why was everything so quiet?" and adds with some rhetorical flourish, "Why are you silent, Great Canal?"[3] Such serenity could also be noted during the July days when these photographs were taken—the boats, barges, trawlers, and even yachts sailing into the White Sea or down toward Lake Onega pass through the nineteen locks dividing the canal's 141 miles, slowly traversing the span between each lock. Solzhenitsyn's question emerged, in part, from the discrepancy he sensed between the canal's contemporary state and the enormous toll its construction had exacted. Among the only sounds punctuating the silence in July was a Russian pop song spilling over from a tour boat docked near the first lock, making even more keenly perceptible the actual discordance contained within the canal's contemporary landscape. With its expanses of water and vast forests, the landscape seen from the canal today is unexpectedly picturesque. Deeper into the forest, however, and far from the view of passing ships, are the barracks and

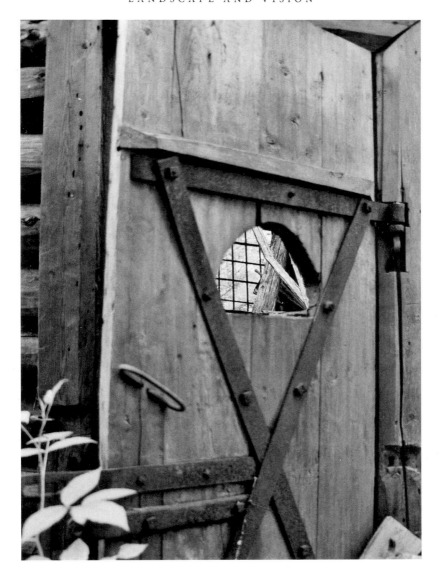

50.1. Rotting door in a prison barrack at the former White Sea–Baltic Canal construction site, 2001. Photograph by Michael Kunichika.

other physical remnants of the harsh conditions endured by laborers more than fifty years ago.

Yet these barracks, which one might hope would stand as memorials to the history of the Gulag, serve as much to index the time that has passed since the closing of the camps. Even though the two photographs give only a partial view of this vast region and its contemporary state, they depict two ways in which vision operated at the canal: the first photograph is of a cell door in a prison barrack and hence reveals the relationship of vision to the exercise of power;

and the second is of a window frame supplying a view of nature. To focus on the landscape in which these barracks remain, and on the forms of vision one finds in them, is not meant to elide the brutality associated with this site, but rather to gesture toward some of the tensions emerging as the site continues to develop and to inquire into how vision, and particularly a vision of nature, resonates with the canal's history and its contemporary appearance and significance.

In the official history of the canal, *Stalin's White Sea–Baltic Canal: The History of Construction* (1934), nature was cast as an enemy. Building the canal was to be "a struggle with stone, marsh, rivers" or "a battle against the stony stubbornness of nature." As Simon Schama remarks, "Landscapes are culture before they are nature; constructs of the imagination projected onto wood, water, rock." At the canal this was fervently so: construction was begun in the harsh Karelian winter of 1931 and continued at a rapid and brutal pace until the canal officially opened in 1933. The ideology of canal construction was guided by the infamous term *perekovka* (reforging), which entailed, by a pernicious logic, not just the transformation of nature but the reforging of the laborer, a logic summarily stated in *The History of Construction*: "Changing nature, man changes himself."[4] Although historians have offered varying estimates of the mortality rates associated with the construction of the canal, that the laborers being "reforged" endured conditions of extreme privation is indisputable.

That this privation was forced upon the laborers at the canal is explicit in the photograph of the door of a prison cell. The surveillance window, still intact, exhibits the function of vision in the exercise of control and power. Unlike other barracks surveyed during the expedition, this one provides sufficient material evidence to ascertain how the window was used. Cells no larger than a few square feet lined both sides of this barrack. One end of the barrack and a portion of a side wall had collapsed, and plants grew in the corridor dividing the barrack. Iron grates were still fastened to the windows; one grate is partially visible through the cell door. It is against this photograph that the second photograph can be read.

Evocative yet indeterminate, the window in the second photograph frames a view of a nature scene. But whose view was it? Who might have gazed onto the scene of nature framed by the window? Of the barrack windows still relatively intact, another on the adjacent wall looked out onto a nearby lake. Unlike the prison barrack in the first photograph, whose structure made its incarcerating function evident, similar physical clues were absent here. Perhaps this barrack was used for housing, a canteen, or possibly a sick room.

The window suggests how contemporary engagement with this site can also mark the seam between vision and knowledge, between what is manifestly present to the eye and what remains difficult to ascertain, between the idyllic landscape that the window frames and the brutal network of which we know it was part. The window introduces the possibility that nature may have been an object of contemplation, not just an enemy or exploitable resource, as the canal's official history characterized it. That something akin to a picturesque landscape could have been historically present within the barracks of the region, and framed as such, is one of the discomforting implications to which the window attests. Surely, to contemplate the scenery amid all that we know to have occurred there would seem to have been afforded to the incarcerator alone, not the incarcerated.

In the memoir of N. P. Antsiferov, we find, however, that the contemplation of nature was also part of his experience while incarcerated at the canal. The author of the famous study *The Soul of St. Petersburg,* Antsiferov describes archaeological and geological surveys he conducted in the region around the canal. He writes: "We found Neolithic pottery shards with typical patterns, and we dug in the sites. . . . These were happy hours. We forgot about our captivity. And we took pleasure in the severe but distinctive nature of Karelia."[5] The passage provides some historical resonance for the tension between landscape and captivity represented in the photographs of the window and the cell door. Even though the overwhelming use of vision associated with the canal belongs to the exercise of power, Antsiferov's remark powerfully, and unexpectedly, suggests that even alongside the deployment of vision for the purpose of monitoring captives, the captives, too, even if only in moments of respite, gained some pleasure from the natural scene around them.

In the theme of "indifferent nature," the Russian literary tradition provides a way of conceiving the tension between landscape and captivity. Recurring throughout the nineteenth and twentieth centuries, this theme contrasts the ephemerality of human existence with the eternity of nature. Codifying the theme in his 1829 poem "Whether I Wander Along the Noisy Street" ("Brozhu li ia vdol' ulits shumnikh"), Alexander Pushkin concluded the poem with the following stanza:

> *And at the entrance to the grave*
> *May young life play,*
> *And indifferent nature*
> *Shine with everlasting beauty.*

We find the theme later taken up in a short tale by Varlam Shalamov, the author of *Kolyma Tales,* which recounts his seventeen-year sentence in Kolyma, a site as infamous as the White Sea–Baltic Canal in the history of the Gulag. In one of the tales, titled "A Child's Drawings" ("Detskie kartinki," 1957), Shalamov radically reversed the tradition of indifferent nature, writing, "Nature in the north is not impersonal or indifferent, it is in conspiracy with those who sent us here."[6] These two statements on indifferent nature provide several possibilities for gauging the significance of the view found in the photograph of the window: Did it override the sense of captivity and supply a vision of beauty? Was the nature viewed in conspiracy with the viewer inside the barrack? And what does it mean now for the region's landscape that nature appears to override all such history with the gradual disappearance of these barracks?

If we understand landscapes as "culture before they are nature," however brutal that culture may have been, then we might also consider how nature can exceed what frames it, and mark out a process whereby the indifference of natural erosion becomes commensurate with human forgetting. Left to the very nature that had once been the object of reforging, the barracks in the region are now subject to nature's inexorable erosion. To recall Antsiferov, what will increasingly become possible as the barracks recede into the ground is that they will add another layer onto the layers he himself dug through while incarcerated at the canal, requiring ever more work with the archaeologist's spade to reveal the history of captivity. However much the landscape of the canal now supplies visions akin to the picturesque, and however much it

might have done so in the past, it is against the forgetting of captivity and of the captives that the contemporary vision of this landscape is compelled to work.

NOTES—1. On the history of the White Sea–Baltic Canal and the labor camps in the region, see Nick Baron, "Conflict and Complicity: The Expansion of the Karelian Gulag, 1923-1933," *Cahiers du monde russe* 42, nos. 2–4 (April–December 2001): 615–48; Baron, "Production and Terror: The Operation of the Karelian Gulag, 1930–1933," *Cahiers du monde russe* 43, no. 1 (January–March 2002): 139–79; Cynthia A. Ruder, *Making History for Stalin: The Story of the Belomor Canal* (Gainesville: University Press of Florida, 1998); Alexander I. Solzhenitsyn, *The Gulag Archipelago, 1918-1956: An Experiment in Literary Investigation,* vol. 2, trans. Thomas P. Whitney (New York: Harper and Row, 1975); *Belomorsko-Baltiiskii kanal imeni Stalina: istoriia stroitel'stva* (Moscow: Istoriia fabrik i zavodov, 1934), translated and published in English as *Belomor: An Account of Construction of the Great Canal between the White Sea and the Baltic Sea,* ed. Maxim Gorky, L. Averbach, and S. G. Firin (New York: Harrison Smith and Robert Haas, 1935).

2. The expedition was organized by the historical research and human rights society Memorial (St. Petersburg). I would like to express my gratitude to the organizers and members of the expedition, especially the late V. Yofe.

3. Solzhenitsyn, *Gulag Archipelago,* 100–101.

4. *Istoriia stroitel'stva,* 13; Simon Schama, *Landscape and Memory* (New York: Vintage, 1991), 61; *Istoriia stroitel'stva,* caption of photograph following p. 206.

5. N .P. Antsiferov, *Iz dum o bylom: Vospominaniia* (Moscow: Feniks, 1992), 386.

6. Walter Arndt, *Pushkin Three-Fold: Narrative, Lyric, Polemic, and Ribald Verse; The Originals with Interlinear and Metric Translations* (Dana Point, Calif.: Ardis, 1993), 232–35; Varlam Shalamov, "A Child's Drawings," in Shalamov, *Kolyma Tales,* trans. John Glad(New York: Penguin, 1994), 76.

Chronology of Russian History

KIEVAN RUS, 860–1240

980–1015	Reign of Grand Prince Vladimir
988	Conversion of Kievan Rus to Eastern Orthodox Christianity

MONGOL INVASIONS AND DOMINATION; APPANAGE PERIOD, 1223–1327

1223	First appearance of the Mongols at the Kalka River
1237–40	Mongol invasions; Kiev is destroyed; Rus is compelled to pay heavy taxes to the Mongol khan, and Rus princes must be confirmed in office by the Mongol patent of rule

THE RISE OF MUSCOVY AND THE MUSCOVITE PERIOD, 1327–1700

1327	Mongols support princes of Moscow against their rivals, the princes of Tver
1328–41	Ivan I, Kalita of Moscow, appointed Grand Prince of Vladimir by the Mongol Khan
1359–89	Reign of Dmitry Donskoy, Grand Prince of Moscow
1425–62	Reign of Vasily II, Grand Prince of Moscow
1453	Fall of Constantinople
1462–1505	Reign of Grand Prince Ivan III of Moscow, called Ivan the Great
1492	Anticipated End of Time, an apocalyptic moment calculated to fall 7,000 years from the Creation
1505–33	Reign of Vasily III, Grand Prince of Moscow
1533–84	Reign of Ivan IV, called Ivan the Terrible
1547	Ivan IV crowned first tsar of Russia
1551	Stoglav (Hundred Chapters) Church Council
1552	Conquest of Kazan
1556	Conquest of Astrakhan
1564	Publication of first book in Moscow
1581–82	First conquests in western Siberia
1584–98	Reign of Tsar Fyodor Ivanovich and the regency of Boris Godunov
1589	Creation of an autocephalous Moscow patriarchate
1598	Tsar Fyodor dies without an heir, ending the ruling dynasty of Rurikid princes
1598–1605	Reign of Tsar Boris Godunov
1605–13	The Time of Troubles (succession of tsars and pretenders to the throne, the False Dmitrys, invasions and social unrest)
1613–45	Reign of Mikhail Alekseevich, the first Romanov crowned tsar
1645–76	Reign of Tsar Aleksei Mikhailovich
1656	Left-Bank Ukraine is incorporated into Russia
1654–67	Church reforms provoke the crisis known as the Schism and lead to the development of the Old Believer movement
1670–71	A major peasant rebellion, led by Stepan Razin
1676–82	Reign of Tsar Fyodor Alekseevich
1682	Peter I is crowned co-tsar with his half brother, Ivan V, under the regency of Sofia
1689–1725	Reign of Peter I, called Peter the Great
1697–98	Peter's "Grand Embassy" travels in Europe

IMPERIAL RUSSIA, 1700–1917

1700	Adoption of the Julian calendar
1703	Founding of St. Petersburg, which becomes the capital city
1700–1721	Great Northern War against Sweden
1722	Creation of the Table of Ranks
1724	Introduction of the poll tax (state tax on peasantry)
1724	Establishment of the Academy of Sciences
1725–27	Reign of Catherine I
1727–30	Reign of Peter II
1730–40	Reign of Anna
1740–41	Reign of Ivan VI with Anna Leopoldovna as regent
1741–61	Reign of Elizabeth
1755	Founding of the University of Moscow
1762	Reign of Peter III
1762	Emancipation of the nobility from compulsory state service
1762–96	Reign of Catherine II, called Catherine the Great
1768–74	War with the Ottoman Empire
1772, 1793, 1795	The three partitions of Poland
1773–75	Pugachev rebellion
1796–1801	Reign of Paul I
1801–25	Reign of Alexander I
1801	Annexation of Georgia
1812	Napoleon invades Russia and is defeated
1825	Decembrist Uprising
1825–55	Reign of Nicholas I: policy of "Orthodoxy, Autocracy, Nationality"
1853–56	Crimean War
1855–81	Reign of Alexander II
1861	Emancipation of the serfs
1861–74	The Great Reforms: a series of thoroughgoing legal and civil reforms, including the emancipation of the serfs)
1865–85	Conquest and incorporation of Central Asia into the empire
1874	"Going to the People" movement and the rise of revolutionary populism
1877–78	Russo-Turkish War
1881	Alexander II assassinated by populist terrorists
1881–94	Reign of Alexander III
1891	Construction of the trans-Siberian railway begins
1891–92	Famine and the resurgence of political opposition
1885–1900	Policies of Russification in the borderlands
1894–1917	Reign of Nicholas II
1898	Russian Social Democratic Labor Party is founded
1904–5	Russo-Japanese War
1905	Revolution of 1905: the October Manifesto promises a constitution and an elected legislature
1914–18	World War I
1917	The February Revolution deposes the tsar and installs the Provisional Government

SOVIET PERIOD, 1917–1991

1917	October Revolution: the Bolsheviks take power
1918–21	Civil War

1921–28	New Economic Policy (NEP)
1924	Death of Lenin; rise of Joseph Stalin
1928–32	First Five-Year Plan
1929	Forced collectivization begins
1932	Issuance of internal passports to urban residents
1932–33	Famine in Ukraine and North Caucasus
1934	First Congress of Union of Soviet Writers; socialist realism is officially endorsed
1934	Sergei Kirov is assassinated
1936–38	The Great Terror: nearly 700,000 people are executed and millions are sent to labor camps
1939	The Nazi-Soviet pact
1940	Soviet annexation of the Baltic states
1941–45	Soviet engagement in World War II, or the Great Patriotic War
1953	Death of Stalin; Nikita Khrushchev becomes First Secretary
1956	Twentieth Party Congress: Khrushchev denounces Stalin in the "Secret Speech"
1953–62	The Thaw: a period of increased cultural and political expression
1958	Boris Pasternak is awarded the Nobel Prize
1962	Cuban Missile Crisis
1964	Khrushchev is removed; Leonid Brezhnev becomes General Secretary
1974	Alexander Solzhenitsyn is deported
1982	Brezhnev dies
1985	Mikhail Gorbachev becomes General Secretary; cultural, economic, and political reforms known as perestroika and glasnost begin
1986	The nuclear reactor at Chernobyl explodes
1989	First democratic elections since 1917
1991	June—Boris Yeltsin is elected president of the Russian Federation
	August—A coup is attempted to remove Gorbachev from power; Yeltsin leads resistance; coup is defeated
	December—Gorbachev resigns; the USSR is dissolved

POST-SOVIET PERIOD, 1991–PRESENT

1992	Economic "shock therapy"
1994	Russia invades Chechnya to suppress independence movement
2000	Vladimir Putin is elected president; he is reelected in 2004

Selected Bibliography

GENERAL RUSSIAN HISTORIES AND ART HISTORIES

Billington, James. *The Icon and the Axe: An Interpretative History of Russian Culture.* New York: Vintage Books, 1970.

Freeze, Gregory, ed. *Russia: A History.* 2nd edition. New York: Oxford University Press, 2002.

Lincoln, W. Bruce. *Between Heaven and Hell: The Story of a Thousand Years of Artistic Life in Russia.* New York: Viking, 1998.

Riasanovsky, Nicholas V., and Mark D. Steinberg. *A History of Russia.* 7th edition. New York: Oxford University Press, 2005.

Stites, R., C. Evtuhov, D. Goldfrank, and L. Hughes. *A History of Russia: People, Legends, Events, Forces.* Boston: Houghton Mifflin, 2003.

VISUALITY READERS AND DOCUMENT COLLECTIONS

Elkins, James. *Visual Studies: A Skeptical Introduction.* New York: Routledge, 2003.

Evans, Jessica, and Stuart Hall, eds. *Visual Culture: The Reader.* London: Sage, 1999.

Foster, Hal, ed. *Vision and Visuality.* Seattle: Bay Press, 1988.

Mirzoeff, Nicholas. *An Introduction to Visual Culture.* London: Routledge, 1999.

Rose, Gillian. *Visual Methodologies: An Introduction to the Interpretation of Visual Materials.* London: Sage, 2001.

Schwartz, Vanessa, and Jeannene M, Przyblyski, eds. *The Nineteenth Century Visual Culture Reader.* New York: Routledge, 2004.

VISUAL HISTORIES, THEORIES, AND COMPARATIVE STUDIES

Aumont, Jacques. *Image.* London: British Film Institute, 1997.

Barthes, Roland. *Camera Lucida.* New York, 1980.

———. *Image/Music/Text.* New York: Hill and Wang, 1977.

Baxandall, Michael. *Painting and Experience in Fifteenth-Century Italy.* Oxford: Oxford University Press, 1972.

———. *Shadows and Enlightenment.* New Haven: Yale University Press, 1995.

Benjamin, Walter. *The Arcades Project.* Edited by Rolf Tiedemann. Translated by H. Eiland and K. McLaughlin. Cambridge, Mass.: Belknap Press of Harvard University Press, 1999.

———. "The Work of Art in the Age of Mechanical Reproduction." In Benjamin, *Illuminations,* edited by Hannah Arendt, translated by Harry Zohn. New York: Schocken, 1969.

Berger, John. *About Looking.* New York: Pantheon Books, 1980.

Bourdieu, Pierre. *Photography: A Middlebrow Art.* Stanford, Calif.: Stanford University Press, 1980.

Bryson, N., M. A. Holley, and Keith Moxey, eds. *Visual Culture: Images and Interpretations.* Hanover, N.H.: University Press of New England for Wesleyan University Press, 1994.

———, eds. *Visual Theory: Painting and Interpretation.* New York: HarperCollins, 1991.

Buck-Morss, Susan. *The Dialectics of Seeing: Walter Benjamin and the Arcades Project.* Cambridge, Mass.: MIT Press, 1989.

Burke, Peter. *Eyewitnessing: The Uses of Images as Historical Evidence.* London: Reaktion, 2001.

Clark, T. J. *The Absolute Bourgeois: Artists and Politics in France, 1848–1851.* London: Thames and Hudson, 1973.

———. *The Painting of Modern Life: Paris in the Art of Manet and His Followers.* New York: Knopf, 1984.

Crandell, Gina. *Nature Pictorialized: The "View" in Landscape History*. Baltimore, Md.: Johns Hopkins University Press, 1993.

Crary, Jonathan. *Techniques of the Observer: On Vision and Modernity in the Nineteenth Century*. Cambridge, Mass.: MIT Press, 1990.

Debord, Guy. *Society of the Spectacle*. Detroit: Black and Red, 1983.

Eisenstein, Sergei. *Metod*. 2 vols. Moscow: Muzei kino, 2002.

———. *Selected Writings*. 4 vols. London: British Film Institute; Bloomington: Indiana University Press, 1988–96.

Elkins, James. *Pictures and Tears: A History of People Who Have Cried in Front of Paintings*. New York: Routledge, 2001.

Erickson, Peter, and Clark Hulse, eds. *Early Modern Visual Culture: Representation, Race, and Empire in Renaissance England*. Philadelphia: University of Pennsylvania Press, 2000.

Foucault, Michel. *Discipline [Surveiller] and Punish: The Birth of the Prison*. New York: Pantheon Books, 1977.

Freedberg, David. *The Power of Images: Studies in the History and Theory of Response*. Chicago: University of Chicago Press, 1989.

Mary D. Sheriff and Daniel Sherman, eds. "French History in the Visual Sphere." Special issue, *French Historical Studies* 26, no. 2 (Spring 2003).

Gombrich, E. H. *Art and Illusion*. New York: Pantheon Books, 1960.

Goodman, Nelson. *The Languages of Art*. Indianapolis: Hackett, 1976.

Harley, J. B. *The New Nature of Maps: Essays in the History of Cartography*. Baltimore, Md.: Johns Hopkins University Press, 2001.

Jay, Martin. *Downcast Eyes: The Denigration of Vision in Twentieth-Century French Thought*. Berkeley: University of California Press, 1993.

Katzew, Ilona. *Casta Painting: Images of Race in Eighteenth-Century Mexico*. New Haven: Yale University Press, 2004.

Kosslyn, Stephen M., and Daniel N. Osherson, eds. *Visual Cognition: An Invitation to Cognitive Science*. 2nd edition. Vol. 2. Cambridge, Mass.: MIT Press, 1995.

Landau, Paul S., and Deborah D. Kaspin, eds. *Images and Empire: Visuality in Colonial and Postcolonial Africa*. Berkeley: University of California Press, 2002.

Mitchell, W. J. T. *Iconology: Image, Text, Ideology*. Chicago: University of Chicago Press, 1986.

Morgan, David. *The Sacred Gaze: Religious Visual Culture in Theory and Practice*. Berkeley: University of California Press, 2005.

———. *Visual Piety: A History and Theory of Popular Religious Images*. Berkeley: University of California Press, 1998.

Mulvey, Laura. *Visual and Other Pleasures*. Bloomington: Indiana University Press, 1989.

Nelson, Robert, and Richard Shiff. *Critical Terms for Art History*. Chicago: University of Chicago Press, 1996.

Nochlin, Linda. *The Politics of Vision: Essays on Nineteenth-Century Art and Society*. New York: Harper and Row, 1989.

Paret, Peter. *Art as History: Episodes in the Culture and Politics of Nineteenth-Century Germany*. Princeton, N.J.: Princeton University Press, 1988.

Pinney, Christopher, and Nicolas Peterson, eds. *Photography's Other Histories*. Durham N.C.: Duke University Press, 2003.

Pollock, Griselda. *Vision and Difference: Feminism, Femininity and the Histories of Art*. New York: Routledge, 2003.

Porterfield, Todd. *The Allure of Empire: Art in the Service of French Imperialism, 1798–1836*. Princeton, N.J.: Princeton University Press, 1998.

Press, Charles. *The Political Cartoon*. Rutherford, N.J.: Fairleigh Dickinson University Press, 1981.

Rose, Jacqueline. *Sexuality in the Field of Vision*. London: Verso, 1986.

Segall, M. H., D. T. Campbell, and M. J. Herskovits. *The Influence of Culture on Visual Perception.* New York: Bobbs-Merrill, 1966.

Sherman, Daniel J. *Worthy Monuments: Art Museums and the Politics of Culture in Nineteenth-Century France.* Cambridge, Mass.: Harvard University Press, 1989.

Sontag, Susan. *On Photography.* New York: Farrar, Straus and Giroux, 1977.

———. *Regarding the Pain of Others.* New York: Farrar, Straus and Giroux, 2003.

Taylor, Lucien ed. *Visualizing Theory: Selected Essays from V.A.R [Visual Anthropology Review], 1990–1994.* New York: Routledge, 1994.

Thomson, Richard. *The Troubled Republic: Visual Culture and Social Debate in France, 1889–1900.* New Haven: Yale University Press, 2004.

"Visual Culture Questionnaire," *October* 77 (Summer 1996): 25–70.

Ward, Janet. *Weimar Surfaces: Urban Visual Culture in 1920s Germany.* Berkeley: University of California Press, 2001.

Weigert, Laura. *Weaving Sacred Stories: French Choir Tapestries and the Performance of Clerical Identity.* Ithaca, N.Y.: Cornell University Press, 2004.

Wells, Liz, ed. *Photography: A Critical Introduction.* London: Routledge, 1997.

Wexler, Laura. *Tender Violence: Domestic Vision in the Age of US Imperialism.* Chapel Hill: University of North Carolina Press, 2000.

Young, James. *The Texture of Memory: Holocaust Memorials and Meaning.* New Haven: Yale University Press, 1992.

Zika, Charles. *Exorcising Our Demons: Magic, Witchcraft, and Visual Culture in Early Modern Europe.* Leiden, The Netherlands: Brill, 2003.

MEDIEVAL AND EARLY MODERN PERIOD

Brumfield, William Craft. *Gold in Azure: One Thousand Years of Russian Architecture.* Boston: Godine, 1983.

———. *A History of Russian Architecture.* Cambridge: Cambridge University Press, 1993.

Flier, Michael S. "Filling in the Blanks: The Church of the Intercession and the Architectonics of Muscovite Ritual." *Harvard Ukrainian Studies* 19 (1995): 120–37.

———. "The Throne of Monomakh: Ivan the Terrible and the Architectonics of Destiny." In *Architectures of Russian Identity, 1500 to the Present,* edited by James Cracraft and Daniel Rowland. Ithaca, N.Y.: Cornell University Press, 2003.

Franklin, Simon. *Writing, Society and Culture in Early Rus, c. 950–1300.* New York: Cambridge University Press, 2002.

Hamilton, George Heard. *The Art and Architecture of Russia.* 2nd ed. Baltimore, Md.: Penguin Books, 1975.

Hughes, Lindsey A. J. *Sophia, Regent of Russia, 1657–1704.* New Haven: Yale University Press, 1990.

Kivelson, Valerie A. *Cartographies of Tsardom: Maps and Political-Geographic Imagination in Seventeenth-Century Russia.* Ithaca, N.J.: Cornell University Press, 2006.

Ouspensky, Leonid, and Vladimir Lossky. *The Meaning of Icons.* Translated by G. E. H. Palmer and E. Kadloubovsky. Crestwood, N.Y.: St. Vladimir's Seminary Press, 1982.

Rowland, Daniel. "Biblical Military Imagery in the Political Culture of Early Modern Russia: The Blessed Host of the Heavenly Tsar." In *Medieval Russian Culture,* edited by Michael S. Flier and Daniel Rowland, vol. 2. Berkeley: University of California Press, 1994.

———. "Two Cultures, One Throne Room: Secular Courtiers and Orthodox Culture in the Golden Hall of the Moscow Kremlin." In *Orthodox Russia: Belief and Practice under the Tsars,* edited by Valerie A. Kivelson and Robert H. Greene. University Park.: Pennsylvania State University Press, 2003.

Smirnova, Engelina. *Moscow Icons: 14th-17th Centuries.* Translated by Arthur Shkarovsky-Raffé. Leningrad: Aurora Art Publishers, 1989.

Uspenskii, Boris A. *Semiotika iskusstva.* Moscow: Shkola "Iazyki russkoi kul'tury," 1995.

Voyce, Arthur. *The Art and Architecture of Medieval Russia.* Norman: University of Oklahoma Press, 1967.

Zhivov, V. M., and B. A. Uspenskii. "Tsar' i Bog: Semioticheskie aspekty sakralizatsii monarkha v Rossii." In *Iazyki kul'tury i problemy perevodimosti,* edited by B. A. Uspenskii. Moscow: Nauka, 1987.

IMPERIAL RUSSIA

Alekseeva, M. A. *Graviura petrovskogo vremeni.* Leningrad: Iskusstvo, 1990.

Baehr, Stephen L. *The Paradise Myth in Eighteenth-Century Russia: Utopian Patterns in Early Secular Russian Literature and Culture.* Stanford, Calif.: Stanford University Press, 1991.

Barooshian, Vahan D. *V. V. Vereshchagin: Artist at War.* Gainesville: University Press of Florida, 1993.

Brooks, Jeffrey. *When Russia Learned to Read: Literacy and Popular Literature, 1861–1917.* Princeton, N.J.: Princeton University Press, 1985.

Buckler, Julie. *Mapping St. Petersburg: Imperial Text and Cityshape.* Princeton, N.J.: Princeton University Press, 2005.

Buganov, A. V. "Historical Views of the Russian Peasantry: National Consciousness in the Nineteenth Century." In Madhavan Palat, ed., *Social Identities in Revolutionary Russia.* New York: Palgrave, 2001.

———. *Russkaia istoriia v pamiati krestian XIX veka i natsionalnoe samosoznanie.* Moscow: Institut etnologii i antropologii im. N. N. Miklukho-Maklaia, 1992.

Cracraft, James. *The Petrine Revolution in Russian Architecture.* Chicago: University of Chicago Press, 1988.

———. *The Petrine Revolution in Russian Imagery.* Chicago: University of Chicago Press, 1997.

Ely, Christopher. *This Meager Nature: Landscape and National Identity in Imperial Russia.* DeKalb: Northern Illinois University Press, 2002.

Franklin, Simon, and Emma Widdis, eds. *National Identity in Russian Culture: An Introduction.* Cambridge: Cambridge University Press, 2004.

Frierson, Cathy. *Peasant Icons: Representations of Rural People in Late 19th Century Russia.* New York: Oxford University Press, 1993.

Geldern, James von, and Louise McReynolds, eds. *Entertaining Tsarist Russia: Tales, Songs, Plays, Movies, Jokes, Ads, and Images from Russian Urban Life, 1779–1917.* Bloomington: Indiana University Press, 1998.

Gray, Camilla. *The Russian Experiment in Art, 1863–1922.* New York: Harry N. Abrams, 1962.

Gray, Rosalind P. *Russian Genre Painting in the Nineteenth Century.* Oxford: Oxford University Press, 2000.

Hilton, Alison. *Russian Folk Art.* Bloomington: Indiana University Press, 1995.

Hughes, Lindsey. *Russia in the Age of Peter the Great.* New Haven: Yale University Press, 1998.

Kaganov, Gregory. *Images of Space: St. Petersburg in the Visual and Verbal Arts.* Translated by Sidney Monas. Stanford, Calif.: Stanford University Press, 1997.

Kizenko, Nadieszda. *A Prodigal Saint: Father John of Kronstadt and the Russian People.* University Park.: Pennsylvania State University Press, 2000.

Knight, Nathaniel. "Grigoriev in Orenburg, 1851–1862: Russian Orientalism in the Service of Empire?" *Slavic Review* 59 (Spring 2000).

Kruglova, Ol'ga V. *Russkaia narodnaia rez'ba i rospis' po derevu.* Moscow: Izobrazitel'noe iskusstvo, 1974.

Layton, Susan. *Russian Literature and Empire: Conquest of the Caucasus from Pushkin to Tolstoy.* Cambridge: Cambridge University Press, 1994.

McReynolds, Louise. *Russia at Play: Leisure Activities at the End of the Tsarist Era.* Ithaca, N.Y.: Cornell University Press, 2003.

Molotova, L. N., and N. N. Sosnina. *Russkii narodnyi kostium.* Leningrad: Khudozhnik RSFSR, 1984.

Newlin, Thomas. *The Voice in the Garden: Andrei Bolotov and the Anxieties of Russian Pastoral, 1738–1833.* Evanston, Ill.: Northwestern University Press, 2001.

Norris, Stephen M. *A War of Images: Russian Popular Prints, Wartime Culture, and National Identity, 1812–1945.* DeKalb: Northern Illinois University Press, 2006.

Odom, Anne, and Liana P. Arend. *A Taste for Splendor: Russian Imperial and European Treasures from the Hillwood Museum.* Alexandria, Va.: Art Service International, 1998.

Piotrovsky, Mikhail B. *Treasures of Catherine the Great.* New York: Harry N. Abrams, 2001.

Rogger, Hans. *National Consciousness in Eighteenth-Century Russia.* Cambridge, Mass.: Harvard University Press, 1960.

Ruane, Christine. "Caftan to Business Suit: The Semiotics of Russian Merchant Dress." In *Merchant Moscow: Images of Russia's Vanished Bourgeoisie,* edited by James L. West and Iurii A. Petrov. Princeton, N.J.: Princeton University Press, 1998.

Ruud, Charles. *Russian Entrepreneur: Publisher Ivan Sytin of Moscow, 1851–1934.* Montreal: McGill-Queen's University Press, 1990.

Sandler, Stephanie. *Distant Pleasures: Alexander Pushkin and the Writing of Exile.* Stanford. Calif.: Stanford University Press, 1989.

Serman, Ilya. "Russian National Consciousness and Its Development in the Eighteenth Century." In Roger Bartlett and Janet Hartley, eds., *Russia in the Age of the Enlightenment.* New York: St. Martin's, 1990.

Smith, Douglas. *Working the Rough Stone: Freemasonry and Society in Eighteenth-Century Russia.* DeKalb: Northern Illinois University Press, 1999.

Sokolov, B. M. *Khudozhestvennyi iazyk russkogo lubka.* Moscow: RGGU, 1999.

Stavrou, T. G., ed. *Art and Culture in Nineteenth-Century Russia.* Bloomington: Indiana University Press, 1983.

Stites, Richard. *Serfdom, Society, and the Arts in Imperial Russia: The Pleasure and the Power.* New Haven: Yale University Press, 2005.

Sunderland, Willard. *Taming the Wild Field: Colonization and Empire on the Russian Steppe.* Ithaca, N.Y.: Cornell University Press, 2004.

Tarasov, Oleg. *Icon and Devotion: Sacred Spaces in Imperial Russia.* Translated and edited by Robin Milner-Gulland. London: Reaktion, 2002.

Tsivian, Yuri. *Early Cinema in Russia and Its Cultural Reception.* Translated by Alan Bodger, edited by Richard Taylor. New York: Routledge: 1994.

Valkenier, Elizabeth Kridl. *Russian Realist Art.* New York: Columbia University Press, 1977.

Whittaker, Cynthia Hyla, with Edward Kasinec and Robert H. Davis, Jr., eds. *Russia Engages the World, 1453–1825.* Cambridge, Mass.: Harvard University Press, 2003.

Wortman, Richard S. *Scenarios of Power: Myth and Ceremony in Russian Monarchy.* 2 vols. Princeton, N.J.: Princeton University Press, 1995, 2000.

Zhegalova, Serafima K. *Sokrovishcha russkogo narodnogo iskusstva: Rez'ba i rospis' po derevu.* Moscow: Iskusstvo, 1967.

Zitser, Ernest A. *The Transfigured Kingdom: Sacred Parody and Charismatic Authority at the Court of Peter the Great.* Ithaca, N.Y.: Cornell University Press, 2004.

SOVIET AND POST-SOVIET PERIOD

Banks, Miranda, ed. *The Aesthetic Arsenal. Socialist Realism under Stalin.* New York: Institute for Contemporary Art, 1993.

Bassin, Mark. "The Greening of Utopia: Nature, Social Vision, and Landscape Art in Stalinist Russia." In *Architectures of Russian Identity, 1500-Present,* edited by James Cracraft and Daniel Rowland. Ithaca, N.Y.: Cornell University Press, 2003.

———. "'I Object to Rain That Is Cheerless': Landscape Art and the Stalinist Aesthetic Imagination." *Ecumene* 7, no. 3 (2000): 313–36.

Bonnell, Victoria. *Iconography of Power: Soviet Political Posters under Lenin and Stalin.* Berkeley: University of California Press, 1997.

Bordwell, David. *The Cinema of Eisenstein.* Cambridge. Mass.: Harvard University Press, 1993.

Bowlt, John. *Russian Art of the Avant-garde: Theory and Criticism, 1902–1934.* New York: Viking, 1976.

Bown, Matthew Cullerne. *Socialist Realist Painting.* New Haven: Yale University Press, 1998.

Boym, Svetlana. *Common Places: Mythologies of Everyday Life in Russia.* Cambridge, Mass.: Harvard University Press, 1994.

Condee, Nancy, ed. *Soviet Hieroglyphics: Visual Culture in Late Twentieth-Century Russia.* Bloomington: Indiana University Press, 1995.

Dobrenko, Evgeny, and Eric Naiman. *The Landscape of Stalinism: The Art and Ideology of Soviet Space.* Seattle: University of Washington Press, 2003.

Efimova, Alla, and Lev Manovich. *Tekstura: Russian Essays on Visual Culture.* Chicago: University of Chicago Press, 1993.

Eisenstein, Sergei. *Metod.* 2 vols. Moscow: Muzei kino, 2002.

Golovskoy, Val, with John Rimberg. *Behind the Soviet Screen: The Motion-Picture Industry in the USSR, 1972–1982.* Ann Arbor, Mich.: Ardis, 1986.

Gough, Maria. *The Artist as Producer: Russian Constructivism in Revolution.* Berkeley: University of California Press, 2005.

Groys, Boris. *The Total Art of Stalinism: Avant-Garde, Aesthetic Dictatorship, and Beyond.* Translated by Charles Rougle. Princeton, N.J.: Princeton University Press, 1992.

Johnson, Vida T., and Graham Petrie. *The Films of Andrei Tarkovsky: A Visual Fugue.* Bloomington: Indiana University Press, 1994.

Kiaer, Christina. *Imagine No Possessions: The Socialist Objects of Russian Constructivism.* Cambridge, Mass.: MIT Press, 2005.

Kleiman, Naum. *Formula finala: Stat'i, vystupleniia, besedy.* Moscow: Muzei kino, 2004.

Le Fanu, Mark. *The Cinema of Andrei Tarkovsky.* London: British Film Institute, 1987.

Lodder, Christina. *Russian Constructivism.* New Haven: Yale University Press, 1983.

Malevich, Kazimir. "The World as Non-Objectivity." In Malevich, *The World as Non-Objectivity: Unpublished Writings, 1922–25,* edited by Troels Andersen, translated by Xenia Glowacki-Prus and Edmund T. Little. Copenhagen: Borgens, 1976.

Nakhimovsky, Alice, and Alexander Nakhimovsky, eds. *Witness to History: The Photographs of Yevgeny Khaldei.* New York: Aperture, 1997.

Neuberger, Joan. *Ivan the Terrible: The Film Companion.* London: I. B. Tauris; New York: Palgrave-Macmillan, 2003.

Papernyi, Vladimir. *Architecture in the Age of Stalin: Culture Two.* Translated by John Hill and Roann Barris. Cambridge: Cambridge University Press, 2002.

Paret, Peter, et al. *Persuasive Images: Posters of War and Revolution.* Princeton, N.J.: Princeton University Press, 1992.

Pinner, Robert, and Murray L. Eiland, Jr. *Between the Black Desert and the Red: Turkmen Carpets from the Wiedersperg Collection.* San Francisco: Fine Arts Museums of San Francisco, 1999.

Prokhorov, Gleb. *Art under Socialist Realism: Soviet Painting, 1930–1950.* Roseville East, Australia: Craftsman House, 1995.

Reid, Susan E. *Khrushchev in Wonderland; The Pioneer Palace in Moscow's Lenin Hills, 1962.* The Carl Beck Papers in Russian and East European Studies, no. 1606. Pittsburgh: University of Pittsburgh, 2002.

———. "Khrushchev's Children's Paradise: The Pioneer Palace, Moscow, 1958–62." In *Socialist Spaces: Sites of Everyday Life in the Eastern Bloc.* Edited by David Crowley and Susan E. Reid. Oxford, U.K.: Berg, 2002.

Rodchenko, Alexander. *Experiments for the Future: Diaries, Essays, Letters and Other Writings.* Edited by Alexander N. Lavrentiev. New York: Museum of Modern Art, 2005.

Sharp, Jane A. "Allusive Form: Painting as Idea." *Zimmerli Journal,* pt. 1, vol. 2 (2004): 74–83.

———. "Identity and Resistance: Late Soviet Abstract Painting in the Dodge Collection." *Zimmerli Journal,* part 1, vol. 1 (2003): 6–19.

Stites, Richard. "Crowded on the Edge of Vastness: Observations on Russian Space and Place." In *Beyond the Limits: The Concept of Space in Russian History and Culture,* edited by J. Smith. Helsinki: Studia Historica 62, 1999.

Struk, Janina. *Photographing the Holocaust: Interpretations of Evidence.* London: I. B. Tauris, 2004.

Tarkovsky, Andrei. *Sculpting in Time: Reflections on the Cinema.* Translated by Kitty Hunter-Blair. Austin: University of Texas, 1986.

———. *Time within Time: The Diaries. 1970-1986.* Translated by Kitty Hunter-Blair. Calcutta: Seagull Books, 1991.

Tatuirovki zakliuchennykh. St. Petersburg: Limbus Press, 2001.

Tsivian, Yuri. *Ivan the Terrible.* London: British Film Institute, 2002.

Tupitsyn, Margarita. *The Soviet Photograph, 1924-1937.* New Haven: Yale University Press, 1996.

Türkmenistanïng Halïlarï — Kovry Turkmenistana — Turkmenistan Carpets. Ashgabat: Turkmenistan Publishing House, 1983.

Turovskaya, Maya. *Tarkovsky: Cinema as Poetry.* London: Faber and Faber, 1989.

Widdis, Emma. *Visions of a New Land.* New Haven: Yale University Press, 2003.

White, Stephen. *The Bolshevik Poster.* New Haven: Yale University Press, 1988.

Wolf, Erika. "When Photographs Speak, to Whom Do They Talk? The Origins and Audience of *SSSR na stroike* (USSR in Construction)." *Left History* 6, no. 2 (2000): 53–82.

Woll, Josephine. *Real Images: Soviet Cinema and the Thaw.* London: I. B. Tauris, 2000.

Zel'ma, Georgii. *Izbrannye fotografii.* Moscow: Izdatel'stvo Planeta, 1978.

Zhadova, Larissa Alekseevna, ed. *Tatlin.* New York: Rizzoli, 1984.

Contributors

Mark Bassin, Professor, School of Geography, Environmental and Earth Sciences, University of Birmingham

A. V. Chernetsov, Professor, Institute of Archaeology, Russian Academy of Sciences, Moscow

James Cracraft, Professor of History, University of Illinois, Chicago Circle

Evgeny Dobrenko, Professor of Russian and Slavonic Studies, University of Sheffield

Adrienne Edgar, Associate Professor of History, University of California, Santa Barbara

Christopher Ely, Associate Professor of History, Florida Atlantic University

Laura Engelstein, Professor of History, Yale University

Catherine Evtuhov, Associate Professor of History, Georgetown University

Michael S. Flier, Oleksandr Potebnja Professor of Ukrainian Philology, Department of Slavic Languages and Literatures, Harvard University

Simon Franklin, Professor of Slavonic Studies, University of Cambridge

David M. Goldfrank, Professor of History, Georgetown University

Helena Goscilo, Professor of Slavic Languages and Literatures, University of Pittsburgh

Alison Hilton, Wright Family Professor of Art History and Chair, Department of Art, Music and Theater, Georgetown University

Francine Hirsch, Associate Professor of History, University of Wisconsin at Madison

Lindsey Hughes (1949–2007) was Professor of Russian History, University College London, School of Slavonic and East European Studies.

Lilya Kaganovsky, Assistant Professor of Slavic Languages and Literatures, Comparative Literature, and Cinema Studies, University of Illinois at Urbana-Champaign

Christina Kiaer, Associate Professor of Art History, Northwestern University

Valerie A. Kivelson, Professor of History, University of Michigan

Nadieszda Kizenko, Associate Professor of History, University at Albany, State University of New York

Nancy Shields Kollmann, William H. Bonsall Professor in History, Stanford University

Michael Kunichika, Department of Slavic Languages and Literatures, University of California, Berkeley

Gary Marker, Professor of History, State University of New York at Stony Brook

Polly McMichael, Lecturer, Department of Russian and Slavonic Studies, University of Nottingham

Louise McReynolds, Professor of History, University of North Carolina at Chapel Hill

Joan Neuberger, Professor of History, University of Texas at Austin

Thomas Newlin, Associate Professor of Russian Language and Literature, Oberlin College

Stephen M. Norris, Assistant Professor of History and Director of Film Studies, Miami University of Ohio

Douglas Northrop, Associate Professor of History and Near Eastern Studies, University of Michigan

Mike O'Mahony, Senior Lecturer, History of Art, University of Bristol

Donald Ostrowski, Research Advisor in the Social Sciences and Lecturer in Extension, Harvard University

Karen Petrone, Associate Professor of History, University of Kentucky

David L. Ransel, Robert F. Byrnes Professor of History and Director of the Russian and East European Institute, Indiana University, Bloomington

Susan E. Reid, Reader in Russian Visual Arts, University of Sheffield

Roy R. Robson, Professor of History, University of the Sciences in Philadelphia

William G. Rosenberg, Alfred G. Meyer Collegiate Professor of History, University of Michigan

Daniel Rowland, Director Emeritus of the Gaines Center for the Humanities, University of Kentucky

Christine Ruane, Associate Professor of Russian and European History, University of Tulsa

Jane A. Sharp, Associate Professor of Art History, Rutgers University

David Shneer, Director, Center for Judaic Studies, and Associate Professor of History, University of Denver

Elena B. Smilianskaia, Professor of History, Russian State University of the Humanities, Moscow

Douglas Smith, Resident Scholar, Jackson School of International Studies, University of Washington

Mark D. Steinberg, Professor of History, University of Illinois at Urbana-Champaign, and Editor, *Slavic Review*

Richard Stites, Professor of History, Georgetown University

Willard Sunderland, Associate Professor of History, University of Cincinnati

Robert Weinberg, Professor of History, Swarthmore College

Emma Widdis, University Senior Lecturer in Slavonic Studies, Trinity College, University of Cambridge

Erika Wolf, Senior Lecturer, Programme in Art History and Theory, University of Otago, New Zealand

Josephine Woll, Professor of Slavic Languages and Literatures, Howard University

Richard Wortman, Bryce Professor of History, Columbia University

Ernest A. Zitser, Librarian for Slavic and Eastern European Studies and Adjunct Assistant Professor, Department of Slavic and Eurasian Studies, Duke University

Illustration Credits

Every effort has been made to credit the appropriate sources of the visual material reproduced in this book; if there are errors or omissions, please contact Yale University Press so that corrections can be made in any subsequent edition.

2.1. Reproduced from *Ostromirovo Evangelie. Faksimil'noe vosproizvedenie* (Moscow: Avrora, 1988).

2.2. Private collection.

3.1–3.2. Library of the Academy of Sciences, St. Petersburg.

4.1. Perm Oblast Museum of Local Lore.

4.2–4.4. Projections by A. V. Chernetsov.

5.1. Reproduced from A. I. Malein, *Zapiski o Moskovitskikh delakh* (St. Petersburg, 1908), 77.

6.1. State Tretiakov Gallery, Moscow. With permission from Scala / Art Resource, NY.

6.2. Reproduced from V. N. Ivanov, ed., *Oruzheinaia palata* (Moscow: Moskovskii rabochii, 1964).

6.3. Courtesy of Smithsonian Institution Traveling Exhibition Service.

7.1. The Museums of the Moscow Kremlin.

8.1–8.2. Reprinted from the archives of Engelina Smirnova with permission.

8.3. Engraving from *Al'bom Meierberga* (1903). Reprinted with permission of Widener Library, Harvard College Library, Slav 3076.52.

9.1–9.2. Russian State Archive of Ancient Acts (RGADA), Moscow.

10.1. Reproduced from *Portrety, gerby i pechati Bol'shoi gosudarstvennoi knigi 1672* (St. Petersburg: Izd. S. Peterburgskago arkheologicheskago instituta, 1903), from the Collections of the Library of Congress.

10.2. From the collection of James E. Cracraft.

11.1–11.2. State Pushkin Museum of Fine Arts, Moscow.

12.1. Reproduced from Yuri Piatnitsky, Oriana Baddeley, Earleen Brunner, and Marlia Mundell Mango, eds., *Sinai, Byzantium, Russia: Orthodox Art from the Sixth to the Twentieth Century* (London: The Saint Catherine Foundation, 2000).

13.1. Hillwood Museum & Gardens, Bequest of Marjorie Merriweather Post, 1973 (Acc. no. 11.33). Photo: Hillwood Museum & Gardens, Washington, D.C., by Edward Owen.

14.1, 14.3–14.4. Reproduced from Andrei Bolotov, *Al'bom ego s risunkami i avtografami otdelnykh lits. 1781–1821,* Russian National Library, St. Petersburg.

14.2. Reproduced from Al'bom "Vidy imeniia Bobrinskikh 'Bogoroditsk'" (risunki A. T. Bolotova i ego syna Pavla 1786 g.), State Historical Museum, Moscow, 76434 i II 1304.

15.1–15.4. State Historical Museum, Moscow.

16.1. © 2007, State Russian Museum, St. Petersburg.

16.2. Reproduced from *Russkii muzei: al'bom-putevoditel'* (St. Petersburg: Izdatel'stvo "P-2," 2001), 12.

16.3. Reproduced from Eleonora Fradkina, *Zal Dvorianskogo sobraniia: zametki o kontsertnoi zhizni Sankt-Peterburga* (St. Petersburg: Kompozitor, 1994), f. p. 199.

17.1. State Tretiakov Gallery, Moscow.

18.1–18.2. Print Collection, Miriam and Ira D. Wallach Division of Art, Prints and Photographs, The New York Public Library, Astor, Lenox and Tilden Foundations.

19.1. Reproduced from Ol'ga V. Kruglova, *Narodnaia rospis' severnoi Dviny* (Moscow: Izobrazitel'noe iskusstvo, 1987).

19.2. Reproduced from Alison Hilton, *Russian Folk Art* (Bloomington: Indiana University Press, 1995).

20.1. State Tretiakov Gallery, Moscow.

21.1. Reproduced from *Le loubok: L'imagerie populaire russe xvii–xix-ème siècles* (Leningrad: Éditions d'Art Aurora, 1984), no. 150.

21.2. Reproduced from *Playing Cards: The Collection of Alexander Perelman; New Accessions, 2000–2002* (St. Petersburg and Peterhof: Abris Art Publishers, 2002), no. 57, p. 76.

21.3–21.4. Reproduced from *Imperatorskie kollektsii v sobranii rossiiskogo etnograficheskogo muzeia: "Tsari narodam — narody tsariam"* (Moscow and St. Petersburg: Passport International, 1995) nos. 36, 38, p. 71.

22.1–22.2. State Historical Museum, Moscow.

23.1–23.2. Reproduced from A. O. Karelin, *Khudozhestvennyi al'bom fotografii s natury* (Nizhnii Novgorod, [18 —]).

24.1. Collection of Christine Ruane.

24.2. The Collections of the Library of Congress.

25.1. Reproduced from S[ergei] N [ikolaevich] Smirnov, *Khram-pamiatnik: stroen v 1910–1911 gg.* (Petrograd: Izd. Vysochaishe uzhrezhdennago komiteta po sooruzheniia khrama, 1915). Cover title: *Khram-pamiatnik moriakam, pogibshim v voinu s Iaponiei v 1904–1905.*

26.1. Reproduced from *Moskovskie pechatniki v 1905 godu* (Moscow, 1925).

27.1–27.2. Collection of Louise McReynolds.

28.1. Collection of James E. Cracraft.

29.1. Reproduced from *A Portrait of Russia: Unknown Photographs from the Soviet Archives* (New York: Pantheon Books, 1989), 192–93.

29.2. Russian Academy of Sciences, St. Petersburg.

29.3. Reproduced from *Istoriia SSSR* (Moscow: Nauka, 1967), vol. 7, p. 83.

30.1. Russian State Archive of Literature and Art, Moscow.

31.1–31.3. Reproduced from *Bezbozhnik u stanka,* nos. 5, 8, 2 (1923). Slavic and Baltic Division, The New York Public Library, Astor, Lenox and Tilden Foundations.

32.1–32.3. Reproduced from Akademiia nauk, *Chuvashskaia respublika: Predvaritel'nye itogi rabot Chuvashskoi ekspeditsii Akademii nauk SSSR po issledovaniiam 1927 g.,* vol. 10, pt. 1, of *Materialy Komissii ekspeditsionnykh issledovanii* (Leningrad, 1929).

33.1–33.2. Russian State Documentary Film and Photo Archive, Krasnogorsk.

33.3. Max Penson, copyright Dina Penson Khojaeva, courtesy of Anahita Gallery, Santa Fe.

34.1–34.3. Courtesy of Larry Zeman and Howard Garfinkel, Productive Arts, USA.

35.1–35.3. State Film Archive of the Russian Federation, Belye Stol'by.

36.1. Reproduced from *Türkmenistaniṅg Halïlarï — Kovry Turkmenistana — Turkmenistan Carpets* (Ashgabat: Turkmenistan Publishing House, 1983).

37.1. Photograph by Mike O'Mahony.

37.2. Reproduced from *Arkhitektura moskovskogo metropolitena* [2. ochered] (Moscow: Gos. Architekturnoe izd-vo Akademii arkhitektury SSSR, 1941), 69. Slavic and Baltic Division, The New York Public Library, Astor, Lenox and Tilden Foundations.

37.3. © 2007, State Russian Museum, St. Petersburg.

38.1. Reproduced from *Sovetskaia arkhitektura za XXX let. RSFSR.* 1st ed. (Moscow: Izdatel'stvo Akademii arkhitektury SSSR, 1950).

38.2. Reproduced from Iakov Isidorovich Shur, *Moskovskii pavil'on VSKhV* (Moscow: Moskovskii rabochii, 1939).

38.3. Reproduced from Ia. F. Zhukov, *Arkhitektura Vsesoiuznoi Sel'skokhoziaistvennoi Vystavki* (Moscow: Gosurdarstvennoe izdatel'stvo literatury po stroitel'stvu i arkhitekture, 1955).

38.4. Photograph by Sergey Nemanov.

39.1. Poster Collection, RU/SU 151, Hoover Institution Archives.

39.2. Poster Collection, RU/SU 1921.1, Hoover Institution Archives.

39.3. Poster Collection, RU/SU 2317.2R, Hoover Institution Archives.

40.1–40.3. Reproduced from *Ivan the Terrible,* Part II (completed 1946, released 1958), director: Sergei Eisenstein.

41.1. Courtesy of the Union of Soviet Art Photographers.

41.2–41.3. Courtesy of the Union of Soviet Art Photographers and Anna Khaldei.

41.4. Courtesy of Michael P. Mattis.

42.1. From a private collection with the assistance of The Museum of Russian Art, Minneapolis, USA.

43.1. Reproduced from V. Yegerev, *Moskovskii Dvorets pionerov* (Moscow: Stroyizdat, 1964).

43.2. Photograph by Georgy Arzamazov, from the collection of Susan E. Reid.

43.3. Photograph by Susan E. Reid.

44.1–44.2. Reproduced from *Ordinary Fascism* (1965), director: Mikhail Romm.

45.1–45.2. Reproduced from *Solaris* (1972), director: Andrei Tarkovsky.

46.1. State Tretiakov Gallery, Moscow.

46.2. Lydia Alekseevna Masterkova, *Untitled,* 1967. Oil and collage on canvas, 100.1 × 83.4 cm. Jane Voorhees Zimmerli Art Museum, Rutgers, The State University of New Jersey. The Norton and Nancy Dodge Collection of Nonconformist Art from the Soviet Union. Photograph by Jack Abraham. 19002.

46.3. Igor Makarevich, *Green Square,* 1989. Encaustic, 79.5 × 79.5 cm. Jane Voorhees Zimmerli Art Museum, Rutgers, The State University of New Jersey. The Norton and Nancy Dodge Collection of Nonconformist Art from the Soviet Union. Photograph by Jack Abraham. 00032.

46.4. Photograph by Igor Makarevich, from the collection of Jane A. Sharp.

47.1. Photograph by Andrei Usov.

48.1 Photograph by Yury Brodsky and Mark Milov. Collection of Elena B. Smilianskaia.

48.2. Photograph by Roy R. Robson.

49.1. © 2007, State Russian Museum, St. Petersburg.

49.2. State Tretiakov Gallery, Moscow.

49.3–49.6. Collection of Helena Goscilo.

50.1–50.2. Photographs by Michael Kunichika.

Index

Page numbers in *italics* refer to illustrations.